James Hamilton is an art and cultural historian. He was until retirement in 2013 curator of art collections and projects in Portsmouth, Wakefield, Sheffield, Leeds and the University of Birmingham, where he is a Fellow of the Barber Institute of Fine Arts. He was Alistair Horne Fellow at St Antony's College, Oxford, in 1998–9.

Also by James Hamilton

Turner: A Life
Faraday: The Life
London Lights: The Minds that Moved the City that
Shook the World 1805–51
A Strange Business: Making Art and Money in Nineteenth-
Century Britain

Turner and the Scientists
Turner's Britain
Turner: The Late Seascapes
Turner and Italy
Fields of Influence: Conjunctions of Artists and
Scientists 1815–60 (editor)
Volcano: Nature and Culture

Arthur Rackham: A Life with Illustration
William Heath Robinson
Wood Engraving and the Woodcut in Britain *c.*1890–1990

The Sculpture of Austin Wright
Hughie O'Donoghue: Painting, Memory, Myth
Louis Le Brocquy: Homage to his Masters
The Paintings of Ben McLaughlin

Gainsborough earned and how much of it went on necessary display, such as grand houses in Bath and Pall Mall. And fascinating it is, too . . . Gainsborough is one of the most lovable of great artists, and his personality shines through. This is an enjoyable biography by a writer who understands him'

Philip Hensher, *The Spectator*

'[A] richly humane biography of the artist . . . [An] astute yet generous book' Kathryn Hughes, *Guardian*

'[A] wonderful new biography . . . Hamilton is fascinating on Gainsborough's experimental and innovative technique, how he moved from what he calls the "dabbing" of the artist's early paintings, with their more doll-like figures and outlines, to the characteristic loose sweeps, the "brushing" style of his later work' Lucy Lethbridge, *Financial Times*

'James Hamilton's wholly absorbing biography is very different from the usual kind of art historical study that often surrounds such a major figure as Thomas Gainsborough. Hamilton is positively in love with his subject, and writes with verve and enthusiasm, yet grounds it on vast research with primary and secondary sources, all impeccably noted'

Marina Vaizey, *The Arts Desk*

'Hamilton's Gainsborough is a "Jack-the-Lad", a "swigging, gigging, kissing, drinking, fighting" good-time city boy in London and Bath . . . [Hamilton] is strong both on the Gainsborough who is stirred by harvest gleaners and woodland cottages, and the Gainsborough who frets about his framing fees and boasts about the musical instruments he has bought . . . [The book] gallops along at highwayman's pace' Laura Freeman, *Apollo Magazine*

'Spendthrift, talking nineteen to the dozen, laddish, musical and often resentful of the sitters that he had to paint in order

to earn a living ("confounded ugly creatures"), [Gainsborough] is brought to lively and likeable life in *Gainsborough: A Portrait* by James Hamilton. The painter was, Hamilton says, more serious about his art than he let on, but it is those trace elements of his personality that give his pictures their sparkle'

Michael Prodger, *Sunday Times* Art Books of the Year

'Were Mr and Mrs Andrews complete pricks? In his delightfully racy portrait of one of our most renowned British portraitists, the art historian James Hamilton suggests that Thomas Gainsborough's wedding picture of a pair of snooty Suffolk landowners is adorned with more pictures of penises than the wall of a public loo. This is just one of many new lights cast on Gainsborough, a "swigging, gigging, kissing, drinking, fighting" Jack-the-lad who, with his gift of the gab and his canny eye on the main chance, cavorts through Georgian England'

Rachel Campbell-Johnston, *The Times* Art Books of the Year

'Glitters from beginning to end'

Jonathan Wright, *Catholic Herald* Biographies of the Year

'This account of the Georgian portrait painter's life is set against a backdrop of dirt and highwaymen and skeletons on gibbets on Hounslow Heath. An 18th-century Scottish sex therapist even makes an appearance. But for all the fun the author has with the painter's penchant for drink and sex, the writing really takes off when Hamilton engages with Gainsborough's paintings themselves in all their swimmy, silken sheen'

Teddy Jamieson, *Sunday Herald* Art Books of the Year

'A fine and empathetic portrait [of] a man who was as lively as his brushwork'　　　　Michael Prodger, *RA Magazine*

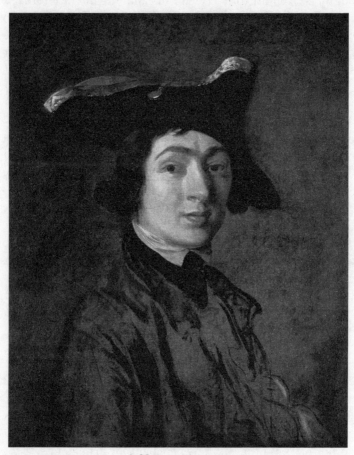

Self-Portrait, 1754.

GAINSBOROUGH

A Portrait

JAMES HAMILTON

WEIDENFELD & NICOLSON

First published in Great Britain in 2017
This paperback editoin published in 2018
by Weidenfeld & Nicolson
an imprint of The Orion Publishing Group Ltd
Carmelite House, 50 Victoria Embankment
London EC4Y 0DZ

An Hachette UK Company

1 3 5 7 9 10 8 6 4 2

A CIP catalogue record for this book is
available from the British Library.

ISBN (paperback) 978 1474 60106 1
ISBN (ebook) 978 1 4746 0053 8

Typeset by Input Data Services Ltd, Somerset

Printed and bound in Great Britain
by Clays Ltd, Elcograf S.p.A.

MIX
Paper from
responsible sources
FSC® C104740

www.orionbooks.co.uk

For my grandsons: Alexander, Benjamin and William

Contents

IV: *Bath*

V: *London again*

Illustrations

Second plate section

Third plate section

Acknowledgements

Thomas Gainsborough has been an exhilarating companion, and I thank his shade with gratitude; but more important to me for advice, information and support during research and writing have been Stephanie Adams, Rosemary Andreae, Elizabeth Clark Ashby, Nigel Bailey, Julian and Isabel Bannerman, Prof. Iann Barron, the Duke of Beaufort, Hugh Belsey, Andrew Bernardi, Ron Berryman, Hugh Bethell, Tom Birch-Reynardson, Jane Branfield, Ceri Brough, Anne Buchanan, Spike Bucklow, Nigel Burke, Geoff Burns, Mary Carr, Jeannie Chappell, Steve Clark, Martin Clayton, Anthony Cobbold, James and Anne Collett-White, Matthew Craske, Brianna Cregle, Simona Dolari, Sophie Drury, Edmund Fairfax-Lucy, Philip Fletcher, Susan Foister, Roberta Giubilini, Julian Hall, Kate Heard, Ben Hoffnung, James Holloway, Penelope Hopwood, Lord and Lady Howe, Pamela Hunter, Thea Innes-Kerr, Edward Jennings, Colin Johnston, Sarah King, Nicole Koutsofta, Sir Charles and Lady Legard, Christopher Legard, Laurie Lewis, Barbara Linsley, Hannah Litvack, Duncan Melville, who maintains the 'Kirby and his World' website, James and Mary Miller, Elaine Milsom, Susan Morris, Philip Mould, Nikolai Munz, John and Virginia Murray, Eva Oledzka, Caroline Palmer, the Earl and Countess of Pembroke, Mark Pomeroy, Martin Postle, Sandra Powlette, Jenny Ramkalawon, Rosie Razzall, John Martin Robinson, Angela Roche, Chris Rolfe, Nancy Scott, Desmond Shaw-Taylor, Therese Sidmouth, Robin Simon, Susan Sloman, Ann Smith, Robert Smith, Mary Smyth, Michael Snodin, Lindsay Stainton, Elizabeth Timms, David Tooth, Penny and Keith Turner, Rosemary and Stephen Watkins, Drew Westerman, Edward and Mandy Weston, Jonathan Wiseman, Julie Wiseman and Amina Wright. I am most grateful to them, as to all the staff of Gainsborough's House, Sudbury, in particular to Mark Bills, Louise Brouwer, Peter Moore and Mary Smyth, to my agent Felicity Bryan and, at Weidenfeld

& Nicolson, Alan Samson, Simon Wright, Kate Wright-Morris and Anne O'Brien. My further thanks go to the John R. Murray Charitable Trust for making a generous grant towards the cost of illustrations, and to Hugh Belsey, Kate Eustace, Robert Maxwell, James Miller and Lindsay Stainton who read, and in every case improved, the text at early stages.

I am most grateful to the following for permission to quote from correspondence and other documents: the Royal Archives, the British Library, the Royal Academy, the Bodleian Library University of Oxford, Bath Record Office Bath & North East Somerset Council, Suffolk Record Office, Gainsborough's House Sudbury, his Grace the Duke of Beaufort and Sir Edmund Fairfax-Lucy. If I have inadvertently omitted any copyright holders would they please let me know.

Finally, my family have for some years had Thomas Gainsborough and *his* family living as lodgers in our house. I thank them, and particularly my wife Kate Eustace, for making room.

James Hamilton
Kidlington
April 2017

1. A portrait of Thomas Gainsborough

Thomas Gainsborough lived as if electricity shot through his sinews and crackled at his finger ends. There is a fire in Gainsborough: it lights up his paintings, but beyond its flicker it also reveals a lifelong sense of unease, and a way of seeing things that he may not always have anticipated.

Economic prosperity in eighteenth-century Britain was volatile and unreliable, a condition that Gainsborough experienced within his family during his youth. If that taught him anything, it was to be a single-minded opportunist, and to realise that painting had its own special power: to create image, to make money, and to build friendship. In his portraits Gainsborough echoed the changes he experienced around him: the early work presents formal, sniff-necked people, doll-like figures who might be sucking lemons. Later subjects relax into their backgrounds as if they swayed with the wind in the trees. His landscapes, however, move another way, from early attention to such detail as modern methods of farming, indicating wealth, good sense, engagement and ownership, to a later dreamland, nostalgia and desire for escape. The direction of his travel in landscape reflects the prototypical swing of the pendulum of expression, which returns a century later in the transition between Pre-Raphaelite intensity of vision and the collapsed formalism of Impressionism. There are already many powerful art histories that explore Gainsborough's work, some of which observe a certain orthodoxy of approach that I have attempted to avoid. This book tries not to be another art history, but biography.

Thomas Gainsborough was blessed in a multitude of ways. He enjoyed the divine gift of the felicitous line: in his draughtsmanship, his handwriting, his piquant turn of phrase, and of course in his skill with the brush: colour, shimmer, the rustle of cloth and the glow of departing light. Learned from penmen at an early age, and from engravers in his adolescence, his handwriting is

cursive and sweetly legible, and he wrote his relatively few sur-
viving letters with elegance, humour and clarity. He was thrilled
by fine penmanship in others, and said so.[1] When circumstances
required he expressed himself with directness and decision, but
some letters were found to be absolutely filthy, and after his death
were destroyed by appalled family members and others concerned
for their own assessment of his reputation. One commented in-
dignantly, before censoring or even destroying a letter: 'It is a
pity that such a genius as Gainsborough should have dishonoured
himself, and sullied pure white paper, with such profane filth.'[2] A
particularly critical acquaintance spoke of 'a very dissolute, ca-
pricious man, inordinately fond of women and not very delicate
in his sentiments of honour'.[3] In the light of these remarks, and
what prompted them, it is likely that his most famous painting,
Mr and Mrs Andrews, is also, silently and intentionally, the one
most heavily spiked with sexual innuendo.

In conversation Gainsborough could make a clear and consid-
ered point as the moment warranted: mumchance he was not. A
number of his conversations survive by report, and all reflect the
speed and urgency of his pattern of speech. His tongue could and
would run away with him: 'if [only] I could have writ as fast as he
spoke', reported a good friend in frustration when Gainsborough
regaled him with an account of a trip to Antwerp in 1783.[4] He
knew where and how to express his opinions: the painter Francis
Bourgeois remembered that 'he talked bawdy to the King and
morality to the Prince of Wales'.[5] He blushed easily when embar-
rassed or challenged, he might guffaw without much warning,
even in the faces of his clients, he waved his arms about, he had
what he called his 'damned grinning trick'; but he was generally
kind, generous and charitable, guided above all by 'the tender
feelings of his heart'.[6] The diarist Joseph Farington reported that
he was 'very familiar and loose in his conversation to his intimate
acquaintance, *but he knew his own value*'.[7] However, we should also
note the words of a later, more reflective biographer, Allan Cun-
ningham, who warned his readers in his essay on Gainsborough
that 'The companions of the artist saved the chaff of his conversa-
tion, and allowed the corn to escape.'[8]

He had mood swings and a volatility that could equally protect,

charm and destroy, and in a temper slashed a canvas when a client refused it.[9] This same volatility, however, also drove his charity, which 'was indiscriminate and his extravagance wild';[10] and it made him part company with the Royal Academy – twice. These impetuous actions, once in 1773 and again, finally, in 1784 when he was at the height of his fame, damaged his public reputation and dramatically reduced the audience for his art. He was not wholly balanced. As his sometime friend Philip Thicknesse put it, there was 'certainly only a very thin membrane which kept this wonderful man within the pale of reason'.[11] Who was he *like*? Jerry Lee Lewis with a paintbrush might not be far from the mark. But more, with a personality that courted chaos, and a talent that drew out divine expression, he touches Wolfgang Amadeus Mozart.

Music became an obsession with Gainsborough, perhaps because he was not as good at it as he thought he was. When he played his violin he did so 'in the wild manner of one who never applied himself to learn'.[12] The actor David Garrick, a real friend, touched on Gainsborough's mental energy and the power it could unleash when it spilled over: 'his cranium is so crammed with genius of every kind that it is in danger of bursting upon you, like a steam-engine overcharged, which, if it were regulated, its powers would be as great'.[13] Gainsborough's hot temper could also express itself in nastiness: he himself told, though with some tone of apology and more than ten years after the event, of the public tongue-lashing he gave to an unfortunate amateur singer when it became clear during the course of a concert that the man could not sing a new piece on sight.[14]

If you are looking for revolutionary or philosophical ideas expressed in painting, you will not find them in Gainsborough: his was not, it seems, a life of the mind. If you are looking for trenchant social comment and criticism of the status quo, you will not find it in Gainsborough. If you are looking for painterly insight into contemporary scientific advances try Joseph Wright of Derby, for you will not find it in Gainsborough: Garrick's use of a steam-engine metaphor to describe him was serendipitous. While you will find some kind of pre-Freudian psychological insight in his portraits of his wife, daughters and close musician and actor friends, it is rare in the portraits of those who paid him, not least

because he disliked so many of them, and they came in and out of his painting room so rapidly. However, while you cannot tell immediately from his portraits of Grace Elliott, Nancy Parsons or Mary Robinson that they were high-class tarts, tall and inaccessible, far above their avalanches of satin Gainsborough presents them with a sadness that remains. In the 1780s, late in both their lives, he gave one short portrait sitting to Joshua Reynolds. He and Reynolds had always had a difficult relationship, and whatever came out of that hour has vanished.[15]

On the other hand, if we seek examinations of particular strata of society – aristocrats, the moneyed gentry – Gainsborough's portraits will supply them with a grandeur that most expected. He invests these subjects with an air of confidence, but one that is sometimes only skin-deep. If we seek a poetic response to landscape and those who work it, there too in his early paintings Gainsborough strikes a resonant chord, though topographical reportage it is not. In his later, most nostalgic evening landscapes, we sense retreat, reflection and the licking of wounds. What Thomas Gainsborough was, it seems, is a clear-eyed, hard-working alchemist who could turn muck, misery and pride into elegant, seductive and eloquent images of either riches or poverty. Indeed, he tended to paint at the extremes: his subjects were, by and large, only the very rich and the very poor. He loved the smell, colour and fluidity of paint, and the smell, colour and fluidity of material: he used one fluidity to express the other. He did not spare himself physically: according to Thicknesse and others he stood 'constantly . . . upon his feet [in front of his easel] during five or six hours every day'.[16] 'Dashing out his designs' was how one friend put it when he saw Gainsborough at work.[17] He could empathise most closely both with the strains of power and position, with human vanity, and with the momentary, passing pleasures of rural life experienced by country people. While he would be on cracking form at Buckingham House or Windsor Castle, engaging amiably with the King and Queen, he generally disliked staying with aristocrats.[18]

Gainsborough was a country lad, he knew the cold breath of poverty and the countless little local tragedies. He will certainly have met 'mute inglorious Miltons'; read 'the short and simple

annals of the poor'; and visited many churchyards where 'the rude forefathers of the hamlet sleep'.[19] But Gainsborough could also maintain an importance with his sitters, teach princesses to paint, and walk with kings. His tragedy – and theirs – is that he failed to teach his daughters to live productive lives, and he never really got to know his wife. His difficulty with Margaret, Mrs Thomas Gainsborough, may indeed have been a spur for his prolific later production as a landscape painter. Margaret Gainsborough was reportedly hot-tempered and controlling. She demanded her husband hand over his income as a portrait painter: she knew who came in and who went out of his painting room, what size the portraits were on his easel, and how much he charged for them. But what she did not quite know was how much he was paid for his landscapes. He made sure of that. With their tempers and passions Margaret and Thomas were the Beatrice and Benedick of art, but, to mix Shakespearean references, which the shrew and which the tamer it is impossible to tell.

Thomas Gainsborough danced through life, danced across his time, and now spins with a pirouette and a bow into ours. He was probably taller than average by the standards of his day. He described himself as 'a long cross-made fellow [who] flings his arms about like threshing flails without half an idea of what he should be at', and as having a forehead that 'runs back a good deal more than common'.[20] His self-portrait with his wife and child of the early 1750s shows a long, lanky, brown-haired young man (Pl. 23); the portrait sketch by Zoffany of 1771 gives us his wide eyes, his strong sharp nose, firm arched eyebrows, and a perpetually questioning and surprised air (Pl. 24). As much as fifty-two years after his death, he was remembered as 'one of the most joyous eccentrics of the last century'.[21] Responsive but irresponsible, observant but obstinate, gentle, generous, impetuous, irritable, and occasionally nasty when frustrated, Thomas Gainsborough was a human being like everybody else. Once a friend he was a friend for life: one friend remembered him as 'charitable and hospitable and kind'.[22] And one of his most loving, affectionate and touching portraits is of the one man who, in all the world, hurt him the most. Though some achieved it, it took considerable effort to fall out with Thomas Gainsborough.

There are relatively few certain dates in Gainsborough's life. Birth and death, of course, and we know the date he married, the date his first child was buried, and the dates he exhibited around one hundred of his paintings – though that does not fully define when they were painted. Only about two-thirds of his one hundred and fifty surviving letters are securely dated, but these are bunched across tight time spans, the 1760s and 1770s, and written to the small number of individuals who took the trouble to keep them.

For the biographer who requires a constellation of dates to steer by, Gainsborough supplies thin pickings. However, the activity, society, incident and enterprise that surround him generates an atmosphere that is rich in reflected light and dense in reportage. That is why he is so intriguing and challenging a subject. 'He is exceedingly shy of being *really* acquainted, but . . . very sincere to the few he professes a friendship for.'[23] So, his life.

I

Suffolk

2. Obliged to pink

Already, when Thomas was born, the youngest in his large family, there were eight surviving children spread out in age as a village will spread wide at a crossroads. Five years after she and her husband had married, Mary Gainsborough, aged eighteen or nineteen, had Robert, the first of her children to live. At least one earlier baby had died. Mary (née Burrough) had been a very young bride, fourteen years old; John, her husband, was twenty-one. Then, one after another, boy, girl, girl, boy, girl, girl, boy, until, two years after her son Matthias, Mary had her last child, one spring day in 1727, another boy. He was christened Thomas at the Independent Meeting House in Friars Lane, Sudbury, in Suffolk, on 14 May 1727.

The press of people in their house in Sudbury was unavoidable for a child growing up under its roof: character, movement, busyness, clothes, temperament and human expression evident from the start. When Thomas was five, Robert, his twenty-three-year-old brother, married, became a father very rapidly, and vanished with his young wife and baby into Lincolnshire.[1] High words, audible to all including a five-year-old, must have been exchanged during that episode, as Robert and Elizabeth's marriage was clandestine and probably urgent. While Robert just disappeared, another older brother, John, hung around the house and around Sudbury, an errant genius with, already perhaps, a dream of inventing brass, leather and wood gadgets that would change the world and make his fortune. But with his nimble hands and twitching eye, young John was erratic, not really trustworthy, and not for nothing was he known in the family as 'Scheming Jack'.[2] Years later we hear that John found it hard to finish anything: something always went wrong with his schemes; his failures he would put down to the urgent flow of ideas: 'if I had but gone on with it I am sure I should have succeeded, but a new scheme came upon me'.[3] This tendency may have had its root in his youth. 'Scheming Jack'

remained a presence in the household, a worry to his parents, and a lifelong burden to his younger siblings. Although in 1743 John had a brush with the law in Beccles, he rarely strayed from Sudbury, and was always in need of money.

So, removing these two much older, useless boys from the picture, we have four capable girls in the house when Thomas was five years old – Mary, Sarah, Susan and Elizabeth – and, in the middle, one other brother, Humphrey, a gentle, good-natured and self-contained boy, then aged fourteen. Thomas therefore could seldom have been left alone; the house will never have been quiet, silence in Sepulchre Street a rare blessing. It was perhaps in such silences that Thomas might watch, help and learn from his mother painting the flowers they picked together. At flower painting, his early biographer the Sudbury printer George Fulcher records, Mary Gainsborough 'excelled'.[4] For domestic and child-minding duties the older daughters Mary and Sarah, nineteen and seventeen respectively, were on hand; Susan and Elizabeth, twelve and ten, the same. They all took good care of Thomas, because, suddenly, when he was three and Thomas still a babe-in-arms, Matthias died 'when a fork he was carrying while running stabbed him in the head'.[5] If this is what killed Matthias, the children had now had quite enough domestic horror in their young lives, and will have been extra careful in looking after Thomas. So, the youngest of this large family, Thomas Gainsborough was a good candidate for doting upon, for spoiling, and the constant object of supreme care from a small, loving team.

Of the two older girls, Mary trained as a milliner, as many girls did in Sudbury, and in 1740 she married a young Church of England parson, Christopher Gibbon, curate and schoolmaster at Cavendish, six miles away. Sarah, known in the family as Sally, stayed at home until 1745 when she married a local carpenter, Philip Dupont. The fourth child, Humphrey, was, like his elder brother John, naturally inventive and practical. Unlike John, however, Humphrey had innate modesty, and a perspective on life that led him in 1736 aged eighteen to the dissenting academy at Moorfields in London, and on to a career in the nonconformist ministry in Newport Pagnell and Henley-on-Thames.[6] He had added genius and dexterity, which opened for him a parallel career

as an inventor of such a degree of ingenuity that he rapidly out-
shone his brother John, and even now challenges James Watt as a
pioneer of the steam engine, John Harrison as a supremely skilled
watchmaker, and Charles and Jeremiah Chubb as the inventors of
many improvements to locks.[7] Thomas always had the security of
an older family way above him: 'Scheming Jack' with yet another
new invention, certain of fame and fortune; Mary and Sally, Susan
and Elizabeth, sewing at home and dreaming of matrimony; and
charming, intelligent, prayerful Humphrey contemplating the
ministry while fiddling with brass, leather and wood in emulation
of his older brother.

That is how it might have looked from outside: the Dextrous
Gainsboroughs. But the Gainsboroughs of Sepulchre Street were
poor, or unlucky, relations. Their father, who was about forty-
four years old when Thomas was born, suffered from thwarted
ambition, ill luck, a desire to keep up in business with his wider
property-owning family, and possibly a chronic lack of judge-
ment. This seems to have led John Gainsborough in 1722 to buy
a twenty-one-year lease on the Gibblins, or Guiblers, a pair of
neighbouring mediaeval half-timbered houses and orchard in
Sepulchre Street, and to link them together with a raised roof-line
and a new forty-two-feet-long brick façade.[8]

Members of the wider Gainsborough family owned property in
the town and beyond on a much larger scale than John, and made
money by renting, and buying and selling properties. However,
this masks a bigger picture. Sudbury had become rich enough
from the wool and weaving trades in the fourteenth and fifteenth
centuries to have three large and highly decorated churches
within a half-mile radius. In the 1730s and early 1740s, however,
it was an unhappy place, and while some of the Gainsboroughs
gained in property ownership, others lost out in the town's vola-
tile and suspicious atmosphere. Sudbury politics were corrupt and
unstable, and endemic bribery, which continued throughout the
century, had been revealed in parliamentary enquiries in 1702
and 1703.[9] During the 1734 general election, the Earl of Bristol,
of nearby Ickworth, tried to put one of his sons into a Sudbury
parliamentary seat, and canvassed the prominent cloth-merchant
William Carter of Ballingdon, who had himself been considered

as a local MP. The Prime Minister, Robert Walpole, warned the Earl against Carter, whom he described as a 'double dealer' who had 'already promised support to a rich London merchant' and would 'do the like by twenty more'.[10] Sudbury was available to the highest bidder. As the historian Susan Mitchell Sommers has put it: 'Sudbury politics were so debased [in the eighteenth century] that elections became little more than financial transactions'.[11] Fear of foreign imports damaging the cloth trade caused dissatisfaction leading to bankruptcies, penury, overheated behaviour and, in 1740, food riots. From Sepulchre Street the Gainsboroughs could hear these disturbances, and their lives were coloured by them.

Whether he was opportunist and ill-advised, or just irresponsible, idiotic, partisan and venal, John Gainsborough took it upon himself to follow family practice and buy up property, leading to his disastrous decision to improve the Sepulchre Street properties. Either as a result of this development, or his own poor business management, he was declared bankrupt in 1733.[12] He was not alone: bankruptcy in Sudbury was commonplace, as the cloth trade required high levels of capital and strong banking support.[13] John Gainsborough had not had an orthodox business career: he was listed in May 1722 as a milliner, and is elsewhere described as keeping a shop, as a 'saymaker', that is, a maker of fine serge-like cloth,[14] a clothier, and a merchant in shrouds for the dead. He travelled into France and Holland to deal in these wares, and for a time employed others.[15] It was a lucrative trade, because sooner or later everybody would have need of a shroud, by now required for burials by Act of Parliament. As a result, the making of shrouds, in all their 'grim neatness of plaitings, stomachers, ruffles and gimping', had become a staple industry in Sudbury. It became John Gainsborough's fate that he was 'obliged to pink', that is, to undertake a lowly occupation in textiles, usually done by women, of sewing eyelets and tapes to fasten the body into its final garment.[16] Insecurity dogged him and his family at every turn, with, in addition, an alleged problem with drink.

John had difficult family ground to compass: he and the other Gainsboroughs were low church dissenters, attending the Independent Meeting House in Friars Lane, one of the town's

nonconformist chapels, where they rented pews and where Thomas and his siblings were christened.[17] Mary, however, the sister of the Rev. Humphrey Burrough, incumbent of St Peter's and St Gregory's, and headmaster of the school her children attended, was a member of the Church of England. This created a fault-line between the families, exacerbated by the low church side quarrelling over the payment for pews. John was left out of his property-owning father's will at his death in 1717, and Mary likewise was bequeathed only £20 when her father died in 1721.[18] On the edge of a volatile family as they were, and John having ill luck and poor judgement in business, the Gainsboroughs of Sepulchre Street were at a permanent social and financial disadvantage. Worse, their daughter Mary married a Church of England clergyman, upsetting the Gainsboroughs, and Humphrey went off to be a nonconformist minister, which might have upset his mother. However, these 'upsets', if that is what they were, were as nothing compared to the social and political background in Sudbury.

3. Sepulchre Street

When Daniel Defoe passed through Sudbury in the early 1720s he caught the edge of the social unrest there, and found 'nothing for which this town is remarkable, except for being very populous and very poor. They have a great manufacture of says and perpetuanas and multitudes of poor people are employed in working them, but the number of the poor is almost ready to eat up the rich.'[1]

Thus it was markedly different in Defoe's eyes from nearby Bury St Edmunds, set on higher ground and with fresher air, 'the Montpellier of Suffolk, and perhaps of England'. 'Perpetuanas' are woollen serges, very hard-wearing as the Spanish word suggests; 'says' are silks. By comparison with Bury's sophisticated ecclesiastical foundation, Sudbury was the Worktown of the region, but a Worktown of discontent and with little reliable employment. It sent two members to parliament, despite being 'under no form of government particularly to itself, other than as a village'. For twenty years following the 1741 election Sudbury was effectively under the sway of Thomas Fonnereau of Ipswich, and was described by the 2nd Earl of Egremont as 'very venal – it may be had by money'.[2] Defoe visited Sudbury soon after the South Sea Bubble, the crash of 1720 that affected the finances of the entire country, with millions of pounds being lost across the nation overnight. A town manufacturing cloth could not have avoided the distress and damage that came so suddenly and brutally, and upset everything.

The town had also seen its share of physical violence and destruction with a religious dimension. Two of its churches had suffered in 1643 at the hands of the official iconoclast William Dowsing, who reported back to the parliamentary authorities that he had destroyed a hundred religious images at St Peter's and 'diverse angels, twenty at least on the roof of the church', and eighty angels at St Gregory's.[3] One fragment, a panel painting

of a merchant, has nevertheless survived in the chancel at St Gregory's. Bonfires of wooden angels and painted panels, the flames twisting and sparking into the night sky by St Peter's on Market Hill, may just have been held within town memory ninety years later. Near that spot the statue of Thomas Gainsborough by Bertram Mackennal now stands.[4]

Sudbury itself was richly decorated, many of its half-timbered houses being covered with carvings of creatures, monsters and other figures, some of which survive. Others disappeared during the eighteenth-century period of façade-building in which John Gainsborough was involved. Gradually across the century decoration came back to the town's churches. The Sudbury artist Robert Cardinall painted a copy of Leonardo da Vinci's *Last Supper* as an altarpiece for St Peter's, and his life-size standing figures of Moses and Aaron are now framed above St Peter's north and south doors. These were installed during Thomas's boyhood. Nearby at St Gregory's, a florid wall-slab and chest tomb for the cloth merchant Thomas Carter, father of William Carter, had been erected after Thomas Carter's death in 1706, with details of his bequest of £70 a year to provide clothes for one hundred of the poorest men and women of the town, and an anniversary sermon.[5]

Sudbury had once been a town with grand ambitions, Southburgh (Sudbury) having been the southern equivalent of Northburgh (Norwich), a city that did indeed come to occupy a larger national stage. The Gainsboroughs were prominent citizens, going back generations: Thomas's uncle Robert Gainsborough was the town's chief constable and a 'Capital Burgess', and will have been well aware of the repercussions and reinstatements following Dowsing's destructions of the local church treasures.[6] Robert's portrait, stern of manner, grim of visage, had been painted by Cardinall in 1729, and it may have been Robert who was behind the commissioning of Cardinall to redecorate St Peter's after the religious destructions. In any event, Thomas cannot possibly have been unaware of his grandfather's portrait hanging in a family property, besides the many other portraits with a strong dynastic purpose commissioned by the family. These serious, admonitory faces can only have galled poor failing John, the shroud-maker of Sepulchre Street.

From the 'multitudes of poor people' that Defoe described, many had found it impossible to survive in the fractured pace of the local weaving industry and its satellite trades, and had already split off to emigrate west, via the port of Ipswich, to America. The will of Thomas Gainsborough, John's brother and Thomas's uncle, refers to 'Edward Burrows then of Sudbury who . . . went to New England and as I have heard is sure dead but have left a child or children who have a right of redemption in all the above houses and tenter yards.'[7] The possibility that this might have been a relation of Thomas's mother, Mary Burrough, cannot be discounted, and reflects how the volatility of Suffolk's economy touched all parts.

Teeming with largely disenfranchised people, Sudbury was not a genteel place – certainly nothing like it is today – but a noisy town of workers and drinkers, with a flaky edge of people contemplating departure, and a thread of families with enough economic muscle to fill the vacuum and take over vacant property. Picture the scene on Market Hill on market days: crowds of men and women in dull, dry, grey-green serge offsetting the sparks of colour as fine people in fancy waistcoats move about like glow-worms at dusk. Thus John Gainsborough, ever hopeful, setting up a lucrative cloth trade, becoming mortgaged to his dream of a grand house for his large family in Sepulchre Street, and gradually seeing his esteemed status as one of the Gainsboroughs of Sudbury slipping away towards ignominy.

When bankruptcy struck John Gainsborough the wider family rallied round to protect its collective interests. John's older brother Thomas, a clothier and property owner in Sudbury and the surrounding county, and his son, yet another John, bought the house in Sepulchre Street and allowed the family to continue to live there. It was unthinkable that the Gainsboroughs should see one of their own become destitute in Sudbury, so the family was made safe in Sepulchre Street. John was found the job of Sudbury's postmaster, thus maintaining a reasonable social position in the small town, while his bankruptcy was 'superseded under the Great Seal of Great Britain', and somehow settled.[8] Later in life – he died in 1748 – John found his equilibrium, and was described by Fulcher as being well dressed, always carrying a sword, and was said to

be '[a] fine old man, who wore his hair carefully parted, and was remarkable for the whiteness and regularity of his teeth'.[9]

While helping John Gainsborough and his family out of their difficulties and giving them the ingredients for a stable future, John's brother Thomas was nevertheless pedantically cautious in the drafting of his will, sworn in February 1738. The huge extent of this Thomas's property holdings in and around Sudbury becomes clear: he lists his houses in the town, and his wool halls, a malting barn, yards, gardens, stables, orchards, two tenements at the Croft, near the River Stour, with yards and gardens, a house and four tenements with tenter fields, yards and gardens near St Gregory's, and four more tenements in Gregory Street. It goes on and on: this is a man of real substance, who did very well in the Sudbury context, and was not going to let it all dribble away after his death.[10] Thus he was absolutely specific about the future of his brother John and his family. He took care of John with realism, circumspection and charity for this perpetual loser, and directed 'that should my brother John Gainsborough live many years he may . . . stand in need of some assistance towards the procuring the necessities of life', and left him an income of five shillings a week.

Naming John's children one by one, he left them £10 each at the age of twenty-one – an age that five of them had already reached. On top of that he gave £20 a year for three years to Humphrey for his training at Moorfields. Most revealingly, however, he continued with Thomas:

> my will is that my executors take care of Thos Gainsborough another of the sons of my Brother John Gainsborough that he may be brought up to some light handy craft trade likely to get a comfortable maintenance by and that they do give any sum not exceeding twenty pounds to bind him out to such trade and I leave it to my executors if he shall prove sober and likely to make good use of it to give him ten pounds over and above the ten pounds I have herein given him the better to enable him to set out into the world.[11]

When his uncle's will was written and sworn, Thomas Gainsborough was not yet eleven years old. Of his siblings, only he and

Humphrey had been singled out like this. While Humphrey was twenty and already at Moorfields College, there must have been a special light shining out of Thomas, and clear evidence to encourage his hard-headed uncle to invest in him at such an unformed age, to give him twice as much money as the others, and to pay for him to go into 'some light handy craft trade'.

4. The very bird of the eye

There are clues as to what might have persuaded Uncle Thomas Gainsborough: the boy will certainly have watched his mother painting flowers, and will have picked them with her, and dabbled in paint beside her as he grew up. This close family example must have been one of the stimuli that later led Thomas to walk out into the fields, to draw outside, and to paint and enjoy paint's tactility. The nimble fingers of his elder brothers John and Humphrey, and his sisters' dextrous skill with the needle, refracted themselves into Thomas's pastimes, not only in his remembered joy late in life in making and flying kites and floating model boats, but in observing animals and making cows and horses out of clay.[1] In one of the most inventive and enquiring of periods in human history, here against a troubled social background were girls and boys quietly making things together around the family table.

However, it was drawing and painting landscapes and portraits that came to the fore in Thomas's early life. Portraits by children always amuse their grown-ups, seeing themselves in a childish image, but the portraits Thomas showed his family were long remembered. His niece Sophia Lane, a daughter of Susan Dupont, spoke decades later of the 'several heads [Thomas] had taken', and two at least of these, both self-portraits, may have survived.[2] An early one, painted perhaps in 1736 or 1737, shows a wistful little boy of about nine or ten years of age dressed in a neat blue jacket, a waistcoat of the same blue, and what may be a lace stock at his neck. If this was painted by young Thomas it is mighty accomplished and would have taken any parent's breath away. The placing of the gold buttons reveals observation of a high order: the lower three on the waistcoat are done up, the upper three left undone. Subtly the artist has noticed the offset between the two groups of buttons; this is certainly something the adult Thomas Gainsborough would notice and depict – and the child?

A second early self-portrait shows Thomas, now aged thirteen or fourteen, brush and palette in hand, standing confidently in front of an out-of-sight canvas (Pl. 20). The eyes are penetrating, the face set firm, and once again buttons play a large part in the portrait's intrigue and decorative allure. They run in a series of white dots up and down his brown jacket, and again up and down his waistcoat – but one button is undone, or missing, and his shirt pokes out of the waistcoat in a manner that offsets formality with real life and bother.[3] Hogarth would do exactly the same thing in his portrait of Thomas Coram, painted and displayed with great public éclat in 1740. Indeed, how broadly similar these two very different portraits are: both are three-quarters poses, looking out to the sitter's left; both hold a significant object in the right hand as if to show it off; both hold a secondary object in the left hand. Major structural identities though these are, that's as far as we can take it, though it shows that already the boy has looked closely at other people's portraits, first of all those in his own family's houses. Here is the young artist at work, perhaps soon after he arrived in London, soon after he realised that he had a very special talent.

Some early landscape subjects support an obituary account of Gainsborough 'painting several landscapes from the age of ten to twelve',[4] as does the well-worn but telling story that Gainsborough forged adult handwriting in the words 'Give Tom a holiday' so that he could go out into the country to draw. There is more than one version of this, however, the most elaborate being that his schoolmaster asked Gainsborough's father to allow the holiday, and that the boy copied the handwriting fifty times and hid the forgeries in a warming pan in the kitchen. It being summer, Tom didn't think the warming pan would be used for weeks – but oh no! somebody in the house was ill; the pan was unhooked, and the little bits of paper fluttered down like autumn leaves months premature. 'Tom will come to an untimely end,' his father said; but when he found sketches around the house he changed his tune.[5] The source of this story, the portrait painter John Jackson RA, added that Gainsborough's father, being suspicious of what Thomas was up to, followed him one day 'suspecting that he kept idle company, but in this he was agreeably astonished, when he

saw him seat himself upon the side of a bank, and begin to make a drawing'.

'Tom will one day be hanged', his father is said to have exclaimed when he heard of the forged notes: forgery was then a hanging offence. 'Tom will be a genius', he continued when he saw the drawings his son brought home.[6]

John Gainsborough's 'genius' remark, apocryphal though it may be, can be supported by the existence of groups of early landscape drawings, some in the British Museum, others discovered in the 1980s, and yet others, first identified by Lindsay Stainton, in the Royal Collection at Windsor Castle.[7] Together these date not from Gainsborough's childhood but from the mid to late 1740s when he travelled between London and Sudbury. There are also paintings which persistently demand consideration as youthful works, the end result of many hours spent wandering in the lanes and fields of Suffolk, where, as he himself much later is recorded as expressing it, he 'studied Nature as he met her in her homely garb, in rude lanes, excavated by deep ruts, or within the plaster walls and moss-grown . . . [word missing]'.[8]

A similar observation comes from Philip Thicknesse, who wrote the earliest account of Gainsborough's life, published as a slim volume a few months after Gainsborough's death: 'not a Picturesque clump of Trees, nor even a single Tree of beauty, no, nor a hedgerow, stone or post, at the corner of the Lanes, for some miles round about the place of his nativity, that he had not so perfectly in his *mind's eye*, that had he known he *could use* a pencil, he could have perfectly delineated.'[9]

There were ways and means for Gainsborough to find out about drawing and painting for himself in these early years: his mother's talent will have been a potent source of encouragement, as might the peripatetic local portrait painters Robert Cardinall and John Theodore Heins, both so proudly commissioned by his uncles. Sixty miles from Sudbury, the Rev. Thomas Page of Beccles brought out his book *The Art of Painting* in 1720, with its encouraging advice for young artists. Describing equipment, methods of mixing paint and techniques of drawing, Page urges his readers to *look* at painting: 'imitate the *Bees* who pick from every Flower, that which they find in it most proper to make

Honey. In the same manner a young Painter should collect from many Pictures what he finds to be more Beautiful, and from his Collections, form that manner which thereby he makes his own.'[10]

Page goes on to encourage artists to study Annibale Carracci, Raphael, Michelangelo, Correggio and 'the immortal Titian', all artists whose work was available through engravings. But, he says resoundingly, know when to stop:

> In your work you must have the Painter's Proverb in mind, that is, *Menum de Tabula*, which signifies, to know when to give over and lay by the pencil. A work may be overwrought as well as underwrought. Too much labour often takes away the spirit, by adding to the polishing ... Work with the greatest ease and celerity as you can, while your spirits are brisk and fluent, and in time you'll find out this great Gift, when to give over.

Page encouraged young artists not to hide their light under bushels, but to 'fly above the height of others, if you have a mind the blind World should see and distinguish you'. On drawing heads and faces Page advises:

> Begin with the Eyes, and observe a squarish sort of Drawing in their Upper-Lids, as also in the very Bird of the Eye, tho' it seem round, always making the Line of the Upper Lid harder over the Bird, than towards its ends, and evermore much bolder than the lower Lid, which must be faint and soft. Draw the Nostrils and the end of the Nose in this square bold manner, and in a word let your whole Drawing be graced with it in Discretion.[11]

This demonstrates the necessity of a distinct graphic technique, and very close and clear observation. There is much more advice, including some on life drawing 'in imitation of the Academy at London'. To draw a face from the life, Page advises the choice of 'a fit Posture agreeing with his nature, and not force him in his picture to do what in his Temper and Behaviour he is no way accustomed unto'.[12] And on landscape painting these good words:

> Let every thing have its proper Motion according to its Nature, as in Trees when they are shaken with the Wind, making the

smaller boughs yielding, the stiffer the less bending ... And in a Word let every thing that moveth, whither essentially or accidentally, have its proper representation. ... And know, moreover, that the intire Perfection of Landskip proceeds from the charming disposition of the Lights, bringing them into your Work after the most advantageous Manner, to produce the best beauty to every thing.[13]

Emerging from the far east of Suffolk, this book maps step by step the path that Thomas Gainsborough of Sudbury would soon begin to take, and suggests a reason why eighteenth-century East Anglia was such an effective cradle for artists. Thomas Page considered landscape and portrait painting to be worthy of equal attention, and to flow equally into one another. So, in time, did Thomas Gainsborough.

5. Joshua Kirby

Meanwhile, a schoolmaster turned miller, John Kirby of Wickham Market, and his friend Nathaniel Bacon, were travelling round Suffolk, surveying its landscape.[1] With them from time to time was Kirby's fifteen- or sixteen-year-old son, Joshua.[2] The trio travelled from town to town between 1732 and 1734, village to village, great house to great house, studying the history, topography and social structure of Suffolk. This was all to a purpose: to compile what became *The Suffolk Traveller*, first published in 1735, an account of the county's society, a directory of who did what and who owned what, and a compendium of fold-out maps of routes between the main towns. Twenty years after the Hanoverian succession, renewed purpose and encouragement arose for entrepreneurs to map and to clarify the social and physical geography of England. Of Sudbury, on the county's southern border with Essex, John Kirby gives an entirely different flavour to that of the more politically minded Daniel Defoe. He writes of the navigability of the Stour for barges to and from Manningtree following canalisation since the 1705 Stour Navigation Act. He tells of Sudbury's three 'beautiful and large Parish churches', and of its historical importance as the town in which Edward III 'put the Dutchmen whom he brought into England from the Netherlands, to teach the English to manufacture their own wool; and the woollen trade has continued here ever since'.[3]

In addition to searching out historical sources, Kirby and Bacon sought subscribers. By 1764, when the second edition of *The Suffolk Traveller* was published, these numbered well over five hundred. Among them are local families whom we will meet again as Gainsborough's life develops. Their shared physical landscape would soon come to nourish him: Carter, Clubbe, Fenn, Fonnereau, Fulcher, Gravenor, Keable, Keddington, Kilderbee, Lloyd, Mayhew, Plampin, Rustat, Trimmer, Venn and Wollaston. The names that launched *The Suffolk Traveller* were the

names that launched that joyful poet of the paintbrush, Thomas Gainsborough.

Social levels were tight in Suffolk and Essex, and while they will not always have known or liked each other, the 'well-to-do' had the kind of blind bonding that gave encouragement to a status-defining art such as portrait painting. Their fellow traveller Nathaniel Bacon had painting in his blood: he came from a family rooted in the art of the Low Countries, the sixteenth-century artist Sir Nathaniel Bacon being the painter of many still lifes and portraits in the Dutch manner, and of the earliest surviving oil landscape painted by a native artist.[4] When Thomas Gainsborough and Joshua Kirby became lifelong friends and collaborators, high among the ties that bound them was a shared love of Suffolk and Essex, an understanding of the rich sources of expression that landscape will provide, and an acknowledgement that, for Suffolk artists, Dutch art and Dutch heritage, melded into Suffolk scenery, provided the deepest root for their inspiration.

Kirby father and son continued successfully with their topographical entrepreneurship. In the 1740s, after *The Suffolk Traveller* had been published, Joshua Kirby led the production of a series of engravings of the antiquities of the county, and entered the prodigious contemporary market for engraved landscape views. The historian, engraver and consummate record-keeper George Vertue commended Joshua Kirby in his extended account of lately published engravings of landscapes, townscapes and significant buildings. These included more than two hundred views in English counties by the productive and distinguished Samuel and Nathaniel Buck, and, among the work of other engravers, there was a particular mention for Kirby's twelve prints of churches and monuments in Suffolk. One of them was a view of Sudbury Priory, 'done in drawing & Graving in a very neat and curious manner better than those of Bucks . . . they have good encouragement by a large subscription . . . a new improvement in manner and Taste of Engraving upon an equality every way with the French Italians or Dutch.'[5] The market in engraved views of this kind paralleled the market in maps and the development of the road system, and altogether demonstrated to an increasingly curious age how the counties of Britain hung physically together.

Joshua Kirby, trained by his father in the uses of topography, was ambitious and determined to succeed. Diversifying his activity, he bought into a coach- and house-painting business, married a Bury girl, Sarah Bull, and moved together with his parents to Ipswich. He continued to develop his printmaking and publishing interest: he was advertising the sale of a print of David Garrick in the *Ipswich Journal* in June 1745,[6] in the town where Garrick had made his stage debut under a pseudonym in 1741, and acted as an agent for Hogarth's prints.[7] The route between Ipswich and London was, through Kirby's initiative, well trodden by the print-making and publishing trades.

Already touched by town bronze, Joshua Kirby was energetic and talented, an engraver, author, publisher, friend of Hogarth, a likely lad, and one to watch, who made it his business to put himself about in both Ipswich and London, and bring town and city together in the purposes of art. Painting and engraving brought Kirby and Gainsborough into a conjunction which would come to articulate their lives.

They were also united in their admiration for the work of Dr Brook Taylor, a pioneer mathematician. Kirby was quick to see commercial opportunities in Brook Taylor's discoveries, and Gainsborough would come along on his coat-tails. What Kirby did was put into reasonable English, with diagrams and illustrations, the thrust of Brook Taylor's dry and practically unreadable study of the mathematics of perspective. He turned what was meat and drink for mathematicians into instruction that even artists could follow. The resulting volume, the not-very-seductively titled *Dr Brook Taylor's Method of Perspective Made Easy*,[8] carried his name into every artist's studio and every school of art.

It has a frontispiece designed by Hogarth and engraved by Luke Sullivan, who would become a wild friend to Gainsborough, in which a plethora of perspectival absurdities enrich a landscape. Kirby sets out his intention:

> to make this hitherto intricate, but useful Art, easy and familiar to every Capacity ... no subject has been treated in a worse manner than this ... I have had Regard to his principles in general, so as to make his meaning more intelligible, and that

kind of perspective of more universal use ... Few have been
able to understand his scheme, and when they have understood
them, have been much puzzled in applying them to Practice.[9]

This is an early and important instance of popularisation in pub-
lishing, and *Perspective Made Easy* became a standard reference
tool, reprinted again and again, bringing much-justified fame
to Joshua Kirby. It was supported by an army of subscribers,
many of them leading artists, while a large number were Suffolk
people. Some of these had been supporters of *The Suffolk Trav-
eller*, and many would also come to support Gainsborough: the
Rev. John Clubbe, the Rev. Robert Hingeston, Samuel Kilderbee,
the Hon. Richard Savage Nassau, the Rev. Thomas Rustat and
Philip Thicknesse. Within the book there is a modest landscape
engraving by Gainsborough, improved, so the rubric indicates,
by Joseph Wood. We are running ahead here, and must now get
back on track, but when he launched Dr Brook Taylor into a wide
audience, Joshua Kirby took Thomas Gainsborough with him.
Perspective Made Easy was a boon for artists everywhere, and a
boost for Thomas Gainsborough. For Dr Brook Taylor there is a
further level of posthumous recognition: he is commemorated by
a crater named after him on the Moon.[10]

II

London

6. Some light handy craft trade

It is 1740, and the thirteen-year-old Thomas Gainsborough has arrived in London. There was no requirement in Uncle Thomas's will that London was where the boy should go to take up 'some light handy craft trade'. Knowing his brother's family as he did, and their unreliable record of application to the task in hand, Uncle Thomas might have been wary of sending the boy to Ipswich, let alone London. Nevertheless a few months after Uncle Thomas's death-rattle in Sudbury, we can see young Thomas on a coach to the capital with his uncle's money sewn inside his coat.

Uncle Thomas was not the only person with means to spot young Thomas's talent and give him the following wind he needed to develop. A note written by his niece Sophia Lane in her copy of Allan Cunningham's *Lives of the most Eminent British Painters, Sculptors and Architects* shows that others were watching: 'an intimate family friend of [Gainsborough's] mother's, being on a visit [to Sudbury], was so struck by the merit of several heads he had taken, that he prevailed upon his father to allow him to return with him to London, promising that he should remain with him, and that he would procure him the best instruction he could obtain'.[1]

The description of an 'intimate family friend' should be set against the unexplained remark in the memory of the Carter family that Gainsborough painted an early portrait of William and Françoise Carter as a return 'for favours done' (Pl. 9).[2] The favour may have included early hospitality and accommodation for young Thomas at the Carters' London house in Gracechurch Street, north of London Bridge. Another source claims that Gainsborough came to live with 'a silversmith of some taste, and from him he [Gainsborough] was ever ready to confess he derived great assistance'. Other candidates for Gainsborough's London supporter are the Rev. William Coyte, the Sudbury parson whose son George had been a close boyhood friend of Thomas, and

who was apprenticed to a silversmith in London.[3] Alternatively it might have been a Dupont relation, through his sister Sarah's marriage to Philip Dupont, who had a London silversmith in his family. The many possibilities tend to cloud the picture.

For anybody passing through the slums around Westminster, or the dangerous Seven Dials area, or the shady shops in Shepherd Market, or Covent Garden at night, London was a stinking, crowded, unhealthy place to be. The poet and playwright John Gay versified on the London of this time, and is not encouraging:

> Here to sev'n streets, sev'n dials count the day,
> And from each other catch the circling ray:
> Here oft the peasant, with enquiring face,
> Bewilder'd, trudges on from place to place;
> He dwells on ev'ry sign, with stupid gaze,
> Enters the narrow alley's doubtful maze;
> Tries ev'ry winding court and street in vain,
> And doubles o'er his weary steps again.[4]

For Mary Gainsborough to have let her youngest go so freely (if she did), there must have been some foundation of real security in this small boy's case, such as the presence of the Carters or the Duponts. Theirs was a horrid age, mid eighteenth-century London a foul, unruly place, with wealth and poverty in every borough, riches and destitution behind every façade, intrigue and deceit in every career, and sex and thievery at every corner. From her upper windows in Sepulchre Street, Mary could see the treetops of Cornard Wood swaying in a distant wind. How could she wave her youngest son goodbye without a shudder of fear?

If ever Mary Gainsborough had had the opportunity to read about the town she was letting Thomas go to, she might have heard horror stories like this one. A party of mummers:

> a parcel of strange *Hobgoblins* cover'd with long Frize Rugs and Blankets, hoop'd round with Leather Girdles ... Of a sudden they ... made such a frightful Yelling, that I thought the World had been dissolving, with the terrible Sound of the last Trumpet to be within an Inch of my Ears.[5]

The local colour on the streets:

By the help of *Paint, Powder* and *Patches* . . . our Airy Ladies grew so very *Mercurial,* they could no longer contain their feign'd Modesty, but launch'd out into their accustomary Wantonness.[6]

The ladies in St James's Park, who:

raise their extended limbs from their *Downy Couches,* and walk into the *Mall* to refresh their charming Bodies with the Cooling and Salubrious Breezes of the Gilded Evening.[7]

Particularly after the disappearance of Robert, their horrific loss of Matthias, and the constant streams of 'castles in the air' dreamt up by Scheming Jack, how much more trusting of the Gainsboroughs it was to give their youngest into the care of the shadowy 'silversmith of some taste'.

Nevertheless, from a painted boat in the middle of the painted river in one of Canaletto's lustrous panoramas, the city was a dappled, breezy prospect when the sun shone. To a pedestrian focused only on architecture in Covent Garden, St James's or Pall Mall it was a place of elegance with a developing sense of proportion. Young Thomas Gainsborough sucked up many of these experiences in his first weeks in London when he lived with the silversmith. He felt the press and colour of the crowd, the pull of the river, the elegance of the squares, and noticed what was perhaps less plainly visible in Suffolk: the eternal fact that money, like the river, is a fluid substance. It flows in and builds fine houses and squares; it flows out and leaves dilapidation and waste behind. Evidence of this, for a boy with his eyes open, was everywhere.

Many of the great London houses built by sixteenth- or seventeenth-century aristocrats were even now, barely a century later, falling to bits, left empty or demolished – Northumberland House, Beaufort House, Montagu House, Clarendon House, Somerset House. Yet even as these very public crumblings gathered pace, other grandees were expending enormous sums in populous places on monumental and decorative sculpture. This was a different kind of expenditure, as monumental sculpture, unlike real estate, could never have any resale value. While sculptors with

curious foreign names such as Rysbrack, Roubiliac and Scheemakers created sparkling marble monuments of superb and enduring workmanship in Westminster Abbey, and regal bronze figures appeared on plinths in London squares, the vast Jacobean Northumberland House at Charing Cross was in the 1740s abandoned, dark and echoing. The grand house built by Sir Thomas More in Chelsea in the 1520s, and renamed Beaufort House when it was bought by the Duke of Beaufort in 1682, was collapsing, 'a frightfull place surrounded with high Trees and overgrown with Briars of thorns and high Brick walls' according to its lonely caretaker.[8] Somerset House was, by 1763, 'an antiquated structure, built in a vicious taste, and partly tottering'.[9] Montagu House, built by the first Duke of Montagu in the 1660s, had been left to decay by his son, and was already a large dark star at London's edge in the early 1740s. Considered briefly as the home for Captain Coram's Foundling Hospital, Montagu House was in 1740 found to require £2,005.10s.8d in repairs.[10] Further out of London, Cannons in Edgware had cost the Duke of Chandos around £200,000 by the time it was completed in 1722 – this is perhaps £15 million today. These were the oligarchs. Their grand palaces outshone royalty. Of Cannons, Alexander Pope wrote in *The Uses of Riches*:

> At Timon's Villa let us pass a day,
> Where all cry out, 'What sums are thrown away!'[11]

Cannons was demolished a mere twenty years later. Immense sums of money could disappear in a moment, as investors such as the Duke of Chandos, scalded in the bursting of the South Sea Bubble, discovered, and as Thomas Gainsborough's family had found on the minor scale in their property dealings in distant little Sudbury.

One of the largest houses in England, Lord Clarendon's Clarendon House in Piccadilly, which jostled for position with its ground-hungry neighbour Burlington House, had stared down towards St James's Palace, an unsettling presence above that asymmetrical Tudor pile. Its street frontage, from Old Bond Street to Dover Street, was 139 paces east to west, on the other side of the road from no. 167 (Itsu in 2017) to the Ritz.[12] It is extraordinary to consider just how big these monsters were. But its stare did not

last long: Clarendon referred to it as 'a rash enterprise'.[13] It was completed in 1667 and demolished sixteen years later to make way for the development of Albemarle, Dover and Bond Streets by a duke called Albemarle and a man called Bond. In the language of the twenty-first century, large uneconomic properties were being downsized and replaced by smaller units, and central brownfield sites redeveloped for domestic and commercial use. Repurposing also progressed: rejected in 1740 as an option for an orphanage, Montagu House was in the 1750s repurposed as the British Museum. This was the first change-of-use in England of a private house into a public museum; the nineteenth and twentieth centuries would see an avalanche of them. As today, developers put their names around wherever they could. The London that welcomed young Thomas Gainsborough was a self-destroying, self-creating masonry-mill, which made money for some, transient employment for many, and evidence of elegance and change for all.

London was the only place in England where the practice of art could be studied and polished so intensively, in all its aspects. That was why the Gainsboroughs risked sending their youngest there. Out of the mud and rubble, inequity and injustice, there were many art and craft disciplines struggling for recognition in Gainsborough's chosen new-found land of art: furniture making, carriage painting, engraving, upholstery, instrument making, colour grinding, silversmithing and so on and so on, besides the fine arts. Huge fortunes could be made in craftsmanship. The Somerset-born William Hallett, for example, made so much money in furniture and frame making at his St Martin's Lane workshop and showroom that he was able to buy the demolished ruins of the Duke of Chandos's Cannons, and, using its leftover materials, build his own grand house on the site.[14]

Silversmiths enjoyed particularly lively business. Theirs was an economy that prospered in affluent times when new houses were being built, new families coming to London, and new family silver being demanded for domestic as well as dynastic use. If Gainsborough was briefly tempted to take up silversmithing – and the 'silversmith of some taste' would no doubt have tried to entice him into his lucrative profession – this was a 'light handy craft trade'

surely acceptable to the memory of his late uncle. There was a secure future awaiting talented silversmiths in London in the 1740s, and even then Gainsborough must have recognised that.

While such a trade was his parents' desire for their boy's future, we might reasonably take it that Gainsborough himself had other ideas. The older streets and courts of London, particularly those around Covent Garden and further east beyond Montagu House and Hatton Garden, held workshops and rooms of painters, sculptors and engravers. Image making was a very good business for those who had the skill to take a likeness, create a figure group or conjure up on canvas an alluring prospect of urban or rural perfection. Those expensive properties that were being leased by the new rich certainly needed upholstered furniture, carriages, painted decoration, curtains and silver, but they also needed paintings and engravings. From silversmithing to engraving is but a small step. Gainsborough will have quickly realised that engraving on silver was essentially a training course in drawing, and one which could hardly be bettered for the precision and concentration required. Hogarth had started his career learning to engrave on silver, and look how far that took him.

7. Key to every man's breast

In these early decades of the eighteenth century a 'Rule of Taste' was evolving out of the writings of the 3rd Earl of Shaftesbury, the essayist Joseph Addison, co-founder of the *Spectator*, and the portrait painter Jonathan Richardson. Addison urged his readers to contemplate the new monuments in Westminster Abbey; Richardson made incisive daily examinations of his own face, marking a new direction for portraiture in England; and Shaftesbury demonstrated the connections between order and harmony in art and architecture, and morality and goodness in life.[1] However, it was one thing for aristos and essayists to draw up rules for art, quite another for artists, never the easiest of professionals to herd, to do consistently as theorists advised. The most voluble, effective and omnipresent advisory figure among artists in London in the early 1740s was the painter and engraver, organiser and teacher, litigant, polemicist, good fellow, Freemason, philanthropist and wit, William Hogarth.

Hogarth's reputation got everywhere; as a workman he was prodigious, as an advocate he was relentless. No artist in London, young or old, was unaware of him, and to a young apprentice artist up from the country he was the alluring captain of the ship. In 1740 Hogarth was in his prime, and had already produced paintings and engravings that bear his reputation now, and which were beacons of his genius then: *A Midnight Modern Conversation* (1733), with its party of repellent moneyed drunkards; *A Harlot's Progress* (1732) and *A Rake's Progress* (1735), with their tragi-comic moral lessons as they take a sweet country girl and a loathsome young toff to their inevitable ruin and death; and the *Four Times of Day – Morning, Noon, Evening, Night* (1738), which reveal the grubby underside at every level of London society.

In *The Analysis of Beauty*, published in 1753, his seminal work of instruction and theory, Hogarth ranged widely over the pictorial landscape that drove his life. On individual artists' styles, and

their impact on others, he suggested that 'Rubens would, in all probability, have been as much disgusted at the dry manner of Poussin, as Poussin was at the extravagant [*sic*] of Rubens.'[2] On 'variety' in painting, he touched on something that Gainsborough would do well to note: 'When the eye is glutted with a succession of variety, it finds relief in a certain degree of sameness; and even plain space becomes agreeable, and properly introduced, and contrasted with variety, adds to it more variety.'[3]

Hogarth's finest piece of analysis, however, comes when he identifies the importance of the serpentine line, so crucial to the composition both of landscape and figure paintings:

> Of these fine winding forms ... [is] the human body composed, and which, by their varied situations with each other, become more intricately pleasing, and form a continued waving of winding forms from one into the other ... the human frame hath more of its parts composed of serpentine lines than any other object in nature; which is a proof ... that its beauty proceeds from those lines.[4]

Hogarth's words did not fully enter artists' bloodstreams until the 1750s, long after Gainsborough had left Hogarth's orbit. However, Hogarth was developing them in his work and conversations across the 1740s, and Gainsborough would not have been immune to their influence.

With Joshua Kirby energetically hawking Hogarth's prints around Suffolk, it could not have been long before some of them, with their rich political, social and sexual innuendos, reached Sudbury. They certainly had a rapid effect on one Suffolk parson, the Rev. John Clubbe, rector of Whatfield and vicar of Debenham. Clubbe was not the usual kind of holy man, but a warm, human and humorous writer who satirised contemporary antiquarians and teased their pretensions.[5] He and Gainsborough came to be good friends – indeed, Gainsborough would twice paint his portrait in Ipswich in the late 1750s. Dedicating a paper on physiognomy to Hogarth, Clubbe praised this artist's modern moral subjects and their cumulative improving effect on their audience: 'We cannot perhaps point to the very man or woman, who have been saved from ruin by them, yet we may fairly conclude, from their general

tendency, many have . . . In truth, Sir, you have found out the phi-
losopher's wished-for key to every man's breast; or you have, by
some means or other, found a way to break open the lock.'[6]

Hogarth's captaincy in the London art world was built on his
infinite capacity for hard work, his magisterial skill as a politico,
his bloody-mindedness as a campaigner, his genius for charac-
terisation, and his integrity and generosity as a raiser of public
passion for grand social causes. He and his achievements have
been subsequently reimagined, reinvented and reinterpreted gen-
eration by generation.[7] But for a country boy bent on painting in
1740 this five-foot-nothing, fleshy-faced, pug-loving storyteller
was the man who held the key to all the doors he needed to pass
through:[8] an art school, a client base, introductions to painters
and engravers, and possibly introductions to lodgings too. There
is no formal evidence that Gainsborough ever met Hogarth; but of
course he did, as small twigs and branches will gather round the
largest when driven by water through a sluice.

Another talented young man, perhaps more abrasive and cer-
tainly less elegant than Gainsborough, landed in town that same
autumn of 1740. While the thirteen-year-old Thomas Gainsbor-
ough had come from the east, Joshua Reynolds, four crucial years
older than he, came from the far west, from Plympton in Devon,
the son of a parson schoolmaster. Sudbury and Plympton were
many days' journey apart, and the social background of the near-
bankrupt John Gainsborough and Joshua's father, the Rev. Samuel
Reynolds, were just as widely separated. Had they been fellow
townsmen, Parson Reynolds might have addressed John Gains-
borough's shortcomings from a lofty pulpit, but in any event, quite
apart from their conflicted approaches to Christianity, they may
not have seen each other as equals. Pondering on his son's future,
Samuel Reynolds had written to a friend in words that, had he the
mind or the energy, John Gainsborough might have written about
Thomas: '[he] has a very great genius for drawing, and lately, on
his own head, has begun even painting'.[9] The elder Reynolds had
no qualms about using whatever influence he could to get a good
start for his son, who had insisted specifically on being bound to
'an eminent painter': no messing about with a 'light handy craft
trade' for the boy Joshua. Samuel Reynolds eventually secured

an apprenticeship for Joshua with Thomas Hudson, another Devonian, and one of the most sought-after and successful portrait painters in London. So Joshua went in at the top. At the end of this important year for the new generation of artists, Samuel reported that his son 'is very sensible of his happiness in being under such a master, in such a family, in such a city, and in such employment'.[10]

So we don't have to worry about him: Reynolds was able to find himself a place to work in St Martin's Lane before disappearing back to Devon in 1743. He was watchful, entrepreneurial, ambitious and ruthless – as he demonstrated in later life – and his natural talent and skill at self-advertisement soon showed through. He was also sober and responsible, qualities that Gainsborough might sensibly have fostered, but seems not always to have done so. Nobody in London would yet see Reynolds' early self-portrait, where he shades his eyes and looks to the future, for this was painted in Devon, but within a few years it would impress new clients when, from 1753, Reynolds set up finally in London after returning from three years' extreme educational endeavour in Italy.

What we know for certain about the young Gainsborough's first few years in London can be listed on one side of a sheet of A4 paper: he was early on apprenticed to an engraver, and developed high skills in the trade; he worked with the artist Francis Hayman painting decorative views and designs in kiosks and supper boxes at Vauxhall Pleasure Gardens; he took rooms in Hatton Garden; he married in 1746; he painted a limpid circular canvas of the Charterhouse orphanage and school and presented it to Thomas Coram's Foundling Hospital in May 1748; he worked as a landscape and portrait painter in both London and Suffolk, travelling between the two places. That's about it. It is likely, even certain, that he attended St Martin's Lane Academy, but the only confirmation is an acknowledgement in the subscribers' list in *Perspective Made Easy*.[11]

An engraver who was an important influence on Gainsborough as a teacher was the irrepressible and brilliant Frenchman Hubert-François Bourguignon, generally known as 'Gravelot'. He had an informal school for engravers, and, as the watercolour

painter Edward Dayes later confirmed, Gainsborough studied there, 'with Grignion, and several others, at his [Gravelot's] house in James Street, Covent Garden, where he had all the means of study that period could afford him'.[12] Gravelot had been living in London for six or seven years when Gainsborough arrived, and had graphic skills of a rarefied quality. Nevertheless, Grignion, a watchmaker and engraver of Russell Street, Covent Garden, remarked to Farington that 'Gravelot could not engrave. He etched a great deal in what is called the manner of Painter's etchings, but did not know how to handle the graver.'[13] These trade subtleties indicate the depth of nuance and rivalry in the mid eighteenth-century print market that would fox the average customer, but meant the world to practitioners.

Gravelot's strong business sense was evidenced by his diversification. He engraved both fine art illustrations for books, and supplied imagery for trade material such as advertisements and announcements. Gravelot's natural sophistication had developed through working in Paris with Boucher and other significant artists at the court of Louis XV, and in the decades of consumption and excess in royalist France. He was undoubtedly the sort of light-hearted, highly talented, slightly irresponsible spirit with whom Gainsborough would chime, and the two were well matched. However, their contact was terminated when Gravelot returned to Paris in 1745, apparently fed up with being thought to be a French spy. He took savings of £10,000 home with him, certain evidence that, in learning to draw, engrave and etch, Gainsborough was on track to make his fortune.[14]

George Vertue gave a vivid description of Gravelot's achievement as an engraver in London which seems to support Grignion's observation, and demonstrates how closely the professions of silversmithing and engraving were allied:

[His] drawings for Engraving and all other kinds of Gold &
Silver work shews he is endowed with a great and fruitful genius
for desseins, inventions of history and ornaments, mighty neat
and correct his drawings are, and besides that he practices etch-
ing or Stylography in which business he has done many curious
plates from his own desseins masterly and free . . . in a higher

degree of perfection than has been done before in England . . .
he is a man of great Industry and diligence, causes himself to
be well paid for his works – and deserves it.[15]

Working with Gravelot, Gainsborough will have seen not only
how money is made in art, but will have experienced the market in
etchings and engravings of all kinds and in huge quantity. Prints
were a vibrant visual currency that flowed about Europe from
publishing houses of all sizes in Italy, France, Germany, the Low
Countries and England. It was prints that conveyed the variations
in regional and personal style, prompted changes in technique,
carried iconographic ideas and details, and proclaimed the artist's
purpose. If we need more evidence to show how Gainsborough
became so immersed in Dutch art, for example, we need only to
look at the Dutch prints that circulated both from Holland and
from the London ateliers of émigré Dutch and Flemish printmak-
ers in the seventeenth and eighteenth centuries. Many of these,
including prints by Hollar, Brueghel and Dürer, entered Gains-
borough's own collection.[16]

Other engravers Gainsborough met were a rum bunch, mem-
bers of a service trade used by painters, publishers and silversmiths
alike, who demanded their skill in translating other people's work
into a mass-producible medium. Idiosyncratic and competitive as
they were, each had his own way of working, his own professional
'tics'. Wenceslas Hollar, for example, though already long dead,
was still remembered for being as honest as the day, and an ob-
sessive timekeeper, who used an hourglass to register the exact
time he was spending on a plate, at a reported fourpence an hour.
When he left his desk he would stop the hourglass so he did not
charge for more time than he was actually employed.[17] A member
of the French community of engravers who might have welcomed
Gainsborough in London was Jean-Baptiste Claude Chatelain. He
had been in the army of Louis XV, had an engaging and unique
talent as a draughtsman and engraver, was tall, good-looking, and
always wore a white coat. However, he had an unfortunate disso-
lute tendency which tended to ruin relationships. While he was
on a handsome scale of payments of two shillings and sixpence
an hour – note how prices had risen since Hollar's day – he set a

poor standard for newcomers to the profession by demanding immediate payment, and in full, and when he had earned a guinea (so after only about a days' work) would down tools and go to an inn to eat and drink himself sick: 'if by accident he earned a guinea, he would immediately go to a tavern, and lay at least half of it out on a dinner'.[18] That at least was the gossip. He got his comeuppance eventually: he died of a surfeit of lobster and asparagus.[19]

Another utterly unreliable engraver whom Gainsborough would have done well to have avoided was Hogarth's friend and collaborator Luke Sullivan. He and Gainsborough were about the same age, and both came from far away – Sullivan from County Louth, Ireland. While in his working day Sullivan engraved with brilliance – Hogarth's *March to Finchley* and the frontispiece to Kirby's *Perspective Made Easy* are his – he was slippery by night and would drift off and get plastered. Hogarth had to imprison him, practically, at his house in Leicester Fields, 'for if once Luke quitted it, he was not visible for a month'.[20] Worse, 'being much addicted to women, his chief practice lay among the girls of the town'.[21] He may well have been one of the routes to temptation for Gainsborough; indeed they may have egged each other on. They would soon have something else, a minor ducal connection, in common: Thomas would marry the illegitimate daughter of the Duke of Beaufort, while Luke was the son of one of the Duke's grooms.[22] Small world.

Perhaps the most impressive and influential printmaking project over this period was the production of two large volumes of what became a set of 119 portrait heads of distinguished Britons, from the fourteenth-century Geoffrey Chaucer and William of Wykeham to the contemporary Joseph Addison and Alexander Pope. This was industrial-scale printmaking and publishing. The lead artist was Jacobus Houbraken of Amsterdam, whose name as engraver appears on the margin or in the plate itself of most of the subjects between 1737 and 1749. George Vertue engraved a handful of others, and all were printed by Paul and John Knapton of Ludgate Street, London, and published by Thomas Birch, in volumes titled *The Heads of Illustrious Persons of Great Britain Engraven by Mr Houbraken with their Lives and Characters.*[23]

While Houbraken is given (or takes) full credit for the portraits,

Jacobus Houbraken, after Sir Godfrey Kneller, *Frederick, Duke of Schomberg*, 1739.

it is likely that the elaborate rococo cartouche ornament, often with detail characteristic of each subject, was finished off in London by the army of engravers then resident. Gainsborough's obituarist tells that the young artist worked with Gravelot to finish the plates before printing, and that may be the case,[24] but in any event the making of the plates entailed much coming and going across the North Sea between London and Amsterdam – eighty-one plates at least crossed the water between 1737 and 1742/3; thirty-eight more between 1743 and 1750/51 – and personal liaison will have been essential. We might consider that there was an opening

here for Thomas Gainsborough to accompany an older artist to Amsterdam, where not only would he have further experience of engraving production, but the opportunity also to find the work of Dutch artists on their home ground. It may be significant that at his death Gainsborough owned, among his very few books, a highly expensive set of Houbraken's *Heads*.[25] This certainly suggests attachment, though it cannot be proof of early engagement by this able, far-sighted, ambitious and dissolute young man so hungry to learn.

The eighteenth-century print trade, fruitful and lucrative, was fishy in its murky depths. The unique set of accounts kept from 1734 to 1750 by the artist Arthur Pond reveals the large sums of money tied up in it.[26] Had he spent less time selling prints and making money, and practised more as a portrait painter, Pond would be better known. As it is he remains one of the smaller fish in a pond dominated by giant pike and crayfish like Hudson, Hogarth and, later, Reynolds and Gainsborough. The market that Pond enjoyed was the market that maintained the lives and work of so many, including Gravelot, Grignion, Chatelain and Sullivan, and all those involved in the Houbraken project. It was the market that fired up Gainsborough.

8. The makings of a rake

Soon at home in the world of engraving, we know that Gainsborough also entered the world of painting through the St Martin's Lane studio of Francis Hayman, a heavy-drinking, womanising, short-tempered, argumentative, but talented painter of portraits and narrative and literary subjects. Hayman was, as Brian Allen has put it, 'an amiable hard-living buffoon . . . no doubt frequently gluttonous and dissolute'.[1] Nevertheless he gave Gainsborough entrée to the nightlife of London, certainly by giving him work in decorating the entertainment kiosks that were among the attractions of the Vauxhall Pleasure Gardens, and probably also by allowing low life to brush past him. According to the strait-laced George Fulcher, Gainsborough 'could learn little of painting and less of morality' from Hayman.[2] This is not entirely fair; Hayman was a respected and involved painter and teacher, but whoever Gainsborough's moral guardian was in London in his teenage years, he or she was probably on to a losing wicket. Gainsborough's period with Hayman was evidently memorable, and he seems to have paid him several visits in the early 1750s, perhaps to collaborate on pictures.[3]

Vauxhall, east of what is now Vauxhall Bridge on the south side of the river, was, with Ranelagh Gardens in Chelsea, one of the two main pleasure gardens in London, presenting permanent *fêtes champêtres* in season. The Frenchman Pierre-Jean Grosley came to London in 1765 and seems to have enjoyed himself at Vauxhall, while keeping his eyes open and his French honour intact. He spotted Hayman's four large recently installed canvases of British military triumphs in the Seven Years War 'which are by no means to the honour of the French . . . I was as short a time about it as possible.'[4] Oliver Goldsmith also visited the gardens, and, writing in the guise of a visiting Chinese philosopher, found delights all around him:

The illuminations began before we arrived . . . the lights every-
where glimmering through the scarcely moving trees; the
full-bodied consort bursting on the stillness of the night; the
natural consort of the birds, in the more retired part of the
grove, vying with that which was formed by art; the company
gaily dressed looking satisfaction; and the tables spread with
various delicacies, all conspired to fill my imagination with
the visionary happiness of the Arabian lawgiver, and lifted me
into an ecstasy of admiration . . . this unites rural beauty with
courtly magnificence, if we expect the virgins of immortality
that hang on every tree, and may be plucked at every desire, I
don't see how this falls short of *Mahomet's Paradise*![5]

Gainsborough had the makings of a rake in those early years in
London. He certainly seems to have looked the part: Thicknesse
wrote of 'the elegance of his person', a compliment that finds
echo in his early self-portrait with his wife; Cunningham called
him 'eminently handsome'.[6] Perhaps this very elegance, with the
'modest deportment' that Thicknesse also notes, got him into
his many relationship difficulties. He later confessed as much to
his actor friend John Henderson: 'Take care of yourself this hot
weather, and don't run about London streets, fancying you are
catching strokes of <u>nature</u>, at the hazard of your constitution. It
was my first school, and deeply read in petticoats I am, therefore
you will allow me to caution you.'[7]

However, the boy had his head screwed on, as there is no doubt
that from the very beginning he was entering the art business to
do well, to make the sort of money that Gravelot made, that Pond
was making, and that his uncles, cousins and grandfather had
freely made in property deals in Sudbury. At all costs would he
avoid the financial torment that had engulfed his father. So when
we look at Gainsborough's developing life we can be assured that,
certainly at the beginning, he was success-driven, money-driven,
and probably had some inner voice that steered him away from
trouble in the nick of time.

The double figure composition in the Louvre, *Conversation in
a Park*, *c.*1746–7 (Pl. 2), has the look of the kind of society that
Gainsborough was aiming at, both professionally and personally.

The young man, the 'elegance of his person' shining through, gestures towards his girl who sits beside him on a bench in a bosky setting with a glimpse of classical architecture in the background. This might be an invention based on scenes of courtship in Vauxhall Gardens: the girl holds her open fan significantly and strategically placed on her lap, while he wears a sword, and seems much more interested in the girl than she is in him. This was long assumed to represent Gainsborough and his wife, Margaret, and while the dalliance may be wishful thinking on Thomas's part, it is more likely to be a narrative invention, perhaps developed from a series of book or other illustrations such as one of the sixty or more songs published in *The Musical Entertainer* in the mid 1730s.[8] Among these, written for singer and flute, with music by William Boyce and others, is 'The Apology', illustrated by an engraving of a very similar couple in a near-identical pose, all set on a bench in a garden landscape: this may have been Gainsborough's source.

> Frown not my Dear, nor be severe,
> Because I did Corinna kiss;
> For all th'Intent, was Compliment,
> And truly no thing else but this.

A number of the songs have illustrations of Vauxhall Gardens night and day as headpieces, and altogether they take us back to that intoxicating fantasy world of warmth, wine and wonder where people made merry and lost their sense of direction:

> See a grand Pavillion yonder,
> Rising near embow'ring shades,
> There a Temple strikes with wonder,
> In full view of Colonnades;
> Art and Nature (kindly lavish),
> Here their mingled Beauties yield;
> Equal here the Pleasures ravish,
> Of the Court and of the Field.[9]

Vauxhall was famous for its music, both organised and impromptu. Presiding over the gardens since 1738 was what was rapidly becoming an icon of musical marble, Roubiliac's statue of Handel, now removed to the Victoria and Albert Museum. This

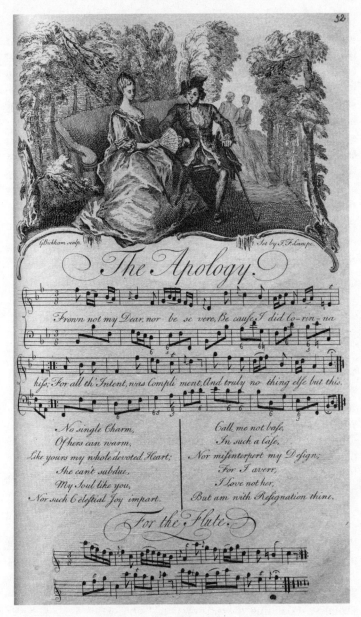

'The Apology', headpiece to a song in
The Musical Entertainer, mid 1730s.

was the essence of rococo, in which the composer's figure seems to sway to the rhythm of the music he is plucking on Orpheus's lyre. The figure, which pre-dates Hogarth's writings about the effect of the serpentine line, was itself a surprising innovation, as living people, monarchy excepted, were not translated into life-size public sculpture. But Vauxhall was a law unto itself: what happened in Vauxhall stayed in Vauxhall. Grosley went on: 'These entertainments, which begin in the month of May, are continued every night . . . These places serve equally as a rendezvous, either for business or intrigue. They form, as it were, private coteries.' However, Grosley also spotted an English reserve in the gardens that is absent from surviving engravings and flyers from the period:

> I do not know, whether the English are gainers thereby: the joy, which they seem in search of at these places, does not beam through their countenances; they look as grave at Vauxhall and Ranelagh, as at the Bank, at church, or a private club. All persons there seem to say, what a young English nobleman said to his governor, *Am I as joyous as I should be?*[10]

While it is certain that Gainsborough enjoyed the Vauxhall Gardens, and found employment and a good time there, we can only surmise that he also joined in the conviviality of Old Slaughter's Coffee House in St Martin's Lane, and attended the St Martin's Lane Academy. This was as formal an art school as there could be in London at that time, and just down the road from Hallett's lucrative furniture- and frame-making workshop. The school was held in a former chapel, where up to forty art students could draw from a nude model, raised on a dais. Vertue recorded that 'Mr Hogarth principally promotes or undertakes it',[11] while Hogarth himself described the school as being a place where there was 'a proper table for the figure to stand on, a large lamp, iron stove, and benches in circular'.[12] So there was light, heat, an adequately visible figure to draw, and space for the students to work. Teachers included Hayman and Gravelot, and if nowhere else, Gainsborough would have come across Hogarth at the Academy, which was not just an art school, but a place of social interchange and

excitement, of noise and laughter, discussion and argument which would carry on at Old Slaughter's nearby.

Artists band together, until other pressures cause fragmentation, and Gainsborough, naturally gregarious, was a young man eager to make contacts and eager to do well. How he interacted with his contemporaries, what particular long- or short-lasting friendships he made, is unclear, except for the fact that among the artists of his generation associated with St Martin's Lane in these years were Joshua Kirby, who became a lifelong friend, Luke Sullivan, who might have led him astray, and Joshua Reynolds, the young man who would go far, and one whom Gainsborough would only circle warily throughout his life. There was, however, another young man whose life would cross and re-cross Gainsborough's: this was Robert Price, from Foxley, a wild demesne in Herefordshire then being tamed by Price's father, the determined traveller, writer and improver of rural landscape, Uvedale Tomkyns Price.[13] Robert would come to inherit Foxley, and come also to have a serendipitous family connection with Gainsborough. It is sufficient now to say that Robert knew Hogarth, Gainsborough knew both, and if little tangible came from Gainsborough's Hogarth association beyond example, instinctive understanding and some guidance in engraving, much would come of Gainsborough's friendship with Price.

So, Gainsborough made four kinds of male friendships in these early London years: with Kirby one of depth, warmth, shared experience, the example of opportunism, and unconditional affection; another with Sullivan which exemplified the misbehaving truculence of the rake; with Reynolds an acquaintanceship which demanded caution, professional respect, and a requirement to keep out of each other's way; and with Price a friendship that drew towards itself new, intense, family connection. These kinds of friendship articulate Gainsborough's life, and provide trig points by which his life was mapped.

9. Hatton Garden

After three or four years in London Gainsborough took rooms in Little Kirby Street, Hatton Garden, on the edge of Holborn, Clerkenwell and Smithfield.[1] He might by now have considered his life as a student was over. Hatton Garden is conveniently on the Sudbury side of London, and nearby Gracechurch Street, where the Carters lived, was a picking-up point for the Sudbury and Ipswich coach. His landlord, John Jorden, was later ordained, so we might reasonably expect him to be a sobering influence on his tenant. Hatton Garden was a community of brick town houses developed in the 1680s in the grounds of the former Ely House, and in the shadow of what remained of St John's Priory. An account published in 1761 described Hatton Garden as 'a broad, straight and long street, in which the houses are pretty and lofty . . . the street must be reckoned amongst the finest in the city',[2] while the parson and author John Strype wrote of Hatton Garden that it was 'spacious . . . very gracefully built, and well-inhabited by the gentry'.[3] Laetitia Hawkins, who remembered Hatton Garden as a girl in the 1760s, described it as 'an esteemed situation for the gentry: no shops at the lower end, and few parts of the town could vie with it'.[4] The 'Garden', of which nothing much remained in the 1740s, had been attached to the house that Queen Elizabeth seized from the priory and gave to Sir Christopher Hatton, whose seventeenth-century descendant developed it. This was all 150 years in the past when Gainsborough first explored its streets, but the history remained to enrich the atmosphere. One might add that the gentrification of the area echoed faintly the gentrification that the wider Gainsborough family was variously applying to Sudbury, making light reminders of home.

Hatton Garden, smart and well connected, was just the place for a young painter to be. Potential patrons lived behind every torchlit door, each with a cadre of servants for anybody to observe and use as a measure of the families that employed them. Nearby

there was vibrancy and riches of a different kind, of business, creativity and charity, which caught the imagination, and became a crucible for new ideas. Hogarth's father, Richard, had run a coffee house, where customers were expected to speak in Latin. When the family was not locked up in Fleet Prison for debt, Hogarth himself was round and about the area. Upstairs in the surviving gateway of the priory was a room used as a theatre, still alive with performances by the young David Garrick in 1740. Crammed somehow into the same gateway were the offices of the increasingly successful *Gentleman's Magazine*, a monthly journal that found wide readership around the country, and carried news, announcements and feature articles to a deepening literate base. Hatton Garden had St Andrew's charity school installed in a former chapel, and nearby also were Lincoln's Inn and Middle Temple. There Joshua Kirby's elder brother John was Under-Treasurer, surrounded by a rich flotilla of members of the legal profession flaunting their silky waistcoats and ripe for painting.

Most significantly, however, Hatton Garden was the crucible for a revolutionary charitable idea that would reconfigure social thinking internationally, lead to a transformation of the ways in which art was publicly displayed, and give Gainsborough himself the special opportunity that would launch his career as an artist. For twenty years the irrepressible and determined ship-builder and sea captain Thomas Coram had been campaigning for the foundation in London of a home for unwanted babies. This was pragmatic as much as it was humane and charitable – what a waste of a rich resource was a tiny bundled orphan left out to die. As a merchant seaman who built ships in New England, and who plied the Atlantic between Old England and New, Coram was fully aware of the nation's need of a constant supply of sailors. He gathered the support of the high end of English society, and by 1739, when he presented his charter for his 'Foundling Hospital' to the King, he had the signatures of twenty-five dukes, thirty-one earls, twenty-six other peers of the realm, twenty-five knights, the entire Privy Council, the Prime Minister Sir Robert Walpole, the Lord Chancellor the Earl of Hardwicke, the Prince of Wales, and politicians, bankers, country gents and government officials by the dozen.[5] Central to the whole political upsurge were women,

principally some notable duchesses whom Coram brought on side – the duchesses of Bedford, Bolton, Leeds, Portland, Richmond and Somerset, and the tough and intractable Lady Mary Wortley Montagu.

Coram was formidable, and soon after declining to proceed with the repairs to Montagu House at such great expense for his purposes, he took a lease on the former home of the financier and MP Sir Fisher Tench in Hatton Garden as a temporary shelter for his foundlings.[6] It was a vivid local sight in the street, generally under the cover of darkness, when from March 1741 Coram's home for foundlings became the destination of people delivering infants for adoption, until the hospital's new building in Bloomsbury opened its doors four years later. Misery and grief, intermixed with the sounds of childish ebullience and play, will have emerged from the building near Gainsborough's rooms, with the children from St Andrew's adding their dimension. Hatton Garden in the 1730s had been a street of sober residences, but in the 1740s, invaded by children, distraught mothers and nurses, it became a buzzing human beehive.

Hogarth was one of the signatories of Coram's charter, and in the same spirit of generosity with which he presented large canvases of the Good Samaritan and the Pool of Bethesda to St Bartholomew's Hospital in Smithfield, he painted his portrait of Coram and gave it to the Foundling Hospital governors to display. Hogarth shows this short, square man looking quizzically out at us, his white hair flying wayward, his red coat a living organism enveloping his stubby frame, his waistcoat buttons popping open. Hogarth makes it clear that Coram is not quite used to a portrayal of this kind, as if he were himself now to be identified as one of the grandees he had for so long been stalking. He holds in his right hand the Great Seal of the Realm, his winning ticket, attached to his Foundling Hospital charter, and at his feet is a globe revealing the Atlantic Ocean, the super-highway for the nation's prosperity and strength.

By 1741 this portrait was hanging in the foundlings' temporary home in Hatton Garden for all the world, including Thomas Gainsborough, to see. Coram's eyes electrify the viewer. Until October 1745, when the foundlings' Bloomsbury home opened,

Gainsborough had at his doorstep the finest object-lesson that any coming portrait painter could ever hope to see. Further, in the houses around lived well-heeled men and women who would also know Hogarth's portrait, and might expect to sit for their own as a matter of course.

10. Go over the face very curiously

Despite these opportunities both real and potential, Gainsborough seems to have had an ambivalent attitude to London. Sudbury may have been unsettled, but in 1745, during the Jacobite Rebellion, so was London. While he seemed happy enough in his rooms in Little Kirby Street, he nevertheless went backwards and forwards by coach between London and Sudbury, certainly as early as 1745, and had probably been doing so since 1740. Thomas Gainsborough was still of teenage years, the youngest child of the family; his mother and sisters were concerned about him, so of course he would go home now and then. Also, a family crisis in 1743 might have drawn Thomas home: his elder brother 'Scheming Jack' had got himself into serious trouble in Beccles, swindling his customers at the watchmaking shop he had recently set up there:

> Whereas John Gainsborough jun. late of Sudbury, Suffolk, watchmaker, did lately set up a business at Beccles in Suffolk, but generally abused the interests of friends and carried off goods and effects given him in trust, this is to apprize persons whom he may offer a watch for sale or to pawn, to stop the watch . . . He is a spare thin person of 5ft 9ins high with large hook'd nose, blinkey'd eye, long visage.[1]

Gainsborough described these features in the portrait of his brother that he began in the 1750s.[2]

The road between London and Sudbury, however rutted and bumpy it might have been in actuality, became a well-trodden path for Gainsborough. If the portrait that he painted of his father across these years is any guide, journeys home revealed complexities in family matters. Fulcher knew this portrait, and seems oddly to have spotted 'humour and indecision . . . stamped on [John Gainsborough's] features'.[3] However, humour is absent in this powerfully incisive work; and what indecision Gainsborough

has revealed in his father is balanced there by a sadness and intro-
spection that is indelible and profound. The son has captured the
disappointment that haunted John Gainsborough across the last
two decades of his life, but has nevertheless evoked his father's
evident pride in his appearance and his strong sense of self. One
can hardly imagine John Gainsborough being flattered by this in-
sight, but he might well have remarked on its truth. This portrait
suggests already that Gainsborough's is not going to be an easy
career to manage, but one in which landscape and portraiture will
always vie for his attention, affection and control.

Much paid work came to Gainsborough from an easterly dir-
ection: his earliest recorded commission, signed and dated 1745,
which must have been painted or at least planned in Suffolk, is a
portrait of a dog, a charming smooth-coated white terrier called
Bumper, with a lively eye, a wet nose and alert pink-lined ears.
Bumper is a sparky little creature who looks, by the set of his
back legs, as if he is about to run off at his master's call; indeed
on the back of the canvas Gainsborough had written: 'a most
Remarkable sagacious Cur'. This is the first of a vivacious side-
line that Gainsborough developed in his work: the portrayal of
elegant, characterful and often exotic dogs.[4] Bumper's master, the
Rev. Henry Hill, rector and lord of the manor of Buxhall near
Stowmarket, was an informed agriculturalist and amateur archi-
tect, who improved farming techniques in his fields, and became
noted by the widely travelled Suffolk agricultural pioneer Arthur
Young as 'a very steady driller' for introducing the then unusual
but successful practice of drilling wheat in eighteen-inch rows.[5]
Accompanying Hill on his walks round Buxhall was this remark-
able, sagacious dog.

There is a mature sophistication about the composition of
Bumper (Pl. 1), and the development of the eighteen-year-old
Gainsborough's painting technique after his five years in London.
His *Bumper* is as assured and natural as one of George Stubbs'
animal portraits of twenty years later, the dog's head being silhou-
etted against a middle-ground stand of trees, and the horizontal
line of his body offset by the vertical trunk of a silver birch. The
sandy bank he stands on is high above a country track with a trav-
eller on it, thus creating a modest narrative spin with a distant

view. Bumper's portrait, and other works painted between 1745 and 1749, suggest that Gainsborough must have been a required presence in Suffolk, called back home from time to time by people who had somehow heard of this talented boy.

The thirty or so finished oil landscapes from this period that are known today, and listed by John Hayes, all play games with the idea of 'place'.[6] They seem initially to represent some specific spot, but prolonged looking shows that there is little in them to prevent their retreat into a kind of general abstraction, as if Gainsborough is giving us the 'idea' of Suffolk rather than Suffolk itself. This might suggest that they were painted well away from the subjects – let's say in Hatton Garden – but it may not be quite so clear-cut as that. Gainsborough seems at the drop of a hat to have been able to conjure up 'Suffolk' scenes at will wherever he was, putting bits together like Lego. He could only do this because he had immersed himself so deeply in Suffolk landscape. Some of them, as their vague and incomplete early provenances suggest, may have been painted as speculations for the painting and engraving trade, in the hunt for a share of the market for landscape paintings that the Dutch taste had been pioneering for years. Gainsborough both ran with the hare and hunted with the hounds, as he also repaired Dutch paintings, and would add figures to them if he felt they needed cheering up.[7] All this diversification was a seriously good way of learning his trade.

Paintings commissioned by known patrons during his Hatton Garden period include the *View of Ipswich with Christchurch Mansion*, commissioned by Thomas Fonnereau, whose house it was, and a wide architectural landscape of *St Mary's Church, Hadleigh* (Pl. 3), commissioned in the late 1740s by Rev. Thomas Tanner, Rector of Hadleigh. Gainsborough also painted and delivered a sign for the new school at Holton St Mary, opened 29 August 1748.[8] These are potent commissions for so young an artist, particularly *St Mary's Church, Hadleigh*, a large canvas about six feet long painted to mark restoration and improvements at the church, with which the versatile Joshua Kirby was also involved.

St Mary's Church, Hadleigh is also a compendium of what Gainsborough was learning in London and who he was meeting: the boys playing marbles on the foreground tomb chest are a

quotation from one of Hogarth's *Industry and Idleness* engravings, published in 1747. Further, the light in the painting, the bright architecture, and the manner of painting the figures' clothing in distinctly defined parts, have the poetics of Canaletto, who was even now painting English subjects in Golden Square, Soho, and employing, as Vertue mysteriously puts it, 'some unknown assistant in making or filling up his [illegible word] with figures'.[9] Who might that have been? To make paintings of the size and sophistication of *St Mary's Church, Hadleigh*, with its thoughtful use of figures, Gainsborough would require space, time, necessary reflection, and easy access to a supply of painting materials. Their scale demands that they would have to be static, painted in one place, in contrast to his smaller portraits which could be moved between sitter and painting room as required.

Between 1745 and 1748 Gainsborough had fully capitalised on his natural talent and become highly and uniquely proficient as a painter. Whoever it was that nurtured him, Hayman or Hogarth or Canaletto or Hudson or other painters such as Arthur Devis who took assistants and apprentices, they all gave him something of what follows. A clear outline of what was required of portrait painters, and what all should aspire to, appeared in an article on 'The Art of Painting, Limning &c', by 'Pictor', published in the *Universal Magazine* in November 1748. 'Pictor' showed that there was so much for a painter to *do*:

> On whatever the painter intends to paint, it must in the first place be prepared by a *primer* ... which ... renders the field very equal and smooth ... [then] they lay on a *layer* of *pastewater*, and then rub it over with a pumice-stone to take off the knots ... When the cloth is dry, then lay on a colour that will not kill the other colours, as red-oker, which is a natural earth of substance, and with which they sometimes mix a little white lead that it might dry the sooner.[10]

That is how to prepare the canvas. Then the equipment he would need: 'easel, palette, smudge-pan, straining-frame, primed cloth, maulstick, colours, pencils [i.e. paintbrushes] of all sizes, from a pin to the size of a finger, Dutch-quills, swan quills, jewelling pencils and bristle pencils'.[11] Then there was advice 'as to the nature

and signification of Colours', where colours are noted according to their meaning, viz.:

Black, signifies wisdom, sobriety and mourning; *Red*, justice, virtue and defence; *Flame-colour*, beauty and desire; *Maiden's blush*, envy; *Flesh colour*, lasciviousness; *Carnation*, craft, subtlety and deceit; *Green*, hope; *Grass green*, youth, youthfulness and rejoicing; *Willow colour*, forsaken; *Popinjay-green*, wantonness; *White*, death; *Milk white*, innocency, purity, truth, integrity.

And so on. Advice is then given on expression in 'painting a face':

Raising of hands conjoined towards heaven signifies devotion; wringing of hands, grief; throwing them towards heaven, admiration; folding hands, idleness; scratching head, thoughtfulness; forefinger on mouth, silence.

And so on. There was a huge amount just to know, even before beginning to create an image. Then, at last:

First sitting apply dead colouring to drawing of face. First colour to begin the face with is the red of the cheeks and lips, somewhat strongly the bottom of the chin if the person be beardless. Over, under and about the eyes you will perceive a delicate faint redness, and underneath the eyes inclining to a purple colour, which in fair and beautiful faces is usual, and must be observed.

This clearly reveals the sheer complexity of portrait painting, a branch of the art that was sufficiently lucrative as to justify the intense labour of brain and hand, and long-drawn-out attention to the client. But the prize was worth the pain:

Second sitting commonly requires four or five hours, in which you are to go over the face very curiously . . . taking notice of the several graces, beauties or deformities as they appear in nature . . . The third sitting commonly takes up to two or three hours, and is spent in closing what was before left imperfect and rough, but principally in giving to every deep shadow the strong touchings and deepenings . . . you must curiously observe whatever may conduce to likeness, as scars, moles &c, glances of the

eyes, descending and circumflexions of the mouth; but never make your deepest shadows so deep as appear in life.

So, the artist is told, be under no illusion that painting is not a life's work, the skill hard to attain, and in the end a young artist has either got it or has not. This is warning of just the same kind uttered by Thomas Page of Beccles in *The Art of Painting*, and a severe endorsement of it.

At the end of the article is a public sign that Gainsborough is emerging as an individual. 'Pictor' publishes a list of fifty-seven names, fifty-seven 'justly esteemed eminent masters' in London. Thomas Gainsborough's name is among them. The others are an interesting roll-call of the art's leading practitioners: there are the Dutch émigrés such as Jan Griffier, Adriaen van Diest, and John Verelst; the artists born in England of foreign, often Huguenot, extraction such as Joseph Goupy, Peter Monamy, Gerard Vandergucht, John Vanderbank and Griffier's sons Jan and Robert; there are well-rooted British artists such as Bartholomew Dandridge, Francis Hayman, William Hogarth, Joseph Highmore, Thomas Hudson, George Knapton, George Lambert and Richard Wilson. Joshua Reynolds is also there in the list, indicating that he, like Gainsborough, was already making waves. However, while Reynolds, by now aged twenty-five, was also at the beginning of a great career, Gainsborough was at twenty-one the youngest of these listed artists. The bulk of them were old stagers – Dandridge, Goupy and Monamy were in their sixties – and the majority in their forties and fifties. What 'Pictor's' list shows is that the world of painting in London was flourishing in the late 1740s, and much enriched by immigrant talent.

The explanation of process and techniques published for the lay audience of readers of the *Universal Magazine* has a further purpose: it amounts to a painter's manifesto and guarantee, assuring potential clients that the trouble that artists have to go to justifies their fee, and suggests that the result should be worth every penny.

11. A marvellous time to be in London

London in the 1740s had a complex and evolved economy of painting, engraving and sculpture, symbiotic arts which could live without each other, certainly, but which had cohabited for generations, and which spoke at their loudest volume when acting in concert. Entries in Arthur Pond's journal show him involved with painting portraits, selling modern and old master prints and drawings, repairing paintings, having them varnished, and arranging for them to be framed, crated and transported – sometimes around London by sedan chair.[1] He gave work to Gravelot, Chatelain, the Knaptons and many others. Gainsborough does not (unfortunately) appear to be in his accounts. Pond was busy and effective, and he and his fellow professionals by their activities brought business to London from all parts.

Taking full advantage of London's open doors to talent from abroad and afar, the sculptors Rysbrack and Scheemakers had come from Antwerp; Roubiliac, Gravelot, and Joseph Goupy's father, Louis, from Paris; the Griffiers from Amsterdam; Canaletto from Venice; Andrea Soldi from Florence; Philip Mercier from Berlin; the portrait painter Allan Ramsay from Edinburgh; and a whole host of Huguenots. They were drawn to this international art city by the free flow of money into art businesses, relatively easy-going religious toleration, and a rich hinterland of country and town houses in need of the enchantment of art. Rivalries of course remained, exacerbated by the influx of immigrant talent: the ambitious young Ramsay bragged in 1740 that he had 'put all your Vanlois and Soldis and Ruscas to flight and now play the first fiddle myself'.[2]

High regard in Suffolk, and a growing regard in London, pulled Gainsborough in two directions, to the extent that he had a confused centre of gravity. In London he was noticed by the art dealer and engraver John Boydell in the Strand, who made engravings for a series *Drawn after Nature*. Four subjects at

least by Gainsborough appear to have been published as prints. Boydell, who would make a famous and highly influential career in print and picture dealing, was developing his business and, in Gainsborough, found an artist of his own generation with the talent and the acumen to engage in a speculative printmaking venture. Boydell was one of the rare birds whom Gainsborough ran into during his seven or eight crucial years in London, those who organised what went on, and changed things: Hogarth was another. A particularly curious entrepreneur was Panton Betew, a silversmith and dealer who was a generous friend to artists.[3] He lived in Soho, where he published prints, and dealt in them and in paintings and drawings: Boydell may have bought Gainsborough's drawings from Betew.[4]

John Boydell, after Thomas Gainsborough, *Drawn after Nature*, 1747.

Betew dressed eccentrically, a trait that might have endeared him to Gainsborough, and was likened by the sculptor Nollekens' biographer J. T. Smith to Henry Fielding's mysterious Man of the Hill in *Tom Jones*, whose 'dress is enough to frighten those who are not used to it'.[5] Known to his friends as 'Panny', Betew was

inevitably a conspicuous figure around London.

> His dress differed from the general mode; he wore a loose dark-brown great-coat, with, generally, a red cloth waistcoat, black shalloon small-clothes, dark-grey worsted stockings, easy square-toes shoes, with small silver buckles, and a large slouched hat with a close round crown, without the least nap, being often brushed, for cleanliness-sake.

This was shabby-chic at its best, suggesting that Betew was doing well, but not that well. He also risked attracting thieves, and smelt of fish:

> He was well-known to all the fish-vendors in Lombard Court, Seven Dials, as a purchaser of fish for two; which provender he was not ashamed to carry home in a dark snuff-coloured silk handkerchief, always taking care to hold it in his right hand, that he might display a brilliant ring, which he said he wore in memory of his mother.[6]

Betew recalled that he had 'many and many a drawing of [Gainsborough's] in my shop window before he went to Bath; ay, and he has often been glad to receive seven or eight shillings from me for what I have sold'. Nevertheless, Gainsborough earned very little from his landscapes. A later recollection has him say, 'I never got the cost of my colours by landscape painting', and, somewhat in contradiction to Betew, 'merely as [a landscape painter] he must have starved. He did not sell six pictures a year.'[7] This is corroborated by a remark passed on from as notable a witness as King George III himself. Discussing painting with the artist James Ward, the King recalled a conversation he had had in the 1780s with Gainsborough, who told him 'when he painted landscapes he was starving but when he painted portraits people bought his landscapes'.[8] Thus at this early stage of his life it was clear to Gainsborough that portrait painting would be the catalyst for a successful career, in whichever direction it might go.

Perhaps in 1747 Gainsborough was invited to join Edward Haytley, Richard Wilson and the younger artist Samuel Wale to make small circular canvases depicting the established London charitable institutions that provided a local philanthropic context for

the Foundling Hospital: St George's Hospital, Bethlem Hospital, St Thomas's, Christ's, Chelsea, the Charterhouse, Greenwich, and the Foundling Hospital itself. Hogarth, who had already given his work generously to the Foundling Hospital, was the controlling genius behind this multi-artist gift with strings attached. Its purpose was to honour London's rich charitable tradition and its successes, to demonstrate that artists were also generous and philanthropic people, and to show to the advocates and supporters of Coram's foundation that artists were content to give to the Foundling Hospital what they also expected the wealthy to pay good prices for. In these formative decades for art teaching and marketing in Britain the Foundling Hospital was one leg of an emerging tripartite system: St Martin's Lane Academy for the teaching; Vauxhall Gardens as the place where ideas were tried out and where artists met informally; and the Foundling Hospital where the finest work could be exhibited.[9]

Haytley, Wilson and Wale presented lifelike and charming roundels. These are all, as Rica Jones has shown, painted on canvas of an identical type, all certainly from the same source, and all painted on a grey ground, as if the canvases were prepared by the same artists' supplier at the same time. Gainsborough's painting, however, of the Charterhouse Hospital (Pl. 5), uses a slightly finer canvas than the others, with two layers of orange ground of the kind advised by 'Pictor' in the *Universal Magazine*. This may suggest that 'Pictor' was a Dutchman. The ground gives Gainsborough's painting a warmth, richness and welcome that the other roundels lack. Dutch artists brought to England the use of ground glass mixed into their pigments. Ground glass, and smalt – ground blue glass – gives a special shine to dried paint, something that English pictures generally lacked. Gainsborough mixed ground glass into his paint from his earliest years, and this is a practice he must have been taught, rather than stumbled upon. That no ground glass has been found in paintings by other older artists who we know taught young Gainsborough – Francis Hayman and Hogarth, for example – suggests that this young artist's early instruction had additional depth, and that a Dutchman or a Dutch experience must have been involved at some early, crucial point in his life.[10]

Unlike Wilson, Haytley and Wale, Gainsborough takes us right up among the Charterhouse buildings. He shows us a couple of boys playing marbles – another echo of Hogarth's *Industry and Idleness* engravings, where he repeats the cramped kneeling pose of a principal figure – and gives us also a plangent splash of light touching the urns on the wall, illuminating the middle ground, revealing the wobbly paving stones, and linking front to back. It is a masterly little painting, reflecting not just an ancient English building, but the manners of the Dutchmen Jan Steen and Vermeer. The rolling cloudscape seems lifted from Ruisdael. So here in the heart of London is a small Dutch painting, contributed not by a Dutchman, but by an artist so deeply schooled in the world of Dutch painting that he might easily be taken as one. A child will pick up accents in speech from parents and playmates: Gainsborough as a young man will have spoken with a Suffolk brogue of one kind or another. In the same way he picked up in his painting a local Dutch accent, sensed not through the ear but through the eye. But there is another accent: the close domestic quality of *Charterhouse* suggests a Dutch source, but in the light and in the massing of the buildings there is another debt being paid, to Canaletto.

Gainsborough's *Charterhouse* required particular preparation. First, he will have walked the few hundred yards from Hatton Garden to Charterhouse in Clerkenwell many times to sit on a wall and choose his viewpoint, draw the buildings, see how the light moves, and watch the boys milling about. Then he would have to assemble his materials – quite apart from the paints, the canvas had to be found, the circular stretcher made, the difficult task of cutting a piece of canvas for attachment to a jointed wooden hoop, assembling it all and applying the red/orange ground. These special skills, the making of the stretcher and the construction of the frame, already made in William Hallett's Long Acre workshop,[11] will have been carried out by others, but the particular choice of canvas and the type of ground to be applied must have been Gainsborough's own, aided perhaps by his local Dutch artist friends. He might well have bought the canvas and prepared it in Suffolk: Ipswich was famous for its sailcloth. How far he knew what the other artists in the Foundling group were up

to is unclear, but what is clear is that Gainsborough chose a very different angle of approach to Haytley, Wilson and Wale. His was not so much a portrait of the Charterhouse buildings as a portrait of Charterhouse life, and specifically about place and time, and the particular way light splashes and shines there, at a particular time of day, in a particular season. While the painting was a gift to the Foundling Hospital from Gainsborough himself, however induced it may have been by others or pushed by the artist, it will certainly have been discussed with the Foundling Hospital committee in advance. Thomas Coram himself must have known about it, as will Hogarth and Michael Rysbrack. It will have been opinion from this level of taste that caused George Vertue to report that Gainsborough's roundel was 'tho't ['throughout', or perhaps 'thought'] the best & masterly manner'.[12] Its place in the scheme of roundels in the Court Room was planned for in advance, and assured.

This is the young Gainsborough as an architectural painter, ambitious, opportunist and with an eye for a refreshing angle. Architecture as a subject was relatively new to him, and what he did know of the lighting and the cast of architectural composition seems to have come as much from the London resident Canaletto as from the Dutch. The architecture of *St Mary's Church, Hadleigh*, and the townscape Gainsborough has painted around it, reveals an accomplished effort at mastering tricky perspective that Gainsborough will have learned from Joshua Kirby, and a splashy way with handling architectural detail and sunlight that can only have come from Canaletto, who was now painting not Venetian canals, but London Bridge, the Thames and Whitehall.

Canaletto was in London at exactly the right time, not only for his own career, but to enable Gainsborough to demonstrate that painting architecture was not something he wanted to do for ever. It would not dominate his portrait painting. Fulcher records that Gainsborough now charged between three and five guineas for a head-and-shoulders, a modest sum for the three sittings and the hours of 'curious' observation and detailed brushwork required for even the smallest canvas.[13] Some of his subjects, for example William and Françoise Carter (Pl. 9), were well established Suffolk people of whom Gainsborough had known all his life. Others,

such as Richard Lloyd and his family, who would soon become an ongoing source of patronage in Suffolk, may first have become so in London. Evidently he was as busy painting in Suffolk as he was in London, so it is not surprising that we find Francis Hayman writing in 1746 or 1747 to his patron Grosvenor Bedford to say, 'I have the opportunity of getting the landscape done by Gainsborough whilst he is in town.' Hayman, being engaged on a double portrait of Bedford's children, and in need of an adequate landscape background, felt that Gainsborough was clearly the best artist to supply it.[14] It was therefore well known that Gainsborough was as much out of London as he was in it, and clear too that his skills were highly sought after in both London and Suffolk. Particularly significant is that Francis Hayman should recommend Gainsborough as a landscape specialist, rather than a portrait painter, where they were already in direct competition. Another portrait, of an unknown woman, discovered in 2016, has an intensity of insight and characterful facial detail that will have made Hayman realise that, without a doubt, he had serious competition on his hands.[15]

The Foundling Hospital commission shows that Gainsborough had given the leaders of the London art world the confidence to entrust him with making a painting for an important collection high in the public eye, with a great deal of political capital riding on it. Such youthful sophistication may also have given confidence to Richard Lloyd and others such as the mysterious Clayton Jones, whose well-waistcoated form has something of the retired city lawyer about him.[16] So also might the local parson Rev. Cutts Barton, rector of St Andrew's, Holborn, who looked for somebody to paint his large and fleshy head, and might well have fallen on his parishioner Thomas Gainsborough.[17] They would, willy-nilly, have known each other: in 1748 Barton buried the Gainsboroughs' baby daughter in his churchyard.

Gainsborough's paintings of the latter part of the 1740s display ambition and achievement, remarkably sagacious in so young an artist, and betray drawing, painting and compositional techniques and iconographical knowledge that could only have been learned in London in the most sophisticated and integrated of pedagogical environments. We know all this; it is self-evident in his paintings,

so it is not good enough to say, as Philip Thicknesse did, 'Madam Nature, not Man, was then his only study',[18] or 'by Heaven, and not a master taught' as his *Morning Chronicle* obituarist headlined it.[19] He picked up knowledge and practice as he wanted and as he chose. Gainsborough was not so much taught as given the opportunities to select what he wanted to know.

These are the threads – landscape, architecture, portrait painting and printmaking – that run through Gainsborough's work of the 1740s and indicate the direction of his early professional life. Their commissioners appear predominantly to be notable lawyers, merchants, parsons, landowners, many of whom were Suffolk gentlemen and their wives and families. These generally had business connections and houses in London, and clearly wanted to support their local young man, who had become extremely good at fostering and satisfying clients at both ends of his 'parish'.

Most of Gainsborough's early portraits show doll-like figures: some, like the Carters, have a touching innocence, rich in errors of scale, perspective and composition, but with elaborate representations of the most sumptuous embroidered waistcoats that money could buy.[20] Waistcoats give pleasure: they are a pleasure to look at, silk is a pleasure to touch, and they clearly gave Gainsborough pleasure to paint. These easy portraits, and more particularly those of his younger sitters, are set in stagey backgrounds of the kind Gainsborough could see nightly at Vauxhall, and are wholebody figures, at the very tip of elegance, from jaunty hat to buckle shoes. A few, however, and these of people very close to him such as his father, are in a different focus and of a different kind. They are Hogarthian: when he painted his father he had Hogarth, not Hayman, Hudson or Devis, in mind. Here is a man Gainsborough knew so very well, whose life struggles he had watched and shared, whose disappointments and failures he too had witnessed and suffered. His portrait of his father takes an approach that he was perhaps not experienced enough, or ruthless or courageous enough, to use on paying customers who felt safer with his dollies. With his *John Gainsborough* portrait, Thomas Gainsborough shows that he has picked up something important from Hogarth, a new significance and personal insight that shows why he would

come to rival Reynolds. For the time being, however, he put that manner aside.

Gainsborough worked with diligence and application, and had sufficiently sensitive antennae to pick up nuance. He got to know people, and travelled: he travelled between London and Sudbury, following whatever money he could get; he might have travelled to Amsterdam; he got to know the London art trade through Hogarth, Hayman, Boydell and Betew. Between Betew and Boydell he could witness himself being part of the trade, and experience how the art trade can slip beyond the artist's control. Painting and sculpture from across the continent were sold in London, including a steady stream of Dutch paintings, both fine works by the leading masters, and copies, fakes and damaged examples. These, in sale rooms such as Christie's and Langford's, were ubiquitous, and Gainsborough took every opportunity to study and draw from them.[21]

Having at least two dealers, Betew and Boydell, interested in his work should have been a special fillip: this was such a *good* time for a young artist to be in London. With the development of Vauxhall Gardens and the decorative painting work that was available to him there, it was a *very good* time to be in London. Further, the plethora of work and training available for young artists, and the growth of the Foundling Hospital as a platform for display, made it an *extremely good* time to be in London. And more: the market in old masters created the opportunity for Gainsborough to study, clean, repair, copy, and perhaps buy, seventeenth-century Dutch paintings. This made it a *wonderful* time to be in London. With the freedom that he discovered, to grow up away from Sudbury, and to meet new people, and have new experiences, it was a *marvellous* time to be in London. Thomas Gainsborough made a success of it. But within all this, nevertheless, London was as hellish, frightening and dangerous a place to live and work in as it had always been.

12. Thomas and Margaret get married

Throughout Gainsborough's life there are regular accounts by others – and his own admissions – which circle around his enjoyment of urban freedoms, and his indulgence in good living, drink, friendship and sex. While he was extremely good company, he was it seems easily led. Writing years later to his friend the painter Giovanni Battista Cipriani he admitted to enjoying 'the continual run of Pleasure which my friend Giardini and the rest of you engaged me in'.[1] This began early, and may already have had Sudbury roots. By the beginning of 1746 Gainsborough had become attached to a handsome girl of his own age, Margaret Burr, whom he certainly knew in Suffolk and north Essex, but could equally have met in London. She was, according to Fulcher, the sister of a travelling cloth agent in Gainsborough's father's trade, and the pair apparently bonded when Gainsborough painted her portrait for the first time after 'numerous and protracted sittings'.[2] It was certainly a bonus for Gainsborough that she turned out to be the illegitimate daughter of the young Henry Somerset, 3rd Duke of Beaufort, with a settlement on her of £200 a year, and had an address in Duke Street, off Grosvenor Square. Among the descendants of Robert Andrews, a Sudbury school friend of Gainsborough, family tradition had it that Robert Andrews introduced them, 'knowing that a wife with an annuity was a very valuable asset for a man following so precarious profession as a painter of faces'.[3] Margaret's cousin, through a connection with her father, was Robert Price of Foxley, and if Price showed any family concern for Margaret it might have been he who was the means to bring her and Thomas together in London. What is equally interesting and important is who Margaret's mother was, where the surname Burr comes in, and why shades of intrigue and mystery still lie about the girl's birth and upbringing.

Gainsborough wrote many letters to his intimate friend James

Unwin, a lawyer, the agent to the dukes of Beaufort, and a banker with offices in Hatton Garden. Thus Unwin is another candidate for the role of cupid to Thomas and Margaret. He lived with his wife and growing family at Great Baddow near Chelmsford certainly by the mid 1760s, and perhaps earlier. Letters to Unwin provide threads that can be teased backwards to give some very sparse clues to Margaret's origins.[4] Great Baddow was, according to *A New and Complete History of Essex* published in 1770, 'one of the sweetest villages in the kingdom', remarkable 'for the number of its polite inhabitants'. Polite they certainly might have been, but they were also well connected, well off and deeply rooted in finance, politics, the law and the cloth trade. The politician Jacob Houblon bought the Manor of Baddow in 1736 and lived at Baddow Hall. He was connected not just to parliament, but to the Bank of England, where his uncles and cousins were prominent, and to the cloth trade through his family's merchant businesses. The Unwins, further, had some textile connections with Sudbury, as yet unrevealed. There were fine houses in Great Baddow: the village itself clustered around St Mary's Church, and nearby were Baddow Hall, Sebright Hall, and a mile or so away Great Sir Hughes, 'an exceeding good mansion house of brick, with noble piazzas in the front . . . fifteen rooms wainscoted, with fishponds about it'.[5] Great Baddow was a fine, widely spread village, a very good place for the natural daughter of a duke to grow up in.

More than once in his letters to Unwin Gainsborough mentions a Mrs Itchener of Great Baddow and asks Unwin to 'remember me kindly as the Country folks say to Mrs Itchener. She is a good little Woman as ever existed to my certain knowledge.'[6] Writing again a few months later he says, 'My Wife's Compliments attend Mrs Itch in here.'[7] For the third and final time in his surviving letters he repeats his good wishes to the lady: 'I beg My Compts to Mrs Itchiner [*sic*].'[8] Mrs Itchener was the former Elizabeth Murvell (or Marvell) of St James's, Westminster, who in 1748 came to Great Baddow to marry the Rev. George Itchener, formerly the deacon, then the curate, and by now the vicar of St Mary's.[9] Of Great Baddow, Gainsborough wrote with some high significance and certain mystification to Unwin: 'I am so well known at Baddow.

They know my Faults, but ask them <u>who</u> knows any of my Virtues. Ah! That a Jack Ass should be so foolish . . . I hope you are happily and pleasantly situated in the House [in Great Baddow] you mention, which my Wife knows extremely well.'[10]

A few months later he was reminiscing to Unwin once more about Great Baddow, and worrying about his reputation there: 'With regard to your Baddow Friends, when you hear them touch on my Character, you may assure yourself that they attempt a thing as ridiculous to the full, as if I undertook to draw their Pictures without ever having seen them, for they know nothing of me.'[11] People have long memories; this must have been twenty years earlier. Gainsborough must have behaved very badly indeed at Great Baddow, something he might have preferred to forget. Margaret may also have been involved: indeed, whatever happened in the village may reflect an early shared life experience between Thomas Gainsborough and Margaret Burr. He continued to Unwin: 'That you know the worst of me, I am not sorry for, because I know you have good sense & Good nature to place things in their proper light.'

Margaret Burr was born on 7 October 1727 and was christened at St James's, Piccadilly, eight days later, as 'Margaret Burr, of William & Margaret'.[12] St James's is also the church where Elizabeth Murvell/Marvell had been baptised, and the parish church of the Duke of Beaufort when his London house was in St James's Square. Margaret's mother was born Margaret Aikman around 1700, possibly a relation of the Scottish painter William Aikman who moved to London from Edinburgh in 1723.[13] She appears to have married William Burr in Edinburgh around 1718, and they had two sons, Isaak (b.1719; probably died young) and Alexander (b.1720), before Margaret was born. The Aikman family had business interests as forwarding agents in Livorno, then known to the English as Leghorn, the busy Italian Mediterranean port through which so many British travellers and their treasures passed. As an example of the trade, ninety-nine cases of marble objects purchased by the 3rd Duke of Beaufort in Italy were shipped out of Livorno in June and July 1728 through the local offices of Winder and Aikman. This consignment was just one of a number for the Duke. The Duke was rich, glamorous, and an unmarried young

man of twenty when he and Mrs Burr became lovers, at the latest in early 1727. The congruence of Elizabeth Murvell/Marvell and the child Margaret Burr in the parish of St James's, and then, the latter as Mrs Itchener, once again at Great Baddow, leads one to suspect that it may have been Elizabeth who brought Margaret up, and came with her to Great Baddow where Margaret and Thomas first met.

As the Duke made clear in the annuity document he signed in April 1744, Margaret Burr was his daughter, his only child, to whom he left a generous annuity that would lift her out of the artisan class for ever.[14] Margaret may not have known the details, but despite the ministrations of his doctors and the attentions of his secretary Mr Perfect (yes, really), Margaret's father died in Bath in February 1745 after a long illness. He charted its course in letters to his younger brother and heir, Lord Charles Noel Somerset: 'My case is a very odd one & I find by pushing ye gout I can't get it any where but into ye calves of my legs which are now too bad I can scarce stand, so I design leaving of the waters & nurse them in a gouty way. As to bathing them they are all enflamed & look as red as your toe or any other part would.'[15]

Whatever happened, however and wherever they met, Thomas and Margaret were married on 15 July 1746. Unwin may well have been behind this arrangement, because he had a foot in both camps, being closely involved with the handling of the late Duke's finances. Thus the hand that managed the Beauforts' affairs was also the hand that influenced Gainsborough, and he may also have fixed the wedding. If Gainsborough and Unwin had secrets from each other, these did not concern either Gainsborough's money or his love life: the licentiousness evident in some of Gainsborough's letters reaches a height of freedom in his letters to Unwin, and as Beaufort's agent it was Unwin who would come to issue payment of Margaret Gainsborough's £200 annuity to Gainsborough's account at Hoare's Bank.[16] So there was nothing much about Gainsborough that Unwin did not know.

Thomas, Margaret, and possibly James Unwin also, joined the streams of couples tripping down Piccadilly towards Hyde Park Corner to be married. This could be arranged for a guinea a time at the unofficial chapel set up off Curzon Street, Mayfair, by the

excommunicated, renegade and by now imprisoned cleric Alexander Keith, or one of his assistants. Official Church of England business was carried on at the new St George's Chapel, fronting the south side of Curzon Street, an outstation of the nearby St George's Church in Hanover Square. Across a side road, however, Dr Keith's people syphoned off fees for marriage licences by promoting weddings for all comers, for which no banns were required and no questions asked. These marriages, held beyond 'a porch at the door, like a country church porch', were, then, perfectly legal.[17] 'Happy is the wooing that is not long a-doing', Keith proclaimed as he took the fees and signed the papers.[18] There were two other weddings at the chapel on Thomas, Margaret and James's day, fifty-nine in that same July, and about nine hundred in that year. Evidently Keith was coining it, even though he was in the Fleet Prison and working through his renegade team. Unofficial these marriages may have been, but with such an extensive take-up they were hardly clandestine. Gainsborough gave his parish as St Andrew's, Holborn, the church near the southern end of Hatton Garden, and Margaret gave hers as St George's, Hanover Square. This was the parish that contained Duke Street, Grosvenor Square, where Margaret is noted as living in her 1744 annuity document. This was just steps away from Beaufort House, Upper Grosvenor Street, so when marrying with Dr Keith, Margaret was indeed 'a woman of this parish', even though the chapel and the priest were not. The couple set up home at 67 Hatton Garden.[19]

What the parents felt about all this we cannot know. Margaret's father was dead by now, so probably was her mother.[20] Deep in Suffolk, whatever their private feelings about the circumstances, Thomas's parents would surely have been mollified by Thomas marrying an heiress, and a well-connected and pretty one at that: 'Master Tommy's wife is handsomer than Madam Kedlington', a Gainsborough servant reported when he was sent off to meet them as they approached Sudbury for the first time as a married couple.[21] Uncle Thomas's investment in young Thomas's future had paid off, and was bringing a rich and handsome dividend home with it.

The cause of all this rushing about to get married was because Margaret was already pregnant; or was she? A pregnancy might

just be gossip, based on Thomas's known womanising tendencies. Dr Keith's chapel was in Margaret's own parish, and the couple's choice of the unofficial chapel over the orthodox Anglican St George's Church could equally have been because Margaret, while illegitimate but acknowledged with her annuity, was eager to keep the wedding quiet and bann-free, and Thomas was brought up a nonconformist. Dr Keith's organisation performed a service to ease these little difficulties for thousands of couples. There was no call or expectation for Thomas and Margaret to be married in Sudbury, or at St Andrew's, Holborn, by Cutts Barton. They had a child after their marriage, if the burial of 'Mary Gainsborough Hatton Garden' at St Andrew's, Holborn, nearly two years later refers to their daughter, but the burial of a child in March 1748 is hardly evidence that it was conceived before a July 1746 wedding ceremony.[22]

Here we have a very successful young London artist, painting pictures, making waves, making some money, being at or near the centre of his profession, and marrying a well-connected young woman with a secure income. The crowning event of this early part of Gainsborough's career had been his invitation to submit a painting to the Foundling Hospital in May 1748. That gift would certainly have led to more commissions and to greater exposure. Within six months he was listed as one of London's 'justly esteemed eminent masters'. Why, then, did he leave all this and go home, with his new wife, to the volatile and depressed little town of Sudbury of all places?

The answer to this question may lie in Hogarth. However well connected, effective and productive Hogarth might have been, he was also essentially anti-establishment. He annoyed people, he spoke truths, he revealed hideous injustices and social evils, he spread his opinions expressed in line and image far and wide and freely through his fecund output of prints. Admired and feared, Hogarth was not, however, loved everywhere. In London, Gainsborough was touching the edge of Hogarth's orbit and making his way. He was too close to him. If they did not have the same clients, they occupied the same professional landscape. Gainsborough had the ambition and the talent to impress: he painted rich fabrics, he could do shimmer, he could, like Hogarth, capture fleeting

personal expression. He could paint people staunch and haughty just as Hogarth could. He was good at telling detail – a letter, a flute, a dog – and adept at context. But what he did not do, and Hogarth did constantly, was bang on about society, class, injustices and politics. Gainsborough wanted to impress, to shine, and to paint for 'the Quality', indeed to paint portraits of 'the Quality', give them what they wanted, and earn his money from them. His private life may have had its Hogarthian aspect, but that was his business. His work was something else.

While he had a wife whose modest fortune was secure, it was nevertheless not his money, even if the law at that time gave him clear rights over his wife's property. We know nothing of the internal politics in the early years of this marriage, but if the future is any indicator of the past, Margaret will have created severe early demarcation lines between her money and his, and made it plain that he should be clear to her about his earnings for the sake of family harmony. John Gainsborough had managed to escape the debtors' prison by the skin of his teeth through family safety nets and advocacy. Thomas Gainsborough, however, living as he and Margaret did within a quarter of a mile of the Fleet, and the Liberties of the Fleet where debtors were curfewed, knew like everybody else of the harsh sudden justice that sent the impecunious and rash to be locked up and maltreated. By his own later admission, Gainsborough could do silly things. Debt and the debtors' prison cast a dolorous shadow – Hogarth knew it from personal experience; the portrait painter John Vanderbank knew it, and experience of the Fleet killed him. This system was legal kidnap, designed to extort ransom money from family and friends because the debtor would in most cases be unable to work to pay his or her way out. While the wider Gainsborough family had come to the aid of John within the Sudbury context, there was little or no chance that they would do the same for Thomas in London twenty years later.

Gainsborough now had a young wife and a baby, and while the couple had good rooms in Hatton Garden, this was no place for people with country backgrounds to bring up a child. Confused already by being pulled in his work between London and Sudbury, with Hogarth on one side demonstrating the artist's radical,

reforming responsibilities, and on the other a wife with money and an upper financial hand, he had to make a choice. The baby died. He chose Sudbury. And so Thomas and Margaret travelled east.

III

Suffolk again

13. Retreat to Sudbury

Thomas's father, the battered but nevertheless undaunted John Gainsborough, died on 29 October 1748. Putting professional calculation and the loss of their daughter aside, this was surely another of the factors that guided Thomas and Margaret home.

Whatever pressures Gainsborough felt in London to leave the metropolis and work away from its lure will have been stimulated and encouraged by an equal attraction from his remaining Sudbury family to come home. Sudbury was something of a whirlpool for them all, dragging them back. 'Scheming Jack', now married to another Margaret, with a growing family, came home after the bust-up in Beccles; Mary Gainsborough married Gibbon and got out; Humphrey became a priest and went away; but after Robert's wife died in the 1740s he came home with their children, married again and became a Sudbury crapemaker.[1] The Duponts stayed and brought up a family, two girls and three boys, one of whom, imaginatively named Gainsborough Dupont, would one day become Thomas Gainsborough's painting assistant. The Gainsborough Christian names double and redouble like baby rabbits in a burrow: Thomas, Thomas, John, John, Robert, Robert, Margaret, Margaret, Mary, Mary – and now Gainsborough, named after his mother's family. The widowed Margaret Gainsborough lived in the family house in Sepulchre Street, now with her two younger daughters, Elizabeth and Susan. Wherever Gainsborough turned in Sudbury there would be a relation nearby, whether he liked it or not. Fresh from professional acknowledgement in London, and glowing from the increasing demand in Suffolk for his work and presence, Thomas back now with his beautiful young wife to live beside his mother and sisters, was balm. The family's ewe lamb had come home, to live in a rented house in Friars Lane.[2]

The Thomas Gainsborough that came home was transformed from the young Thomas who set off for London eight years

before, now grown up, accomplished, confident and married. The tension which he experienced throughout his life was showing itself with some rawness: between landscape painting, at which he was profoundly talented, and the painting of portraits, at which he was very accomplished, and which made him some money. He was also trying his hand at engraving and etching, but it was messy, slow, and he was clumsy with the acid. Already many people thought he was extremely good at painting portraits, and for that reason he could continue to make a living at it. But while we certainly go to Gainsborough's portraits for likeness, exuberance of spirit, status, and sumptuousness of costume, fabric and fur, with a few notable exceptions we do not go to him for insight into character. He catches the nature of his people through their clothes; rarely, however, through their eyes or expression. That is not his business: after all, he would later describe himself merely as 'your *likeness* man', not as 'your examiner'.[3] Was he frightened of too close an engagement with the source of his income; was he just being a prudent and watchful courtier; or did he simply not have the time to examine his clients as they passed in and passed out of his painting room at such a rate? Where Gainsborough does seem to put his finger on a pulse of thought or motivation it is in his few self-portraits, and those of his wife, daughters and close friends. Continually, decade by decade, Gainsborough lived a double or even a triple life: portrait painting created his wealth; landscape painting bolstered his sanity; and sex, drink, wild-living and music came as his main sources of relief. Where Gainsborough touches a core (usually his own core), it is in his letters.

Sudbury had a rich musical life across the 1740s, one echoed in other Suffolk towns. In his portraits of John Chafy and William Keable he signalled his interest in music at an early date. A series of Tuesday subscription concerts was running in Sudbury when Thomas and Margaret came home.[4] Flower shows were popular and frequent in the county – a 'fine shew of tulips' at the Rising Sun in Bury; the annual show of auriculas 'at the house of Mr Joseph Rivers at the sign of the Fleece in Ipswich' – the prize 'a piece of plate to the value of 2 gns . . . each person shall produce six pots of his own blowing'.[5] Towns in Suffolk swayed to the local

music, and blossomed with competitively grown tulips and au-
riculas with their multitudinous variations in colour and pattern
around their small, tight, smiling rosette blooms.

Gainsborough had work waiting for him in Sudbury. He had
already painted William and Françoise Carter of Ballingdon
House, friends of the family, both steeped in the cloth trade; he
had begun a series for the Lloyds of Queen's Square and Hint-
lesham Hall; and had painted the double portrait of his good
friends Joshua and Sarah Kirby. He might already have painted
the Rev. Cutts Barton.[6] His school contemporary Robert Andrews
and his new wife, Frances, of Bulmer, south-west of Sudbury (just
inside Essex), were yet to sit for him, as were the Browne family
of Tunstall near Snape. A host of single men were soon to join
the procession towards the easel of this bright young man of
Sudbury. Many of these were around his own age: John Plampin,
Robert Andrews, Peter Muilman and Charles Crokatt were all
in their late teens and early twenties in the late 1740s; like him,
they were likely lads parading city elegance and county swagger.
One by one or in small groups they came, and he kitted them
out like a fashion parade in their stylish hats, fancy waistcoats
and natty shoes. Tricorn hats and an infinite variety of splendid
waistcoats is a constant theme, all set about in unspecific bosky
landscapes with their slight touches of Suffolk in a sandy bank
or a rolling vista. We need not feel in any way concerned about
the professional future for this energetic, talented and personable
young man.

The years in Sudbury are pivotal. He keeps the coach trade
busy between London and Sudbury as he sells drawings to Panton
Betew and continues some kind of business relationship with John
Boydell. He and Margaret have another daughter, Mary, born in
1750, and a second, Margaret, in 1751. If the Mary Gainsbor-
ough left behind in the Holborn churchyard was indeed their
first daughter, this second Mary became a speedy replacement
in this radical recalibrating of their lives. Despite evident money
worries – his worries, not Margaret's worries; worries of cash
flow, being paid or not being paid – Gainsborough evidently felt
opportunities in Suffolk were there for the plucking when he and
Margaret left London. His groups of portraits, landscapes, and

portraits-in-landscapes show how well and diligently he used old or long-developed connections for new professional adventures: links with families, which suggest continuity of friendship, and multiple portraits which themselves indicate that his patrons considered him to be consistently reliable, arguably as much a conquest for them to have engaged him, as for him to have landed the job.

Landscape, however, hovered about him like an old flame. The central work of this period is *Cornard Wood* (Pl. 4), whose dating he obfuscated by a casual remark in a letter years later when he asserted that *Cornard Wood* was 'begun before I left school'.[7] This large, sophisticated oil is certainly the culmination of a number of drawings and oil studies, both of Cornard Wood near Sudbury, and of rural subjects around and about, so it is best to consider these early works together, all part of the same stream of precocious talent, and clearly all linked. *Cornard Wood*, its studies and variants are, as Gainsborough himself told Henry Bate Dudley, 'an early instance of how strong my inclination stood for Landskip . . . the means of my father sending me to London'.[8] There is so much going on in *Cornard Wood*, people hanging about as if they are waiting for something, or somebody, and a forest of trees. When Gainsborough said 'begun before I left school', he must have meant a whole series of connected early drawings and studies, not only the final accomplished painting in the National Gallery. He may equally have meant before he left his art school in London, as much as his grammar school in Sudbury. The scale and accomplishment of *Cornard Wood* prompts questions: it is *big* – four feet by five – a scale that must direct us to realise that this cannot be the miraculous product of an infant prodigy, but a painting with a hinterland, a purpose and a destination that is now forgotten. It shows us, also, that he dares to confront scale.

The album of drawings by Gainsborough in the Royal Collection at Windsor includes an important and highly revealing squared-up study for *Cornard Wood*, demonstrating the depths of planning Gainsborough put into his landscape compositions.[9] The drawing is evidently the end of the composition process, and is itself the culmination of a long period of immersion in the local

landscape, and a distillation of Gainsborough's early reflections on his home landscape in the light of what he has learned in London. The drawing also demonstrates that 'begun before I left school' means what it says, and that its completion took place long after he left school and after much preparation and effort.

With *Cornard Wood* and its variations on the theme of wooded tracts, sandy banks and occluded vistas available for purchase, Gainsborough greatly expanded his practice as a landscape painter. He reached this standard of sophistication only through going out into the country as he had as a boy, and drawing, drawing, drawing. The Royal Collection album amply shows the extent of his application.[10] These twenty-five drawings, each around twelve or more inches wide, are vivid, exploratory evocations of the landscape around Sudbury. Gainsborough's black chalk makes out the main formations – the sandy bank, the fallen tree trunk, the cattle – while his white chalk skitters about with highlights, in the lively manner that in due course he will translate beyond landscape into his painting of the play of light on fabric. In the Windsor drawings he was developing his freedom of hand and wrist, and would come to master this technique, and to teach others to do so. One sheet has a portrait study of a young woman on the reverse, suggesting that he might not always have been alone out in the country.[11]

In the period that ended with his departure for Bath in 1758 Gainsborough produced perhaps seventy landscapes which range from the ruminative and poetic, as in *Wooded Landscape with Herdsman Seated*;[12] incident laden, such as *The Fallen Tree*;[13] and the curiously pregnant *Rest on the Way*, the apparent earliest, dated 1747.[14] Others, such as *Landscape with a Woodcutter and a Milkmaid*,[15] which can be securely dated by its receipt for 21 guineas to 1755, and the very ambitious, large-scale *River Landscape with a View of a Distant Village*,[16] have a touching narrative that binds the figures, livestock and landscape into an engaging whole. The latter, with its dull, dull title, which has been dated on no real evidence (basically, a guess) to around 1750, was probably commissioned to hang over a fireplace in a grand house. The common factors in all these is their sandy-banked landscape redolent of Suffolk, but not descriptive of it; a few straggled country figures

dressed in rough cloth or leather, certainly not the kind of people who Gainsborough was paid to paint; and soft late afternoon light with burgeoning effects of cloud that fifty or more years later would become labelled 'cumulus'. With the exception of distant churches, or a few fragments of masonry or mossy cottages in landscape backgrounds and as staffage for portraits, architecture no longer features as a subject in Gainsborough.

Gainsborough's early landscapes are seductive works which draw the eye and mind into their conceits, but they have little or no sense of place, and have no titles because they went straight to the purchaser or commissioner and were never exhibited in public or catalogued. As the Windsor album demonstrates, however, these subjects are based on rigorous observation and a strong sense of composition that developed when Gainsborough went out to draw in the field. If he had given them titles, he might have dreamt up something like 'Love at the Well', the title he wrote on the receipt made out to 'Scott Thompson Esq' for 'one Painting', for the sum of £35, and £5 for its frame.[17] *Love at the Well* has not been traced, as far as is known, but it may be a lost title for one of his vaguely titled known works with their little vignettes of rest and rustic courtship under a wide and loaded sky, or a subject intended for engraving.

The eye can take a walk across Gainsborough's landscapes of this period, and measure the few miles between a foreground feature and a distant church tower or spire. We are given a field-by-field approach to a church tower in for example *Wooded Landscape with Peasant Resting* that might be in or near Sudbury.[18] He plays games with his home landscape, says 'you're here', and then suggests you're not. If you get drawn in too much to these paintings you risk finding yourself in the wrong village with an out-of-date map. Nevertheless our eyes assure us that we are most certainly in southern Suffolk, on the border with Essex.

In London, more specifically perhaps in or around Hatton Garden, Gainsborough had met Richard Lloyd, a King's Counsel, a bencher at Middle Temple and an ambitious and clever lawyer who lived in Queen's Square, a few hundred yards west of Hatton Garden. The youngest of his four children, Heneage, was christened at St

Andrew's, Holborn, on 28 October 1742. Lloyd, who was born and educated in Litchfield, the son of a soldier, had a radical change of fortune when in 1745 the ninety-year-old dowager Countess of Winchilsea left him her entire estate, 'inexplicably'.[19] This dowager was Elizabeth, née Ayres, the widow (and fourth wife) of Heneage Finch, 3rd Earl of Winchilsea, a remarkable and effective ambassador to the Levant. Elizabeth Finch, an heiress in her own right,[20] had had three children by the 3rd Earl, and plenty of her own money, so the bequest to Lloyd must have come by special measures, its passage towards him being no doubt eased if not signalled when the Lloyds gave their younger son the unwieldly but significant name Heneage. The Winchilsea bequest led to Lloyd being able to raise his game and become an MP, then get a knighthood, and in 1747 buying Hintlesham Hall.[21] He later became a judge and Recorder for Harwich, Orford and Ipswich, where he had yet another house. Lloyd was of the rising, clever generation who found wealth on the handles of the law, preferment in politics, status through marriage, and, in acquiring fine houses east of the metropolis, fresh pools of county esteem. Touching England's eastern counties brought further connections between the cloth trade, its legal requirements, and its secure banking needs, and created the opportunities for dynastic links which endure.

What began in London in 1745, when Richard Lloyd came into money and may then have commissioned two double portraits from Gainsborough, continued in Suffolk across the next few years. The first was probably the double portrait of the eldest son, Richard Savage Lloyd, fifteen or sixteen years old by now, and his mother, Elizabeth (Pl. 10): she is dressed in a white silk gown, Richard in a dark blue jacket and waistcoat, while over the arm of a garden bench Elizabeth has cast a mourning gown – mourning perhaps for Elizabeth Finch, whose money was paying for all this.[22] The bench is intertwined by ivy, a sign of eternity, fidelity and affection. In the colour code explained in the same *Universal Magazine* article that promoted Gainsborough as a 'justly esteemed eminent master', blue is the colour of true faith and continued affections, and milk white the colour of innocence, purity, truth and integrity. In the second double portrait, of his

daughter Lucy and young Heneage, Lucy, dressed in white, holds Cupid's arrow in check, while Heneage sports a black hat – black: wisdom, sobriety and mourning – and fine red trousers – red: justice, virtue and defence. [23] A third portrait, of the paterfamilias, a head–and–shoulders of Sir Richard Lloyd himself, would come later in the 1750s. [24]

In the Lloyd portraits sequence Gainsborough is portraying a fine, upright, faithful, affectionate, innocent, wise, just, sober, virtuous etc etc family, one which at the very time Gainsborough needed support and encouragement gave them to him in good measure. He seems to be already tightly and wholly integrating his commissioned work into the injunctions that the *Universal Magazine* published. Following the published rules of colour, Gainsborough has also very closely observed the faces of his sitters, obeying the magazine's instruction: 'go over the face very curiously'. Such observations demand not only sharp eyes on the painter's part, but also physical proximity, what in the twenty-first century might be referred to as an invasion of body-space. We license dentists a close approach of this kind; in the mid eighteenth century it was the requirement also of portrait painters. Physically close observation of his sitters was a manner that Gainsborough practised and refined throughout his career, and it appears to have begun for him at the beginning.

While the faces were painted from life, the bodies of all these people would, however, have been completed when the sitter was absent. Gainsborough's tool here was the lay figure, a small, jointed doll-like mannequin that could be posed at will, and dressed as appropriate. With his nimble fingers he was fully able to make his own lay figures; he of all people would not have to buy them until he could afford to do so. [25] There would be no shortage of bits of stuff of the highest quality around the Sudbury weavers' sheds, and of any colour, type or weave. Silk cuttings, no problem. Gainsborough could dress his lay figures at will, without the need to burden the sitter with the responsibility of attending every session in his or her best outfit.

Woven around the Lloyd portraits are Gainsborough's three early portraits of members of the Kirby family: the double of Gainsborough's friend Joshua and his wife, Sarah, and one

each of the parents, John and Alice Kirby.[26] There is a further serendipitous connection here: Joshua's older brother John was Under-Treasurer at Middle Temple, and one of Richard Lloyd's colleagues.[27] When this younger John Kirby died in 1750 he bequeathed to 'my dear and ever worthy and honoured master and friend Sir Richard Lloyd' the sum of twenty guineas 'for a ring or some other remembrance of me'.[28] Gainsborough's double portrait of Joshua and Sarah suggests that he is tending to become, we might say, monotonous. Charming though this Kirby portrait is, it is a composition Gainsborough had rehearsed, and will rehearse again and again over the next few years: a couple, in a woody landscape, side by side, on a bench or a grassy bank, looking out at or entertaining the viewer in much the same way as the couple in the headpiece for the song 'The Apology' that he had picked up in Vauxhall Gardens. A composition type that Gainsborough's older colleagues such as Arthur Devis or Francis Hayman considered fashionable was eventually inherited by studio photographers and done to death.

However, mortality strikes when Gainsborough painted himself and Margaret in exactly the same pose, but here with their dog lapping at a stream, and a daughter beside them (Pl. 23).[29] Which child is this? Seemingly aged about two years old, this might be the second Mary, thus dating the portrait to 1752. On the other hand, we could be looking at a portrait of Thomas and Margaret with their first Mary, who could also have been two years old when she died: this would date the painting to around 1747 or 1748, and give it an additional emotional charge.

Gainsborough painted himself and Margaret, Joshua and Sarah Kirby, and the Lloyds, all with some kind of strangled background narrative in stagey studio landscapes. However, he painted the Kirby parents, John and Alice, in a pair of formally observed portraits, head-and-shoulders in each case, and without any flippant or fashionable setting (Pls 11 and 12). Alice Kirby, née Brown, has a quiet, wry smile playing about her lips, which appear to conceal a toothless set of gums. Aged in her early to mid sixties as she would have to be by this time, this is hardly surprising for the period; what is plain, however, is the directness of Gainsborough's approach to her person, as direct here as it

was allusive in the Lloyd portraits. Her trim bonnet is deliciously painted, the light from the left shining here and there on the white linen, the ruffles of lace giving a show of tidy humour to this evidently charming older woman. Her eyes are tired, her skin has lost its elasticity, and Gainsborough gives us all this in a manner that echoes his experience of the engraved Houbraken *Heads*, and evokes seventeenth-century Dutch portrait painting. All in all, this is a seventeenth-century portrait, the figure in a plain brown dress enlivened with shining white linen, before a plain brown backdrop. The roundel echoes the Houbraken compositions, and is a statement of respectable formality, reflecting the honour and status that Alice Kirby evidently carried in Gainsborough's heart.

Alice's husband, John, is shown with a different kind of formality, as if he were a seventeenth-century divine rather than an eighteenth-century schoolmaster, turned miller, turned traveller and surveyor (Pl. 11). However, unlike his wife, who sits comfortably back in her frame, John Kirby leans forward slightly, his right hand plunged into his coat, his white-and-grey hair shining in the same sidelight that lights up Alice. His beady eyes are on us, and they and his cheeks, red with burst blood vessels, together bring life to the face and give it a lively irregularity. This Hogarthian portrait, a certain match for the portrait of his servants that Hogarth would paint in the early 1750s,[30] gives us yet another perspective on the brilliance and versatility of the young Thomas Gainsborough, who once again shows he can challenge Hogarth in perspicuity and insight. Gainsborough can do well-dressed dolls prettified in model landscape; he can do 'very curiously' observed features; he can do recherché heads and shoulders, painted versions of Houbraken's engravings; and now he shows he can do serious men who burst out of their frames and confront us with mortality.

Gainsborough tended to paint his portrait subjects in close family circles: Lloyds, Kirbys, Carters, Gainsboroughs. Following this line, there are at least two orphan portraits of gentlemen from this period who might perhaps be John Kirby: one, known as *Man in a Wood with a Dog*, shows a fine fellow in another splendid waistcoat, a tricorn hat and leaning on a well-turned walking stick, standing, as the given title indicates, in a wood with a dog.[31]

The other shows a soberly dressed legal or clerical gentleman seated with a book in another artificial Gainsboroughesque setting of trees, wall and vista.[32] One or other of these might be John Kirby; equally neither might be. But seeing how Gainsborough wove his friends' family networks into his output – or his friends did the weaving by commissioning him – this idea should certainly be examined.

Some clients fell by the wayside for one reason or another. An X-ray of a typical Gainsborough landscape with the descriptive given title *Wooded River Landscape with Peasant Sleeping and Couple on a Bank*, reveals, beneath its surface, a man in a hat under a tree.[33] Why was this painted out? Was it obliterated in a youthful Gainsborough fury because the man did not like it and refused to pay?

Another orphan subject, a couple who have now completely lost their identity, was painted by Gainsborough over another already-used canvas. He shows them in a landscape, side by side, under a dying oak tree, leaning against a bar fence or stile at the edge of a corn field.[34] In the distance is a church tower, a brick bridge, and further away a larger bridge over a river that winds off into the horizon. This looks very much like Suffolk or Essex. The woman, inadvisably dressed for the country in a wide hooped dress, holds a porte-crayon and a drawing she is working on. This is undoubtedly a pair painted from life, but nobody yet knows who they are. With his portraits of the Lloyds, the Kirbys and the Carters, this unknown couple, set like Robert and Frances Andrews would be into a landscape – their landscape? – we are getting deeper and deeper into Suffolk and Essex patrons and provenances, and can demonstrate Gainsborough's indelible attachment to his home county both while he was learning his trade in London, and subsequently.

The tight and incisive portrait of Rev. John Chafy most probably also comes from the Sudbury period: certainly it was begun in Sudbury. Chafy sits in just the same kind of landscape, and beside just the same sort of tree as the Lloyds, Kirbys and Carters. With music and perhaps birdsong, Chafy, curate of Great Bricett, a village north-east of Sudbury on the road to Needham Market, is shown celebrating enjoyment of life.[35] There is the stock tree,

conveniently placed for leaning against; there too is the sandy
bank, on which Chafy sits playing his cello. In the background,
however, are large hills quite alien to Suffolk. But Chafy was to
leave the county in 1752 for the richer livings of Broadchalke and
Alveston in Wiltshire, where he married, so this portrait must
be his farewell to the county and to Gainsborough, with the hills
being Gainsborough's attempt at the wilder Wiltshire landscape
that he had not yet seen. The cello indicates Chafy's musicianship,
a skill that Gainsborough himself envied. Perhaps they played to-
gether; perhaps they were good friends; in any event the portrait
was always close and dear to Chafy, and when the time came he
left 'the picture of myself playing on the violoncello which was
drawn by Gainsborough' to his niece.[36]

The four years in which Gainsborough consolidated his life and
his career in Sudbury brought him not only two daughters but also
the series of commissions both for landscape and portraits which
gave him the exercise that his profession required, and the level of
employment that can only have boosted his confidence. Andrews,
Carter, Chafy, Cobbold, Kirby, Lloyd, and others whose names are
now unknown, knew each other, or knew people who knew them.
They danced at each other's balls, they met at markets, they sold
farm produce to one another, poked each other's pigs, visited, paid
respects. Their children intermarried – they were county society,
the very lubrication that portrait painters need to understand in
order to be able to slip about among them. In the later years in
Hatton Garden, Gainsborough had been multi-tasking: he had to
travel to and fro between London and Sudbury, and with work
awaiting him at both ends of the journey he had to keep a studio
and materials in both places. A set of nineteen contemporary paint
bladders discovered in 1966 in the attic of Gainsborough's House
may come from this Sudbury period.[37]

For all his professional focus, Gainsborough retained in his
early married years at least the laddish tendencies that overcame
him now and then: 'O dear O dear I don't think I'm a bit altered
since I lived in Hatton Garden'.[38] We will see how he was wiped
out for weeks after drinking bouts with the boys in Ipswich and
London, and he may also have had some heavy times followed
by guilt and self-loathing with those three smart-looking chaps

Muilman, Crokatt and Keable, before, during or after the weeks
it will have taken him to paint their group portrait (Pl. 13). Peter
Darnell Muilman, Charles Crokatt and William Keable were pals
in town and country: they may have met in London where Muil-
man and Crokatt's fathers had prodigiously successful trading
businesses: Muilman east with the Netherlands, Hamburg and
the Baltic, Crokatt west across the Atlantic with the Carolinas.
The money they made from the ends of the earth enabled each
of them to buy grand properties in Essex, and begin overtures
of inter-marriage. The plan was for them all to become one big
happy family, and that is undoubtedly the spin Gainsborough was
hired to project. Charles Crokatt did indeed marry Peter Muil-
man's younger sister Anna, but nothing came of the projected
marriage of Peter to Charles's sister Mary.[39]

It had previously been accepted that Muilman is the figure on
the right and Crokatt on the left, but this is no longer clear. Wil-
liam Keable, playing the flute, was a local musician and portrait
painter who might momentarily have been a professional threat to
Gainsborough, and may also have been teaching the lads to play.
The portrait, commissioned by one or other of the fathers Henry
Muilman and James Crokatt, is a dynastic statement with music
attached. Henry himself had not had much luck with marriage, so
he had high hopes for his son. He had in 1724 briefly married the
already-much-married and alluring courtesan Teresia Constan-
tia Phillips, and subsequently had to spend large sums of money
trying, finally with success, to annul the marriage, which was
found to be bigamous. The whole thing turned to ashes when
Peter failed to marry Mary, and then in 1766 died. Three years
later, amid reports of financial misconduct, Crokatt killed himself,
leaving Anna a widow.[40] This fragmentation of the principal fig-
ures in a stag party that came slowly to grief was complete when
Keable moved to Italy, where he lived for the rest of his life. Out
of this ghastly story only Gainsborough emerged smiling, as he
pocketed his fee.

By 1750 Gainsborough had palpably high ambitions, despite
the later self-serving claim of Philip Thicknesse that they were
not high enough, and that Gainsborough merely 'considered him-
self as one, among a crowd of young artists, who might be able

in a country town, by turning his hand to every kind of painting, to pick up a decent livelihood'.[41] We shall meet Thicknesse in due course, and see how he set his own agenda in his posthumous life of Gainsborough, to make himself the hero of the story.

14. Mr and Mrs Andrews of Bulmer

Gainsborough's *Mr and Mrs Andrews* (Pl. 14), now one of his most famous paintings, celebrates the coming together in marriage of two local families to ensure the cohesion of an extensive local property near Sudbury. This was not a long dynastic inheritance, no deep family memories were at risk here, as the land had been relatively recently acquired.

The Andrews family were deeply local, and proud to be so. Their land straddled both sides of the River Stour, the boundary between Suffolk and Essex, so they looked equally to Ipswich and Bury, Colchester and Chelmsford, and to the sea and to the city. Like the Gainsboroughs, some of the Andrews took local political responsibility and were burgesses of Sudbury. The father of the Robert Andrews in the painting, also Robert, was himself the son of a yeoman farmer in Bulmer, just across the river from Sudbury. He was noted for being aggressively protective of his property, having tried to sue the parish of St Gregory's in 1723 for cutting his trees down.[1] He clearly had dynasty in mind, for he meticulously planned his youngest son's inheritance. This was the young Robert Andrews who Gainsborough depicts with his muzzle-loading rifle and his dog and his new wife. Despite the elder Robert Andrews' care in setting out his wishes, his widow, Martha, his fourth wife, had a fight on her hands. Robert's eldest son, Joseph Andrews, an apothecary in Sudbury, his son by his second marriage, must somehow have fallen out with his father. He objected to the terms of the will, and challenged it. Joseph lost his case in January 1737 and had to pay costs. When Robert Andrews' will was proved nineteen days later, this ill-advised apothecary was left just one shilling, a parcel of land in Great Cornard and a cottage in Middleton nearby.[2]

Being 'cut off with a shilling' for this fifty-year-old was not much better than a poke in the eye: Joseph's ten-year-old half-brother, Robert, got everything else, including land and properties

around the border and in Sudbury itself. Among these properties was Auberies, the remains of a convent dissolved under Henry VIII, and its lands and outbuildings on the edge of the village of Bulmer. This was a mile or more up the hill running out of Sudbury towards Chelmsford, and straddled the ridge between the Stour valley and Great Yeldham. While Auberies is on relatively high ground, the folds in the landscape cut it off from wide views.

Auberies had not been in the Andrews family for long. The late Robert had bought a moiety, or half-share, of the property in 1717,[3] while his neighbour William Carter bought the other half. Issuing a severe warning in his will that his widow would lose everything if she remarried, Robert Andrews assured Martha of 'the use' (but not the ownership) of the delapidated ecclesiastical pile 'for so long time as she shall remain my widow and no longer', and that she may occupy the parlour, the hall and the two rooms and a garret above, the chapel, the staircase and the buttery beneath. Martha could use all the household goods and furniture, and could enjoy 'the liberty of baking brewing and washing in the brewhouse', and of taking water at the pump, and come and go as she wished.[4] This could hardly be clearer; though these were golden handcuffs, Martha was safe from being forced out of Auberies by her son, were he of a mind to do so when he grew up.

The owner of the other half-share, William Carter, the Gainsborough family friend, was a very successful merchant, with cloth-trading interests in London and the Low Countries. He and his wife, Françoise, the daughter of a wealthy Huguenot cloth merchant, Claude Jamineau, lived at Ballingdon, the village adjoining Sudbury on the Bulmer side of the river (Pl. 9). Carter's brother Bernard, a clothier, had been Thomas Gainsborough's father's principal creditor.[5] The three families were woven together like threads on a loom.

On 10 November 1748, thirteen years after his father died, and after attending Sudbury Grammar School and University College, Oxford, twenty-year-old Robert Andrews married sixteen-year-old Frances Carter, the daughter of William and Françoise. As the terms of the wills suggest, this marriage must have been long

planned by the parents; young Robert and very young Frances
may not have had much of a say in the matter. When William
Carter wrote his will, in August 1749, he named his son-in-law
as co-executor, and left him 'all that my moiety or half part of my
freehold estate . . . in the parish of Bulmer, Little Henny and Mid-
dleton'.[6] William Carter died in 1750. Auberies was small change
for him as property: he does not give it so much as a name in his
will. His land holding in Essex and Suffolk included properties in
Halstead (95 acres), Gestingthorpe, Little Maplestead (70 acres),
Little Cornard and Great Cornard, Hartest and Lawshall (185
acres), and other properties including his house in Gracechurch
Street. These he left variously to his own sons, William, Claude
and Jonathan, but the particular bequest to Robert Andrews was
his sign of the desire to create a local dynasty, and was an ul-
timately successful outcome after Joseph Andrews' unfortunate
intervention some years earlier. Victory for Joseph would have
ruined it all.

While we could date Gainsborough's double portrait *Mr and
Mrs Andrews* to 1748, as a celebration of marriage, it is more likely
to have been painted in 1750, as a celebration of inheritance, and
commissioned by Robert. His mother died in 1749, making Robert
and Frances the secure occupants of their house and estate.[7] They
sit on an elegant rococo metalwork bench decorated with Venus's
shell with their backs to an oak tree. The house is nowhere to be
seen, and its owners pay no attention to it in their gaze: it is at
least 200 yards away to the left. This is a portrait of the extent
and promise of the land and its owners, not of the splendour of the
edifices built upon it. Robert Andrews had no particular feeling
for the old wreck: he soon pulled it down and built anew. The oak
tree they sit under was still, in 2017, flourishing on a high dome
of land that falls away steeply to the north and east.[8] So much
is it a portrait of Andrews' land that Gainsborough reconstructs
the landscape to show far more than can be seen from that spot,
then or now: there is much more landscape in the painting than
can possibly meet the eye. Sudbury can be seen through the trees
much as in the painting, but Cornard Wood cannot, nor could
Middleton, and nor the roofs of Ballingdon, though this may have
been possible before the trees grew up.

This is why the painting is so revolutionary. It does not follow the traditional pattern of portraits of houses in landscape, because the new house was not yet there, but instead the extent of the natural landscape that was by design now under the control of one family. By including the roofs of Ballingdon and Middleton, Cornard Wood and the tower of All Saints, where Robert and Frances were married, Gainsborough observes the Andrews/ Carter ecology in its entirety: not just the product, but the crucible wherein the family elements reacted together. Even the oak under which the couple sit would be under continued observation: Arthur Young measured it and two other 'fine oaks in the same meadow', the girth of the largest being in 1786 11 feet 1¼ inches in circumference (nearly 3.4 metres).[9] While Gainsborough presents a closely observed and unified scene, *Mr and Mrs Andrews* is a mosaic of different viewpoints which touches on the technique David Hockney came to use in his photographic landscape works of the 1980s and 1990s.

The corn in Robert Andrews' field is cut and set in stooks, so it must be September, given the healthy crop, and perhaps the touch of turning early autumn foliage on the trees. The stubble reveals the modern practice of eighteen-inch-wide planting, the technique that the Rev. Henry Hill had adopted in Buxhall. Like Hill, and John Plampin of Chadacre Hall, who Gainsborough would come to paint, Robert Andrews' work as a farmer was greatly admired by Arthur Young, who asserted that 'his husbandry is excellent . . . I had viewed Mr Andrews' farm before, and found him a very able cultivator'.[10] Young added: 'I have long known Mr Andrews one of the most careful and practical farmers I have anywhere met with.'[11] In the middle distance is a newly fenced field full of sheep, but in reality the field is a steep upward slope. A much more topographically accurate view of the Auberies estate may be the painting now known as *Wooded Landscape with a Cottage and Shepherd*, and it is possible that in it we see Gainsborough's research notes for *Mr and Mrs Andrews*.[12] Gainsborough shows Robert as the pioneer agriculturalist he would become, and demonstrates that he is starting as he means to go on. The Auberies is rich, valuable farmland, of which, years later, Robert Andrews wrote: 'My estate is fortunately on a very fertile [soil]. It is a mellow

strong loam on a clay bottom; some small part of it is so dry as to admit of turnips.'[13]

Gainsborough had known and walked this landscape from his childhood. He also knew the sitters: he had been to Sudbury Grammar School with Robert, who was just a year older than he, and in the small, tight world of their home town he must have known something of the family planning that had gone on. The elongated shape of the canvas suggests it was painted as an overmantel – it is the same proportions as Gainsborough's *St Mary's Church, Hadleigh* and the extensive landscape in Edinburgh – and would be a constant reminder to Robert and Frances that this was their landscape, their property, and their parents' investment in their future.

But while everything seems just right for Robert and Frances, Gainsborough is not being entirely deferential, indeed he is getting rather personal. At Robert's belt, a bag for his shot and powder hangs – the shot in the left section, the powder in the tube with the knot in it on the right.[14] This is what Robert's muzzle-loading flintlock needs to fire. Now whatever does the bag look like? Yes, its shape unmistakably echoes male genitalia, while its form and the proximity of the gun demonstrates explosive purpose. It is placed decidedly beside his crotch, so we may be being led to understand that Robert is remarkably well hung. However, on the left, above the tower of what is possibly Long Melford Church, dark clouds are gathering, and in the enclosure below, more or less where a swimming pool is now, and set on the same horizontal line as Robert's significant powder-and-shot bag, is a pair of trapped donkeys. Did Gainsborough see his patrons as trapped donkeys? Despite their proximity they seem far apart.

What Gainsborough seems to be presenting us with is a portrait of a marriage designed to keep a fertile estate intact, but the two imprisoned donkeys is nevertheless a silent jibe which Robert and Frances may never have noticed. It is curious and perhaps significant that Gainsborough has not painted anything on Frances Andrews' lap – there is a blank space for a cat perhaps, or a small dog, or a dead pheasant, or a baby. Why did Gainsborough leave an empty space there? It is one of the most famous blanks in art history – compare with the blanks in Michelangelo's *Entombment*

and Piero della Francesca's *Nativity* in the National Gallery – but in reality it is not blank, and Gainsborough's frustrated intention is clear. The empty space is more or less egg-shaped, with, in its upper segment, a small pale pink dab for the skin-tone of Frances's lower left arm emerging from her lacy-edged sleeve. But in her right hand an apparently meaningless furry or feathery extension, nearly as long as her lower arm, emerges from the partially expressed object on her lap. The drily painted beginnings of a small oval, merely a swish or two of the brush, runs over thin grey under-drawing which extends down to a dangling knob-shape. It is unquestionably there, in plain sight. This is not a pet cat, or a lap-dog, or a baby, but a dead cock pheasant – or it was going to be.

Had Gainsborough completed it, the pheasant's head and neck would rhyme exactly, and rather too clearly, with the limp game bag at Robert's waist and the flabby glove in his hand. As it is, as Gainsborough has left it, Frances Andrews has a drawing of a penis on her skirt. It all seems fairly obvious sexual symbolism which may be trying to tell us something.[15] In any event, Robert and Frances went on to have eight children. We do not know how well Thomas Gainsborough and Robert Andrews knew each other at school, whether they were childhood friends or enemies, or what schoolyard insults they threw at each other, but we do know that for his part Gainsborough was potent and sexually active, and had no qualms in expressing it. Whether they liked or loathed each other, now that they were grown-ups Robert Andrews could not have got a better painter to record the happy settlement of his late father's affairs than Thomas Gainsborough. But this final detail might have been too much.

A painting with such a high finish and express detail as *Mr and Mrs Andrews* would not have been left in that state, and delivered, without a clear understanding, a serious discussion, or a fundamental falling-out. In the mid eighteenth century a portrait such as this with clear dynastic intent, and direct social markers, would have been completed unless death or another such disaster had intervened. If there had been a clear understanding that the space would soon be filled, then it would quite swiftly have been filled. If there had been serious discussion about its content, the discussion

would have been resolved. The only reason left is fundamental falling-out, and given Gainsborough's volatility, his ability to endure and then to snap, we have a final curt argument as the most likely reason for the lack of finish. Is this a manifestation of the same characteristic anger that would drive Gainsborough to slash a painting refused by its patron, and perhaps paint out his earlier portrait of the unknown man? Gainsborough never referred to the picture again as far as we know. It was never given a title; it was never engraved, but put away out of public gaze like a mad aunt until the twentieth century when all involved were long dead and whatever controversy there was, forgotten.

Despite, if not because of, the topographical liberties it takes, this is a real landscape inhabited, indeed shown off, by real people whom Gainsborough knew well, and depicted with a sharp realism of pose and facial expression that comes down from Hogarth. It is the clearest and most specific populated landscape view that Gainsborough painted. If he can paint like this at so early a point in his career why did he not paint such a picture again? It would have made him some money. He had throughout his life a tendency to repeat his formulaic paintings, so why not this one? It is possible that the unknown couple in the Dulwich Picture Gallery are standing in their own landscape, as might *Mr and Mrs John Browne of Tunstall* be in theirs, and both paintings may be comparable in this respect to the Andrews, but just because he could do something once was no reason, it seems, for Gainsborough to do it again. The painting went straight into Auberies, and, being unfinished, it was effectively unexhibitable. While of interest in the twentieth- and twenty-first-century history of the painting, the blemish on Frances's skirt must have raised questions across its early history, even if these were limited to the Andrews family and friends. It has become one of the small handful of world-famous portraits by Gainsborough – *The Blue Boy*, *Mrs Siddons* and *The Morning Walk* are among the others – but it was not seen in public until 1927 when it was exhibited in the Gainsborough bicentenary exhibition in Ipswich. It had descended quietly through the Andrews family, and when it was bought by the National Gallery in 1960, it was a sleeper that became famous overnight, like Byron.[16]

Frances Andrews died in 1780; Robert married again the following year.[17] He became Receiver-General for Essex, that is, responsible for county taxes, and at his death in 1806 he was described as 'an active and impartial magistrate (of which he was the oldest on the list in Essex if not in Suffolk) as a landlord; a master; a friend; and as the father of a numerous family; his loss is deeply felt and sincerely lamented'.[18] Within four months Auberies was sold by Christie's, so if the Andrews and Carter elders had ever dreamt of a dynasty of a thousand years, their descendants had other ideas, which they expeditiously expressed. The house and estate fetched £30,160.[19] Its new owner, the banker and army agent Charles Greenwood, demolished it, and by 1810 had erected a new, more extensive house on the footprint of the old.[20]

On Sunday 22 August 1751, Thomas and Margaret's third child was christened at St Gregory's in Sudbury. She was named Margaret after her mother, and perhaps with decision after her mysterious maternal grandmother also. Along Curds Lane[21] up the shallow slope past the cowsheds and the dairy they took the baby, clouds of family coming after them – two Marys, grandmother and granddaughter, aunts Sally, Elizabeth and Susan, some Johns and Thomases, and perhaps an Uncle Humphrey as well. If the Gainsboroughs did family parties, a high-summer christening was the time to do one, though this just might be putting too twenty-first century a spin on it. Thomas was twenty-four, a family man now, with responsibilities and a bright future ahead of him; but Margaret, his wife, now perhaps twenty-three, the mother of two girls that lived, could already see the pattern of her life mapping itself out into the future. She was a woman with a private income secure for life, but one robbed of the grand title and the infinitely grander income she would have had had her parents married. Margaret can only have seen a stultifying future in Sudbury, surrounded by discontents, weavers, and talk of the price of cloth.

The bright, wide church, set on high ground running down to the River Stour, opened its doors to them; the congregation opened its enclosing arms. Like St Peter's and All Saints, St Gregory's and

its destroyed decoration was the product of Sudbury's past wealth and political circumstance, profits generated by the East Anglian wool trade three or four hundred years earlier. Where had that all vanished? Why had Sudbury become such an unhappy place? The imposing and ever-present Carter monument displayed its significance and local status in the south aisle, and subtly indicated where the Gainsboroughs stood in their reduced circumstances. Thomas and Margaret had been living on top of his family in Sudbury for nearly two years now. If there had been a row with the Andrews over the portrait he failed to finish, with the Carters taking their side, professing shock and disappointment, and making the wider Gainsborough family uncomfortable, Sudbury might just have become too hot for young Thomas Gainsborough. This was the time to go.

Almost exactly ten years later, a well-dressed, brisk and persistent gentleman called on a friend of his in London. There was nobody at home, just the servant. On the table was a small landscape painting which caught the man's attention. He picked it up, looked at it closely, turned it over. 'Ruisdael improved,' he thought to himself. 'Warmer colouring, as truly drawn and painted as Ruisdael, but more spirited.' It was quite clear from the back of the canvas that this was a new, modern picture, not Dutch seventeenth century. The following conversation was published in 1772:

'James, where did your master get this picture?'

'At the auctioneers Langford's, sir, I have just brought it home.'

'Do you know whose it is?'

'My master's, sir.'

'Fool! I mean the painter.'

There was a knock at the door. James let his master in.

'Who painted that picture?' demanded the visitor.

'Who do you think?' replied his friend.

'Don't know, tell me instantly!'

'Come, come – you are a judge of pictures, and a bit of a painter yourself. It's a gem, isn't it?'

The visitor was even more intrigued.

'You will like it so much more when I tell you it is painted by an artist who is unknown, unfollowed, and unencouraged.'

'What's his name?'

'Gainsborough.'[22]

15. They did not know his value till they lost him

Thomas and Margaret Gainsborough had money worries of their own, reminiscent of the troubles of Thomas's parents. Margaret's endowment was finite, even if it was always wholly available to him. Gainsborough desperately needed funds, which suggests that he was either too profligate, or his income from Sudbury as a painter was drying up, or both. In November 1751 he would try to borrow £300, using Margaret's annuity as security.[1] This was no way to conduct a marriage, and who knows if Margaret did not tell him so. She kept, as the years went on, a very close eye on his income, became 'very prudent and managing',[2] and this may have been where that scrutiny began.

Twenty miles to the east of Sudbury, via Hadleigh and Hintlesham, lay Ipswich: fresh sea, fresh air, fresh and intriguing people. This was where Suffolk society came together for entertainment and shopping, and where trade deals in wool, cloth, corn, shipping and the famous 'Ipswich double' sailcloth were made. Ipswich in the early 1750s was a town that loved its concerts and its balls, its flower and raree shows, its street performances of wonder and delight. It was essentially a very large Sudbury – with warrens of fat streets of half-timbered houses over-reaching the spaces between so residents might just be able to shake hands with each other across the gap. Many of these houses, as in Sudbury, were decorated with grotesque carvings of animals and figures, but these by now were well weathered by coastal wind and rain. A few façades were in the process of improvement, new brick frontages flattening overhangs and destroying carvings, but making the houses cleaner, more elegant, safer from fire, and much more like the better parts of London. More, however, lay empty: the town had long been gripped by depression and a lack of money for development as the wool trade seeped away. The diarist Caroline Lybbe-Powys passed through thirty years later, and nothing much seems to have changed:

> We ... got to Ipswich about 7 in the evening where we staid
> most of the next day, at the White Horse, ye most nasty, noisy,
> Inn, I think I was ever at in my life, but indeed the Town
> itself is dreadful, narrow streets, poor looking old houses, and
> altogether a most melancholy place, we ... were not ye least
> concerned to leave Ipswich, which we did in the evening.[3]

Like Sudbury, Ipswich in the mid eighteenth century was gripped
by chronic bouts of political fever. It had been a town that people
left – it was known nationally as 'a town without people'[4] – with
abandoned houses and tales of departure. It had already seen mass
emigration across the previous century, when thousands of people
from East Anglia took to little boats and risked the wide Atlantic
to escape religious intolerance, violence and hatred. Then, their
destination was the seductive eastern seaboard of America, where
independent protestant communities were heard to be growing
in peace with their neighbours; log cabins, stockades, new settle-
ments, religious freedom, turkeys and whatnot. That was the sales
pitch migrants were given as ships' captains took their money
and promised them safe passage to utopia in the west, in the new
settlements of Ipswich and Sudbury, Massachusetts.

In the 1740s, economic depression was the cause of another
shredding of the town. The strong man in Ipswich, now, was
its MP, Admiral Edward Vernon, the naval hero of the War of
Jenkins' Ear (1739–48), fought against Spain in the seas around
the West Indies. Vernon was a bold and courageous tactician
who, in addition to taking on the Spanish on the high seas, later
challenged the British government and the Admiralty in political
campaigns on dry land. Vernon was a hero to his sailors: they
honoured him not only for his victories, but also for introducing
regular rations of rum and citrus to improve drinking water on
board, an innovation that had the incidental benefit of reducing
scurvy. It was Vernon's Ipswich that the Gainsborough family
entered.

In the spring and summer the town became a theatre for flower
competitions, which eased the effect of its dismal economics. A
wondrous mechanical contraption, Henry Bridges' 'Microcosm;
or, The World in Miniature' was set up in the Cross Tavern across

New Year 1753: this was like a Roman temple decorated with painting and sculpture which played music with 'an amazing variety of moving figures', orbiting planets, the sun, the moon, Jupiter and comets, all dancing to the command of unquestioning clockwork. What very heaven this would have been for 'Scheming Jack' and Humphrey. A few days later, 'the famous Italian Female Sampson' came by. She performed for a week outside the Bear and Crown; and also that summer a troupe of dancing bears, fun for all the family, 'brought to foot it to a violin . . . The largest of them is eight foot high . . . [they] are separated by a partition, that gentlemen and ladies may see their performance without fear.'[5]

From the intertwined worlds of the law, the church, the army, navy, politics and trade there would be good portrait business, if only Gainsborough could attract people to sit for him. He needed patrons, but he also needed local friends. Joshua Kirby and his wife were living in Ipswich now, with their two children, Sarah and William, aged ten and eight respectively. Kirby had contacts: as a print-publisher, writer and editor he was a useful man for Gainsborough to know. He was already advertising his prints around the county: in the *Ipswich Journal* there are advertisements for *Perspective Made Easy*, and for his maps and engravings.[6] With the opportunity Kirby gave to Gainsborough to contribute an etching to *Perspective Made Easy*, he added, in the text, a discreet puff for the etcher, describing Gainsborough, but not naming him, as 'a very great Genius in that [landscape] way'.[7] Other joint ventures followed. Diversifying his life, Kirby had also become an entrepreneurial house-painter and decorator, inn sign and coach painter, and may have engaged Gainsborough in these mundane painting exercises.[8] Fulcher tells a story about Gainsborough being invited to paint at a large house in Ipswich. He arrived prepared and full of anticipation, only to find that he was expected not to paint the landscape, or its owner, but to repair and decorate its windows.[9]

Ipswich was far enough from Sudbury for the Gainsboroughs to make a new, fresh start. On arrival, or perhaps a little later, they rented a house in Foundation Street, with a ninety-foot-long garden backing on to Lower Brook Street, and opposite Ipswich Shire Hall and the Grammar School.[10] It seems to have been

enormous for a small family: a hall, two parlours, five other rooms and garrets, with a kitchen and wash-house, stable and cellar, but property was cheap in this depressed town.[11] Nevertheless, Gainsborough seems to have developed anxieties, stemming perhaps from unfamiliarity in new surroundings, a lack of ready cash, or fear of ruin, but as time went on, portrait commissions came in and he soon needed to learn how to handle success: as much as he might have wanted to slow the relentless pace of commissions, he was understandably 'afraid to put people off, when they were in the mind to sit'.[12] As a relief from this routine, he sketched extensively in and around Ipswich, particularly the wide, watery landscapes of the Orwell estuary, and, as Fulcher remarks, he 'painted many more landscapes than he could dispose of'.[13] He gave many of them away, and it is impossible to tell whether this was his warm and generous nature at work, or simply an acceptance of the obvious, that his landscapes had little commercial value. Security of sorts gradually ·came from portrait painting, or at least the income from a fixed and certain scale of charges. In Ipswich he began to charge 5 guineas for a head and 15 guineas for a half-length: over the years he put his prices up.[14] Nonetheless, there remains an implication in his writings that even at this stage of his life he much preferred painting landscapes to portraits.

It would be a while before he and Margaret could enjoy the concerts and balls in Ipswich together – if they ever did – but for his own part Gainsborough found a way in to the Ipswich music scene, where, with mates of his own age and older, he gathered at the Ipswich Music Club to make music. 'Ipswich Music Club' suggests it had some kind of formal structure, and maybe it did: Gainsborough later described himself as a steward to the club, and by his own account he was clearly an effective and even an officious steward.[15] But the club was also a good excuse for some lively men to gather together to drink and play. No trace of it under that name has been spotted in the *Ipswich Journal*, though it may feature silently in the many advertisements such as the one on 30 December 1752 which announced 'twenty-six concerts, given on Thursdays, approx two each month' which would take place the following year.[16] The Ipswich Music Club, so-called, that Gainsborough belonged to may have been at times too rowdy for

the town's quality, but that is a tricky judgement to make given that it included the distinguished composer Joseph Gibbs, organist at St Mary-le-Tower in Ipswich. Gibbs will have been in his fifties when Gainsborough turned up. Other club members included the Marine captain Abraham Clerke and a local dancing teacher, John Wood, both about ten years older than Gainsborough, of whom they evidently made quite a bit of fun as the youngster of the group. If they sought places to perform, Gibbs would have given the club some bottom, and opened doors to the better venues in Ipswich.

The events of one particular concert evening in Ipswich suggests that it was an entirely decorous organisation. 'I will tell you a story', Gainsborough wrote to David Garrick in 1768, and proceeded to describe a benefit concert where he was a steward, 'in which a new song was to be introduced'. He asked 'the honest cabinet-maker', Josiah Harris, if he could sing at sight, because

> I had a new song with all the parts written out. Yes, Sir, said he, I can – Upon which I ordered Mr Giardini of Ipswich to begin the symphony and gave my signal for the attention of the company. But behold a dead silence followed the symphony instead of a song; upon which I jumped up to the fellow,
>
> 'D[am]n ye. Why don't you sing? Did you not tell me you could sing at sight?'
>
> 'Yes, please your honour, I did say I could sing at sight, but not first sight.'[17]

There was, once, a portrait of the lads playing on one of their evenings together, and another, a group of them singing as a choir. Fulcher appears to conflate these paintings, but it is likely that they are, or were, two distinct works. From Fulcher's description of the group of musicians, this was one of the few multi-figure group portraits by Gainsborough, and has the ring of a Hogarthian study of inebriated jollity. The choir painting, however, was first recorded by John Constable in 1797 when he was asked by the engraver and biographer J. T. Smith to have a look round Ipswich to see if he could find any traces of Gainsborough in the town, and jog peoples' memories there forty years on. But Constable drew a blank: 'I have not been able to learn anything of

consequence respecting him: I can assure you it is not for the want of asking that I have not been successful.'[18]

Maybe nobody wanted to talk, because Constable said he did ask people who had known Gainsborough. He concluded that he touched on some sense of regret in the town because they had let this extraordinary genius slip through their fingers: 'I believe in Ipswich they did not know his value till they lost him.'[19] While one of Constable's contacts spoke about Gainsborough sketching in the landscape of the River Orwell, the best that the people of Ipswich could remember about him was the rowdy parties thrown by the Music Club. His wig was snatched from his head, someone recalled, and chucked about the room. Gainsborough, he said, was 'generally the butt of the company'. The quality of his musicianship in Ipswich was not recorded, but his presence and *joie de vivre* was.

Nobody seemed to know where the choir painting had got to, but it was thought to have been somewhere in Colchester when Constable was snooping around. The Music Club painting, however, was known in the mid nineteenth century, when its then owner, J. G. Strutt,[20] described it as being 'very slight and unfinished, [but] exceedingly spirited.' Gainsborough had apparently painted his friends from memory, and created a riotous composition of a night scene lit by candles, with the artist himself holding a glass, and he and Abraham Clerke leaning together like a couple of drunkards. They are looking across at John Wood playing the violin, while playing the cello is their friend Mills, who is only drawn in outline because Gainsborough 'could not recollect the expression of his phiz.' Joseph Gibbs is shown fast asleep at a table. It seems to have been chaotic and colourful – claret, scarlet, blue and grey – with drinking glasses catching the light, candleholders and a music stand as dressing in the shifting candlelight.[21] Already, then, Gainsborough could do chiaroscuro and dramatic action, with a sensitive palette and subtle lighting, and hold together the kind of dynamic Hogarthian composition he will have learned during his days (and nights) at Vauxhall Gardens with Hayman and their fellow artists.[22]

Gainsborough's youngest daughter, Margaret, touched on her father's relatively youthful behaviour when, twenty years after his

death, she was quizzed by the irrepressibly nosey diarist Joseph Farington. He had a journalist's way of getting people to talk, and drew from Margaret an insight that reflects the way her father presented himself in Ipswich, as much as in Bath or London: 'He was passionately fond of music . . . and this led him much into company with musicians, with whom he often exceeded the bounds of temperance & his health suffered from it, being occasionally unable to work for a week after.'[23]

What this shows us is what we already know, that Gainsborough had a riotous life outside his work and family, with many friends, 'pretty boys they all were in their day',[24] and was evidently happy to let that be known. While Margaret will have been too young to remember much of family life in Ipswich, her memory of her father's behaviour acknowledges something of the explosive effect that Thomas Gainsborough had on his family.

16. Gainsborough de Ipswich

Despite the hangovers, when Gainsborough could pull himself together he was able to work and to charm people into employing him to paint their portraits. Among his Ipswich sitters were other drinking friends, including the lawyer Samuel Kilderbee, later Town Clerk of Ipswich. He was a lifelong friend far beyond the haze of drink, and came to own several Gainsborough landscapes, many of them gifts from the artist.[1] There was once a clutch of letters from Gainsborough to Kilderbee, but these were destroyed by Kilderbee's relations, apparently because they were too obscene for them to keep. Indeed, somewhere there is a Gainsborough letter with the obscenities sliced out, like the lacy remains of a blackmailer's demand.[2] Theirs was a libidinous age.

Another sitter was John Plampin of Chadacre Hall, nearer to Sudbury than Ipswich, a gentleman farmer of Gainsborough's own age and pioneering attitude. Plampin is shown relaxing on a grass-topped sandy bank, leaning against a tree, his dog gazing at him expectantly. He was 'a young man with advanced ideas wearing country clothes', in the view of the costume historian Stella Newton.[3] In the distance are a group of cottages and a church tower, probably All Saints, Lawshall, about two miles from Chadacre. Plampin was, like Henry Hill and Robert Andrews, a man of action, a dedicated modern agriculturalist who, like Hill and Andrews, also impressed Arthur Young, and who sent articles for publication in Young's *Annals of Agriculture*: he did not spend all his time lounging about in a natty frock coat on a sandy bank with his leg up. In 1759, two years after he inherited Chadacre from his rector father, Plampin began an experiment in forestry by fencing off an acre of rushy land adjoining an ancient wood. He manured it, ploughed it and hoed it before planting oak and ash, which, by 1785, and after programmed croppings and gleanings, had grown into a thriving wood, with trees between twenty-five and forty feet high, each six or eight feet apart. Plampin reported this

success to Young, and calculated that theoretically, after twenty-six years, he had made two shillings per acre per year profit on the whole enterprise. This, he demonstrated, was 'proof that the soil [at Chadacre] is well adapted to the production of that noblest of vegetables [the oak], the beauty and protection of this happy isle'.[4] Men of action, intelligence and resolve, like Hill, Andrews and Plampin, recognised in Gainsborough a fellow pioneer, and, by hiring him, acknowledged the wayward but zestful talent that drove him.

Of quite a different type to young Plampin was the severe and serious Anglican parson the Rev. Robert Hingeston, headmaster of Ipswich Grammar School.[5] He and his wife, whose portrait Gainsborough also painted, clearly took Gainsborough under their wing – they were neighbours, their gardens ran side by side[6] – and despite his grim visage, Hingeston was kindly and appreciative, and given the nature and duties of his profession, would also have given sympathetic concern to the artist's wife and family. Fulcher published Hingeston's son's recollection of the relationship between patron and artist:

> [Gainsborough] was a great favourite of my father; indeed his affable and agreeable manners endeared him to all with whom his profession brought him in contact, either at the cottage or the castle; there was that peculiar bearing which could not fail to leave a pleasing impression. Many houses in Suffolk, as well as in the neighbouring county, were always open to him, and their owners thought it an honour to entertain him. I have seen the aged features of the peasantry lit up with a grateful recollection of his many acts of kindness and benevolence.[7]

That 'peculiar bearing which could not fail to leave a pleasing impression' chimes beautifully with Thicknesse's remark about 'the elegance of [Gainsborough's] person', and, as Cunningham put it, his 'ready grace and persuasive manner'.[8] As the Hingeston recollection suggests, and the Plampin portrait demonstrates, Gainsborough's growing portrait-painting practice in Ipswich required him to travel around the county and beyond. Hingeston and Plampin join the many other sitters certainly painted in the Ipswich period, including Acton, Barry, Bassett, Browne, Clubbe,

Dade, Gibbs, Gravenor, Innes, Kilderbee, Lloyd, Lynch, Mayhew, Rustat, Savage, Vernon, Wayth, Wollaston and Wood. Many were interconnected – Actons and Barrys intermarried; Wayth was the father-in-law of Kilderbee; Kilderbee and Browne were brothers-in-law; Mayhew a good friend of Clubbe; Vernon and Lloyd were deadly political rivals – and all indicate the power of word of mouth and local esteem that was now developing around Gainsborough. Lambe Barry, for example, was High Sherriff of Suffolk; Gainsborough painted him twice. He had found the portrait painter's ability, with necessary tact and charm, to rise above the social networks, scan across them, and draw his benefit. By no means can his be called a sluggish practice, so why was he chronically short of money? We are now, happily, entering the period in Gainsborough's life when documentation begins to survive, and we are able to read his frank and sprightly letters, and suggest some conclusions.

William Mayhew, a Colchester lawyer, commissioned a portrait in 1757, and then offered to get more work for Gainsborough in his town, almost as far south-west from Ipswich as Sudbury was due west. This was new and lucrative territory, and a sign of Gainsborough's spreading esteem, reflected in the inscription written on the back of Mayhew's portrait: 'Gainsborough de Ipswich pinxit 1757'.[9] 'I thank you, Sir', Gainsborough wrote to Mayhew, 'for your kind intention of procuring me a few Heads to paint when I come over, which I purpose doing as soon as some of those are finished which I have in hand.'[10] Work was piling up faster perhaps than he expected: 'business comes in . . . chiefly in the Face way', and he did not want to refuse clients. It was this unexpected pressure that prompted him to take Joshua Kirby's son, William, on briefly as an assistant.[11]

From the two recorded letters from Gainsborough to Mayhew it is hard to tell which of the pair is the fussier, artist or sitter. In the first, Gainsborough asks Mayhew to 'place your picture as far from the light as possible; observing to let the light fall from the left', while in response Mayhew appears to have complained about the roughness of the picture's surface. This drew clear and plain opinion from Gainsborough about a painter's duties and expectations:

You please me much by saying that no other fault is found in
your picture than the roughness of the surface, for that part
being of use in giving force to the effect at a proper distance,
and what a judge of painting knows an original from a copy by;
in short being the touch of the pencil [i.e. paintbrush], which is
harder to preserve than smoothness, I am much better pleased
that they should spy out things of that kind, than to see an eye
half out of its place, or a nose out of drawing when viewed at a
proper distance.[12]

Evidently, Gainsborough and Mayhew had had a good rapport as
they sat staring at each other for hours together in Colchester or
Ipswich. They must have been able to laugh a bit, because Gains-
borough went on to say:

I don't think it would be more ridiculous for a person to put
his nose close to the canvas and say the colours smell offensive,
than to say how rough the paint lies; for one is just as material
as the other with regard to hurting the effect and drawing of
a picture. Sir Godfrey Kneller used to tell them that pictures
were not made to smell of.

Plain-speaking to his clients was, and would continue to be,
Gainsborough's forte and his weakness. It won him equally
straight-talking subjects, but lost him others as we shall see. The
Rev. John Clubbe was almost certainly one of the 'Heads' that
Mayhew procured for Gainsborough. With Mayhew, Clubbe was
another of the sitters to whom Gainsborough could talk freely
and could laugh with: they seem to have had so much fun together
that Gainsborough painted Clubbe twice. 'I am sure I could not
paint his picture for laughing', Gainsborough told Mayhew.

He gave such a description of eating and drinking at the Tank-
ard [in Tacket Square, Ipswich], I little thought you were a
Lawyer when I said not one in ten was worth hanging. I told
Clubbe of that and he seemed [to] think I was lucky I did not
say one in a hundred. It's too late to ask your pardon now, but
really, Sir, I never saw one of your profession look so honest in
my life, and that's the reason I concluded you were in the wool
trade.[13]

As well as being good company, Clubbe also gave Gainsborough guidance, as he did to young clergymen, on how a clergyman should dress:

> Do no office in the church upon any occasion without a *band*, nor on Sundays, without a *Gown* and *Cassock* . . . nor think it a trifling correctness to keep a *Beaver-Hat* and *Rose* to wear with your habit . . . In your undress, let me advise you to keep to that *colour*, which custom and good men have appointed, as most suitable to your station, and not run into *motley mixtures*. A dangling crape hat-band from a gold-laced hat makes not a more ridiculous appearance, than *white waistcoats* and *white stockings* on a clergyman.[14]

This is just the kind of professional low-down that Gainsborough might need when planning his portraits of clergymen, of whom he painted ten or a dozen in Ipswich. One, an exception to the rules, was his elder brother, the nonconformist priest from Henley, the Rev. Humphrey Gainsborough.[15] He paints Humphrey, whom he loved greatly, with a touch of irony, taking a route that was new to him. Humphrey is presented in sharp profile, grimly tight-lipped, and wearing a hat with a prominent brim that echoes the shape of his fine nose. The whole has the air of a medallion portrait, or of a seventeenth-century portrait of a Flemish divine, showing none of the humanity of Gainsborough's Houbraken- or Hogarth-inspired portraits of the elder Kirbys. Humphrey Gainsborough took up his appointment in Henley in 1748 or 1749, and it may be that this portrait was painted in subsequent years to mark Humphrey's new position, and to set a tone for his congregation. But as they would soon find out, Humphrey was no dull killjoy, but an entertaining and perceptive inventor who would begin to transform mechanical thought and contribute significantly to Henley's infrastructure.[16] His training at Moorfields Academy had included compulsory courses on mechanics, hydrostatics, physics and astronomy, unheard of on other theology courses, to produce a new breed of men who would lead their Christian flocks not only by knowledge of the word of God but also by an understanding of the workings of the physical world.

*

There are more than fifty portraits by Gainsborough with secure Ipswich provenances, a reasonable production rate over the eight or nine years that the Gainsboroughs lived in the town. The Ipswich sitters can be gathered into groups – clergymen, service-men, politicians, landowners, lawyers, his friends and his family – a pattern of constituencies that mirrors the kind of people he had painted in London and Sudbury. Inevitably the emphases change in Ipswich, where he paints fewer pioneering farmers than he had in Sudbury, but more politicians, lawyers and clergymen. Illus-trative perhaps of his status as a family man, grown up a bit, he was seen in Ipswich, *pace* his Music Club behaviour, to be reliable and moderately priced. He was also beginning to relax into his subjects, to soften the stiffness that he had seemed unable to shake off from his doll-like portraits in the late 1740s. His paintwork became freer, even scabrous, abandoning the tight, inch-by-inch manner of covering his canvases for the broader strokes of the well-filled brush and the relaxed right arm. He also began to in-crease the size of his portraits: from the standard of around thirty by twenty-four inches in Sudbury, his Ipswich portraits become more imposing and prominent, led perhaps by the forty-eight by forty inches of his portrait of Admiral Vernon, painted in 1753.[17]

Nevertheless he was having distinct money problems. Cash-flow difficulties forced him to rob Peter to pay Paul. To pay his landlady Elizabeth Rasse the £6 a year rent due he was forced to borrow from an unnamed friend against money he would soon (he hoped) earn from the Vernon portrait.[18] This roundabout way of doing things was, three years later, still giving him trouble, despite his apparently buoyant portrait business. Writing to a creditor in May 1756, he disarmingly tries to steer his way out of trouble by charm, transparency, and the offer of a picture:

I don't pretend to say but my debt is of too long standing, and I believe I could borrow the money, though with this inconven-ience that nobody lends a painter without [a] picture in it. Now as I am already indebted to you for so long, why won't you stay till I can pay you, and let me give you a picture: this I assure you I shall willingly do, for I am neither so ungrateful or ignorant as to think you wrong in what you wrote me, so far from it, that

what I'm obliged to do in the picture way to end this affair I had
much rather do for you than another who might lend me the
money; for besides the disagreeable job of asking, take my word
that no one does me services of that nature without a picture.
Excepting one man and he is far from home. These truths but
[word crossed out] yet secrets, therefore trust that you'll not let
this letter be seen.[19]

To close this difficult arrangement, Gainsborough proposed to
paint a landscape for his creditor, or paint his portrait, 'or a girl
[if] you'd rather'. He added frankly that he owed money to three
other people already, one as much as £6 to a man who kept sending
'an old crooked woman' round to his door to put the frighteners
on him. 'She I got rid of by threatening to draw her picture.' One
might reasonably wonder why he was in such financial trouble
with a modestly wealthy wife and a good business. What were his
other outgoings?

One witness to Gainsborough's behaviour, most probably
during this Ipswich period, states that he was 'very lively, gay, and
dissipated'. This is a remark by Mrs Dupuis, Samuel Kilderbee's
daughter, made many years later to Thomas Green of Ipswich,
whose diary of the 1790s was first published in 1810.[20] We now
understand 'dissipated' to mean the state of a wastrel, usually
through excessive drinking and drug-taking. Dr Johnson's def-
initions from the eighteenth century, however, include 'to spend a
fortune', and that may be what Mrs Dupuis meant. Later behaviour
suggests this was characteristic of Gainsborough, but we shall
come to that. Mrs Dupuis goes on to say that Gainsborough was
'rapid in painting – his creations sudden', an observation that also
tends to confirm the artist's impulsive qualities. Without wanting
to point the finger unduly, it may be Mrs Dupuis who was behind
the destruction of Gainsborough's letters to her father.

We can identify many sources of income for Gainsborough
during his Ipswich years – the portraits at his reported price in
1758 of 5 guineas for a head or head-and-shoulders, and 15 guineas
for a half-length.[21] He charged the Duke of Bedford 36 guineas in
1755 for a pair of landscape paintings with figures, and, in 1759,
as has already been mentioned, another client, Scott Thompson,

paid £35 for the now lost landscape *Love at the Well*, with an additional £5 for the frame. There seem to be about forty head portraits and eight or ten half-lengths from the Ipswich period, and perhaps a dozen or more smaller portraits in landscapes which might be from Ipswich, as well as around fifty landscapes: say 110 or 120 works altogether.[22] This is vagueness itself – we can never be certain of much on the financial side – but allowing for his natural generosity in giving work away, or doing it for nothing for friends, we might suggest that Gainsborough earned around £500 to £600 from his work in the six years he was in Ipswich, about £100 a year. That is a conservative estimate, and was not riches, but with Margaret's £200 a year in addition the family will not have starved. In the kitchen not an egg were they short; the girls were always well fed, and by June 1757 he was doing well enough to repay with interest the £300 loan he had taken out six years earlier on the security of Margaret's annuity.[23] He therefore had a lot more than housekeeping and child-rearing to be grateful to Margaret for, and it is no wonder that he was furious when he thought that Thicknesse had put it about in Bath that the Gainsborough girls had run around without shoes or stockings on in Ipswich.[24]

Gainsborough's concern and care for his family is evident in his paintings of the 1750s, and these may give us an idea of what he spent his money on. He was submerged by fashion when he went to his clients' grand houses to paint their portraits, and will have seen enough fancy male waistcoats to send him mad with desire. He had two beautiful, healthy daughters whom he was proud to paint dressed in fine cloth; he loved the shimmer of silk and the plush plump matt surfaces of velvet, so soft to the touch of the eye. Cloth was his stock-in-trade, as seductive to his eye as were the wearers of the petticoats, in which he confessed he was 'much read', to his body. How could he, as painter to Suffolk society, be seen, or his family be seen, dressed in hand-me-downs or tatters? Just as a salesman or marketing person or builder must drive an expensive car in the twenty-first century to reassure the world that he or she is doing all right, so in the eighteenth a portrait painter had to look neat, confident and successful to attract the custom he needed. Fine clothes were very expensive indeed, and much

aspired to: flash car and flash waistcoat are probably equivalent as status signifiers, if not in monetary terms. Here is a 'Receipt for Modern Dress – taken from the London papers', published in the *Ipswich Journal* in 1753 – just the place where aspirations were aired and encouraged locally:

> Before, for your Breast, pin a stomacher Bib on,
> Ragout it with Cutlets of Silver and Ribbon . . .
> Let your Gown be a sack, Blue, Yellow or Green,
> And frizzle your elbows with Ruffles sixteen . . .
> Throw Modesty out from your Manners and Face,
> A-la-mode de François, you're a Butt for his Grace.[25]

While that's all a joke, truth pulls like the tide: fashion was relentless, exported from the capital to the counties, and expensive. For an idea of costs, the seamstress to the gentry Mrs Gubbins of Henrietta Street, Covent Garden, presented Lady Blois of Cockfield Hall, Yoxford, Suffolk, with a quotation for clothes for herself and her new baby in 1764:

> I have put down as few as are[?] ever made for anybody of fashions . . . the expense of a whole set of Baby Cloaths and all things proper for your self may be had from seventy to Two or 3 Hundred pounds. I [am] now making a set at this time that comes to ninety, another that comes to Two Hundred.[26]

Mrs Gubbins got the job, and six months later wrote with pleasure to Lady Blois:

> Your Ladyship gave me Great pleasure to hear you licket [*sic*] the things and that they was agreeable to your orders give your ladyship joy . . . As to white satin mantles they are . . . in price from a Guinea and a half to four and a half. I fancy your ladyship means Satin robes which may be had from two Guineas to 3 and a half. I am now making one at 3 Guineas that is very handsome and a very genteel Christening suit that has at least 25 yards of lace in it. The caps open worked thro the head and very fine for 6 Guineas and a half. I hope your Ladyship will make choice of one as I assure your Ladyship nobody shall or can serve you cheaper.[27]

While these were top prices, it was the kind of money that could be spent on clothes for a wealthy mother and her new baby: anything from £70 to £300; a baby's lacy cap alone might be nearly £7. This is a huge amount, bearing in mind that Margaret's annuity was only £200. So to keep up with the county, and provide the best clothes that his wife and daughters wear in their portraits, Gainsborough needed much more money than he would earn in Ipswich as a portrait painter. We could unkindly suggest that Gainsborough needed money to pay for drink and keeping up with the lads, but with Margaret the Duke's daughter and their girls waiting for him at home this is unlikely. Much more likely is the thought that he and Margaret insisted that the family dressed well. The 'dissipation' that Mrs Dupuis spotted in Gainsborough might simply have meant that he spent a fortune on clothes for his family and himself.

17. They say I'm a quarrelsome fellow

Gainsborough's Ipswich watershed is his portrait of Admiral Edward Vernon of 1753 (Pl. 15). This marks his impulse to move out of his early doll-like style that reached its apogee in *Mr and Mrs Andrews*, to a broader manner in both brushwork and composition, with a big, bruising client taken on full square. There is also a confusion here – either that or a very canny tactic to please a conservative client. The composition Gainsborough uses for Vernon harks back a generation to the portraits of Thomas Hudson, with their swagger and pomposity, and the hint of pot belly and pigeon chest. Depiction of Vernon's military prowess was surely a means to an end here, as Vernon, Mr Big in Ipswich politics, was to stand again as the anti-government candidate in the 1754 general election. It may be that Vernon considered that such a pose and setting – cannon's mouth, smoke, sea battle, exploding West Indies fortress – would make a fine platform for his re-election bid. 'As you wish,' Gainsborough may have said, as they sized each other up at Orwell Park, Nacton, Vernon's grand house on the bank of the river east of Ipswich.

What may not have been shared between them was the fact that Vernon was being challenged for his parliamentary seat by another Gainsborough client, a long-standing and friendly client, Sir Richard Lloyd of Hintlesham Hall. A further ingredient in this volatile mix was a third Gainsborough supporter, Thomas Fonnereau, the government-aligned MP for Sudbury, and another of Vernon's political enemies, who had commissioned Gainsborough's landscape view of his house, Christchurch Park, Ipswich, some years back. While the Vernon portrait has the ring of an election manifesto, Gainsborough's undated portrait of Richard Lloyd, also from the Ipswich period, is modest in manner and presentation, except for the splendid waistcoat, so redolent of Gainsborough in Sudbury. Vernon won the vote, while Lloyd withdrew, having been considered to have 'starved the cause', that

is, not spent enough money bribing people. In a conversation with the King, the Lord Chancellor, Lord Hardwicke, head of another family that would soon come to engage Gainsborough's services, said that Lloyd had spent £3,000 on his campaign. Being in favour of Lloyd remaining an MP – he had already represented Mitchell in Kent and Morden in Surrey – the King expected 'that he might be taken care of at some place or other'.[1] Within months Lloyd had been found a parliamentary seat at Totnes.

The political parties did not yet have names that voters could coalesce around. Rather, they were identified by colours whose political directions the electorate was expected to understand. Vernon stood for the 'Blue' interest, while Lloyd ran for the 'Yellows', so Gainsborough, following his own painting interest, was well spread across the colour spectrum. As a large man, with large experience, generously distributing largesse, Vernon ran a vivacious campaign, visiting nearby Hadleigh (another Gainsborough interest) a few weeks before the vote. There he enjoyed the 'universal joy of the people ... ushered in with colours flying, music playing and bells ringing'.[2] He was said – perhaps he said it himself – to embody virtue over the corruption identified with the Yellows, who supported the Whig Prime Minister, the corrupt Robert Walpole.[3]

Another politician of the Yellow interest who sat to Gainsborough was William Wollaston (Pl. 17). This commission, which came perhaps in 1758, some years before Wollaston was returned to parliament in 1768, is of an entirely different cast to either the Vernon or Lloyd portraits. Gainsborough shows him with a sheet of music on his knee, and his gentle Van Dyckian hands fingering his flute. He leans back in his chair, relaxed and, if his distant rightward gaze is any indication, seems to be transported by the power of the music he has just played. Wollaston is a good-looking fellow in his sumptuous red velvet waistcoat with gold braiding and a fine blue coat with silvery silk lining. Gainsborough did not go halves on cloth, the clothes became the man and he showed it to full effect here. Perhaps Wollaston and the artist had become friends – they certainly shared music as an interest, and who knows, they may have played together.

By the time Gainsborough came to paint Wollaston he was

having itchy feet. He had met a man who began to have a curiously
unsatisfactory influence, but one who did nevertheless bounce
Gainsborough out of provincial complacency and show him the
exciting possibilities that new horizons might offer. Philip Thick-
nesse, the son of a Northamptonshire rector, has been variously
described as 'a boisterous ruffian', 'a poor, crafty, superannuated
lunatic' and 'by no means a gentleman'. Those various descriptions
were in fact made in one breath by one man, Lord Mountgarret,
who did not have a good word to say about him.[4] Elsewhere we can
find that Thicknesse had a gift for quarrelling, though he claimed
he never quarrelled with a poor man; a fantasist who claimed to
have killed three rattlesnakes in America with a single shot; a
gold-digger who married well (three times); and a compulsive
gambler and laudanum addict. His many targets as a quarrelling,
litigious contrarian included his first parents-in-law (he took that
quarrel as far as the House of Lords), his eldest son, George (to
whom he left his right hand, to be cut off and presented after his
death); and Francis Vernon, the nephew and heir of Gainsbor-
ough's well-connected sitter Admiral Vernon, whom he libelled
through broadsides printed on a press bought for the purpose. He
lost that one, and spent three months in the King's Bench Prison
for his pains. He even quarrelled with the Methodists Charles
and John Wesley and with the Archbishop of Canterbury; and
for our story he managed to quarrel with Gainsborough, quite
an achievement in itself. He loathed Margaret Gainsborough,
and would no doubt have quarrelled with her had she not got the
rolling pin out and bashed him with it.[5] Fulcher summed him up
well: Thicknesse, he said, 'had, in a remarkable degree, the faculty
of lessening the number of his friends and increasing the number
of his enemies. He was perpetually imagining insult and would
sniff an insult from afar.'[6] 'They say I'm a quarrelsome fellow',
Thicknesse versified,

> God rot it, why how can that be?
> For I never quarrel with any,
> But all the world quarrels with me.[7]

Nevertheless, Thicknesse was brave and principled according to
his lights, and, after a short and murky military career mainly in

Jamaica where (so he said) he fought in Vernon's fleet, he used his second wife's money in 1753 to buy the Lieutenant-Governorship of the military fort at Landguard, near Felixstowe, on the tip of the estuary of the Stour and the Orwell, close to Nacton, and at the heart of Vernon's orbit of social and political influence.

He and Gainsborough met, according to Thicknesse, when the latter was in Ipswich and spotted the figure of a man leaning over an orchard wall. This turned out to be a *trompe-l'oeil* painting that Gainsborough set up as a scarecrow to stop people stealing his fruit.[8] Thicknesse sought Gainsborough out, and that is where their turbulent association began, when, as Cunningham eloquently put it, he 'instantly threw the mantle of his patronage over him'.[9] Thicknesse was the equivalent of the beguiling character in Pinocchio who led the wooden boy into all sorts of temptation and danger, as if Gainsborough were not perfectly capable of leading himself astray. In Gainsborough's studio in Foundation Street 'this vain deity', as Cunningham described Thicknesse, claimed to have seen the portrait of Admiral Vernon on the easel, along with others which he described as 'truly drawn, perfectly like, but stiffly painted, and worse coloured . . . [and] little landscapes and drawings'. By these Thicknesse says he 'was charmed, those were the works of fancy and gave him infinite delight; Madam Nature, not Man, was then his only study, and he seemed intimately acquainted with that BEAUTIFUL OLD LADY'.[10]

'Several portraits . . . stiffly painted' suggests that, even as late as 1753, when he painted the grandiloquent Admiral Vernon, Gainsborough still had some of his lay-figure portraits in his studio, Plampin and Chafy, perhaps. By 1753 he was as ready for change as Thicknesse was ready to prompt it. What Thicknesse's observation tells us is that Gainsborough took a long time to move to his larger portrait format, and may have been reluctant to do so. Indeed, Gainsborough was probably painting both types of portrait at the same time for some years. Ipswich was the turning point.

The consequence of this discussion was that Thicknesse, controlling and quick to take offence, put his hand on Gainsborough's shoulder and invited him to Landguard Fort to have a look at it and make some sketches there, and paint the scene with the fort,

and the hills and Harwich beyond. Thicknesse wanted a long-format painting to hang over his fireplace, with shipping sailing by and guns saluting.[11] This was not an immediately typical Gainsborough subject – seascape was not really his thing – but the long-format was fine: he was quite used to that shape, so of course he accepted.

It did not take him long – when Gainsborough put his mind to something a result soon appeared: 'in a short time after, he brought the picture,' Thicknesse remembered. Gainsborough asked, tentatively, for fifteen guineas: 'he hoped I would not think fifteen guineas too much' – that is about £800 in today's money. Thicknesse paid up immediately, saying the painting would fetch twice that in London. Pushing ahead, Thicknesse took it to the engraver Thomas Major, who had recently set up in Chandos Street, off St Martin's Lane. Major, like Gainsborough, had learned his art with Gravelot, and like all those people frequented the St Martin's Lane Academy. Major had already had a life: he had been to Paris with Gravelot, and spent some years there building the lucrative Anglo-French print market. *Inter alia* he was thrown into the Bastille for ten days.[12] He and Gainsborough already knew each other well, and Major will have had some idea of what he was taking on in engraving Gainsborough's work. Nevertheless – or consequently – Major prevaricated, wondering, according to Thicknesse, who would buy such a print, 'as it was only a perspective view of the Fort'.[13] There is some misinformation here, or Thicknesse has misremembered: it is nothing of the kind, the fort is far away and tiny, with little direct appeal to military people. In the engraving, which is all we have to go on because the painting is lost, the sandy landscape stretches out to a long-distant point with no real sense of place or structure; and there is a lot of sea and sky and a few straggling figures. It is not really 'composed', and is so unlike anything Gainsborough had done before in the landscape way that it is practically a new language for him. However, Thicknesse persisted with Thomas Major, and offered to buy ten guineas' worth of the prints. At a likely price of three shillings each, that would be seventy prints immediately sold, a very large number to be taken from one plate, and more than enough to wear the copper out.[14] Major had got

1. *Bumper, a Bull Terrier*, 1745. The 'most remarkable, sagacious cur' that caught Gainsborough's eye in Suffolk, one of his earliest commissioned 'portraits'.

2. *Conversation in a Park*, c.1746–7. Spiced with rococo elegance and wry humour, this youthful dalliance is an invention, prompted perhaps by a literary source.

3. *St Mary's Church, Hadleigh*, 1747–8. Gainsborough's most complex architectural subject, a genre he subsequently avoided. Now in his early twenties, Gainsborough shows extraordinary confidence in handling this sophisticated commission.

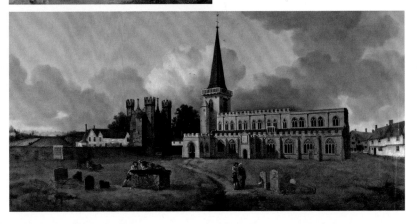

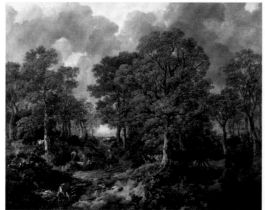

4. *Cornard Wood*, 1748.
The culmination of
Gainsborough's many
youthful landscape
studies, and a clear
reflection of his pleasure
in Dutch painting.
Already he shows he can
handle a large scale.

5. *The Charterhouse, London,*
1748. Twenty-one-year-
old Gainsborough's
contribution to the
pioneering Foundling
Hospital. The clouds and
splashing light suggest
both Dutch townscape and
Canaletto's paintings.

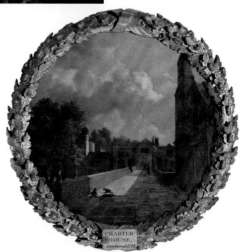

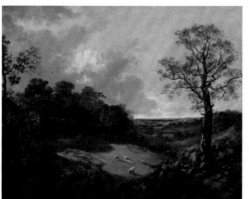

6. *Wooded Landscape with a
Cottage and Shepherd*, 1748–
50. This is remarkably close
in appearance to the actual
topography of Auberies,
the home estate modified
by Gainsborough as the
setting for *Mr and Mrs
Andrews* (Pl. 14).

7. *River Landscape with a View of a Distant Village, c.*1750. Another large and sophisticated commission from an unknown patron. The rhythm of its quiet rural narrative is underscored by the sinuous flow of the clouds.

8. *Landscape with Gipsies,* 1753–4. Slashed by Gainsborough in a fit of temper, this was repaired and given by the artist to his friend Joshua Kirby. The central seated figure holds the eye with a compelling gaze.

9. *William and Françoise Carter*, c.1747–8. An early portrait, painted in return for a special kindness. Despite the ridiculous errors of scale, the portrait has affection and charm, and a particularly splendid waistcoat.

10. *Lady Lloyd and her Son, Richard Savage Lloyd, of Hintlesham Hall, Suffolk,* late 1740s. One of a group of portraits painted of the Lloyd family to reflect the status of Gainsborough's patron Sir Richard, a King's Counsel, MP, and Recorder for Harwich, Orford and Ipswich.

11 and 12. *John* and *Alice Kirby*, both *c*.1750. The parents of Gainsborough's lifelong friend Joshua. This pair demonstrates the depth of Gainsborough's engagement with portraiture and the breadth of style he had by now mastered. Here he emulates the manners of Hogarth and of Dutch seventeenth-century portrait painters.

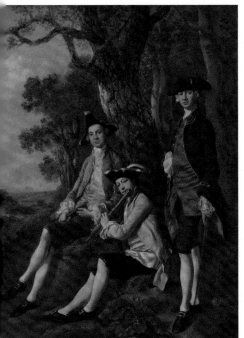

13. *Peter Darnell Muilman, Charles Crokatt and William Keable, c.*1748–50. These three young men of Suffolk pose together at the prime of their lives, figures of chic urban elegance in a rural setting.

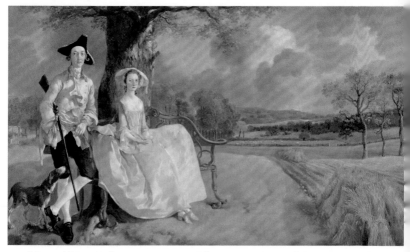

14. *Mr and Mrs Andrews*, *c.*1749–50. The masterpiece of Gainsborough's early manner. The landscape, though pin-sharp, bears little resemblance to the surroundings of Auberies near Sudbury that it purportedly represents.

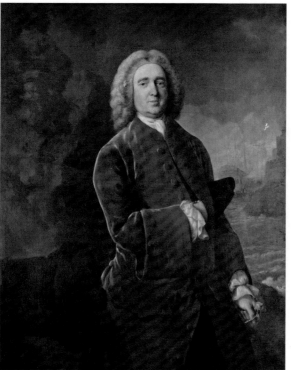

15. *Admiral Vernon*, *c.*1753. Vernon was a controversial naval figure, admired by sailors but ultimately loathed by the Admiralty. He commissioned this portrait when standing for re-election as an MP for Ipswich.

16. *Wooded landscape with a country wagon, milkmaid and drover*, 1765–6. This was bought in Bath by Gainsborough's friend Sir William St Quintin. Its dark mood combines echoes of *Cornard Wood* (Pl. 4) and *The Harvest Wagon* (Pl. 19).

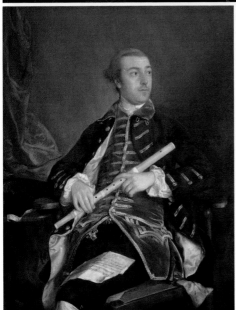

17. *William Wollaston, c.1759.* Here Gainsborough breaks away from the stiff doll-like figures of the Carter, Lloyd and Andrews portraits, to find new relaxed harmonies in the spirit of Van Dyck.

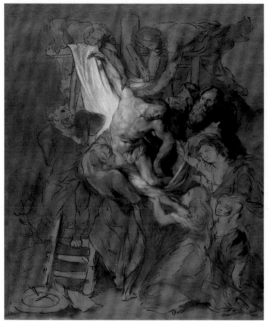

18. *After Rubens, The Descent from the Cross, c.1765.* Painted from an engraving of Rubens' original in Antwerp. This fluid and contained study provided the source for the exuberant celebration of rural life, 19. (*below*), *The Harvest Wagon, c.1765,* where Gainsborough is at his most relaxed and erudite, playing with the composition both of the Rubens and the Roman sculptural group *The Horse-Tamers.*

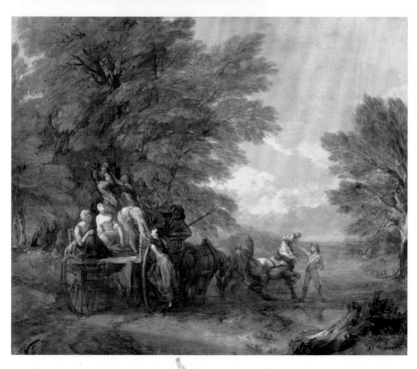

a very good deal, and he worked fast: the finished engraving is dated 5 August 1754.

Thomas Major, after Thomas Gainsborough, *Landguard Fort*, 1754.

It is generally sensible to take a look behind any initiative of Philip Thicknesse and seek ulterior motives. He had just been appointed Lieutenant-Governor of Landguard, and had to stay on the right side of his commanding officer, Governor George Beauclerk, Colonel of the Nineteenth Regiment of Foot. A painting and an engraving fulsomely dedicated to the Governor would be a very healthy start: the Beauclerk coat of arms and motto *'Auspicium melioris aevi'* ('Token [or hope] of a better age'), is central and prominent in the margin, and can be read equally as representative of the fort, the Governor, or Philip Thicknesse. Thomas Major, himself a man on the rise, who would become engraver to the King and the first engraver to be elected an Associate of the Royal Academy, added his own tribute in the print's margin: 'this South East View of the said Fort is most Humbly Inscribed by his Lordship's Dutifull and most Obedient Humble Servt Thos Major'. As is often the case, the ownership of the painting is recorded – here, 'in the possession of Capt. Thicknesse' – with its dimensions, '4 feet ten inches broad, 2 feet 9½ high'. Gainsborough's name is in

there too, 'T. Gainsborough pinxit', but you have to look for it, and it is on a considerably smaller scale than the names of the other two partners. So in the Landguard Fort initiative we see three men on the make: Thicknesse, Gainsborough and Major, and Thicknesse may in addition have put himself in the picture as the little figure with his leg up, like John Plampin, on a sandy bank in the left foreground.

In Suffolk, Gainsborough was in the thick of it as a portrait painter. Whatever local issue there might be, political, administrative, military, even musical, he was sure to have clients on both sides of the argument. In Sudbury there was Carter versus Fonnereau; in Ipswich Edward Vernon versus Lloyd, and Francis Vernon versus Thicknesse. There was also Thicknesse versus Lynch, and Thicknesse versus Kilderbee, for Thicknesse quarrelled with William Lynch, one of his officers at Landguard and a client of Gainsborough, and he made fun of Kilderbee.[15] Most inconvenient of all, there was Thicknesse versus Margaret Gainsborough.

With disobediences, a spell of imprisonment, absences, libels, lies and fantasies, it is remarkable that Thicknesse remained commander of Landguard Fort as long as he did. The sycophantic dedication on the engraving did not help him for long. He was eventually forced to go in 1765 when the Secretary of State for War, Shute Barrington, wrote to him by royal command: 'His Majesty is so dissatisfied with your conduct as to consider you utterly incapable of Command. It is therefore His Majesty's Pleasure & command that you do forthwith resign your command of Lieut. Governor of Landguard Fort & that you do not pretend to reside either there, or in the neighbourhood thereof.'[16] Thicknesse was clearly not the resigning sort. He did go, not with his tail between his legs, but by selling his commission on for £2,400, twice the amount he had paid for it.[17]

Gainsborough extended his reach as an artist in Ipswich by diversifying into printmaking. He already had the techniques at his fingertips – he had learned about engraving and etching and the use of acids and paper in London a decade ago, and nothing technical had changed. The next big thing in printmaking, aquatint,

a medium in which Gainsborough would become a pioneer, would not appear until the 1770s. What had developed, however, were the networks of trade and the increasing number of art dealers in London publishing prints for the domestic and burgeoning continental markets. While there was a lucrative market for paintings, particularly old masters and their mimics, the print market supplied the middle range of picture buyers who might stop and admire works for sale in Panton Betew's shop window in Soho, or John Boydell's when he set up in the Strand in 1746. Gainsborough's involvement with Thomas Major over the *Landguard Fort* engraving will have greatly increased his exposure. The large number of engravers recorded by Vertue is echoed by the market for books illustrated with engravings, illustrated trade advertisements and the more complex and interesting topographical and narrative subject series. This was a wholly different market to that for portrait engravings, the latter celebrating status and individuals living and dead, the former entertainment, education, enjoyment and escape. In his work Gainsborough offered both, but it would not be until he got to Bath that his portraits would be engraved, and when that time came the engravings would be made by others, at the subject's or a dealer's behest. Gainsborough did not engrave his own portraits. Landscapes, however, were different: here was another market for his work, and one which he began tentatively to explore.

In a retrospective musing after Gainsborough's death, Thicknesse claimed that the *Landguard Fort* engraving made Gainsborough's name known 'beyond the circle of his country residence'. We can interpret this as meaning 'beyond Suffolk', but that is ridiculous. He had been spotted in London as a 'justly esteemed eminent master' for some years already, and his practice was blooming. Thicknesse may be underestimating him and his ambition when he said that Gainsborough 'had not formed any high ideas of his own powers', and that he believed himself to be merely 'one, among a crowd of young artists' who might be able to pick up a decent living in a country town, and was now 'happily settled for life'.[18] However, there may be a grain of truth there: Gainsborough was easily distracted, by music, by women, by drink, and by his friends. On top of that, marriage and plenty

of work in Ipswich could have made him complacent, and Thicknesse may have put his finger on something. There are, certainly, enough portraits from this period whose ungainliness (we might just say innocent charm) suggests that he may have been losing focus.

Landguard Fort was an immediate success, because Thicknesse bought up so many of the proofs, and may have distributed them, an early marketing equivalent of Brian Epstein buying up quantities of the Beatles' 45 rpm single 'Please Please Me' in Liverpool in 1963. This clearly encouraged Gainsborough to look at printmaking as a useful way of spreading his work around further. One of the earliest prints Gainsborough made to stand alone to be mounted and framed is the etching known as *The Suffolk Plough* (1753–4).[19] This may have been drawn in Ipswich, but it was bitten and printed in London with the help of Charles Grignion. There is a report of a studio accident in which the acid was applied too freely: 'he spoiled the plate by impatiently attempting to apply the aqua fortis, before his friend, Mr Grignion, could assist him, as was agreed'.[20] There is an impetuosity implied in this account of the incident, and the proof in Gainsborough's House bears the inscription: 'Begun to be Etched by Mr Gainsborough from a Picture of his own but spoil'd & never finished. The Plate was never used.' Gainsborough does not appear to have made another print for five or six years: printmaking seems for the moment to have brought out impatience in him. His engraving *The Gipsies* (1759) also emerged out of a moment of impetuosity – fury in fact, as the painting from which it derives was in progress on the artist's easel when its commissioner, 'a gentleman near Ipswich', called and rashly said he was 'not pleased with it . . . he did not like it'. So in a flash of anger Gainsborough said 'then you shall not have it', and slashed the canvas with his penknife.[21] Gainsborough must have deeply regretted the outburst, because, according to Henry Trimmer, as told to Walter Thornbury, he painted a second version of the subject for the patron, and gave the torn canvas to Trimmer's grandfather Joshua Kirby.[22] With Grignion's help, and with more assistance from Joseph Wood, the print of *The Gipsies* came into being.

Gainsborough's need of assistance in his printmaking in these

John Wood, after Thomas Gainsborough, *The Gipsies*, 1764.

early years suggests that either he was too busy as a portrait and landscape painter to become much involved in making prints, or he was simply not sufficiently competent at the very tricky technical requirements, or both. Though he was trained as an engraver it was a painter he became, and the reason for this may be that at this early stage of his career he simply did not enjoy the messy business of printmaking, and could do without it. But in any event both Betew and Boydell courted him. While we know that Betew displayed Gainsborough's drawings in his shop, John Boydell would soon invest in employing Francis Vivares to make

engravings of paintings by Gainsborough that Betew owned. There was a flurry of marketing activity to pick up on the fashion for engraved landscape views from the 1740s: Betew and Boydell were entrepreneurs here, and Gainsborough and other landscape painters including George Lambert, Richard Wilson and Ebenezer Tull quickly joined in. While Lambert and Wilson had important careers, Tull, a schoolmaster in Southwark, never made it as a landscape painter, and died young. Many of Gainsborough's engraved paintings were owned by Betew, so their inscriptions tell, but the status of his ownership may have been that Betew merely took them from the artist as stock for resale.

Philip Thicknesse continued as a presence in Gainsborough's life in Ipswich, and we might suggest he was known to the whole family, and much to Margaret's dismay would come to call. He tended to claim a greater influence on the artist than was reasonable, or true. He records a self-promoting anecdote in which he tells that Gainsborough, having delivered his *Landguard Fort* canvas, picked up Thicknesse's violin, 'an excellent fiddle; for I found that [Gainsborough] has as much taste for music, as he had for painting, though he had then never touched a musical instrument'. [23] That cannot be true. Gainsborough must by 1753 have been quite proficient on the violin, involved as he was with the Ipswich Music Club. Nevertheless, Thicknesse goes on: 'at that time [Gainsborough] seemed to envy even my poor talents as a fiddler, but before I got my fiddle home again, he had made such a proficiency in music, that I would as soon have painted against him, as to have attempted to fiddle against him'. This gives us a picture of Gainsborough sawing away on his instrument back home, filling the house with screechy cat-gut noises, and annoying Margaret, and making the girls laugh. Then Thicknesse makes his extravagant claim: 'I believe however it was what I had said about the landscape and the Thomas Peartree's head, which first induced Mr Gainsborough to suspect (for he only suspected it) that he had something more in him, which might be fetched out, he found he could fetch a good tone out of my fiddle, and why not out of his own palette?'

By 1753 Gainsborough had painted and delivered *Mr and Mrs Andrews*, *The Rev. John Chafy* and the Lloyd family portraits and

so much else, quite enough evidence that Thicknesse gives mis-
leading information about Gainsborough, and that Gainsborough
knew very well the talent he had within him. Unfortunately, the
idea rapidly got around after his death that Gainsborough owed
his early success to Thicknesse. A review of Thicknesse's *Sketch
of the Life and Paintings of Thomas Gainsborough, Esq.* has it that
Gainsborough owed his 'introduction to the world' to the 'early
friendship and discernment of Mr T'. The author of the review in
The General Magazine and Impartial Review goes on to say that 'Mr
T. is well known to be one of the "gentlemen who write with ease,"
and his present Sketch is in his usual and lively manner, which
sets criticism at defiance'.[24] It may however have been the case
that Thicknesse, with his veneer of metropolitan sophistication,
now put the idea into Gainsborough's head that he should move
to Bath, explore the wider world, 'and try his talents at portrait
painting in that fluctuating city'.[25]

There are distinct Jack-the-Lad tendencies about Gainsborough
the young man, although marriage to the strong-willed Margaret
and fatherhood will have tempered him, as they would temper
any. The cocksure attitude of the cliché, the nineteenth-century
song about Jack-the-Lad 'swigging, gigging, kissing, drinking,
fighting', had echoes in the youthful Gainsborough. The first four
qualities are particularly apt, but he was probably much too sen-
sible and fond of his looks to get involved with the fifth, fighting.
We have a lot to thank Margaret for. Without her command-and-
control personality, Gainsborough might have gone completely
off the rails, and faded out, or be lost in a ditch with his riotous
London friends.

We can watch the measured pace of Gainsborough's journey
from dissipation to sobriety in the two self-portraits of the 1750s:
in the earlier one (see Frontispiece) his tricorn hat is at an ungainly
angle – it is not 'jaunty', it is just slightly askew – and he seems to
be holding his eyes open with sticks, so heavy and tired are they.[26]
In the other, perhaps painted as he was taking the plunge to move
to Bath, he shows himself as his clients might want to see him:
neat, alert, self-contained, reliable and sobriety itself (Pl. 21).[27] He
has pulled himself together in time.

*

A month after Gainsborough had left Ipswich for Bath, a well-dressed, brisk and persistent gentleman arrived in Ipswich making enquiries.[28]

'Landlord, do you know Mr Gainsborough the painter?'

'Very well, sir.'

'Do tell me where he lives?'

'He has not lived here a good while, sir.'

'No! Where then?'

'I believe he is in Bath, sir.'

'Enquire, enquire.'

The landlord goes into the back of his inn. There are mutterings and silences and exclamations.

'Yes, sir, my people tell me that he has been in Bath many months. They are sure of it.'

Time moved slowly in Ipswich. If the date of the gentleman's diary entry, 7 November 1758, is correct as published in this magazine article of 1772, Gainsborough would not have been gone so long as the landlord remembered, and his family would still be in town. Nevertheless, here, forty years before Constable poked about Ipswich looking for traces of Gainsborough, is reasonable evidence that the world was now on his tail. Sometime in the near future, Joseph Wright would be happy, even determined, to be known as 'Joseph Wright of Derby'. Thomas Gainsborough, however, had no intention of being known as 'Gainsborough de Ipswich'.

18. The painter's daughters, a butterfly, their cat, and a sad little girl

The Gainsboroughs' daughters, Mary and Margaret, brought them great joy with an admixture of pain and foreboding. The girls were Gainsborough's most regular and repeated subject: he painted them, so far as we know, six times as a pair, more than he is known to have painted his wife, and he painted them individually perhaps three or four times. To avoid confusion with all the different Marys and Margarets in Gainsborough's history, I shall from here on call the daughters by their family nicknames, Molly and Peggy respectively.

The earliest, and perhaps the most lyrical and charming double portrait of Molly and Peggy, is titled *The Painter's Daughters Chasing a Butterfly* (Pl. 25).[1] This was not exhibited in Gainsborough's lifetime, except perhaps at the sale he arranged in October 1759 as the family left Ipswich, and so the title is a description which has been attached to it by tradition. It is a spontaneous celebration of childhood, with a dark undercurrent touching on the perils and pleasures of life. The older child, Molly, has a firm but careful hand restraining her sister, who is rushing forward to try to catch a butterfly. Peggy's eyes and gesture are focused on nothing but the butterfly, but Molly sees beyond it, and is looking at the thistle that her little sister is about to grab unsuspectingly. With its touching symbolism about concealed dangers, and wisdom within innocence, it is a bold and exciting composition with strong weight and colour on the right anchoring what is the focus of attention, the butterfly, on the left. As an expression of childhood, it is without compare in its period and foreshadows Gainsborough's later, and one must add gloomier, paintings of childhood in his final decade. As their lives progressed the roles of Molly and Peggy as reflected in the painting became reversed: Molly was to make a bad marriage which ended worse. Ultimately she lost her mind: Farington remembered her

at the end of the 1790s as being 'melancholy'; Henry Trimmer, more bluntly, a boy's recollection of the 1810s, said she was 'deranged'; another correspondent wrote that she 'thought herself a queen'.[2] Peggy became the bossy one, as younger sisters often do, and her father called her 'the Captain', which suggests that even as a little girl she ruled the roost.[3] At the end of their lives Molly and Peggy lived together in Acton as spinster ladies, Peggy returning until her earlier death the care and concern which their father had so tenderly observed at so young an age in her sister.[4]

At over one metre square, *The Painter's Daughters Chasing a Butterfly* is a large painting for one which seems to have been made for private consumption in a busy portrait painter's household. It is so close to being finished, and so integrated, that its purpose for Gainsborough in working out his expression of childhood is clear. A source might be Van Dyck's *Wharton Sisters*, engraved *c*.1715,[5] but in composing *The Painter's Daughters* Gainsborough has watched his daughters play, makes the subject his own, and reveals his love and anxiety for his girls. He touches also on John Bunyan's fable of the boy and the butterfly, and the dangers of carefree innocence:

> He halloos, runs, and cries out, 'Here boys here!'
> Nor doth he brambles or the nettles fear.

The boy runs through 'nettles, thorns and briars . . . to get what will be lost as soon as won', so we cannot equate Gainsborough's sensible girls with Bunyan's silly boy. If this has anything to do with a popular fable, it is as nothing to Gainsborough's delight in reflecting instinctive childish sense and guidance, and his knowledge of his own children. It is remarkable, however, that rather than take this wonderful painting with the family to Bath, he either sold it or gave it – the latter much more likely – to his Ipswich friend and neighbour the Rev. Robert Hingeston. Certainly Hingeston knew the girls, and we can surmise that he saw them play together in the next-door garden. For the headmaster of the town's grammar school *The Painter's Daughters Chasing a Butterfly* was as topical a subject as it was for Gainsborough, so of course he should have it. From Hingeston it eventually made

its way, via the Henry Vaughan Bequest in 1900, to the National Gallery in London.

Molly and Peggy drew some profoundly thoughtful and ruminative paintings out of their father. When he paints them he is never in flippant mood; he saw their lives and futures as far too serious for that. We see them again in another portrait that marks their lives, the one known descriptively as *The Painter's Daughters with a Cat* (Pl. 26).[6] This may have been made soon after the family moved to Bath. It is a masterpiece of relaxed and loving innovation: fresh, informal and slightly wicked, the girls look at us with their large brown eyes, and soft full lips. Molly's tousled hair is just enchanting. She has her arm round Peggy, showing control and care, while 'the Captain', being softly alluring, plays flirtatious eye games with her father. There are few comparisons with this pose outside French painting – Boucher and Fragonard reveal more adult seductive expressions of eye-contact – while in English painting Hogarth's *Shrimp Girl* comes near it, but we have to wait nearly eighty years for an equivalent in the 'secret painting' that Queen Victoria commissioned in 1843 from Franz Winterhalter (and he was German) as a present for Prince Albert.[7]

The Painter's Daughters with a Cat – its title was given by curators when the portrait entered the National Gallery in 1923 – is an earlier 'secret painting', for family consumption. The light, quick brushwork reveals exactly how Gainsborough now began his canvases, with suggestions of trees, and the breath of moving air. Prominent (though also not prominent) is the sketchy form of the family's cat, annoyed at having its tail pulled, and with a clawed paw ready to scratch, adding a touch of narrative, truncated when Gainsborough stopped working on the picture. He undoubtedly intended to finish it, but that just didn't happen, probably for exactly the same reason that others of his portraits dragged on and on: pressure of work from paying clients. We see here a development of the understated tension that Gainsborough had evoked in *The Painter's Daughters Chasing a Butterfly*. There Peggy is about to be pricked by a thistle; here, one or other of them is about to be scratched by the cat.

A double portrait of the girls now in the Victoria and Albert Museum was cut into two in the mid nineteenth century. The

halves have since come together, but with an awkward joint. Molly is on the left; Peggy on the right: Molly is in charge this time and attending to Peggy's short-cropped hair, and seems to be attaching silk flowers or a pompom to her sister's head, similar to the flowers she herself is wearing. Once again they have those heavy, enquiring, even interrogative expressions, large wide eyes and clear-complexioned faces that in Gainsborough is so immediately affecting. Theirs are very serious expressions for little girls messing about, as if they are posing for a subject picture for their father – it might be something gory like Judith with the head of Holofernes, or David and Goliath; or a happier subject such as a nymph crowning a muse with laurel. Such subjects were certainly not Gainsborough's stock-in-trade, but with his daughters he could experiment with ideas. He would soon devise poses that echo old master narrative and history paintings, and this loving, though odd, painting of his daughters may be an early skirmish.

If the V&A double portrait is the result of cutting and pasting with two or three bits of canvas, then another portrait of one of the girls, probably Peggy, is all that is left of another pictorial experiment, cut down in the nineteenth century. In the painting given the title *Margaret Gainsborough as a Gleaner* (Pl. 27), Gainsborough gives us a sad little girl who is apparently being handed a sheaf of corn in a harvest field by a missing figure to the right.[8] Given the clear pattern of Gainsborough's use of his daughters for experiment in double portraiture, the missing figure was surely her older sister, Molly. Peggy gives a melancholy glance to whoever she is working with, and is holding her dress rather than taking the sheaf in her (unfinished) arms. She is not wholly engaged in what is going on. The oddest aspect of the painting is the purpose of the scrappy piece of cloth she wears round her head. Is this something ineffective to keep the sun off, or was she suffering from earache? Might it be the cotton or muslin lining for a prickly straw hat that has blown away, and why is she wearing a tattered old ball gown out in the fields? In any event what began as a double portrait has perforce evolved into a curious piece of rural realism unequalled until Jean-François Millet or Gustave Courbet in France over a hundred years later. The subject also reflects, by the way, on the rural nature of the outer fields of Bath

across the river, where corn was grown and fields were gleaned. The painting was briefly exhibited in 1824 before the right-hand half was cut off, and it was probably also trimmed along its lower edge. W. H. Pyne described it as 'portraits of [Gainsborough's] two daughters, in the garb of peasant girls, dividing their gleanings . . . The painting is . . . left in part unfinished'.[9]

In September 1764, when the girls were thirteen and fourteen years old, Thomas and Margaret sent them to London to attend boarding school in Blacklands House, on Chelsea Common just north of the King's Road.[10] The school had a French aspect to its management so Thomas and Margaret could expect new etiquette, poise and decorum instilled into their daughters away from the dangers of Bath, as well as tuition in French, music, dancing and drawing. History was not repeating itself here: in the 1760s Chelsea was a remote village, far from the fleshpots of Covent Garden that Thomas had himself experienced twenty years earlier. He was evidently anxious about them, so far away, and wrote regularly. Peggy particularly remembered that his letters 'contain[ed] instructions for drawing', but to their later regret, the girls subsequently lost them all.[11] Careless, casual, uncaring, or what?

Perhaps as the girls were going off to Blacklands Gainsborough painted the double portrait of Molly and Peggy with their drawing portfolios, porte-crayons and a table-size version of the Farnese *Flora*.[12] In the shadows at their feet is a Venus. Gainsborough clearly spent a great deal of time and reflection on the painting, and changed the composition radically. It began with Molly dominant, looking from left to right, but eventually a solution emerged in which his daughters are so much more grown up than they were in the carefree *Butterfly* and *Cat* paintings. Now they reveal an anxiety of adolescence, an undertow of foreboding. This is Gainsborough's manifesto for his daughters, a view of how he hoped they might develop. Writing to James Unwin he expressed the thought that landscape drawing might be a secure profession for them, 'an employment not so apt to lay snares in their way as portrait or miniature painting, because they may be retired'. By that I suggest he means 'are able to work alone', that is, not to have to deal with the kind of sitting clients that so dogged

(and enriched) his own life. There is also a suggestion here that Thomas and Margaret did not expect their daughters to marry.

It is Gainsborough's concern, and it does seem to be *his* concern – he does not appear to give much mind to his wife's opinion – that he should keep the girls away from the distractions of Bath: 'I think (and indeed always did myself) that I had better do this than make a fine trumpery of them, and let them be led away with vanity, and ever subject to disappointment in the wild goose chase. I've marked the end of it sufficiently.'[13] He has seen them disappointed before, seen their romances end in tears. He continues: 'I am in earnest and shall set about it in good earnest.'

When he was not agonising about their behaviour, their attitude and their future, Gainsborough's daughters were a source of study for him, a source of ideas for poses and composition. The unfinished nature of these five works – there would be a sixth later – suggest work in progress, while the alterations and hesitations within them demonstrate Gainsborough's desire to make changes, to move ideas around and to test them to destruction. In touching Van Dyck, Boucher, Fragonard and Hogarth, and even Millet and Courbet, Gainsborough reveals the power, potency and freedom of thought in his experiments. He was a man of creative passions that he was able to express by pushing, squeezing and shoving his work until it gave him what he wanted, or failed in the process.

19. Freedom is the only manner:
Gainsborough's landscapes

———————

Even in Gainsborough's earliest landscapes, *Mr and Mrs Andrews* only excepted, there seems to be a distinct feeling or expression of descent. Either the sun is descending, a herd of cattle is moving slowly downhill, or a personal relationship might be coming to an end. The low-toned conversations taking place in *River Landscape with a View of a Distant Village* (*c*.1750; Pl. 7) suggests that two boy–girl relationships are going nowhere.[1] Only the dog barks. In *Wooded Landscape with a Cottage and Shepherd* (late 1740s; Pl. 6), another title that demonstrates the inconvenience of the artist's inability to give his paintings proper names, the landscape itself is descending.[2] How helpful an artist's title would have been for this painting in particular, as it is quite possible that it depicts fields on the Auberies estate. Slow, downward tendency in a painting might signal melancholy, but it also suggests relaxation, change, even relief.

Towards the beginning of his career, the mood Gainsborough evokes in his landscape paintings is never one of excitement or of joy at being alive. These early landscapes are not expressed through the emotions, they are constructed by the brain, from fragments collected in the field. The fifty or more pencil studies in the British Museum, and the twenty-five drawings in the album in the Royal Library at Windsor, reveal Gainsborough at his most inquisitive and energetic.[3] Nowhere among the British Museum drawings, an important group initially collected by the late eighteenth-century connoisseur Sir Richard Payne Knight, is a view that can be identified as a place.[4] There are some anonymous farm buildings, paths leading through trees, a moody moonlit landscape, some bulky plants, a goat, a bull and a donkey, but nowhere specific.

The Payne Knight Collection, bound together in a volume, comprises drawings made on sheets of white paper each no more

than eight inches square. These were perhaps drawn in Suffolk in the 1740s or 1750s, and from such fragments Gainsborough would construct his paintings. One or two of the drawings are splashed with ink or oil, suggesting they have been lying around his painting room, while most reflect the physicality of Gainsborough's drawing manner: black chalk with white highlights, and smudged with a 'stump', right-handed hatching creating deep shadow and strong light, and a close attention to country detail.[5] One drawing has been folded into diagonals, probably to find a centre for compositional purposes.[6] The Windsor drawings, on the other hand, are largely of a piece, all being about the same size, around sixteen by twenty inches, and most having such specific reference to subject that they all have the hallmarks of being drawn on the

Wooded Landscape with Tree and Silver Birch in Foreground, undated.

spot. Some of them have similar oil stains to those in the British
Museum album, indicating comparable treatment in the painting
room, and one is also folded in a complex and deliberate manner
that indicates purpose of some kind.[7] Another drawing has been
identified by Lindsay Stainton as a squared-up study for *Cornard
Wood*, as discussed earlier, while a third may be an initial view of
the landscape at Holywells Park, Ipswich.[8]

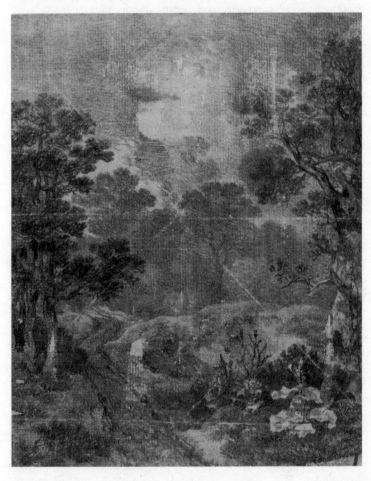

A Woody Landscape, undated.

The paintings that come out of these and other studies have distinct poetic foundations – hints of Milton's *L'Allegro*, of Thomas Gray's *Elegy* and, later on, of Oliver Goldsmith's *Deserted Village* (published 1770). This tends to suggest that this apparently un-literary young man must have had some kind of sensitivity and access to the written word, and would ruminate as he painted. Gainsborough's fury at the refusal of a client to accept *Landscape with Gipsies* (Pl. 8) is a measure of his depth of engagement with work in progress.[9] This is a beautiful little picture in which, per-haps for the first time in a Gainsborough landscape, one of the figures addresses the spectator directly, and holds the eye. It is a masterpiece of declining light: the last touch of late afternoon sun shines on the baby's bonnet, the mother's headscarf, and the sis-ters' hats and shawls, and glances off the trunk of the oak. Anyone would be furious if such an innovative gem were refused; though perhaps only Gainsborough could have been so volatile as to have slashed it there and then.

Gainsborough's many hundreds of finished landscape draw-ings, rather than his fragmentary studies, and his liberality in giving so many of them away, testify further to the richness of resource that he found in landscape as a subject, even if he drew many of these at home, at night, with a candle for illumination. They are constructions and variations, fugues like those his mu-sician friends would play, with themes, figures and staffage that came round and round again: boy leaning against tree stump with tired horses; tired horses standing by stable at dusk; dusky stable with cottage and cows by stream; stream and bridge with an am-bling line of cows; cows with tree stump and tired boy; tired boy leaning against tree stump with horses; and so on. The energy in the diagonal strokes of chalk or brush, the smudging and fin-gering, and the strong tonal contrasts that chalk and low light can conjure, are all witness to the centrality in Gainsborough of landscape drawing. The care he took in protecting the methods he had invented for himself (see Chapter 28) further reflects the value to Gainsborough of his drawing techniques and hard-won knowledge. His concern to maintain his own high standards is additionally reflected in Thicknesse's story that he tore up a drawing that he thought was not good enough, only to find that

it was a copy by a Thicknesse daughter of one of Gainsborough's own drawings.[10]

Gainsborough's pictorial fugues can only have developed with such richness of variety and conviction through long immersion in real landscape. His experience of Suffolk is anecdotally documented, as is his knowledge of the lanes and rides above Bath, sometimes, he tells us, experienced in the rain. He will from time to time have taken drawing materials with him, but there is only rarely a record of where he was when he drew. When he made his countless journeys between London and Ipswich, and London and Bath, the landscape was always there, changing before him, and challenging him. He travelled to King's Bromley, Staffordshire, in the late 1760s to make drawings for a landscape painting, to North Devon, Derbyshire and perhaps the Lake District, and to Wilton, Stratfield Saye, Bowood and Corsham among other great houses. In 1782 he travelled into the West Country again, and the following year to Antwerp.[11] So although he did not see Italy, and all that would have hung from that, he had experienced a good slice of the round world for his period, even if he chose not to express atmospherics, weather or meteorological change. A group of seven drawings about three inches square in the British Museum's Payne Knight Collection have the feel of proposals for landscape compositions, perhaps to show a commissioner before beginning a work, or compositon records after the event.[12] These little compositions, all bounded by a ruled line, reflect Gainsborough's professionalism, his powers of planning and organisation, and his concern that the client should get what he wants.

Drawing was also a source of freedom, a way for Gainsborough to escape in his head from the distractions of home, the rule of his wife, the challenge of his daughters, the pressure of his portrait-painting business. To be in a land of his own invention, emerging into its own dim light by every gesture of his wrist, was a blessed release. 'Remember', he advised Constantine Phipps, 'that there must be truth of hand, as well as freedom of hand in drawing ... freedom is only the manner.'[13] Being so immersed in his art, heart and soul, it follows that he would give drawings and sometimes paintings freely to those who appreciated him, but would

slash or paint out diligent work that was unkindly or ignorantly rejected.

There is a long-drawn-out moment in Gainsborough's development as a landscape painter where his manner moves gradually from dabby to brushy. *Cornard Wood* (Pl. 4) is distinctly dabby, the green of the leaves applied spot by spot, and only varying in their tone between dark green and greeny-yellow. Dab, dab, dab. He is going by the book, Thomas Page of Beccles' book, *The Art of Painting*, published in 1720: 'In touching the Trees, Boughs, and Branches, put all the dark Shadows in first, raising the lighter *Leaves* above the darker . . . the uppermost of all express last of all, by touching the exterior edges of the former Leaves, with a little Green Masticot and White.'[14]

The young Gainsborough carried on with brushwork of this kind for a decade or more, becoming extremely competent with the manner that he had first espied in Dutch seventeenth-century painting, and carried into portrait groups with landscape settings such as *Mr and Mrs Andrews* (Pl. 14). Gradually, however, he loosens up; this is a natural looseness probably prompted by time-pressure, another client waiting, or simply by sheer boredom at the mechanical nature of his early manner. Gainsborough had a very low boredom threshold; he would not spend days painting a hand or a foot or a waistcoat – at any rate, not after the first few years – when he could dramatically suggest them with cursive sweeps of his loaded brush.

So by the mid 1750s, when he was living in Ipswich, Gainsborough's landscape manner became freer, his paint more fluid, and the leaves on his trees brushier, as if they were actually growing there, and moving in the wind, rather than stuck on with glue. *Wooded Landscape with Two Carthorses* at Woburn, one of the paintings commissioned by the Duke of Bedford in 1755, is an early example of this change, and *Wooded Landscape with a Country Wagon, Milkmaid and Drover* (exhibited in 1766; Pl. 16) is a more mature transitional work, which harks back to *Cornard Wood* in its dense tree-cover.[15]

The painting that marks the completion of the change, however, is *The Harvest Wagon*, exhibited in 1767, and painted during the middle years of Gainsborough's time in Bath (Pl. 19).[16] *The*

Harvest Wagon is perhaps the only Gainsborough landscape that denies the general tendency of descent. This painting ascends triumphantly. From the firm horizontal of the cart the figures aspire to become a human pyramid: two girls and a boy provide the pyramid base, and support two young men, one of whom is helping his friend take a swig from a barrel. The figure who would become the topmost acrobat on the pyramid is being sprung from the ground by her friend. Up she goes . . . but this is a painting, not a circus, and she's not really going anywhere.

At forty years of age Gainsborough had reached a maturity and command as an artist that allowed him to handle multiple sophisticated sources with apparent ease and evident enjoyment. *The Harvest Wagon* evolved out of Gainsborough's study not just of the landscapes around him, or the construction of farm wagons, but from the paintings of his other great Flemish influence, Peter Paul Rubens. Gainsborough knew Rubens' *Descent from the Cross* both because he had seen the artist's study for it at Corsham Court,[17] and probably owned a proof of its engraving by Lucas Vorsterman. From this he made his own fluid study (Pl. 18).[18] But instead of echoing the solemnity of the subject of Christ's body falling down, in *The Harvest Wagon* Gainsborough defies gravity and enables his figures to bounce joyfully upwards. Out of an image of misery and defeat, Gainsborough has delivered a moment of celebration, joy and delight, despite the figure in the front of the cart who has already had too much to drink and holds his head in his hands. The Rubens is a strictly contained composition: the nine figures are held within a tight rectangle, the body of Christ providing the dynamic diagonal. The seven figures in Gainsborough's cart, however, are uncontained, and closure in this composition is provided by the staunch figure of the young man to the right who holds a restraining hand on the spirited grey leading horse.

This grouping has its source, too, in a sixteenth-century print of *The Horse Tamers*, an antique figure group on the Quirinal Hill in Rome. Thus Gainsborough's *Harvest Wagon* is rooted not only in the landscapes that surrounded him, but also in the classic work of his artist predecessors, be they sculptors in ancient Rome, a baroque engraver of antiquities, or Peter Paul Rubens himself.

More than any other work, *The Harvest Wagon* demonstrates the depth of Gainsborough's application to the profession of painting as an intellectual, cultural and instinctive practice, rather than a creative and commercial service for the rich and vain. He knew his own mind. Enthralled as Gainsborough was by Rubens and Van Dyck, he did not toe the line of fashionable taste concerning Claude: 'he thought his pencilling [i.e. his brushwork] tame and insipid'.[19] Gainsborough kept *The Harvest Wagon* back after he had exhibited it, and probably displayed it in his showroom. But when he left Bath he gave it to his friend the carrier Walter Wiltshire, who must have had a few carts like that one, and who reportedly lent him the grey horse that stands proudly against the horizon.

In Sudbury and Ipswich, landscape painting was part of Gainsborough's stock-in-trade: he took commissions for landscapes and treated them on a par with his portrait commissions. Life and work in Bath, however, put a new perspective on his landscape-painting practice, and recalibrated its position in his painting life. In his earlier years he was known as a painter; in Bath he was a *portrait* painter. This too has to be qualified, however, because it was in Bath that the scale of his landscape paintings increased, gradually, by minor increments. His landscapes had by the early 1760s reached around five feet square, as in *Sunset: Carthorses Drinking at a Stream* (perhaps as early as 1760, more likely around 1763),[20] the so-called *Grand Landscape* of 1763,[21] and the 1766 *Wooded Landscape*. Landscape gave him a format change from portrait painting: tall and narrow for full-lengths, comfortably rectangular for head-and-shoulders, but always upright. The breadth of the horizontal canvas comes as something of a relief after the strict verticality of the portrait, while to be alone with a landscape painting and not having to share his presence with a sitter must have been a blessing.

There is a further strain in his landscapes which indicates that they represent a kind of relief to him: they are, certainly from the Bath period, invariably end-of-day, dusk-descending scenes, people or livestock going home, settling in for the evening, a last glimmer before nightfall. 'Now fades the glimmering landscape on the sight', wrote Thomas Gray in his *Elegy*, published in 1751.[22] He might have been writing it for Gainsborough. In painting

landscapes as he did, from models and little studio constructions lit by candles (see Chapter 25), Gainsborough too was settling in for the evening. The end of the day that Gainsborough painted was also the time of day he painted it.

IV

Bath

20. I pant for Grosvenorshire

Whoever caused Gainsborough to think of moving to Bath was leaning against an opening door. His mother had died in 1755, so there were now no elderly parents to keep him in Suffolk, and, what might have been worse, his cousins were expressing themselves in Sudbury when in 1759 they installed a splendid new tomb chest in All Saints' churchyard to commemorate Uncle Thomas's prosperous side of the family.[1] Gainsborough was already in Bath early in October 1758 for the season, to see the lie of the land and to begin to prospect for custom, so he might have had the notion in his head to move for some time. The 'season' in Bath ran from September to May. But being in Bath was not the single most important event for Gainsborough at this time; the transformative event was the coming to Bath. As he made the journey from London he began to discover a sequence of new landscapes different entirely from the slow undulation of the Suffolk–Essex borderlands, and the long, winding road between Ipswich, Sudbury and the capital. Those landscapes had years before made him a painter, and rhymed neatly with the paintings of his beloved Dutch masters. Scene by scene, however, the new immersion he experienced as he travelled to Bath was enough to explode his understanding of landscape.

From London, his route by public coach will have taken him to Hammersmith and Brentford, and across Hounslow Heath where, every so often, the rotting bodies or crow-picked skeletons of highwaymen hung from gibbets, just to discourage everyone. Then through Slough, past Windsor Castle, and, with many stops to change horses and rest, through Reading, Newbury and Marlborough, Silbury Hill and Calne, to Chippenham and then down over the southern edge of the Cotswolds to the deep depression in which Bath settles. According to the milestones that marked the way, it was 107 miles from Hyde Park Corner to Bath. On this journey he travelled through a succession of river valleys,

wooded hills, small market towns, high, bleak, dangerous open country, ancient remains and the vast, steep, stubborn limestone bowl containing Bath and its hot waters. A fellow traveller, Celia Fiennes, who had preceded him by sixty or more years, described her arrival in Bath, in her case from the south, via Berkley and Norton St Philip: 'five miles down a very steep hill and stony, a mile from the town scarce any passing and there descends a little current of water continually from the rocks. The ways to the bath are all difficult, the town lies low in a bottom and its steep ascents all ways out of the town.'[2]

Roads had improved in those sixty years, but the geography was unchanged, presenting steep hills, slippery surfaces and tidal flows of travellers to be negotiated. The road into Bath from London was described at this time as made of 'chalk and soap'.[3] By the end of the 1750s new arrivals had only increased in number and sophistication, becoming more controlled by organised entertainment, enjoying a multiplied spending power, and seduced by such misinformation as this: 'The roads around Bath have been lately repaired . . . you may ascend the hills . . . with the greatest ease and safety.'[4]

For a painter, the landscape around Bath was dramatic, even sublime. 'Take Bath, and 20 miles round it', Benjamin West told Farington: 'There is not in the world anything superior to it. Rocks of the finest forms for a painter that he had ever seen, large, square forms. Quarries worked out, now most picturesque and romantic.'[5]

Ready for business, Thomas Gainsborough arrived to garner influential friends and clients and make some money. Philip Thicknesse, living in Bath, was ahead of him, ready and waiting to lead him about. Perhaps at Thicknesse's instigation 'Mr Gainsborough' is listed in the *Bath Journal* as arriving during the week of the opening of the winter 1758 season's balls, plays and concerts. Mr and Mrs Smollett — he the viperous novelist-reporter on British life and society — arrived in the same week. It was customary, as Susan Sloman points out, for people who wanted to say 'here I am' to register their presence in the town on arrival.[6] If we need assurance that this is indeed our friend 'Gainsborough de Ipswich' it can be found in a letter from William Whitehead, who

arrived the following month as companion to the Earl and Coun-
tess of Jersey, and who, as Poet Laureate and as a playwright, had
from time to time his plays performed in St James's Theatre in
Orchard Street.[7] Whitehead, a long-standing and trusted friend of
the Jersey family, was the tutor and companion to their son Lord
George Villiers. For years Whitehead had carried on a sparkling
correspondence, part gossip, part pedagogical, with another of
his pupils, Villiers' good friend and neighbour George Harcourt,
Viscount Nuneham. Whitehead, who was never more at home
than when surrounded by thespians, songbirds, minstrels and
artists, gave Nuneham news of the jollities in Bath, despite miss-
ing London dreadfully: 'I pant for Grosvenorshire,' he moaned.[8]

But he pulled himself together, given the good crush of London
society that now surrounded him in Bath. Other arrivals over
these weeks included the distinguished young naval commander

William Ensom, after Benjamin Wilson, *William Whitehead*,
published 1821.

Lord Howe and his wife, a bullish army colonel Philip Honywood, the Duke and Duchess of Dorset, and the jovial and companionable Yorkshireman Sir William St Quintin and his second daughter, Mary.[9] Whitehead really had no need to be so keen to get home. And nor need Thomas Gainsborough after his long journey, either: some of his Suffolk friends turned up too, the Muilmans, the Rustats, Lambe Barry and William Wollaston and his daughter, and his friend from London Robert Price.[10] Just like home.

It was a grand time to be in Bath: the King's seventy-fifth birthday fell on 10 November, and there were noisy and colourful celebrations. Bells were rung, cannons fired, and the city was illuminated with lights and fireworks in honour of King George II. There were balls and concerts, and, to raise money for the General Hospital, a performance of Handel's *Acis and Galatea* to enjoy.[11] Among the celebrities who Whitehead noted were passing through was the young musician Ann Ford: 'you would be desperately in love with her in half an hour, & languish & die over her singing,' he told Nuneham.[12] And a painter 'who takes the most exact likeness I ever yet saw'.[13] He adds that Villiers had sat 'only twice' to him – portrait painters generally needed more. But this painter was a quick worker: 'his painting is coarse and slight, but has ease and spirit'; and as to the likeness, well, it was perfect: 'it is he himself . . . The painter's name is Gainsborough'.

The host of Whitehead's party in Bath, and the man who paid Gainsborough's fee, was the 3rd Earl of Jersey, whose wife was unwell and had come to seek treatment. The Jerseys, of Middleton Stoney, north of Oxford, were near neighbours with the Harcourts of Nuneham Courtenay, south of Oxford. Both Nuneham and Villiers were on course for elevation, as in due time they would become the 2nd Earl Harcourt and 4th Earl of Jersey respectively. The task that Gainsborough had chosen to take on in Bath was to record fragments of the many dynasties that settled in front of him.

There was no better nor more contained a place in England to do such work than Bath, with its transient and captive population of the titled and rich, young and elderly. As well as Villiers he painted the 3rd Earl of Jersey himself, and, for that same family, copied or interpreted another artist's portrait of Viscount

Cornbury, a Jersey relation, lately dead. This was a rich seam for Gainsborough, and people came to sit for him, one after the other, straight away: William and Philadelphia Lee of Hartwell, near Aylesbury, paid him to paint their portraits, head and shoulders; Sir William St Quintin had one, perhaps two, of his daughters sit for him. Robert Price, and possibly other members of the Price family of Foxley, also paid for Gainsborough's attention. These were not Bath locals; all, like Gainsborough himself, were the incoming crowd. Such interest assured him of a fair wind, and soon convinced him that this was the place to be, and that he should live in Bath permanently with his family, setting up in business as a portrait painter. Gainsborough saw a good future for himself in Bath.

Having your portrait painted was the pastime of dozens of Bath visitors who chose the method and medium that best suited their purse: the scale rose from a tiny locket-sized portrait by one of the dozen or so miniaturists working in the town in the 1750s and 1760s, at a guinea or so, to a pastel by William Hoare, the best portrait artist in Bath until Gainsborough arrived. Hoare charged five guineas, unglazed. Other resident artists who would do head-and-shoulders included Edward Alcock, George Allen, William Hibbart and Thomas Worlidge.[14] Thomas Gainsborough was joining an already-crowded market. That his ability to catch a likeness, and his speed, so impressed Whitehead suggests that the others were much slower, and that he was far more interesting, accommodating and charming than they. Undoubtedly Gainsborough knew this too. Artists were allowed to set up examples of their work in the Pump Room, the heart of Bath's medico-entertainment complex, and this is perhaps where Gainsborough's first clients came upon him and noted his manner and prices.[15] Gainsborough was certainly opportunist enough to work that advantage, and to bust in on a settled commercial ecology like a rat on a tropical island.

Philip Thicknesse gave a quick sitting to Gainsborough, at Thicknesse's own bossy insistence, for a sample of work which would draw attention to his friend's presence in Bath. This is what Thicknesse described as 'a decoy duck': 'Business came in so fast, at five guineas a head', Thicknesse wrote, 'that though he did not

much mend in his colouring, or style, yet he was obliged to raise his price from five to eight guineas.'[16] It was far too early to say what he would charge for three-quarter or even full-length portraits in Bath.

There was another sighting of Gainsborough in Bath across these months, but one not published until fourteen or fifteen years later. The anonymous gentleman who was so impressed by his landscape paintings that he had tried to track Gainsborough down in Ipswich was persistent enough to travel on to Bath. He arrived in mid November 1758, and that first evening he was directed to Gainsborough's apartment, only to be told by his servant that the painter was not at home. But from somewhere in the building violin music wafted out: 'I'll swear if I heard a fiddle,' the visitor said. At ten o'clock the next morning, the visitor presented himself at the apartment again.

'There is someone sitting, sir.'

'Sitting! What, is he a portrait painter? When can I see him?'

'Not until the evening.'

The visitor would not be put off, and called again in the dusk. 'Please to walk upstairs,' said the servant.[17] And so the anonymous visitor and Gainsborough met at last. It is not clear who the visitor was – it may indeed have been Philip Thicknesse himself creating a narrative history years later – but the picture that the exchange draws is one of a busy professional, who relaxed with music, and who had found a lucrative and satisfactory way of life with portraiture, even if it denied him much opportunity to paint his landscapes. This report has the ring of truth, though it is dressed up and misleading. Growth in the portrait way did hamper Gainsborough's landscape manner, but he found, when he went outside, and got on a horse, and rode up Lansdown Hill, that he was now in a landscape which offered new ingredients and demanded a radically new approach to that prompted by his experiences in Suffolk. He also had to decide which of his two arts – portrait or landscape – would lead for him. Strong advice from his wife, queues of people wanting to have their portraits painted, his own intuition, and his children needing new shoes and stockings – all these were ingredients in making the decision a simple one: portrait painting was the thing.

The date on the receipt made out to Scott Thompson for *Love at the Well*, 9 May 1759, indicates that Gainsborough went home to Ipswich after seven months in Bath via Hatton Garden.[18] He must have delivered *Love at the Well* on the way, and at the same time got rid of his old Suffolk manner. There would be nothing with such a coy title again: it suggests that it is of the kind that Panton Betew bought from Gainsborough for engraving by Francis Vivares in the early 1760s.[19] These all had Gainsborough's name in large letters on the rubric, so he was also now to be reckoned with as a landscape painter, a name to be remembered. He had made his decision to move to Bath, and in due time the following advertisement appeared in the *Ipswich Journal*:

> To be sold, opposite the Shire Hall, Ipswich. On Monday and Tuesday next, the 22 and 23 inst [October 1759]. All the HOUSEHOLD GOODS of MR THOMAS GAINSBOROUGH, with some PICTURES and original DRAWINGS in the Landskip way by his own hand, which, as he is desirous of leaving them among his friends, will have the lowest prices set upon them. The house is to be let immediately. Enquire of Mrs Elizabeth Rasse, Ipswich.[20]

Released from his chattels in Ipswich, released too from early work that he was now putting behind him by sale or gift, Gainsborough went west, and took his family with him.

Thicknesse and Gainsborough walked around Bath together looking for somewhere for the painter to work, and for him and his family to live. That, at least, is what Thicknesse claimed. He kept Gainsborough under his wing, well protected, and when they arrived he gave the family a temporary roof over their heads. 'I accompanied him in search of lodgings, where a good painting room as to light, a proper access, &c could be had.'[21] Thicknesse knew Bath well; he had lived there across the winter seasons for twenty years, or so he said, and had made himself an influential and important social figure in the town. He does not give a date for the house-hunting expeditions, and he may be conflating the two periods, winter 1758 and winter 1759, by which time Margaret and the girls had arrived, and Margaret was 'impatiently waiting' for results.[22] Gainsborough told her that he had found

lodgings 'in the church yard' for £50 a year which would suit them well. 'Fifty pounds a year, Mr Gainsborough! Why, are you going to throw yourself in gaol?'

They had only been paying £11 a year in Ipswich,[23] and Margaret feared, according to Thicknesse, that the Bath rent would have to come out of her annuity, a remark that indicates that even at this relatively early date in their association Thicknesse knew all about the family finances, and he may not have been alone. Bath was expensive – the property in the churchyard was the kind of lodging that a temporary visitor to Bath might take, and even that was nearly five times the price of Ipswich, and offering much less for the money. House prices and rents were hiked to abnormal market levels, and £50 a year, thought Margaret, would be ruinous and money down the drain.

Thicknesse then set out an alternative: take a whole house at £150 a year, and make some income by letting out rooms. He added that if Gainsborough did not do that, he would: there's money to be made. This must have struck the same business sense in both Thomas and Margaret Gainsborough that had already drawn them to the conclusion that portrait painting was where the money was for an artist. Thicknesse may have had a particular property in mind, one bang in front of the Abbey, on the way to the baths. Perfect. So Margaret's 'alarms were moderated', as Thicknesse expressed it: she could see a good deal when presented with one. On 30 May 1760 Gainsborough signed a seven-year lease on a brand-new house, far more than he could easily afford, and far grander than his incomer-artist status would warrant. It was in the centre of town, and had only just been built to the designs of John Wood the Elder, Bath's entrepreneurial developer, as part of a new development owned by the Duke of Kingston beside the Abbey. They may have read about the new development in the *Bath and Bristol Guide* before they left Ipswich, that the former Abbey House, 'a very old structure', had been demolished by the Duke of Kingston 'this summer [i.e. 1755] in order to erect more commodious buildings'.[24] Like a family of cats jumping off a ledge, the Gainsboroughs had landed on their feet.

Gainsborough would not have much difficulty in letting rooms. Within two years his tenant on the ground floor, opposite his

showroom, was his recently widowed sister, Mary Gibbon the milliner, who used it as a shop for her business.[25] Brother and sister seem to have bided their time: another milliner, Miss Barnes, was in business nearby, behind the Abbey in Wade's Passage. When she sold up to a saddler in December 1761, Gainsborough and Gibbon seized the opportunity, and Mary moved in.[26] Not only was the house close to the Abbey and baths, but it also had a public passageway along its southern side, wide enough for pedestrians and sedan chairs to pass through. It was decidedly convenient for all amenities, and could really not be better.[27]

This was not, however, where artists lived. The surroundings of the Abbey was a quarter for retail in the luxury trade, and expensive lodgings for visitors. William Hoare had been in Bath for nearly twenty years, and lived in a much duller apartment in Edgar Buildings on George Street. Others such as the sculptor Giuseppe Plura, and actors and singers, lived in the streets around Pierrepont Street, nearer the river and the theatre. The Abbey Street house had the bulk and grandeur that many of Gainsborough's clients might recognise as on a par with their own great piles, or aspire to. Its three-storeyed ashlar façade was asymmetrical, with eight bays, and an off-centre arched front door counter-balanced by the slightly larger arched entrance to the passageway from the baths on the left.[28] It was so grand: add a set of columns and it would practically have a 'palace front'; the pediment had Kingston's coat of arms carved into it. Up three or four stone steps, through the front door, was a hall ten feet wide, with a flight of stairs directly ahead. To the right and left were generous rooms, each almost square, and each about twenty or twenty-two feet wide. While there were matching rooms on the first floor, that is where the similarity of Gainsborough's house to his clients' grand mansions ended: his was only one room deep, it had a kitchen range in the basement, and bedrooms on the second and third floors. While its rooms were generous enough in size for Gainsborough's professional purposes, the house was in fact not much more than a façade, and not nearly as grand as it looked. Nevertheless, it really was something in scale, position and effect after Foundation Street, Ipswich: and it was shining bright and new, with modern equipment, 'completely fitted up with locks and

keys to all the doors, fixed grates in all the chimneys, a boiler and a copper, and the rooms of the first and second floors and the front parlour hung with paper, and a smoke jack in the kitchen chimney'.[29]

Gainsborough now had to set out his stall: he may very soon have put up a large signboard, reading something like 'THOMAS GAINSBOROUGH, Painter'. This was what artists in Bath did; Thicknesse hated the practice, thinking it was suited only to 'hairdressers, milliners and mountebanks'.[30] He was nevertheless ever ready, ever leaping to Gainsborough's side with career advice. Nothing was too much trouble. He gave his friend an old painting he fancied, a 'portrait of a little Spanish girl painted upon copper, with a guitar in her hand, and a feather in her hair'.[31] Then Thicknesse sat for the 'decoy duck' portrait, 'but the first sitting (not above fifteen minutes) is all that has ever been done to it'.[32] For a while Gainsborough's quick portrait sketch of Philip Thicknesse, now lost, if it ever existed, must have hung in Gainsborough's showroom for people to see. They loved his painterly verve and attack, and the 'roughness of the surface' for which he was also criticised.[33] Thicknesse hype notwithstanding, we know that Gainsborough had been an accomplished portrait painter for years already. His old friends including Lambe Barry, the Rustats, William Wollaston, and Robert Price and his father, Uvedale Tomkyns Price, kept him going with work and encouragement, and Villiers, the Lees and St Quintin discovered him in Bath for themselves early on. Many new clients, intrigued by his manner and charm, soon came to sit: the Hon. Benjamin Bathurst, Barbara Mostyn, Robert, Earl Nugent (twice), William Poyntz, and a hard-to-please and demanding couple, the Byams.

The problem Gainsborough faced in Bath was that he was an incomer. The city had a tight circle of locals – the medical profession, the people running the Pump Room and the rival Assembly Rooms, the civic grandees in the Town Hall. It seems to be the case that the client base from which Gainsborough drew his customers was also largely made up of incomers, the health-tourists who kept the doctors and the apothecaries employed, the actors and musicians who entertained them, and those out looking for a good time. However, of the visitors who arrived in the same months

of Gainsborough's first venture to Bath, some, including the Howes, Col. Honywood and the Dorsets, would come to remember him. Gainsborough was now hemmed in by two very strong personalities, Thicknesse and Margaret, both giving probably contradictory advice. No doubt Molly and Peggy, now ten and eleven years old, stuck their oars in as well. When Allan Cunningham came to write his own brief account of Gainsborough's life, first published in 1829, his primary sources of information would have been the elderly Molly and Peggy. From their evidence he distilled the following: 'As [Gainsborough] began to assert his own independence, the esteem of [Thicknesse] subsided, and the vain friend became the avowed enemy.'[34]

It must therefore have been a relief for Gainsborough to go to his painting room and observe other personalities captive before him, paying for the privilege.

21. That fluctuating city

In that hypochondriac age most visitors made journeys to Bath for health and cure:

> As we all came for health, as my body may say,
> I sent for the doctor the very next day.[1]

Some, however, came just to look. In 1735 Peter Muilman, whose brother Henry would commission Gainsborough, had stopped off in Bath with his father-in-law, Richard Chiswell, on their tour of England. They thought little of the waters; they were both Turkey merchants, and had seen better waters in Turkey: 'What is remarkable in Bath is a fine Square there built of Stone. The Waters I don't mention, & I have seen them in much greater Quantity at Bursa.'[2]

The young Lord Royston, a visitor in 1763, was reserved about his initial experiences. He came to Bath for the waters, and within weeks he would be painted by Gainsborough. He set the scene writing to his father, Lord Hardwicke, Lord Chancellor of Great Britain, a political colleague of another of Gainsborough's clients, Richard Lloyd: 'We change our habitation tomorrow ... Our present Lodging is in a confined & noisy Part of the Town; the other is quiet & airy, & will improve every day, as the Season advances.'[3]

Commodore Richard Howe, Viscount Howe, who had already been in Bath during Gainsborough's first few weeks there, came again with his beautiful wife and their daughter to Bath in 1763 to find a cure for gout, and rediscovered Gainsborough. Colonel Honywood, by now General Philip Honywood, also came back to Bath in the middle of the 1760s and commissioned Gainsborough. These – Muilman, Royston, Howe, Honywood – were the wealthy upper, merchant and military classes on whom Bath thrived. Gainsborough thrived on them too: big fleas and little fleas; big fees and little fees follow. The services in the town were

reassuringly expensive, but there were nevertheless dark under-
currents. It took William Whitehead to reveal the true situation
in 1759. The Jerseys' party had come both for treatment for the
Countess, and for the others to have a good time. They did not,
however, reckon on a serious health scare. In Chelwood, not ten
miles from Bath, a sexton, exhuming the body of a villager who had
died of smallpox thirty years earlier, accidentally broke the coffin,
and the ensuing 'most nauseous stench' affected those gathered
around the grave. Fourteen people went down with the disease
within days.[4] In Marlborough, thirty miles away, smallpox killed
many more.[5] This held natural terrors for all, and the authorities
in Bath tried to keep the infection quiet: there is no hint of it in
the *Bath Journal*, the surviving General Hospital records, or the
Bath council minutes, except for the note that two years earlier
the Bath Council had banned the practice of inoculation within
four miles of the city.[6] Rumour, however, like disease, will travel,
and Whitehead reported on it: 'Young Mr Fermor . . . has the
smallpox here . . . Tomorrow or next day are looked upon as the
critical days of the distemper . . . Both the smallpox and measles
are very here, tho' they endeavour to conceal it.'[7]

William Whitehead had travelled in 1754 with Villiers and
Nuneham through Europe on the Grand Tour. Whitehead's
letters to Nuneham are direct, loquacious and a touch tetchy,
and as a whole throw a bright light on life in Bath in the 1760s,
and on the fluctuations of the city flowing on around and about
him:

> I am settled at Bath in the most quiet of Lodgings, have a
> dining room, Bedchamber, & room for a servant, without a pos-
> sibility of having other Lodgers taken in to the House. I have
> every thing handsome about me, in a small way, and, thanks
> to my Servant's abilities, breakfast, dine, and sup at home very
> comfortably.[8]

A week later:

> My Bath Life continues still agreeable . . . I lodge in the house
> of a miniature painter, who has a daughter that is a miracle. Her
> drawings are greatly admired & she gets premiums every year

from the Arts & Sciences . . . They know I have been in Italy, I must therefore be very cautious of exposing my ignorance in the <u>fine arts</u>. I have forgotten all the terms, but hope by means of a judicious reserve, & a little obliging admiration to come off tolerably.[9]

This may have been the house of William Hoare, the highly successful Bath portrait painter, whose daughter, Mary, had won the first prize at the Society of Arts in London for 'a lady under sixteen' in 1760. She subsequently exhibited there regularly. Hoare was not technically a miniature painter, but this may be a misunderstanding on Whitehead's part.

A year later Whitehead is back in Bath, this time staying with a musician, with whom he talked 'as wisely, & as cautiously, upon music, as I did last year upon painting'.[10] The following year, 1768, he is somewhere else again: 'I am lodged in the Market-Place, have a spacious first floor, & can chuse my dinner from the windows of my best room, & the sauce to it from my gallery, which looks into the herb market . . . I am in that best of situations, alone in a crowd.'[11]

It was all good, noisy, fluid fun, offering the kind of jollity and engagement that would in centuries to come transfer to the seasides of Britain and to the resorts of the Mediterranean. People chopped and changed in their choice of lodgings. While regular visitors changed their places in the city, Bath itself was also changing as property developers, notably John Wood the Elder and his son, John Wood the Younger, rushed to cater for the incoming trade.

In *The Expedition of Humphry Clinker*, published in 1771, Tobias Smollett observes the city's rapid evolution:

One sees new houses starting up in every out-let and every corner of Bath; contrived without judgment, executed without solidity, and stuck together with so little regard to plan and propriety that . . . they look like the wreck of streets and squares disjointed by an earthquake . . . they are built so slight, with the soft crumbling stone found in this neighbourhood, that I shall never sleep quietly in one of them.[12]

That is rather as Gainsborough had seen it. He told a client in 1767 that

> I believe Sir it would astonish you to see how the new Build-
> ings are extending in all points from the old center of Bath,
> The Pump Rooms. We almost reach Landsdown & Cleverton
> Down, north & south, but not quite to Bristol & London for
> East and West. I think verily the End of some of our <u>Master</u>
> Builders will be to meet some of their Marylebone Friends near
> a certain Ditch.[13]

Gainsborough pointed out that these were not owner-occupied houses, but ones built for the buy-to-let business: 'The Lodging-House <u>Cats</u> are endeavouring to draw more Talons upon us, by having Houses in all Quarters.' He was a 'Lodging-House Cat' himself, let's not forget. Of course, still people came. Through his character Jery Melford, Smollett notes: 'Here we have minis-ters of state, judges, generals, bishops, projectors, philosophers, wits, poets, players, *chemists, fiddlers* and *buffoons* . . . all degrees assembled in our public rooms, without distinction of rank or for-tune . . . a vile mob of noise and impertinence, without decency or subordination.'[14] Smollett's 'vile mob of noise' was the crowd that Whitehead was content to be alone in.

The city council's minute books reflect the increases in the cost of leases and ground rent, and the enthusiasm with which Bath residents went in for speculative development.[15] In the mid 1760s the prices were generally doubled from mid 1750s levels. We can still see fragments of these property speculations on the streets of Bath today: not just the larger developments such as Edgar Buildings, but examples of quick, smaller-scale individual opportunism. The house on the corner of Monmouth Place and Little Stanhope Street, a storey higher than its neighbours, may be one such example of providing accommodation for visitors such as Whitehead and his friends, and the heightened corner of Broad Street and Broad Street Place may be another. Bath had a new Guildhall (built in the late 1720s), a new General Hospital (opened 1742) and by the 1750s five hot and cold baths filled from the natural springs, from the King's Bath and Queen's Bath, to the Leper's Bath, 'which is not so much frequented as the others

are'.[16] At the Pump Rooms, shrouded by a mixture of steam and black coal smoke, and to the rich and reedy sounds of the bands of musicians, 'often several hundred ladies and gentlemen [are] there at one time who make a very splendid appearance'.[17] Later on in the day they would progress to one of the large Assembly Rooms by the Pump Room, Wiltshire's or Simpson's.

Across the years of Whitehead's later visits, the city provided a rich source of clients for Gainsborough as he worked in his painting room with his 'shew room' or picture shop downstairs on one side, and his sister making hats and selling fine clothes and lace and frills in her millinery business on the other. Smollett's 'vile mob' and Whitehead's 'crowd' provided Gainsborough's source of income. When the grander visitors arrived in Bath, the peal of eight bells rang and the band struck up. The Abbey bells were 'generally caused to be rung when the nobility and gentry arrive', as the 1755 *Bristol and Bath Guide* reported,[18] but you had to pay a handsome fee to the ringers to have them rung for you. There will have been times when the Abbey bells and the bells of the nearby St James's Church never seemed to stop, filling Gainsborough's brain with noise and clangour. Whitehead spotted a gradually changing demographic. Whereas in the early 1760s these were the Harcourts, the Villiers, the Lees, the Prices, the St Quintins, the Roystons, the Howes, and so on, now it was the Blunderheads from up north, and John Richardson from Oxford, with his observant niece, Dorothy. Whitehead gave Nuneham his gossipy opinion that in April 1767 'there are the fewest people of Quality here that I think I ever remember in so full a season'.[19]

The satirical writer Christopher Anstey spotted the practice, and reported the reaction of his colourful character Mr Blunderhead:

> I thought like a fool, that they only would ring
> For a wedding, or judge, or the birth of a king;
> But I found 'twas for *me*, that the good-natur'd people
> Rung so hard that I thought they would pull down the
> steeple;
> So I took out my purse, as I hate to be shabby,

And paid all the men when they came from the Abbey;
Yet some think it strange they should make such a riot
In a place where sick folk would be glad to be quiet;
But I hear 'tis the business of this corporation
To welcome in all the *great* men of the nation.[20]

That was a joke, of course, but in real life even tutors, if they were regular enough, were welcomed with a tune of one kind or another. Whitehead was proud to report that: 'Mr Derrick the Master of the Ceremonies has done me the honour to take notice of me; I feel some vanity on that subject. The music congratulated my arrival with a very pretty minuet.'[21]

Whitehead was the kind of visitor Bath loved, a returner. He notes the superficial chaos of the city: 'we abound . . . in numbers, & a crowd of strangers is no unpleasant thing to a looker on'.[22] But despite that, there was a strict organisation to the facilities in Bath, and a professional way of managing the crowds and their entertainment, led by the Master of Ceremonies, or 'King of Bath'. For much of the 1760s Samuel Derrick was the King of Bath, having succeeded the charismatic operator, and founder of the role, Richard 'Beau' Nash. These men, with their roving eyes, their sparkling features, and their way with the ladies, personified the vibrant and vivid tides that ran through the city, and kept everybody smiling and busy enjoying themselves. When Derrick died after a long-drawn-out process in 1769, Whitehead was there to witness the scene: 'The little King of Bath died this morning, after being expected to die every hour for this month past. The whole Bath world are at the rooms & the town hall, raving & squabbling about who shall be his successor.'[23] And 'raving and squabbling' there was: groups of rival supporters tore each other's wigs off, hair down, rouge smeared and so on; shocking. This was the Battle for Bath, hooliganism long before that word was coined, but in the end Captain William Wade won the title.

One later Bath visitor who took the waters, which she described as 'very pleasant, clear, soft, & warmer than new milk', was Dorothy Richardson, in town in May 1770 from Oxford with her uncle. She hugely admired the new 'King', whose noble portrait

Gainsborough painted in 1771 and gave to the New Assembly Rooms where it still hangs.

> The Room was crowded, & the company elegantly dress'd; Captain Wade the Master of the Ceremonies appeared there with his Badge; which was hung round his neck by a Broad Blue Ribbon, & look'd very elegant . . . On a Sunday Night the company meet to drink tea, & walk about. On all other nights they play at cards, except on Ball nights.[24]

Dorothy gave close attention to the Master of Ceremonies, but was attentive also to the day-to-day life of the city. She was transfixed, for example, by the variety of fish on offer in the market, a real indication of Bath's vibrant commercial life, and an acknowledgement that only the best would do. Like the people who came to take the waters, the fish were rich and various, and demonstrate the extent of mass-catering that Bath generated under the eyes of council officials such as the Supervisor of Fish and Flesh, Ale Tasters, and Supervisors of Leather. 'Fish common in the Market at Bath', she wrote, were

> Turbot; Maids; Thornbacks; Scales; Sole 2 sorts; Place; Whiting; Jack a Dory; Brill like Turbot; Grayling; Herrings; Red white & grey Mullets very dear; Chard, like Trout; Flounders; Salmon; Smelts & Sprats; Mackerel; Lump Fish; Eels & Lampreys; Gurnet, Red & Grey, very hard heads; Fresh Sturgeon; Cod & Haddock brought from London; Sea Perch; Sea Crayfish; The Piper; Sand Dabs like Soles; Lobsters; Crabs; Shrimps; Prawns; Escallops; Oysters; Cockles; Muscles [sic]; Periwinkles; Crawfish; All sorts of fresh water fish.

William Whitehead and Dorothy Richardson were sensible and accurate in their observations. Smollett's ice-cool reportage, however, cuts into the thin veneer of Bath and reaches for the entrails inside. There were myriad overlapping circles in Bath: the baths and the assembly rooms where company gathered, the King of Bath who tried to recognise everybody and keep everybody happy, and, what might have been for some the best thing about Bath: the coach to London. All shades of commerce were there, from the priciest of hairdressers to panniers of coal

delivered to your door on the backs of the dozens of colliers' don-keys that plied the city's streets.[25] There was even a sex therapist in town, Dr James Graham, a Scots physician who had pioneered his therapy in Pontefract, Philadelphia and New York. There was music always, choirs and concerts, two theatres, dozens of chapels, peripatetic lecturing, and the literary and intellectual life which spawned the musicians Abel, Bach, Ford, Giardini, the Herschels, the Linleys and Tenducci, actors such as Garrick, Henderson, Quin and Siddons, and writers such as Sheridan and Whitehead. What was performed in London would soon appear in Bath – and vice versa. Science was there – or soon would be, at its most advanced when William Herschel gave up playing the organ at the Octagon Chapel in Milsom Street in 1777. He moved with his wife, Mary, and sister Caroline to New King Street to apply his genius to astronomical discovery. Gainsborough touched most of these worlds, had a high old time, and made a lot of money. Bath was no different to any smart twenty-first-century city, but calibrated to the eighteenth. As in London, New York or Sydney today – if you wanted it, then you could get it in Bath.

Christopher Anstey, on the other hand, made public fun of Bath visitors for the general enjoyment of the many. His Blunderhead family were hugely excited when they arrived in Bath for the first time:

> We are all a wonderful distance from home!
> Two hundred and sixty long miles have we come![26]

Anstey was a highly accomplished, literate, intellectual and amusing Bath visitor. He was a poet, philanthropist and father of ten from Trumpington, Cambridgeshire, who first came to take the waters at more or less the same time as did Gainsborough himself. At 260 miles the Blunderheads had clearly come from far further afield than London or Cambridge, so they were prob-ably north-country people, sitting ducks for the effete humour of the metropolitan sophisticates. Anstey mercilessly satirises them in his *New Bath Guide; or, Memoirs of the B[lu]n[de]r[hea]d Family: in a series of Poetical Epistles*, first published in 1766. The jaunty, popular verses were a parody that clearly touched a

chord, and a reflection of the attitudes and behaviours of many of those who patronised Gainsborough. Anstey parodied Cornelius Pope's semi-official, and serious, *New Bath Guide*,[27] the *vade mecum* that everybody, including these Blunderheads, carried as they came rollicking on to the scene with their demands for medication.

And what demands they were: Bath visitors gave themselves licence to be overwhelmingly body-ish, far more so than they ever might have allowed themselves to be back home:

> He determin'd our cases, at length (God preserve us!);
> I'm bilious, I find, and the women are nervous;
> Their systems relax'd, and all turn'd topsy-turvy,
> With hypochondriacs, obstructions, and scurvy,
> And these are distempers he must know the whole on,
> For he talk'd of the peritonum and colon,
> Of phlegmatic humours oppressing the women,
> From feculent matter that swells the abdomen;
> But the noise I have heard in my bowels like thunder,
> Is a flatus, I find, in my left hypochonder.

Among the physicians who attended the Blunderheads and others were Abel Moysey, Rice Charleton, Ralph Schomberg and Philip Ditcher. Gainsborough would consult each of them for himself and his family, and each had wide city practices that drew grand fees from the grandees. Make money they did: Rice Charleton, the physician at Bath General Hospital, owned a large house in Gloucestershire, a town house in Alfred Place, Bath, and collected pictures. Ditcher was the General Hospital's surgeon, and a property developer who went into partnership with an apothecary, William Gallaway, to develop a site near the Abbey.[28] Moysey, another physician at the General Hospital, was described by Parson Woodforde as 'high and mighty but sensible'.[29]

The career of Ralph Schomberg (Pl. 42) demonstrates how open to abuse, and how easy to break into, the medical profession was in the eighteenth century. Schomberg seems to have had as many adventures as Philip Thicknesse in his early life: a failed medical student in Germany, a failed notary in London, a bouncer of cheques as a tutor in Barbados when he had to leave the island.

Nevertheless, when he came home he married a rich ropemaker's daughter from Wapping, and embarked on a medical degree by correspondence with Marischal College, Aberdeen. How 'hands on' this distant medical course was is impossible to know. Schomberg came to Bath in January 1761, moving his practice there from Great Yarmouth, and set about making money.[30] While he had additional but unsuccessful ambitions as a playwright and poet, Schomberg built a lucrative medical business among the ailing visitors to Bath, and Gainsborough became a patient. The painter's gratitude was such that Schomberg became the subject of one of his finest portraits, acquired by the National Gallery in 1862. Schomberg had a particular love of money, and was once found to have had his finger in the church collecting plate, as a Bath resident reported in 1777:

> Lawyers have been noted for cheating; but what shall we say of a physician at Bath, Dr Schomberg, who was appointed last Sunday to hold the plate for charity at the Church door, where a large collection was expected for the Hospital, and was detected by several persons in stealing the money? Above seven pounds in guineas and half crowns were found in his coatpocket, when he was charged with the fact. Yet this man, who was base enough to attempt this uncharitable fraud, married a woman with eight hundred a year, I am heartily sorry for her and their family: He has left Bath, and must hide his face for ever.[31]

Bath was a secular Well of Bethesda, with magic, mystery and not so much effective medicine attached, a place of pilgrimage for the healing of the temple of the body. Where the well-heeled sick gathered, physicians were there to greet them. Thicknesse listed ten physicians, nine surgeons and twenty-two apothecaries working in Bath in 1778.[32] The physicians had plenty of work to do, but much of it was caused in Bath to sick visitors just by being there. Their patients might have been less ill if they had stayed at home. On rainy days sedan chairs 'stand soaking in the open street, from morning to night, till they become so many boxes of wet leather, for the benefit of the gouty and rheumatic, who are transported in them from place to place'.[33]

Being set so deep in its valley, air in Bath was apt to stagnate: 'there is hardly to be felt such a thing as a stiff breeze.' In the summer, out of season, the air was filled with the chalk dust thrown up by animals and traffic, and in the wet and cold of winter it became 'a deep mire'.[34]

Lord Royston came to Bath to find a cure for his stomach complaint: 'The Waters do not disagree with me; but I have not yet taken them long enough to judge . . . I have felt more of the uneasiness in my Stomach, than I have done for the last Fortnight at least. Dr Moisy [sic] says that out of 5 cases that appear to be the same, the Bath waters will cure 4 & miss in the 5th witht his being able to account for the difference.'[35] After nearly a month of Dr Moysey's treatment, Royston was unable to report any real success, but no doubt he was obliged to shell out a guinea a consultation:[36] 'I cannot say that [the waters] have yet removed the Complaints for wch I was advised to try them . . . Dr Moisy has offered me a draught by way of Bracer & I ride as others as often as the Weather permits, so that it will not be my fault if Bath does not set me up again.'[37]

However it was – through the efficacy of the waters, good nursing, modest medication or luck – people did pull through. But nevertheless many remained sceptical of the doctors' ministrations and their cost. Indeed, Gainsborough came to make a gossipy allusion to Lord Royston about Moysey's cupidity: 'Dr Moisy has had a severe fit of the Ague, and (as I am told) says he should make himself very easey with the loss of the Money if he could get rid of the Ague. But whether the loss of the Money might not bring on a shaking fit that form'd itself into an Ague I must leave.'[38]

Among the myriad performers who came to Bath to entertain and to make a living, one in particular stood out in the early months of Gainsborough's residence. This was the twenty-one-year-old Ann Ford, Philip and Elizabeth Thicknesse's tall, elegant, bewitching friend and lodger. She was with them in Bath in flight from her controlling father, Thomas Ford, a lawyer who had for some years promoted Ann by staging her Sunday concerts in his London drawing room. Ann sang, danced and performed her own music on the viol da gamba and guitar. She was an extrovert, a

bombshell, and had a tendency to direct expression, and to do exactly what she wanted. It was well remembered that at a dinner party given by the influential convert to Methodism, Selina Hastings, Countess of Huntingdon, Ann could not contain herself when the Countess recited a long and excruciating 'methodistical grace, with strange intonations' and rolling eyes. Everybody else looked at the floor and the ceiling in embarrassment; the footmen faced the wall, trying desperately not to laugh. Ann Ford, on the other hand, 'actually *tittered* aloud', to the mortification of her father. As a penance to Lady Huntingdon, Ann settled down and set the Methodist hymn 'All ye that pass by' to music, which was widely sung then, and still is.[39]

Ann Ford's impetuous nature, her desire to perform on public stages, and her coming of age in February 1758, put her beyond her father's control. He had persistently tried to have her arrested when she dared to perform publicly in London, and so she left home for Bath, where, staying with the Thicknesses, she prepared for her musical engagements. Dozens fell for her, as dozens had in London, Whitehead among them. In the same letter of November 1758 in which he first referred to Gainsborough, he told Nuneham: 'I have seen Miss Ford, nay almost lived with her ever since I have been here. She has a glorious voice, & infinitely more affectation than any Lady you know. You would be desperately in love with her in half an hour, & languish & die over her singing as much as she does herself in the performance.'[40]

Three weeks later, he wrote, 'Miss Ford is still here, but leaves us next week.'[41] Then, in an inspired move, Whitehead tried to manoeuvre Ann Ford into marrying Nuneham. Just one little obstacle: 'She is unfortunately in love already . . . but [he] having a wife & three children and what is still worse, being at present on an expedition in Senegal, we are in hopes we may prevail.'[42]

It must have been in these few autumn weeks that Gainsborough first met Ann Ford at the Thicknesses, and hatched a plan to draw some pencil studies in advance of a portrait. As Whitehead had discovered, painting was 'her most favourite amusement', so no doubt she would be game.[43] The portrait would not be for

sale, but would be kept as an advertisement and displayed for their mutual benefit in Gainsborough's showroom, and empower Gainsborough's big leap into Bath fame (Pl. 33). We shall come to this. The plan has Philip Thicknesse's fingerprints all over it.

That we can collect together so many disparate accounts of Bath from people who had already had, or very soon would have, some brush with Thomas Gainsborough, suggests that even before he had taken a final decision to settle there, Gainsborough had a sense that things would turn out all right. The friable connection he had through his wife to nearby Badminton will have been of no consequence, indeed potentially damaging if roused. The 5th Duke, still a minor, had inherited the title by now, and was unlikely to embrace his late uncle's illegitimate daughter, who, each year, was draining £200 from his estate's income. On his own account Gainsborough had made, in London, the link with the Prices, who had their own Beaufort connections. Indeed, Robert Price may have been one of the means to his introduction to Margaret Burr in the first place.

Though Bath may have initially been *terra incognita* to him, there was additional coincident advantage for Gainsborough by living in Somerset. With their great collections, the fine houses in the region – Wilton, Corsham, Bowood, Longleat, Stourhead, as well as Badminton – were ripe for visiting and studying, and their owners were all potential clients. Bath itself was also a vibrant place to see old master paintings, as Whitehead reported on the collection formed in Bath by Daniel Webb, the author of *An Enquiry into the Beauties of Painting*, published in 1760: 'I was much entertained the other morning with a very good copy of the famous Correggio picture at Parma. Mr Webb, whom we saw in Italy, is in possession of it. He has likewise a Holy family by Julio Romano touched up by Raphael, which is very fine. You must never pass thro' Bath without seeing them.'[44]

When he ran out of steam in Ipswich, it was the west of England that drew Gainsborough, and not London, where he was still remembered, and where he had had such early *succès d'estime*. There were already quite enough portrait painters in London. With a hop and a skip, leaping over the metropolis, he was attracted to the fresh fields and pastures new of Bath, knowing that

he had the skills required to milk and please the city's visitors. He could do it on his own account; he did not need the patronage of his wife's semi-detached, uninterested and uncommunicative family.

22. The nature of my damn'd business

Gainsborough's mission in Bath was his own professional advancement in the exercise of his art, the balancing of his accomplishment in painting and music, and the assurance of his family's security and prosperity: in an order of importance that was probably circular. Whether the painter liked it or not, Philip Thicknesse considered himself to be Gainsborough's guide, philosopher and friend, at least at his introduction to professional practice in Bath. It was under this baleful influence that he began his breakout from being the provincial painter 'Gainsborough de Ipswich' to becoming a leading spirit of the age. From a whimmy creative who could not really decide whether he was a musician or a painter, Gainsborough grew from his first openings in Bath to become a man focused and alert to the main chance, even though this left ragged edges, lost opportunities, and a sense of casualty that only hard work, fancy footwork and special endeavour could put right.

Finding relaxation and escape as a landscape painter was also now becoming increasingly necessary for him, for while he had perhaps been uncertain which way he should direct his energies when he lived in Suffolk, and had been as well known there for landscapes as for portraits, in Bath, now, he was in business as a portrait painter. Across his Bath years, 1758 to 1774, he painted more than three hundred portraits, in sizes ranging from the twelve feet by eleven of General Honywood, the eight by eight of the Byam family, via eight-foot-high full-lengths of considerable grandeur, to modest bread-and-butter head-and-shoulders. Such variety of scale was not so unusual in, for example, the careers of Rubens or Anthony Van Dyck, who had populous workshops, and came from a different era of princely, ducal and religious patronage and requirement. A painter of portraits to a transient population in the eighteenth century, when the work was paid for and taken away immediately, had a different production

model. Gainsborough's subject range embraced monarchs and mistresses, dukes and duchesses, lesser peers and judges, actors, brewers, musicians, physicians, painters, soldiers and politicians. Looking across his entire career, he painted self-made wealth, inherited wealth and the wealth of creativity, but there is nevertheless a severe gap in his portfolio: he did not do writers or those who might broadly be called intellectuals. While he came to own marble busts of Rousseau and Voltaire, there is no Smollett or Sterne, Gray or Goldsmith, no Fielding in his oeuvre. Given his particular fondness for actors and musicians, and painting his family and friends, the absence of writers, or intellectuals such as Edmund Burke, Charles James Fox or Dr Johnson, suggests deliberation and choice. It also suggests manoeuvring by other portrait painters such as Reynolds, more concerned than Gainsborough to score with that branch of society. Either the intellectuals kept clear of him because they thought him too flippant, empty-headed or unpredictable, or he did not encourage them to sit for fear of having to engage in heavy-going discussion. Likewise with writers, though it follows that an artist who 'was not a man of reading'[1] might find it difficult to work with some of the finest wordsmiths of the age for fear of having to discuss their latest book. Happy though he was with musicians, such as the Linleys, Tenducci, Abel, Bach and Fischer, he did not paint that excellent organist and composer William Herschel or his sister Caroline. The Herschels were gentle, charming, open people, but perhaps too prone to scientific talk to be attractive to Gainsborough. The Herschels were rare birds indeed, and this brings another point to bear: the dominant accents Gainsborough heard in his circle, out of the mouths of his closest friends, were French, Italian and German. This lent an exotic touch to the way he led his life, and subjected him to a rich and unusual mix of social influences.

One gets the sense that, increasingly over the years, the locals did not much like Gainsborough: too grand himself, too presumptive, he comes to Bath from the farthest east, pretty well unknown, takes the grandest and most central of houses, and creams off the richest visitors. Then, later on, he takes another grand house up Lansdown Hill, then another in the King's Circus, practically

next door to the Duke of Bedford. Not for Thomas Gainsborough the cheaper places like Edgar Buildings or the other little streets down by the river. Then he consorts with singers, musicians and actors, doesn't contribute to the life of the city like William and Prince Hoare, who are both regular visitors to the General Hospital, and doesn't subscribe to the New Assembly Rooms. He gives a portrait of William Wade to the Assembly Rooms, but insists on being paid for the frame. And then he's always going off to London – and that woman he's married to, with her airs and graces and claims of nobility! He's only a face-painter, for goodness' sake.

Gainsborough's range of scale, and the quantity of his full-length portraits – that is, those of eight or nine feet high – reflects another kind of cultural shift: the burgeoning of building and remodelling of houses across the country for the rich and influential. Gainsborough painted more than 140 full-length portraits, for perhaps one hundred clients across his career, and while only a handful were for royalty, the others reflect something of the extent of country- and town-house building, the construction of town halls, hospitals, assembly rooms and other public amenities, the rise of the professions, the extent of social mobility, the perceived obligation of dynastic continuity, and individual pride in riches, achievement and marriage. It also demonstrates the unrelenting physicality required of him in his work. The nation was expanding in industrial, financial and political influence in the mid and late eighteenth century, and, as the careers of so many portrait painters such as Copley, Cosway, Downman, Hayman, Hickey, Hoare, Hogarth, Hone, Hoppner, Hudson, Kauffman, Kettle, Liotard, Mercier, Opie, Raeburn, Ramsay, Reynolds, Richardson, Wright, Zoffany, as well as Gainsborough himself, demonstrate, so was the art and business of portrait painting. Others noticed this: André Rouquet noted critically in his *L'Etat des Arts en Angleterre*, published in an English edition in London in 1755, that the successful portraitist assumes an 'air of importance and superiority over the rest of his profession', and thinks of 'nothing but monopolising the whole business'.[2]

William Hoare, the portrait artist of reputation, quality and esteem when Gainsborough arrived in Bath, was twenty years

older than Gainsborough, and had built up his successful city practice since he first arrived from London around 1738.[3] Then, he was just back from ten years in Italy where he had soaked up sun, style and substance, and found commissions from British Grand Tourists. Some of the men and women Hoare met and befriended in Rome would give him work in Bath in years to come, among them the 3rd and 4th dukes of Beaufort, Margaret's father and uncle. The Beauforts certainly did not come to Gainsborough. Hoare was softly and sweetly handsome – or so his self-portrait assures us – a kind, untroubling face whose gaze, while keen, would not disturb the sensibilities or composure of the most nervous aristocratic sitter.[4] Hoare did well in Bath immediately. He used the new medium of pastel, a soft, crumbly chalk that could catch fleeting expression, introduce veils of atmosphere, and quietly glow within a glazed frame without any of the pugnacious qualities that came with oil painting. With none of the paraphernalia of palette and fluids associated with oils, pastel needed no drying time, so the client could take it away there and then, or have it sent on.

Hoare's brother, Prince, was a leading Bath sculptor. Both were tall and personable, and in addition Prince was 'somewhat skilled in music', as Vertue puts it,[5] and was from time to time a concert organiser. But he was lazy, and, perhaps because he had married money, developed a habit of letting things slide, a disastrous quality in a monumental sculptor, from whom all manner of economic forces descend. William, on the other hand, was better organised, with more drive than his younger brother. By the late 1740s William was, as Vertue noted, 'living in a handsome, genteel manner', having had 'great employment at Bath by most or many people of distinction for many years'.[6]

During the 1750s, William Hoare had the local portrait market effectively to himself, despite the additional presence of Alcock, Hibbart and Worlidge. Together, the Hoares had the city wrapped up. William was drawing pastels of the great at a great rate, and turned also to oil painting, perhaps because proficiency in oil was to be expected of a portrait artist, but more to the point he soon had Gainsborough to compete with. Nevertheless, there was a conservative sameness to Hoare's portraits, whether in pastel or oil:

they were almost invariably head-and-shoulders, three-quarter poses, closed mouth, rosebud lips, and, male or female, young or old, had expressions of such pertness that they all look as if they are about to come out with a devastating comic one-liner. The scale of Hoare's pastel portraits was usually about two feet high, the price five guineas unglazed, and eight guineas glazed: it was essential to glaze friable pastel.[7] These were the same as Gainsborough's prices when he first came to Bath. Hoare's manner had stuck with him; it had done well for him; his patrons knew what they would be getting. If you commissioned Hoare you got a Hoare.

In Abbey Street, five minutes' brisk walk downhill from Hoare's apartment in George Street, a languorous full-length was beginning to emerge on Gainsborough's canvas (Pl. 33). Even with the perspective of two hundred and fifty years, Gainsborough's *Ann Ford* is a most dynamic and explosive painting, the kind of work that could only fill William Hoare, and anybody else with the slightest interest, with wonder. At nearly seven feet high and five feet wide, the serpentine form that Gainsborough gives to Ann Ford is the painted equivalent of Roubiliac's serpentine marble figure of Handel in the Vauxhall Gardens, ever fixed to its plinth.[8] The company of hypochondriacs at Bath, those at any rate who would enter Gainsborough's rooms on business intent, would all know Roubiliac's *Handel*, and many would spot its rhythm in *Ann Ford*. They might also – those who knew painting – remark on Ford's pose being more appropriate for an expressive biblical or mythological subject, such as the dying Sophonisba as painted during the Baroque period, or, closer to home, Hogarth's *Sigismunda*, or the spirited woman in Hogarth's *The Lady's Last Stake*.[9] These were Gainsborough's sure-footed intentions: to present a portrait of uncompromising scale that would be permanently on view in the shadow of Bath Abbey, on the pedestrian route to the baths, bringing modern life in all its uncomfortable unseemliness colourfully and controversially to the forefront of Bath society. This echoes Hogarth's intentions in hanging his *Captain Coram* in Hatton Garden. With *Ann Ford*, Gainsborough added extra titty to the fluctuating city.[10]

There was yet more to it, of course. Ann Ford offended many,

enthralled some, and left few unaffected.[11] She was at the cusp of her career, and nobody was to know where it would go; but wherever that was, Gainsborough's portrait would be Ann Ford's trumpeter; and Ann would be Gainsborough's. He shows her looking out to her right, her determined, intelligent and reflective face attentive only to an off-stage presence. She idly fingers her hair, she embraces her beloved guitar, and daringly crosses her legs. This was generally accepted as a male pose, casual, easy-going, artistic – as Handel in Roubiliac's statue – but much too bold for a young woman, sitting there like any common tart. Her left elbow rests on a pile of music books, where some sheets spill out so the music can in part be read: it is legible music and must be a song from her repertoire. In the background, partially obscured by the rich red silk curtain, is Ford's seductively glimpsed viol da gamba, of which we will hear much more. The work is a virtuoso performance, Gainsborough displaying with the paintbrush what he fondly hoped he could also display as a musician. But alas he had to recognise that that talent was for others; his task and genius was to give his musicians life long after their last chord had died away. In Ann Ford's dress Gainsborough creates rhythms in silvery-white ruched silk and lace that echo the rhythms he finds in the notes he painted. In Ann Ford's dress we hear the music play. When Gainsborough hung the portrait in his painting room in 1760, Ann Ford's flashing eyes, the snowy avalanche of her dress, her limbs tossed here and there, her musical instruments hinting at louche narrative to come, William Hoare was faced with an explosive challenge.

There was in Gainsborough, running beside his rakishness and 'fits and starts', a strong moral streak which may have made him wary of Ann Ford even while he painted her in so voluptuous a manner. Despite her rich clothing, there is an alluring nakedness in her attitude which brought Mary Delany, a correspondent and commentator of the grandest kind, up short. It indicates that, as Gainsborough had intended, his showroom was becoming a destination:

This morning went with Lady Westmoreland to see Mr Gainsborough's pictures (the man that painted Mr Wise and Mr

Lucy), and they may well be called what Mr [Daniel] Webb *unjustly* says of Rubens, 'They are *splendid impositions.*' There I saw Miss Ford's picture, a whole length with her guitar, a most extraordinary figure, handsome and bold; but I should be very sorry to have any one I loved set forth in that manner.[12]

Lady Westmorland cannot have been too put off by Ann Ford's allure. Her husband sat to Gainsborough and the sky did not fall in.[13]

Gainsborough was uneasy about Ann Ford: he was well aware of the electricity coming out of her, which sparked dramatically when she began to consort with Thicknesse after his wife died. She and Philip Thicknesse married in September 1762. Gainsborough came to say, when discussing the education of his daughters with James Unwin some four or five years after painting Ann, 'I don't mean to make them only Miss Fords in the Art, to be partly admired & partly laugh'd at at every Tea Table.'[14] Ann Ford had had her electric effect on one particular grandee in Bath: Gainsborough's other early client, the 3rd Earl of Jersey. He was fifty-two, she twenty-one. A liaison between them would not have been so odd or unusual in their society in the mid eighteenth century: he, after all, was rich and titled, she extremely pretty and very talented. But Jersey probably did not reckon on so spirited a reaction from Miss Ford when eventually she got the message that he was pursuing her. Jersey's wife, Anne, was ailing and was expected to die; but she clearly decided to hang on, so Jersey gave Ann Ford the opportunity to be his mistress, a chance he sweetened by offering her £800 a year for the privilege, with certain promotion to wife when the present Lady Jersey died. Ann Ford turned him down flat. Nonetheless the old goat persisted, prompting Ford to publish a blistering rebuke the following year, describing him as 'a man hackneyed in the wiles of debauchery', telling him to walk, and setting out her career plans in *A Letter from Miss F—d to a person of Distinction.* He was ill-advised enough to respond, whereby the whole thing escalated and they began to squabble over the meaning of a bloody head of a boar that Jersey had sent to Ford as a love token, 'because I perceived you loved it'.[15] This generated a scurrilous cartoon and of course hoots of laughter

among the warm splashy waters of Bath. Such was the heated atmosphere that surrounded Gainsborough on his arrival in Bath. Not only smallpox and measles were setting the city alight, but emotion and the vivid flux of inter-patron relationships as well.

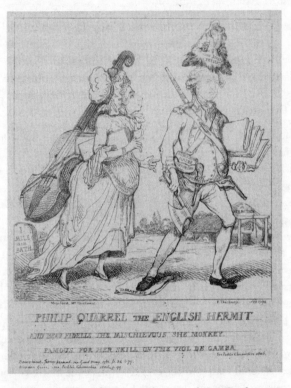

PHILIP QUARREL THE ENGLISH HERMIT

AND BEAU FIDELLE THE MISCHIEVOUS SHE MONKEY

FAMOUS FOR HER SKILL ON THE VIOL DE GAMBA

Artist unknown, *Philip Thicknesse and Ann Ford*, 1790.

Gainsborough's first few years in Bath found him working under far higher pressures than he had yet experienced. He had put his prices up to stem the flow, but this did not really work, and still they kept coming, to the extent that he had to put his prices up again and again, until by 1766 they had more than quadrupled, to twenty, forty and sixty guineas for head, head-and-shoulders, and full-length. Custom was seeping towards him from others.

Hoare was beginning to lose out: he 'suffers Gainsborough here to run away with his business'.[16] The great Thomas Hudson was also feeling the chill, as Gainsborough's friend and regular patron David Garrick told the actor James Quin. Garrick had been trying to get Thomas Hudson to paint his portrait, but Hudson seemed to want to avoid the commission:

> It was hinted to me that the much, and Deservedly admir'd Picture of you by Gainsborough has piqu'd [Hudson] not a little, & *Hinc Lacrimae*; if it is so, I sincerely pity him, For Indeed there is merit sufficient in that portrait to warm the most Stoical Painter, & what must it do when it works among the Combustibles of our Friend Hudson.[17]

Occasionally we do see Gainsborough slipping into the conservative mode of William Hoare, who became a good friend, and producing head-and-shoulders portraits, three-quarter poses, pert expressions, sitters in their best finery. It is what people wanted, and Gainsborough did sometimes go off the boil. Things were already getting on top of him when, in April 1762, he wrote to warn Henry Townsend, a captain in the Foot Guards off to war in Germany, that he could not get to London just yet, 'from the nature of my damn'd business'. Townsend's sister wanted Gainsborough to make some alterations in London to her brother's portrait before he went away. He was clearly happy to carry these out when he could find the time, indicating not only his willingness to please, but also showing that artistic temperament, and blanket refusals to cooperate, were not foremost among Gainsborough's personal and professional traits. In the event, while he may have carried out alterations to Townsend's portrait, Gainsborough did not press for payment, neither for the painting nor for its frame: 'let it alone till your return; I assure you Sir, that's the least of my thoughts, since if I had never heard your Name, your Countenance I should think security for more than I should ever get by Painting.'[18] Townsend did not return; he was killed at Kassel a few weeks later; it would have been uncharacteristic of Gainsborough to have pressed his sister for payment, ever.

To Garrick, Gainsborough touched on more of the pressures he was facing: 'With this sensible scull of mine I have ordered

my Business so as to have three sitters one after the other to-morrow, besides having caught a d-m'd cold riding in the rain this afternoon.'[19] Occasionally his sitters followed not one after the other across the day but altogether as a pair or group. George Byam, the owner of inherited sugar estates in Antigua, brought his new wife, Louisa Bathurst, to Abbey Street so they could be painted as a couple. The Bathursts were already known to Gains-borough: Louisa's uncle Benjamin was an early Bath client who had commissioned a portrait of two of his younger children in 1759.[20] Gainsborough presented them as doll-like, formal, tiny grown-ups; still, in his early Bath years, he was apt to slip into the conservative waters of his Ipswich manner, even a reprise of his innocent early London and Sudbury style. But George and Louisa Byam were having none of that: they wanted scale, a proud, bold statement in this canvas of about eight feet square, of them walking together in the landscape that George is indicating with outstretched arm and tricorn hat. This is clearly not the West Indies, but a bosky, sandy piece of England with a sturdy column and a distant cottage, which suggests Byam has returned home after war in the Caribbean forced him to leave.

A composition of this kind will have evolved through dis-cussion, through an appreciation by all parties of the length of the patron's purse, and through Gainsborough's understanding about how and where the painting would hang: in due course this would be the Byams' house Apps Court, near Walton-on-Thames, Surrey. It also shows how large a canvas Gainsborough could now paint in Bath. George Byam wore a blue waistcoat, his wife a pink dress with black silk bracelets and a black choker. However, after the completion of the portrait, the Byams requested fundamental changes: the blue waistcoat went, and George now wore a red-and-gold one; Louisa changed from her pink to a richly scalloped blue silk dress. The no-longer-fashionable black bracelets were painted out.[21] What was initially 'Mr and Mrs George Byam in their Landscape' became 'The Byam Family', as by now their daughter Selina had arrived, and aged two or three holds her mother's hand. She wears a black lace shawl suggesting that per-haps she had had older siblings who died. What this indicates is not only the Byams' desire to have an up-to-date dynastic portrait,

with their surviving child included, but a further suggestion, as Hugh Belsey has pointed out, that they needed to be seen to keep up with fashion.

This frustrating and unsatisfactory commission for Gainsborough came back to bother him, and its size will not have made the changes easy to deal with. The portrait had returned to his studio in 1766 when it was seen by a visitor, who reported that it cost £120.[22] Usefully this correspondent also tells us that 'the Limner's price is, for a Quarter Piece 20; for a Half Piece, 40; for a Whole Length, 60'.

Despite the return of this portrait for alterations, Gainsborough kept his head professionally, and evolved relaxed relationships with sitters of all kinds. This is a requirement from barbering to portrait painting, service industries which deal one-to-one with their clients. He struck up a particular friendship with Sir William St Quintin, a Yorkshire baronet then resident in Bath, who had commissioned portraits of one and perhaps both of his surviving daughters during Gainsborough's first year. Mary St Quintin is sweetly shy in her pale blue lacy silk dress, just off to the ball, and wearing a sprig of myrtle leaves, symbol of luck and love in marriage.[23] Her father, however, has no such reserve in his portrait, but settles comfortably into the studio chair, engaging with his painter friend, just as William Mayhew and Rev. John Clubbe had done in Suffolk. There is an immediate rapport here that Gainsborough has captured, and falls upon with some relief. The eyes are gentle and neither critical nor haunted, the smile is unforced and enjoying a companionable silence; they may have been talking lightly. St Quintin's hands have a quiet animation, his left relaxed and tucked into his coat, the right holding the rim of his hat. This is a charming and important portrait of a friendship of value to them both. St Quintin wears a soft, dusky red velvet jacket which Gainsborough has shown enlivened with white highlights, beautifully evoking the pile, laid with a quick, energetic gesture, a waterfall of white cascading down his shoulder.

Gainsborough's easy relationship with St Quintin is self-evident. With other sitters his relationship varies: the gallant serving officer Townsend attracts Gainsborough's brisk and accommodating manner; David Garrick induces his frankness;

the Byams bring out his diplomatic agreeability. George Lucy of Charlecote, Warwickshire, who commissioned two portraits of himself in 1760, and so was one of Gainsborough's first patrons in Abbey Street, came to the painting room with an egregious and chattering cadre of hangers-on to keep him company: 'There is I dare say a likeness, not so striking a one, as I have seen in some others, which Convinces me there is something in my face not so easily hit, tho I sat to all the advantage Imaginable, having my friends always with me.'[24]

With the influential and titled Lord Royston, however, Gainsborough's approach changed to formal but friendly, able, efficient and clear. Gainsborough had not been Royston's first choice of portrait painter: that had been William Hoare; Royston had told his father so in early April.[25] Gainsborough might have known this, and been quietly satisfied that he was continuing to make inroads into his rival's customer base. Once client and painter had settled on each other the pair got on swimmingly. By the beginning of May 1763 Royston told his father, 'I have sat 3 times for my Picture to Gainsborough';[26] and nearing completion, Gainsborough wrote happily to his client: 'I . . . shall spare no pains to make it as good a Picture as I possibly can.'[27] Royston must have been pleased with the portrait because he was encouraged some time later to invite Gainsborough into his employment once more.

At some point after Royston had become the 2nd Earl of Hardwicke, he wrote to Gainsborough to invite him to paint another picture for him. He had, in 1740, married the eighteen-year-old Jemima Campbell.[28] He was heir to estates at Wimpole, near Cambridge, and she was the heir of her grandfather the Duke of Kent, who died within a fortnight of the marriage. This left Jemima to become the Marchioness Grey, mistress of Wrest Park, Bedfordshire, and of many further estates in Bedfordshire, Leicestershire, Wiltshire, Essex and Herefordshire beside.[29] The marriage, which became a long and happy one, united the vast Hardwicke and the yet vaster Grey estates. Hardwicke's letter of invitation to Gainsborough is lost, but the context of the artist's undated reply shows that the required subject was highly prescriptive and included landscape to a considerable degree. This would perhaps be Hardwicke's home landscape at Wimpole, or

his wife's at Wrest nearby – or both, somehow combined: the estates can be seen from each other, so a grand prospect would have been possible. Now Gainsborough's personal history may have threatened to repeat itself: where Robert and Frances Andrews, extremely modest landowners by comparison with the Hardwicke Greys, had commissioned him successfully to paint them in their united estates, a new landscape commission seems now to have been on the horizon. We cannot know what was in Hardwicke's mind when he made his invitation to Gainsborough: did he want a straightforward view of his estates, or a conversation piece with himself and his wife together? There would be nothing surprising in that: the landscape-with-owners genre was still very much alive in the 1760s. Gainsborough's response, however, is plain, and reveals a complete change of attitude and intention to that which he displayed in the late 1740s: he would not paint a real landscape view for Hardwicke; he would not paint a 'Mr and Mrs Andrews' again. Gainsborough writes abruptly in the third person:

> Mr Gainsborough presents his Humble respects to Lord Hardwicke; and shall always think it an honor to be employ'd in any thing for His Lordship; but with regard to real Views from Nature in this Country, he has never seen any Place that affords a Subject equal to the poorest imitations of Gaspar or Claude. Paul San[d]by is the only Man of Genius, he believes, who has employ'd his Pencil that Way.[30]

That 'he has never seen any place that affords a subject' etc is simply not true: he saw them everywhere in Suffolk – not only Gaspard Poussin and Claude subjects, but Ruisdael, Rembrandt, Hobbema, Wynantz and countless other Dutch masters as well. He is making excuses for himself. He goes on:

> Mr G. hopes Lord Hardwicke will not mistake his meaning; but if His Lordship wishes to have anything tolerable of the name of G. the subject altogether, as well as figures &c must be of his own Brain; otherwise Lord Hardwicke will only pay for encouraging a Man out of his way – and had much better buy a Picture of some of the good old Masters.

The tone was rash. There was no friendly greeting at the end of

this letter, as is so often the case in Gainsborough's letters to his patrons, so it is little surprise that there appear to have been no further commissions from the Hardwickes. He might reasonably have expected Lord Hardwicke to commission a portrait of his wife, but by his dismissive attitude Gainsborough had shot his bolt with them.

The point to be made here is that while in Sudbury and Ipswich in the late 1740s and early 1750s Gainsborough was willing enough to accede to commissioners' requests, in the decades to follow he became his own man, chose his own subjects, and expected his clients to fall in with him. This resolution, driven by a characteristic volatility which risked social indiscretion, remained firm with him in his professional dealings throughout his life. He told his musician friend William Jackson how he dealt with people who turn up without an appointment. He got his servant to ask them what they wanted. If they requested a portrait, he would respond 'please to walk this way and my Master will speak to you'. If all they wanted was to say, 'Mr Gainsborough I love your work', his response would be, 'Sir, my Master is walk'd out.' But a woman on her own was a different matter: 'Now if a Lady, a handsome Lady, comes 'tis as much as his Life is worth [to send] them away'.[30] This may have been the circumstance in which he first met Mary, Countess Howe. 'But this is . . .' he continues – but here, for reasons we do not know, but might guess, the rest of the page has been torn away.

23. The foolish act

James Unwin, who like Philip Thicknesse – but also quite unlike him – had been orbiting Gainsborough's life for years, knew all about his friend's volatility and aptitude for plain-speaking. Unwin the banker and lawyer had long been a benign presence in Gainsborough's life. They had been through much circumstance together, Unwin being as entwined in Thomas and Margaret's private life as Thicknesse seemed ready to be in Gainsborough's professional life. Thicknesse had ambitions to control and direct, while Unwin considered he had a duty of care for his close and loyal friend.

It is in Gainsborough's Bath years that his correspondence with Unwin develops: there are six surviving letters to Unwin in the crucial twelve months between July 1763 and July 1764, and together these throw a clear light on the professional and personal pressures upon the artist, on the pattern of his portrait-painting practice, and on whatever it is he refers to as '<u>that</u>', written with an underline. As the 1762 letter to Townsend indicates, and his Unwin letters confirm, Gainsborough travelled regularly to London from Bath, a relatively easy journey by coach along the new fast turnpikes. He had been called unexpectedly to the capital in mid July 1763, and was able to see Unwin's brother very briefly. He had expected to spend 'a grave evening' with him but was waylaid: 'such is the Nature of the D— place, or such that of this T. G. that I declare I never made a Journey to London th[at] I ever did what I intended. 'Tis a shocking place for <u>that</u> and I wonder amongst the number of things [short word scratched out][1] I leave undone which should be done, that I don't do many more which ought not to be done.'[2]

What does he mean here in paraphrasing the Anglican General Confession? He must have had a touch of guilt: he is surprised that, because he leaves undone things which he should have done, he doesn't do 'many more' that he shouldn't. Is he surprised

therefore at the extent of his self-control? He promises Unwin that he will get on with his work, and mentions a portrait of Mrs Thomas Saumarez which he seems to have had on the stocks for three years, and asks Unwin please to assure Saumarez that he will get it one day soon. And he is contrite also about the time he is taking to complete his portrait of Fanny Unwin, James's wife: pressure of other work. Fanny had been on or near his easel for a year or more, and by now she was in the seventh or eighth month of pregnancy. Gainsborough asks darkly: 'Could not you <u>divert yourself</u> with the original for one week longer? I hope Mrs Unwin is not so round but that you can bring that about.'

Some weeks later he writes again to Unwin: there was probably no letter from Gainsborough in between. He was suffering greatly, possibly as a result of what he would later refer to as 'the foolish Act'. His expression has a breathless quality: 'This is the first time I have been able to hold a pen since I wrote to you before I have had a most terrible attack of a Nervous Fever so that for whole nights together I have thought it impossible that I could last 'til the Morning.'

He tells Unwin of the 'care and tenderness' of Dr Charleton, who gave him a concoction of bark and salts to drink.[3] He first expressed this as '*great* care and tenderness', but crossed out the 'great': perhaps there are signs here of Gainsborough beginning to doubt Dr Rice Charleton's abilities – some months later he would write 'Charletan' after his name in a letter, but, again, rapidly crossed that word out.[4] He was also treated by Dr Moysey: like Charleton's, his was tough medicine, hard to palate, but Gainsborough's other carer, his beloved sister Mary, went one better and made him drink 'six glasses of good, old Port, which she made me swallow one evening when I should have thought two or 3 must have knock[ed] me off the stage'.

Treatment was not only bed and medicine, however. Gainsborough began to feel better under Charleton, Moysey and Mary's ministrations, and perhaps soon after he wrote this letter, 15 September, he got up and out into the fresh air too soon. He had bought or been given a horse, 'not handsome but perfectly sure footed and steady upon the road', by 'my good friend' William St

Quintin: 'what I purpose is to be as indolent as possible in every thing but observing the exact quantities of food and exercise best for me, and to stick to the 6 glasses of Port at night. By this means I shall weather the point'.

In the event, this was a very bad idea. He went downhill fast and was expected to die. According to the *Bath Journal* of Monday 17 October 1763, he did die: 'the same day [i.e. Friday 14 October] died Mr Gainsborough, an eminent painter, of this City.' Somebody very close to the patient must have given this news to the paper in anticipation and good faith, but who? The candidates nearest to the information will have been his doctors; possibly either Dr Charleton or Dr Moysey believed death to be inevitable and jumped the gun to be first with the news, or whispered it about that death was coming and the *Journal* got quickly to hear about it. Well, they were all wrong. St Quintin arrived back in Bath that very week and must have read the news of Gainsborough's 'death'.[5] Did he go right round to Abbey Street expecting to see Margaret and the girls in deep mourning, but instead found his good friend still alive and grinning, sitting up in bed with a glass of port in his hand? In any event, perhaps through St Quintin's intervention, the *Bath Journal* published a retraction, right down at the foot of the last column of the next issue: 'Mr Gainsborough (an eminent Limner of this City) is not dead, as mention'd in our last.'[6]

The day after the *Journal's* retraction, Gainsborough wrote again to Unwin, describing more clearly his illness and its cause: 'Excuse my answering your letter a little longer, for I am but just able to hold a pen, and not able to know well what I say to you.'[7] He was contrite. Going out riding so soon had been a serious mistake, and it was particularly unfortunate that St Quintin should have tempted him with a horse. Gainsborough continued to Unwin: 'I have kept my bed 5 weeks to morrow excepting two hours sitting up for the last 3 days of a most terrible fever.' Working back five weeks to 15 September, this shows that Gainsborough had been up and about for five or six days before his relapse into a 'terrible fever'. So contrite was he that he told Unwin all; but Unwin had already guessed:

It has been all upon my spirits from the <u>first</u>, that is from a single trip I made to London, as you guessed; and occasioned by the uncertainty which followed the foolish Act. I was safe in the opinion of two of the best men in their way, but possessed in my mind that I was ruined. O my dear friend nobody can think what I have suffered for a moment's gratification. My life was despaired of by Doctor Charleton after he had tried all his skill, and by his own desire Dr Moisey was called in, when in three days my faintings left me and I got strength. I am now what they call out of danger: I wish my dear friend I could sleep refreshing sleeps, then all would be well again. You shall hear from me again soon . . . Keep my secret.

While in his earlier letter he had praised his sister Mary for her attractive but rash prescription of six glasses of port a night, this time, having looked death in the eye and recovered, Gainsborough's gratitude lay squarely with Margaret: 'My Dear Good Wife has sat up every night til within a few and has given me all the comfort that was in her power. I shall never be quarter good enough for her if I mend a hundred degrees.'

Gainsborough's business as a portrait painter was strong enough to survive these three months of inactivity. He had made enough money in Bath to manage, and, with Margaret's annuity, their days of scrimping and saving were long over. He could now slow down, throw off the pressure that was a contributory cause of his illness, certainly weakened him, and made him more susceptible to the effects of a sexually transmitted disease. He, and Margaret, decided to move the family out of what he described as 'the Smoake' of Bath to the clearer air of Lansdown Hill, and let some spare rooms.[8] Given the comparatively clean air of British cities in the twenty-first century, it is easy to forget that Bath in the mid eighteenth was as filthy as anywhere else. As in London or Manchester, buildings in Bath were heated by coal, and with its large fluctuating winter population, and its constricted valley that trapped the smoke, Bath may have been smokier than most places. Indeed, coal in Bath was cheap, being mined locally and transported with relative ease, and there was a lot of it around to

burn. 'In blowing weather', Smollett reports of the Circus,

> most of the houses in this hill are smothered with smoke, forced
> down the chimneys, by the gusts of wind reverberated from the
> hill behind, which . . . must render the atmosphere here more
> humid and unwholesome than it is in the square below; for
> the clouds, formed by the constant evaporation from the baths
> and rivers in the bottom, will, in their ascent this way, be first
> attracted and detained by the hill that rises close behind the
> Circus, and load the air with a perpetual succession of vapours.[9]

Gainsborough took his own action, as he told Unwin: 'I have taken
a house about three quarters of a mile in the Lansdown Road, 'tis
sweetly situated and I have every convenience I could wish for. I
pay 30 pounds per year; and so let off all my House in the Smoake
except my Painting Room and best parlour to show Pictures in.'

He also told Unwin explicitly that he was reducing his output,
though there is a note of caution in the way he expressed it: 'Am
I right to ease myself of as much painting work as the lodgings
will bring in. I think the scheme a good one.' His calculation was
that while he retained the left-hand (south) room on the ground
floor as his showroom, opposite Mary Gibbon's millinery shop,
which would remain, and the right-hand (north) room on the first
floor, which would remain as his painting room, he could let the
rest of the house and use that income to offset against a possible
future reduction in his income as a painter. The shop had arched
windows which, with the rising slope of the pavement, could shine
and glitter to attract passers-by. For that reason, if none other, it
would have been totally unsuitable as a painting room. So, on one
side of the building there was a shop displaying and selling fine
fabrics, hats and coats, perfumes, lace and ribbons, and on the
other was Gainsborough's own gallery with a long unbroken end
wall showing his paintings of people wearing just this same stuff.
This was an ideal partnership: hard-working Thomas Gains-
borough, single-minded and driven, and busy Mrs Gibbon, her
ample form dressed like a sofa, carrying on as the clever business-
woman she was. So prominent was she on the Bath commercial
skyline that Christopher Anstey picked her up and captured her in
a couplet:

Whether deck'd in lace or ribbons
Thou appear'st like Mrs Gibbons.[10]

The house the family moved into on Lansdown Hill is known now as Lansdown Lodge, a neat, then new detached stone house designed by John Wood in five bays, the central three slightly projecting below a pediment, with a central pedimented front door.[11] It is a quarter of an hour's walk up the steep hill from the Abbey, up Broad Street, across George Street, and up, and up. The house looks out not over Bath, but south-west across to the next bit of Bath real estate that John Wood was colonising. From the first floor Gainsborough could see exactly where he would be going next: the King's Circus, already a-building, with carts, stone, masons and scaffolding, and beyond that the yet grander Royal Crescent.[12] Lansdown Lodge is a symmetrical version of the Gainsboroughs' house in Abbey Street, and yet more like the properties of some of his richer clients. Gainsborough painted grandeur, and wanted a touch of it also for himself and his family. But convalescence was slow. 'I ride every minute in the day unless it rains pouring,' he told Unwin, and revealed '[I] do intend when I can, to be down from eleven to one o'clock, in my office [ie. at work], but not a moment longer for the King [of Bath]. I think I shall do yet my Friend.' Gainsborough missed Unwin greatly, and wrings his hands in contrition at the silly action that led to his serious illness:

> I long to see you more than all my relations, for not one of them <u>knows what you do</u>. I always thought you extremely clever; but whether I have not made you more knowing than you could have been had I been a close cunning fellow, that I must leave. I always think one cannot be too open to sensible people nor too reserved for fools; nay I believe I should have blushed to have confessed that to an Ass, which I did to you, and so much for secrets.

Gainsborough's movements can be tracked through his surviving letters, and from a few signed documents: he was in London in March 1765 to sign the Obligations when admitted as a Fellow to the Society of Artists, and he may have painted portraits of the

Duke and Duchess of Bedford at this time.[13] An article published in 1790 tells of Gainsborough and other 'ingenious gentlemen' meeting at the Turk's Head in Gerrard Street, Soho.[14] Others in the group were Dr Johnson, Reynolds, Goldsmith, Edmund Burke, Benjamin West and Richard Wilson, 'with his convivial disposition'. According to its author, the painter and critic William Henry Pyne, Gainsborough called this heavyweight group of artists and literati the 'blackstocking fraternity' in honour of Dr Johnson's black worsted stockings.[15] At the Turk's Head, Gainsborough would have met others including the MP and poet Robert Nugent, the judge John Dunning (later Lord Ashburton), and the playwrights Richard Brinsley Sheridan and George Colman. All of these he knew or had painted, so this was familiar ground where conversation was free-ranging, and where Dr Johnson might observe Gainsborough in conversation. 'Your sprightly friend', Johnson described Gainsborough to Garrick; and 'the ingenious Mr Gainsborough'.[16] At Garrick's table, when Gainsborough and Johnson came together, the painter was absorbed by Johnson's involuntary twitch, the 'St Vitus' Dance' that James Boswell and Reynolds both observed and commented on.[17] 'This obtained . . . strange possession of Gainsborough's imagination', to the extent that 'I became as full of megrims as the old literary leviathan himself, and fancied that I was changed into a Chinese automaton, and was incessantly shaking my head'.[18]

There are other observations of Gainsborough from Pyne, which seem to rise to a peak of excitement and move into fantasy in *Wine and Walnuts*, Pyne's recollections and anecdotes about the artists he knew. These were published altogether in 1824 under his pseudonym 'Ephraim Hardcastle'. Pyne, as 'Hardcastle', describes riotous evenings with Garrick and others, including Lawrence Sterne and Caleb Whitefoord, who have joined the crew, with Reynolds on the fringes as a kind of dull fall-guy. They ate and drank together at Garrick's Adelphi apartment, at the Bull and Bush, and climbed Hampstead Hill and looked out over the landscape, and talked into the small hours. 'Look, Sir Joshua!' says Gainsborough to Reynolds from the top of the hill. 'How that sweep betwixt Hendon and Mill Hill reposes in dusky shade! What aerial perspective! How prismatic! Tis like viewing

nature through the medium of a lens!'[19] It goes on for pages. The account is so detailed, so larded with theatrical lines, and so long after the event, that it is probably a cock-and-bull story. However, there may be a sliver of truth within: Cunningham writes of Gainsborough's lodgings at Hampstead, where in the summer he went 'for the sake of the green fields and the luxury of pure air'.[20] If he went there for the view he kept that to himself, because there are no grand views of London from Hampstead by Gainsborough, as there are by so many other artists.

As an indicator of relative character, Pyne's account does have some value. Of Reynolds, Pyne/Hardcastle says: 'his was a steady philosophic course, whilst that of . . . the lively Gainsborough, was a skipping and gambolling backwards and forwards from side to side on the same road to fame . . . none for enthusiasm and vivacity could compare with he.'[21] Musing on the distance between Reynolds and Gainsborough, Pyne/Hardcastle has Garrick ask them why they are not 'oftener seen with your legs under the same table? Why, Tom O'Bedlam, do you not go and learn sobriety from our Sterling Josh?' Pyne/Hardcastle answers these questions for himself: 'Reynolds was wise and sagacious; he thought deeply, and never committed himself. Gainsborough was all genius, and the impetuosity of his imagination led him away. He gave utterance to all he thought. Hence the evening ebullitions of fancy sometimes awakened morning reflections that made him frown and bite his lips.' Further, Pyne/Hardcastle quotes Garrick, 'Poor Tom! Storm or gentle breeze, he never takes in sail, but is always before the wind with his sky-scrapers.'[22]

It is across these visits to London, however embroidered they may have been by Pyne, that Gainsborough took part in a fully engaged social life, and became attracted also to the casual sexual encounters that punctuated his life. How many or how regular these were is impossible to tell. His natural common sense and evident remorse after the event – as well as the fact that he does not appear to have caught another sexually transmitted disease – might lead us to the conclusion that he usually, though not entirely, managed to contain himself. Sex was a relatively casual transaction in the mid eighteenth century, and had a clear health warning attached, like cigarette packets today. William Mostyn,

the brother of Gainsborough's Bath sitter Barbara Mostyn, told Margaret Gainsborough's uncle, the 4th Duke of Beaufort, that he had decided to mend his ways. He might have been giving up cigarettes:

> That keen appetite for a Petticoat is much abated in me, not that I have any particular reason of late to Complain of the [female] Sex. The thing is my father has made me some tolerable offer if I chuse to settle, & I think I ought to wean myself from the loose part of the Sex. To speak the truth I find the dangers too great to be risked oftner than can be avoided.[23]

It may be the case that Gainsborough's long near-fatal illness had nothing to do with his sex life; only his guilty conscience brought the two together in his mind. Perhaps he just caught a chill, and was simply exhausted by the demands of his profession.

Given the pattern of Gainsborough's future life, it is no surprise that he seems to be in London more frequently in the early 1770s than he had been in the 1760s. He was in London with Jackson, looking inter alia at pictures in dealers' shops in early 1768, and again in 1770 and 1771, both times surely also to see the Royal Academy exhibitions in which he was showing.[24] Later visits, before he and his family moved back to London permanently, were, according to the letters, for business, but with some dysfunctional diversion on the side. 'My Flight to Town was so sudden & transient,' he wrote to his friend and patron Constantine Phipps, Lord Mulgrave, in 1772. He regretted not seeing Mulgrave that evening, but he had spent a jolly musical evening in Harley Street with Fischer, Bach, Abel and pals, and on his way home he bumped into a prostitute, 'a little Venus <u>rising from the Sea</u> in my way to my Lodgings, the same that was puff'd off at our Exhibition I believe for her hair was d—md red.' How confused Gainsborough was by image and reality: James Barry was that very month exhibiting a red-haired *Venus Rising from the Sea* at the Royal Academy, and in his recollection Gainsborough seems to have elided the two.[25] Perhaps it was the same girl; more likely not. Writing to Giovanni Battista Cipriani in February 1774, only a few months before his final move to London, Gainsborough confessed:

I have done nothing but fiddle since I came from London, so much was I unsettled by the continual run of Pleasure which my Friend Giardini and the rest of you engaged me in, and if it were not for my Family, which one cannot conveniently carry in ones Pocket, I should be often with you, enjoying what I like <u>up to the Hilt</u>.[26]

Giardini was a bit of a problem to all of them. Charming, brilliant and sometimes out of control, he is recalled by Fanny Burney as someone who 'loved mischief better than any man alive'.[27]

After his illness, Gainsborough was in danger of becoming overwhelmed again, and he was well aware of it. To cap it all, serious family concerns were emerging on his horizon. Peggy and Molly were now seventeen and eighteen years old, and having left school in Chelsea were back in Bath having a good time. Unwin made a very helpful suggestion as one friend to another: 'You have my sincerest thanks for your kind offer and intention in regard to Molly,' Gainsborough responded. What the offer was we do not know, but in any event Gainsborough felt he had the problem of his daughters in hand. He was trying to teach them both to paint landscapes, 'and that somewhat above the common Fan-mount stile' – that is, paintings that were not just ephemeral decoration of the kind painted on ladies' fans. 'I think them capable of it, if taken in time, and with proper pains bestowed.' He wanted them to be able to earn some money, and neither of them to become another Ann Ford, now the butt of local gossip as Philip Thicknesse's new wife and collaborator. Peggy and Molly were also learning to play musical instruments:

The Captain begs her Compts, only she is making a damnd Jangling upon the Harpsichord this moment. Molly and Mam also desire their best respects – thank God they are all well and too Good for [word or words torn: these seem to be in crucial places, and intentionally removed] but says you again ['W] hy I know that [word or words torn: one presumably 'you'] do know a good deal I must confess but still I defye you to be certain how much I really am Your Affectionate & sincere Obedt. Servt. Tho Gainsborough.[28]

Two big things are clearly preying on Gainsborough's mind: his daughters' futures now that their schooldays were over, and his deep concern for their morals and welfare. Still, nearly a year later, he is perturbed again about his own reckless sexual encounters. Continuing from his remark about the portraits he has painted for Charleton and Moysey, his train of thought takes him back to his wild youth. The Unwins lived in Great Baddow until 1765, and it is this that prompted Gainsborough's recollection of what may have been his earliest encounter with Margaret Burr. A hint of the confessional tends to linger within Gainsborough's letters to Unwin: 'I am so well known at Baddow. They know my faults, but ask them <u>who</u> knows any of my Virtues. Ah! That a Jack Ass should be so foolish . . . you'll find me happy with Old Margt I hope, and [. . .]ally much yours.'[29]

24. Zouns, I forgot Mrs Unwin's picture

The illness made Gainsborough stop and think. When he tells Unwin, 'I don't remember to have enjoyed better health & spirits any part of my life than at present', he means it. He has his feet firmly on the ground now, and is painting at his best. He is even finding time to get on with the portrait of Fanny Unwin: 'The Beauties of Mrs Unwin's drapery like <u>our Virtues</u> have laid concealed for some time only to flash out the more suddenly, and to surprize those who least expect them.'[1]

Now in his late thirties, he was active, busy, in demand. His sitters' book in Bath, assuming he had one, would have bulged with the names of old clients, new clients, their friends and relations and their various requirements. They came in streams which had somehow to be managed so that they would bump into each other as little as possible in Abbey Street, and then at 17 King's Circus where the family moved early in 1767. That is guesswork, of course, because if Gainsborough ever had a sitters' book – and he must have done, he was organised – it has vanished along with every other scrap of documentation, letter, bill, schedule, list, all cleared out after he died, presumably at Margaret's behest. What survives in the way of letters and bills comes from elsewhere, from the people to whom they were sent.

There were the other unfinished portraits for Gainsborough to get on with. He may have painted the Howes at Abbey Street, William St Quintin, the Byam family and dozens of others, but he had still not finished Mrs Unwin, Mrs Saumarez, and had probably not yet corrected Henry Townsend either. As he told Unwin, he had had a mysterious approach by 'a letter with nobody's name to it, desiring his wife's picture might be finished and sent as soon as possible; sure it could not be honest Saumarez'.

With such a reputation and so rich a client base at his doorstep, his problem now was, once again, how to handle success. A postscript concludes this letter to Unwin, with an admission

that he knows he has to be careful with his health, and careful with the way he handles himself. Using the metaphor of a donkey that recurs within his painting and writing, Gainsborough adds: 'Don't you think a Jackass three quarters asleep upon the ridge of a bank undermined and mouldring away is very expressive of the happiness of not seeing danger?'[2]

James Unwin was a good friend to him. He was somebody Gainsborough could open up to, from whom he had no secrets, and to whom he did not have to explain anything. It is regrettable that we do not have Unwin's side of this correspondence, but in Gainsborough's letters we do nevertheless see Unwin reflected in a mirror. 'I received yours with very great pleasure,' Gainsborough writes in March 1764.[3] He is much better now, chastened, reflective, and seeing life afresh: 'I never had better spirits in all my life than I have now. I'm certainly reprieved for this time and have got a new lease [of life]. It has been of service to me my friend; I think better, and will act better for the future.'

He is also rebalanced financially, telling Unwin that his rooms in Abbey Street are bringing in rental income, despite the additional expense of buying furniture, and in retrospect he now sees that his illness was 'only the wag of a dog's tail out of the straight road: I may say I have already more than recovered the expenses of it'. Since his recovery, he has painted, so he tells Unwin, 'a whole length, three half lengths and seven heads, exclusive of a full-length of Doctor Charleton ['Charletan' crossed out], and a half-length of Doctor Moysey's son'. At his 1764 prices he would have earned perhaps 60 guineas for the full-length, 120 guineas for the half-lengths at 40 guineas each, and 70 guineas in all for the seven heads. That is 250 guineas altogether in three or four months, assuming that he painted the Charleton and Moysey portraits for nothing, in lieu of medical fees.[4] If this was the case – and perhaps it was – the physicians got very good value out of this patient, as well as posthumous but probably not fully deserved fame. Gainsborough could have had one hundred consultations from Moysey and Charleton for the services he had rendered in exchange. And what portraits they are: his *Dr Rice Charleton* expresses once again a joy that Gainsborough found since his youth: the joy of buttons. Charleton's

buttons perform an elegant dance, circling into line along the physician's coat and cuffs like a flight of swallows. It is details like this that lift Gainsborough's portraits – even this one, for a man who did not universally please him – from the mundane to the lyrical.

Despite finding such innocent delight in buttons, Gainsborough is bugged by the fact that his portraits of Fanny Unwin and Mrs Saumarez are still not yet finished: 'Zouns, I forgot Mrs Unwin's and Capt Saumarezs picture. I shall work upon them soon, depend on't.' Margaret ribbed him about this unconscionable delay, pointing out that in the time he had been failing to finish Fanny Unwin's portrait Fanny herself had been through three pregnancies.[5] It was the same nearly six years later:

> I'm so ashamed to mention Mrs Unwin's picture that D—mme I wish I was a Razor-grinder – I'll begin a new one of Her & you together if you'll come. Poor Mrs Saumarez too O Lord [that] I should behave worst to my best friends [and] best to my worst – I hate myself for this tho even my Enemies say I have some good qualities. If there is any one Devil uglier than another 'tis the appearance of Ingratitude join'd to such a Face as mine.[6]

To Unwin he could say anything he liked, and vice versa:

> It would never be in your power to offend me even by telling me the worst of my Faults, as I should esteem any correction as a favour from Mr Unwin . . . I should think it a very bad sign was I capable of taking anything ill from a person of your sense and good Qualities: it would be scorning to look at Vandyke whilst conscious of being yet but a dauber. No sir, I'm not quite so far gone neither.[7]

He could even tell him that Fanny Unwin had gone to the back of the queue again. Townsend must surely have been done by now, but he was still way behind with Mrs Saumarez as well. He continues to Unwin:

> My Health is better than ever, and everything goes on to my wishes, except Mrs Unwin's Picture and that stands still, still in

my Painting Room, notwithstanding I have the greatest desire
to finish it (Pl. 36); I have no oftener promised myself the Pleas-
ure of sitting down to it but some confounded ugly creature or
other have pop'd their Heads in my way and hindered me.

Always easy and accommodating to his friends, and a generous
painter of their portraits, Gainsborough may have innocently
adopted this open approach when he met the young poet Thomas
Underwood. In September 1767 Underwood reminded Gainsbor-
ough of an agreement between them where the poet understood
that the painter had promised to paint a full-length five months
earlier for display at the Society of Artists:

> Presuming upon Friendship shown,
> In April last at Bath when down,
> I should ere now addressed a Letter
> (perhaps like this for want of better),
> And begged to be indulged the Reason
> You came not up in May's fair Season?

The portrait did not appear, because, as Underwood expressed
it, 'shoals demand your wondrous skill'. Underwood subsequently
became something of a pest when Gainsborough denied that he
had made any such offer:

> Gainsboro', an artist in this place,
> I told you was to draw my face,
> And *gratis* promised to supply
> A picture for the Public Eye.
> *Apostate*-like denies his word,
> In fine has acted so absurd
> And treated me with such neglect,
> Though I've behaved with all respect
> That I've engaged – am in advance,
> To treat him with Satyric Dance.[8]

Even if only published by subscription in Bath, this doggerel
caught Gainsborough on the raw, as it challenged his ascendency
in the lucrative Bath arena. He must have let drop an unguarded
compliment to Underwood, or somehow led him to believe that he

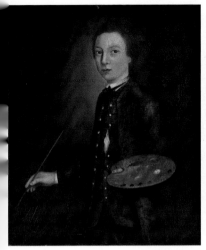

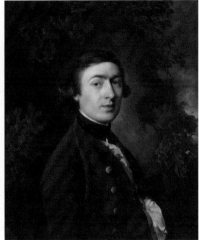

20. *Self-Portrait Aged about Thirteen,*
*c.*1740. Probably painted soon after
Gainsborough went to London.
While naïve and stiff as a figure,
there is charming informality in the
burst button, and a clear desire to
learn in his careful arrangement of
the palette.

21. *Self-Portrait, c.*1758–9. The
young, confident artist ready for
business in Bath. Gainsborough
presents himself as he might paint
his clients, and undoubtedly used
this as an advertisement.

22. *The Pitminster Boy,*
*c.*1767–9. A touching and
modest portrait of an
eager young artist, much
as Gainsborough himself
had been thirty years
earlier.

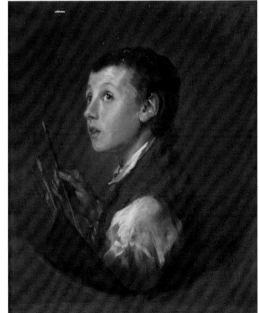

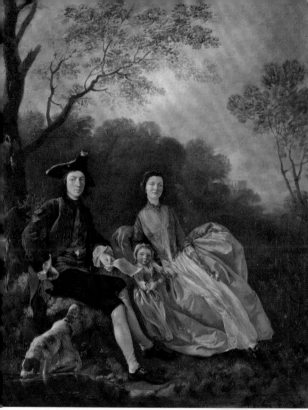

23. *Margaret and Thomas Gainsborough, with their Second Daughter, Mary,* 1748 or *c.*1751/52. A poignant family group. It is not clear if the child is the Mary who died in 1748, or the younger Mary who was born in 1750.

24. Johan Zoffany, *Portrait Study of Thomas Gainsborough,* 1772. Painted when it was expected that Gainsborough would be included in Zoffany's group portrait of Royal Academicians. We might detect Gainsborough's high spirits and volatility.

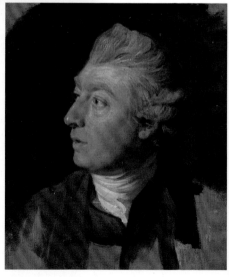

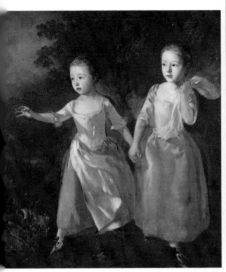
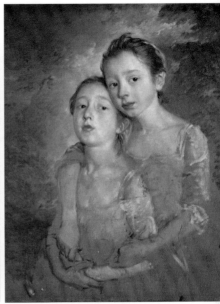

25 and 26. *The Painter's Daughters Chasing a Butterfly*, *c.*1756, and *The Painter's Daughters with a Cat*, *c.*1758–9. Two ruminative and eloquent studies of Molly and Peggy growing up. The ephemeral butterfly, the prickly thistle and the scratching cat carry these double portraits to profound levels of reflection and insight.

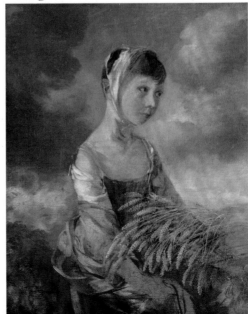

27. *Margaret Gainsborough as a Gleaner*, *c.*1758–60. This is the surviving half of another double portrait of Gainsborough's daughters. Peggy's unsuitable dress, her odd headgear and the question of the missing portion render it an eternal puzzle.

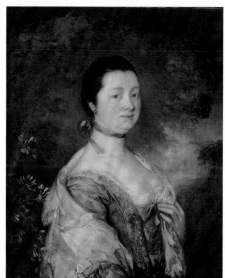

28, 29 and 30. *Margaret Gainsborough*, *c*.1758–9, *c*.1778 and 1780s. Gainsborough's portraits of his wife reflect their mutual affection and respect, despite the reported turbulence of their long marriage. He told a friend after recovery from his near-fatal illness: 'I shall never be good enough for her if I mend a hundred degrees.'

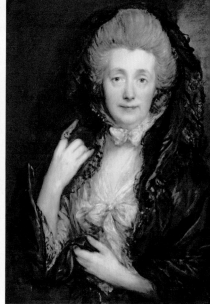

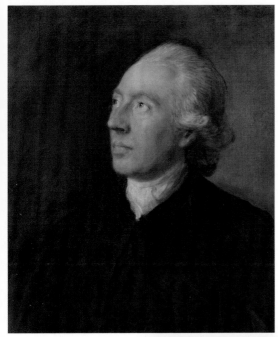

31. *The Rev. Humphrey Gainsborough*, 1775. Gainsborough's beloved elder brother, a non-conformist minister and one of the most prolific inventors of his generation.

32. *Gainsborough Dupont*, c.1772. Gainsborough's nephew, who was trained by his father as a carpenter. He became his uncle's valued studio assistant, and an accomplished painter and engraver in his own right.

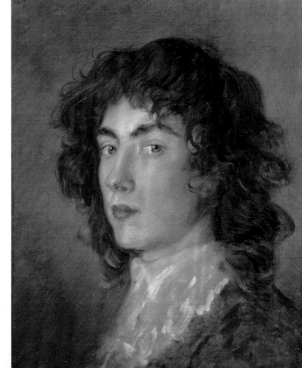

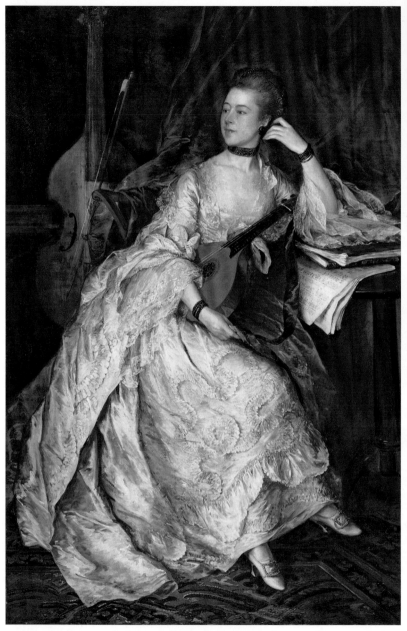

33. *Ann Ford*, 1760. A singer and instrumentalist whose performances were taking Bath by storm when Gainsborough first arrived in the city. This exuberant portrait was painted to demonstrate Gainsborough's extravagant style to potential patrons.

34. *Sir William St Quintin, 4th Bart,* 1760–61. Gainsborough and he became good friends in Bath, able to make easy conversation as this fluent portrait suggests. St Quintin commissioned other portraits from Gainsborough, and bought the landscape at Pl. 16.

35. *Uvedale Tomkyns Price, c.1760.* This thoughtful and enigmatic man was a pioneer of landscape design, and the grandfather of Uvedale Price, a seminal figure in the Picturesque movement.

36. *Fanny Unwin,* 1763–71. Gainsborough took eight years to paint the wife of his good friend James. It was intended as a gift, but was continually put aside as commissioned work took priority.

37. *Maria Walpole, Countess of Waldegrave,* 1764/6. The Academy rejected this portrait from the 1772 exhibition for fear of offending the King, whose brother had secretly married the widowed countess. The rejection earned Gainsborough's 'implacable resentment' against the Academy.

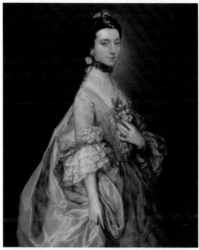

38. *Mrs Mary Carr*, 1763–5. The sitter's penetrating gaze is offset by her magnificent spray of myrtle and dog rose, the former a symbol of love and marriage, the latter of pleasure and pain.

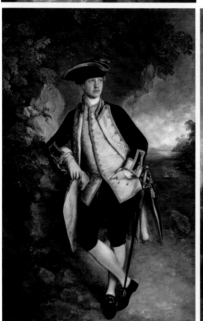

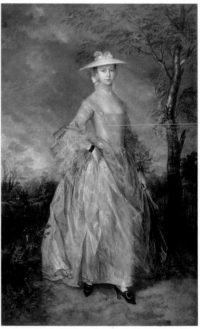

39 and 40. *Commodore Richard Howe, 1st Earl Howe*, 1763–5, and *Mary, Lady Howe*, 1763–64. While the Howes may have come together to Gainsborough's painting room in Bath, the finished portraits hardly constitute a pair. The one is grumpy and indifferent, the other confident, poised and engaging. Together they demonstrate the selectivity Gainsborough exercised in his commissions, and his refusal to be dominated by his patrons.

had time for this 'jingling scribbler'. It was still annoying him as late as 1771 when, as a post-script to a letter to David Garrick he wrote 'damn Underwood'.[9]

Every April, from 1761 to 1768, the year of the founding of the Royal Academy, Gainsborough showed new paintings in London with the Society of Artists in Spring Gardens. During those seven years he made sure he was represented by portraits and landscapes that would act as his calling card for London patrons who might consider commissioning him: his first exhibit in 1761 was his *Robert, Earl Nugent*; in 1762 he sent his *William Poyntz*. And so it went on over the years with *James Quin* and *David Garrick*, and *Lady Grosvenor* and the grand portrait of the Duke of Argyll representing him. Together these portraits demonstrated the social range of his clientele, from actor to aristocrat, and the bravura of his work. When in 1765 he showed the vast *General Philip Honywood*, he also demonstrated the physical scale and military rank he could command. A sequence of three landscapes shown at the Society over the years, including the *Wooded Landscape with Country Wagon, Milkmaid and Drover*, helped to keep his pastoral subjects in the public eye. Nevertheless, it seems half-hearted, given the bravura of the portraits he had painted in Bath over the years, notably *Lady Howe* and *Mrs Henry Portman*. Perhaps, as Susan Sloman suggests, Gainsborough saw London as the provincial outpost and his Bath showroom as his main national centre. That would be consistent with his contrarian nature, but we should observe that he was constrained in which portraits he put into an exhibition by his clients' willingness to let them go. They were the paymasters. Generally Gainsborough expected his clients to be in Bath, or to travel there to him, though he made regular exceptions. If the money or the likely prestige of a particular sitter was adequate, he would come to them in London or wherever, within reason, they might be.

The Society of Artists, which evolved out of a chaos of artists' groups circling around the St Martin's Lane Academy after Hogarth's death, was led somewhat ineffectively by its president, Gainsborough's old mentor, Francis Hayman. The Society had become the only public forum promoting the status and cohesion

of the profession of artists in Britain. Living in Bath as he did, Gainsborough was, however, an absent member, and not having the slightest interest in committee work he became detached from its affairs, while benefitting from the additional reach it gave him as an artist. The Society provided a platform for him until, at the end of 1768, it collapsed after months of politicking, recriminations and skulduggery.[10] As the painter Thomas Jones put it in his *Memoirs*, 'nor could all the good humour of our jolly and facetious President *Fran. Hayman*, persuade the disputants to lay aside their mutual Bickerings, and drown their Heartburnings in bumpers of wine'.[11] Jolly President Francis Hayman was replaced by Joshua Kirby, drafted in at the last minute to try to hold things together. Kirby wrote in near-despair to his brother the solicitor William Kirby:

> I am made president of the Society of Artists of Great Britain. It is an honour unexpected and undeserved. It is very like dressing a man in a fine robe, & then fixing a weight to the train of it, that he with all his abilities is but just able to tug after him. I am placed at the head of a respectable but divided body of men; God grant that I may introduce that kind of union amongst them that I sincerely wish could be effected throughout every part of this divided and distracted kingdom ... I now verily believe that neither my mind nor my body will find any rest, so long as I continue so unfashionable as to act upon honest and generous principles.[12]

But it was too late: the rise of the Royal Academy was unstoppable, steered as it was by the cunning Joshua Reynolds who had kept a strategic and wary distance from the Society of Artists. In a final attempt to keep the show on the road Kirby offered Directorships both to Reynolds and to Gainsborough, but both for their own reasons – 'Particular Reasons' as Gainsborough put it – pulled out. Reynolds had his bigger fish to fry, and Gainsborough likewise sensed greater benefits in migrating to the new Academy and becoming one of its founding artists.[13]

There is a sense in which Gainsborough was becoming de-mob happy in Bath. More visits to London, more meetings and so on seem to be taking place, though the partial documentation is

not a reliable measure. What is clear, however, is that when the annual Royal Academy exhibitions began in April 1769 Gainsborough exhibited with hammer blows that had been absent from his Society of Artists entries. The Royal Academy was, initially, important to him in a way that the Society of Artists was not. The Academy did not reach its long-term home at Somerset House until 1780, so, for all Gainsborough's time in Bath, showing at the Royal Academy meant showing in a modest-sized gallery on the south side of Pall Mall, owned by Richard Dalton, the King's Librarian. He had bought it some years earlier as a speculative art warehouse and emporium to sell prints. This was royal London, down by St James's Palace and the Pall Mall home of the Duke of Gloucester. It was not social London, up in the estates of Mayfair, nor commercial London in the Strand and beyond, nor ecclesiastical or political London in Westminster, nor yet civic and guild London in the City. London held many Londons.[14]

At the Academy's first exhibition Gainsborough showed, alongside such colleagues and rivals as Joshua Reynolds, Francis Hayman and Richard Wilson, two consummate full-lengths, catalogued as 'Portrait of a lady; whole length' and 'A portrait of a gentleman'. The Academy Council's minutes refer to all works sent to the exhibition not as paintings, sculpture and so on, but as 'performances'. Gainsborough's contributions were, most certainly, performances: his portrait of *Isabella, Viscountess Molyneux*, with her shimmering satin and reverberating glance, is a performance of contained grace (Pl. 41), while his *George Pitt, 1st Lord Rivers*, Gainsborough's 'well-bred, accomplished and debauched' friend, has a similar sideways glance, but in his case decidedly shifty.[15] To hang nearby, and this must have been a determined choice of his, Gainsborough also submitted what was catalogued as 'A boy's head', most probably the small portrait now known as *The Pitminster Boy* (Pl. 22).[16] Whoever this boy was, Gainsborough's decision to show it at the Academy's first public outing reveals his determination to demonstrate his breadth as an artist – both as a portrait painter on the grand scale, and also as a painter of ordinary people in which he could capture innocence, aspiration, youth, and hope in the future. The composition of *The Pitminster Boy*, set in an oval, harks back to Gainsborough's early portraits

such as that of Joshua Kirby's mother, with its Houbraken engraving roots, and prefigures the 'fancy pictures' that he would come to paint in the 1780s. As fresh and appealing as his portraits of his daughters, this might also be a wistful self-portrait of Gainsborough as a boy, carrying paintbrushes, a palette, and dreaming of a great career as an artist in London. Dreaming also of being fully accepted as a landscape painter, Gainsborough showed at his first Academy exhibition a work that was catalogued merely as 'a Large Landscape'.[17]

This was the start of Gainsborough's public career as the Royal Academician he had immediately become, now living at his fine address in King's Circus, Bath. The following year he showed five portraits, including *David Garrick* (Pl. 44), *William Jackson*, *Dr Ralph Schomberg* (Pl. 42) and the mesmerising *Blue Boy*, listed as 'a portrait of a young gentleman'. This is Gainsborough as he perhaps would have liked to present himself at that age. While not a self-portrait, it is a self-portrait conducted by other means, daring, self-assured, and with a direct gaze that drills, as if Van Dyck himself had submitted to the Academy. In addition there was one landscape and, unusually, a 'book of drawings': 'very good', said Horace Walpole.[18] By any measure this was a heavyweight group of paintings, unparalleled in its quality and impact. Gainsborough had become a solid presence, and so he continued: in 1771 he showed his portraits of the Ligoniers, and of Captain Wade, the current King of Bath, the portrait he then presented to the New Assembly Rooms, just now opening beside the King's Circus.

But there were bouts of unhappiness and discord at home in the King's Circus. He was ill again, Molly was ill, and to cap it all he was nearly killed when part of a chandelier fell from the ceiling of the New Assembly Rooms. These had been under construction the entire time the Gainsborough family had been living in the Circus, only about one hundred yards away from number 17. They were living beside, if not on, a building site. Apart from a note to pay 'Mr Gainsborough . . . the price of the frame of Mr Wade's Picture [crossed out] Portrait', he is significant by his absence from the Rooms' records.[19] What decorative painting there was to be done in the interior, in this case painted blinds on the windows, was not given to Gainsborough – far too busy – but to the

workmanlike Edmund Garvey, his 'particular friend', who lived
further down the hill, in the smoke.[20]

By the summer of 1771, when the Rooms were preparing to
open, activity was intense. Dozens of people had bought subscrip-
tions to pay for the construction and furnishing: William Hoare
was among them; Gainsborough was not.[21] The quantities of cut-
lery and utensils ordered gives an idea of the numbers of people
expected by the management, the noise Gainsborough could
expect near his house, and also of course the endless possibility of
new business in the portrait and landscape way:

> 30 pr of best plated candlesticks at £3.10 a pair; 30 Turkey
> coffee potts; 35 doz burnished tea spoons; 4 doz large spoons;
> 4 doz small spoons; 550 cups; 550 saucers; 100 basons; 6 doz
> bordered plates 2 gross desart plates; 200 coffee cups; 150
> breakfast basons; 100 jugs for cream; 100 brown tea potts; 5
> doz quart decanters; 30 doz common drinking glasss; 12 doz
> champain glasses; 5 doz rummers; 160 doz bottles.[22]

This was a critically important new entertainment venue for
Bath, so the bits of chandelier crashing from the ballroom ceil-
ing was bad news. Dancing had been allowed far too soon, and
the vibrations brought some of the chandelier's arms down. One
after another they fell, causing near-misses and terror on the
dance floor: 'so long as a chandelier of Mr Collett's remained',
the committee wrote to the crestfallen manufacturer, 'the general
apprehension of danger would never be removed'.[23] Gainsborough
and his friend John Palmer, a highly influential figure in Bath,
a brewer, theatrical impresario, and the city's postmaster, were
together when a fall occurred: 'We narrowly escaped having our
crowns cracked', Palmer told Garrick, but this was nothing com-
pared to Gainsborough's domestic distress: 'Mr Gainsborough
has been so very indifferent, from his attention to – and confine-
ment – with his daughter in her illness.'[24]

Palmer had called at 17 King's Circus once or twice, but Gains-
borough was 'too ill to see anyone'. When Palmer writes 'Miss
Gainsborough is now as well as ever she was', there is a suggestion
that all had not been right for a while. The doctors were next to
useless. Moysey passed Molly's illness off as 'a family complaint

... he did not suppose she would ever recover her senses again', so he paid no more attention to her. Schomberg and Charleton's opinions, however, were more hopeful: 'delirious fever' they called it, and Molly seems, for a while, to have got better.

Demand on him in London continued. In 1772 he showed 'two young ladies, whole length', the singers *Elizabeth and Mary Linley*, daughters of the musician Thomas Linley of Bath; *William Pulteney*, also of Bath; and two other portraits, listed as anonymous, of his friend *Constantine Phipps, Lord Mulgrave*, and of *Lady Margaret Fordyce*. He also sent his portrait of *Lady Waldegrave*, the Duke of Gloucester's long-term mistress and now wife (Pl. 37), with two landscape paintings and eight smaller landscape drawings, listed as being 'in imitation of oil painting'.[25] Under this growing pressure, Gainsborough finally cracked and took on an assistant. Being a Gainsborough, he did not look out for somebody in Bath, but called home and found a likely member of the family in Sudbury, the second son of his sister Sarah and her husband, Philip Dupont, the carpenter. Gainsborough Dupont, now twenty-two years old, no longer a boy, must already have picked up good carpentry skills with his father, so will at the very least have been adept at making stretchers. So Gainsborough signed up Gainsborough in articles of apprenticeship in January 1772, and thus he had his own tight studio team in place in the very busy months before the next Royal Academy exhibition.[26] To mark the moment, what better than a quick portrait of the young man: so there, head and shoulders, painted in perhaps less than an hour, is young Gainsborough (Pl. 32). He looks shyly, even cautiously, towards his uncle. Family history is mirroring itself, a new Uncle Thomas giving his nephew an apprenticeship opportunity in London. In this masterpiece of quick Van Dyckian expression, Gainsborough looks at Gainsborough and sees a beautiful boy setting out with nothing but his talents into a dangerous city.

Gainsborough fretted over the full-length portrait of William Pulteney, a hugely influential MP, a man of immeasurable wealth, and the owner of estates in America and the West Indies. Nearer home, Pulteney owned Bathwick across the River Avon. Gainsborough had finished the portrait by early April, but kept going back to it in his painting room, looking at it again and again.

One Sunday he resolved to ask Pulteney if he would be so kind as to come again for another sitting. 'I generally view my Works of a Sunday, tho I never touch', he wrote – by that he meant he never took up his brushes on a Sunday. He wanted to heighten the colour and light in the portrait:

> I think we could still finish a little higher, to great advantage, if it would not be intruding too much upon your good nature, to bestow one more little sitting of about half an hour . . . I am fired with the thoughts of Mrs Pulteney giving me leave to send you to the Royal [Academy] exhibition, and of making a good portrait of you.[27]

And so the portrait was completed, and sent, and it represented Gainsborough well. After much local controversy, William Pulteney had at last built his fine bridge across the river, and was even now planning the next stage, the beginnings of a new turnpike towards London, starting with Great Pulteney Street, a grand terrace of palaces more than worthy of the capital, built on his own Bathwick land.[28] The portrait, shown in London, signalled a Pulteney family message that Bath was on its way. In portraiture if not yet by a new road, Bath reached the capital in 1772.

Then, however, there was an almighty row. The hanging committee of the Academy refused to show Gainsborough's *Lady Waldegrave*, probably on account of the fact that she and the Duke of Gloucester, the King's brother, had married in secret, causing much fuss at court, and leading to the passing of an Act of Parliament defining royal marriages. During every Academy exhibition there was a day set aside for a royal visit, so there is no doubt that the King would see Gainsborough's *Lady Waldegrave* if it were to be hung. Sir Joshua Reynolds needed at all costs to avoid the King's annoyance, and *Lady Waldegrave* was made the scapegoat, and not shown. Gainsborough was not at all impressed by this, and within days of the opening the following appeared in the *Public Advertiser*:

> We hear that the Gentlemen upon the Committee for managing the Royal Academy have been guilty of a scandalous meanness

to a capital artist by secreting a whole-length picture of an English Countess for fear their Majesties should see it; and this only upon a full conviction that it was the best finished picture sent this year to the exhibition. The same artist has been affronted in this manner several times before, from which they may depend on his implacable resentment, and will hear from him in a manner that will very much displease them.[29]

This reads like dictation taken down from 'a source close to the artist' – almost certainly the furious artist himself. It is not clear what, if any, the earlier 'affronts' had been.

There were other irritations in the press, unsolicited advice for Gainsborough from anonymous journalists. Two publications, for example, criticised his use of colour, 'his one fault', according to the *Middlesex Journal*, 'a fault upon the side of excess – his colours are too glowing. It would be well for him if he would borrow a little of the modest colouring of Sir Joshua Reynolds.'[30] That was advice he did not need. The *Westminster Magazine* added more detail to this apparently coordinated critical appraisal, suggesting 'that he throws a dash of purple into every colour', as if he failed to clean his brushes properly, or that this was 'a reflection of the purple colour from his eye'.[31] A modest example of Gainsborough's discreet use of purple, so subtle that it is seems to masquerade as brown, is his portrait of the Hon. Harriot Marsham (late 1770s).[32]

There had been tremors of other kinds: Gainsborough's attitude to organised art activity had already kept him apart from the management of the Society of Artists, and he was now in trouble with the Academy for delay and uncertainty, as well as the impertinence of submitting a portrait that would upset the King. 'When you mention Exhibition Pictures, you touch upon a String, which once broke, all is at an End with me': interesting that he should use a musical analogy in this letter of May 1772 to Edward Stratford, whose portrait was even now on Gainsborough's easel.[33] When a fiddle string breaks, that's it, no more music; when a painter fails to deliver as promised or delivers something that cannot be shown, that too causes damage. So Gainsborough promises Stratford results very soon 'in my best manner'. The decision to omit *Lady Waldegrave* had already been taken, but Gainsborough

remained surprisingly tactful. All he said was: 'I was obliged to cobble up something for the Exhibition or else (so far from being knighted [as Joshua Reynolds had been in 1769]) I should have been expel'd the Society, and have been looked upon as a deserter, unworthy of my Diploma sign'd with the King's own hand.' He kept his diploma framed and hanging behind his painting-room door, and was proud of it.

There were clearly concerns about Thomas Gainsborough RA emerging from Academy circles. Continuing to Stratford, Gainsborough says, 'I wish you would recollect that Painting & Punctuality mix like oil & Vinegar, & that Genius & regularity are utter Enemies, & must be to the End of Time.' There seems to be a hinterland here: 'I wish you would recollect' suggests that this is not a new subject under discussion between them, and the 'oil and vinegar; painting and punctuality' metaphors suggest special pleading. Reynolds did not have such a problem. Further, there is the conundrum of Gainsborough's absence from Zoffany's highly constructed group portrait of the Royal Academicians exhibited in 1772, a clear and determined statement of intent, and a greeting to the world from the new artistic elite.[34] Zoffany came to Bath early in 1772, and there likely made the revealing portrait study of Gainsborough (Pl. 24).[35] Zoffany shows Gainsborough to be anxious, breathless and exasperated, and so he might have been. The pose is in profile, looking to the left, so he was clearly intended to be to the right of the composition beside Nathanial Hone, Joseph Nollekens, Richard Cosway and Gainsborough's fellow Bath artist William Hoare.[36] In the event, despite his long-acknowledged stature as a dominant force in painting, Gainsborough was not included among the thirty-six artists gathered together.[37] His is a glaring absence, like a proscribed politician erased from the photograph of a Soviet politburo line-up, so what's up? Could there perhaps have been some issues of temperament, lack of co-operation, or growing dissatisfaction among the Academy leaders that caused a breakdown in their relationship? Did he refuse to be included in the group, in retaliation for the exclusion of his *Lady Waldegrave*, or was he barred? In Academy politics, he was living on the edge, so no wonder Zoffany spotted such complexity in the energetic pose.

Changes were afoot at home: in March 1773, as a result of amendments to the running of the Duke of Beaufort's estates, the source of Margaret Gainsborough's annuity was redirected, to become an expense on the Duke's farms at Skenfrith, Monmouthshire, rather than as originally on his hunting grounds at Netheravon in Wiltshire. It is of little importance for this narrative, except to say that Thomas Gainsborough was one of the signatories to the amended deed and so was closely involved with the management of his wife's income. His participation was a legal requirement.[38]

Gainsborough did not send to the Academy the year after the rejection of *Lady Waldegrave* and as Horace Walpole, Lady Waldegrave's uncle, put it in his copy of the 1773 exhibition catalogue, 'Gainsborough and Dance, having disagreed with Sir Joshua Reynolds, did not send any pictures to this exhibition.'[39] Interestingly, Nathaniel Dance does not appear in Zoffany's group portrait either. However, Gainsborough was not entirely without his understanding supporters. He ends the letter to Unwin in which he rails against 'the people with their damned faces' with the PS: 'God bless that good woman Mrs Somarez.'[40]

25. In the painting room

When Gainsborough posed one of his 'confounded ugly crea-
tures' – actually, the sources of his livelihood – politely on
the chair or dais in front of him, he was able to consider the subject
carefully, consider his approach, and by adjusting the shutters on
his windows consider, control and adapt the light coming into the
room. The young painter Ozias Humphry watched Gainsborough
closely at work in his painting room and reported clearly and fully
on the way he stage-managed his subjects, and set the scene on
what went on there. Humphry also clarifies what we understand
about Gainsborough's painting techniques, and introduces us to
Gainsborough's young cousin by marriage Uvedale Price, who
would, thanks in part to his early friendship with Gainsborough
and his youthful immersion into the artist's way of life, become a
pioneer of landscape study and appreciation:

> These Pictures (as well as his Landskips) were often wrought
> by Candle Light, and generally with great force, and likeness.
> But his Painting Room even by Day (a kind of darkened twi-
> light) had scarcely any Light; and our young Friend [Uvedale
> Price] has seen him, whilst his Subjects have been sitting
> to him, when neither they or their pictures were scarcely
> discernible.[1]

So Gainsborough worked practically in the dark, illuminated only
by a few flickering candles. When painting a large portrait he
preferred to have the canvas loose enough to be flapping:

> If the canvases were of three quarter size, ¾ of a yard in length
> the common size for heads in oil, he did not desire they should
> be loosened upon the straining Frames; but if they were half
> lengths, or whole lengths, he never failed to paint with the
> Canvas loose, secured by small Cords, and brought to the ex-
> tremity of the frames.

In effect he was painting on a ship's sail, rigged perhaps like a small yacht, the canvas prone to bellying with every move he made. He would draw the position of the sitter's face in chalk, and so arrange the canvas that the head of the sitter and the painted head were only inches apart: 'They were so placed upon the Easel as to be close to the Subject he was painting, which gave him an opportunity (as he commonly painted standing) of comparing the Dimensions and Effect of the Copy, with the original both near and at a distance.'

He put much energy into his painting, stepping back from the canvas, going forward, stepping back. It was a restless process for all. Henry Angelo wrote of him 'dashing out his designs'.[2] This is when he must have used his long-handled, six-feet brushes described years later by J. T. Smith and Allan Cunningham.[3] However, it is surprising that Humphry does not mention these bizarre and very evident pieces of equipment, which must have simply been his ordinary larger brushes bound with leather thong or rope on to ash, willow or hazel broom handles. None of these seems to have survived, nor are they recorded elsewhere, which is odd as such an unusual contraption would surely have generated comment and imitation in the nineteenth century. 'By this method (with incessant study and exertion) he acquired the power of giving the Masses and general forms of his models with the utmost exactness.'

It may also be the case that in order to get the face of the sitter in line with the face on the canvas he had to roll up the lower part of his full-length portraits. All the sitter needed to do was sit for the face and general pose while the often complex costume was painted on a model in the sitter's absence, as was commonplace. This would particularly benefit Gainsborough's women subjects, many of whom led busy lives, and is really no different from his practice in the 1740s and early 1750s when he painted the clothed bodies of his sitters from a lay figure. He had at least three women at hand who could model for him: Margaret, Molly and Peggy. 'Having thus settled the ground Work of his Portraits, he let in (of necessity) more light, for the finishing of them; but for him correct preparation was of the last Importance, and enabled him to secure the proportions of his Features as well as the general

Contours of Objects with uncommon Truth.' Preparation was vital: by 'last importance' Humphry means 'highest importance'.

What this reveals is that Gainsborough's portraits, in common with his landscapes, were tightly and determinedly constructed. The proximity, cheek to cheek, of painter and sitter is a continuation of Gainsborough's training in the 1740s, articulated in the *Universal Magazine* of 1748. This is not the fresh, natural painting that Gainsborough celebrated in his portrait of Molly and Peggy with their cat, or that fifty years later Constable would practise in his landscapes, but artifice built on a rococo model. It also goes some way to explain the contained darkness in the portraits of *Sir William St Quintin* (Pl. 34), *Mrs Mary Carr* (Pl. 38), *Lady Tracy*, *Mrs Henry Portman* and *Uvedale Tomkyns Price* (Pl. 35), all painted between 1760 and 1765, the years surrounding Gainsborough's illness.[4] Cunningham tells that 'in winter he was often seen refreshing his eyes with light at the window, when fatigued with close employment', and it may be that a long-term result of his illness was that Gainsborough could not bear too much light, and that it hurt or strained his eyes.[5]

For whatever reason, Gainsborough preferred to paint in neardarkness, and as a result the temper of the artifice that he created was increased by the candlelight that he chose to paint under, even on a sunny afternoon. This manner emulated the example of Caravaggio and his followers, whose subject matter was made darker and tenser under a candle's flicker. But for Gainsborough candlelight was used less for dramatic effect than to create mood in his later landscapes and to enhance the shimmer of fabric. Each of this group of sitters appears lit as if from a crack in a shutter, as much as by a candle or two, particularly *Harriet, Lady Tracy*, the cast light creating a vertical line from her head to her lowered right hand. The creases on Sir William St Quintin's dark red jacket dance in the light from its controlled source. In Mary Carr's portrait the shutter has opened slightly wider, and with Mrs Portman the light has been allowed in further, as if to permit a special look at her sumptuous dress. The light also reveals something of the room where Mrs Portman is sitting, Gainsborough's Abbey Street painting room: the door has the, albeit ubiquitous, proportioned panelling also seen in the shutters in his portrait of Robert

Nugent, painted 1760–61, and the dark red leather brass-studded armchair on which Mrs Portman sits is practically identical to the one containing the modest form of the Bath apothecary Thomas Haviland in Gainsborough's portrait of *c*.1761–2.[6]

St Quintin sits on the same chair, but here Gainsborough has painted it green. Behind Mrs Portman is the corner of a picture frame with a glimpse of a sunset landscape: this is a common compositional trait, inherited from Dutch painting, and one which Gainsborough used, as the decision took him, in a number of portraits of his early to middle Bath period. The double portrait of Molly and Peggy with their drawing equipment also reveals the edge of an elaborate gilt picture frame to the right, and behind *Uvedale Tomkyns Price* is a crisp and elegant gold-and-black-edged frame displaying a typical Gainsboroughesque drawing.[7] The overlap of descending rectangles in this subtle and important portrait, the picture frame, the print folios, the drawing in Price's hand and the back of the red plush armchair – a different armchair to the one in which Mrs Portman, Haviland and St Quintin sat – indicate that, while Gainsborough's brushwork may be spontaneous, his sense of composition was thoughtful, measured and planned: we can find comparison here in portraits by Ingres and David, two artists who otherwise could not be further in outlook from Gainsborough.

Uvedale Tomkyns Price was an experienced maker of landscape – real landscape, planned and realised at Foxley – and an appreciative and perceptive writer on landscape themes. He is shown by Gainsborough to be illuminated by the same narrow admitted light that falls on Mrs Carr, Lady Tracy and Mrs Portman. It shines on Price's old-fashioned wig, enlivens his lacy cuff, illuminates the drawing of trees that he has just been amending, and reveals an expression that is as disgruntled as St Quintin is cheerful. Uvedale Tomkyns Price hated Bath, or at least Gainsborough depicts him thus. By this time Price was near his own death, and had experienced enough sorrows for any artist to spot ingrained misery in a sitter: three of his four children had died, his wife had died, and then in 1761 his only surviving son, Gainsborough's friend, Robert, and *his* wife, died, leaving his fourteen-year-old grandson, Uvedale, an orphan: Uvedale Price

would be his grandfather's apotheosis, and become the seminal writer and theorist of the Picturesque, read and attended to by generations.[8]

Uvedale Tomkyns Price, the grandfather, in his mid seventies when he and the thirty-one-year-old Gainsborough first met, was the fascinating and experienced elder who came to Gainsborough at precisely the right moment. He was old enough to be Gainsborough's grandfather, with a large house and grounds in the country, and having the vital practical desire to make Foxley into a living painting, with paths that wind and trees that sway – a canvas in which the leaves actually fall in autumn. This was very heaven for a younger man bound into exploring the pictorial prospects of landscape. The Prices were a family rich in achievement and intellect, energetic and capable. Tomkyns Price and his wife, Anne, née Somerset, had built a 'New Grand House' at Foxley where they ran an efficient farm, and managed a landscape of woods and meadows to intrigue the eye and entertain the mind. The grove at Foxley was 'so shaded with trees that one may in the hottest day walk without the least uneasiness', and a woody mount with 'a vast many pretty walks in it'.[9] It was a little Eden. Tomkyns Price handed Foxley over to Robert in the 1740s and retired to Bath, but as the drawing in his hand suggests, he kept his wooded demesne constantly in mind.

Because Gainsborough and Robert Price knew each other so well from London days, Foxley was an obvious destination for the Gainsboroughs when they came to live in Bath.[10] Tomkyns Price's wife, Anne, had been Margaret Gainsborough's first cousin (twice removed), and their host Robert Price was therefore Margaret's second cousin (once removed). Thus, with the Prices, the Gainsboroughs were family. In allowing the teenage Uvedale Price into his painting room, drawing blinds and tending candles, Gainsborough was entertaining an intelligent, perceptive, impressionable and probably lonely young cousin.[11] The family-minded Gainsboroughs saw themselves not just as hosts, but *in loco parentis*. The friendship that developed with this third Price generation lasted a lifetime, and produced a group of letters, now lost, between Gainsborough and Uvedale Price, and the memory, in Uvedale, of rides around Bath with his older artist friend.[12]

Friendship with three generations of Prices came to Gainsborough as balm. Price trumped Thicknesse. Here at last was a secure and sensible background against which Gainsborough could refresh his needs as a painter, and also begin to create a body of work that satisfied the other side of his nature, the landscape side that he might have involuntarily suppressed in the light of the influence of Thicknesse, and the overwhelming commercial demands of his portrait-painting practice. In allowing him to rekindle and redirect his landscape-painting programme, the Prices of Foxley gave Gainsborough renewed purpose.

The conjunction in Bath of Thomas Gainsborough and the young Uvedale Price was one of those lucky strikes that cannot be anticipated, nor can the extent of its consequences be immediately understood or measured. Uvedale's quiet presence in Gainsborough's painting room changed the boy's life as much as it enhanced Gainsborough's own by introducing a significant and sensible presence capable of empathy and conversation into the painting room. Uvedale's close observation of the rigging and machinery of the portrait painter's art, his love of riding horse-high through the landscape, and with such a companion as Thomas Gainsborough, his unique distillation of the prospects he saw with his transcendent painter friend around Bath, all these ingredients contributed to the genesis of Uvedale's writings on Picturesque theory forty years later. We might also suggest that Uvedale's youthful enthusiasm for Gainsborough's landscape drawings and paintings, and his first-hand experience of the processes involved in gestating and forming them, were the trigger that this fourteen-year-old required to fire him up for the beginnings of his own influential career. Further, the energy and passion that the older man poured into his informal and heartfelt landscape studies around Bath was encouraged by the responses of a young man whose spirit he may have recognised from his own youth in Sudbury. As much as Gainsborough inspired Uvedale, the young Uvedale revivified Gainsborough.

Uvedale Price witnessed something of the informal, even slapdash, techniques that Gainsborough developed when evolving his landscape inventions. Another teenage friend, Henry Angelo, saw Gainsborough at his easel in Bath:

[He] had in his experiments exhausted all the legitimate methods, and all the tricks of painting, in his oil pictures. He had established a reputation for a style in drawing, as desultory in its way, when not acknowledging bounds to his freaks, instead of using crayons, brushes, or chalks he adopted for his painting tools his fingers and bit of sponge. His fingers, however, not proving sufficiently eligible, one evening, whilst his family and friends were taking coffee, and his drawing thus proceeding, he seized the sugar-tongs, and found them so obviously designed by the *genii* of art, for the express purpose, that sugar-tongs at Bath were soon raised two hundred per cent.

He had all the kitchen saucers in requisition; these were filled with warm and cold tints, and, dipping the sponges in these, he mopped away on cartridge paper, thus preparing the masses, or general contours and effects; and drying them by the fire (for he was as impatient as a spoilt child waiting for a new toy), he touched them into character, with black, red, and white chalks.

Some of these moppings, and grubbings, and hatchings, wherein he had taken unusual pains, are such emanations of genius and picturesque feeling, as no artist perhaps ever conceived, and certainly such as no one has ever surpassed.[13]

Gainsborough was particular to the point of obsession about the paper on which he drew and 'mopped away' upon, and discovered a perfect source in the paper that the 1767 edition of the *New Bath Guide* was printed on. This he found was 'what I have long been in search of for making wash'd Drawings upon . . . There is so little impression of the Wires, and those so very fine, that the surface is like Vellum.'[14] He added that it was as good as old Italian drawing paper, having very little glaze, and asked the Pall Mall publisher James Dodsley to send him half a dozen quires – that is, twenty-four folded sheets – to the White Horse Cellar in Piccadilly, where it would be collected by Walter Wiltshire's wagon on its next trip to Bath. Ever grateful, Gainsborough thanked Dodsley profoundly: 'I had set my heart upon getting some of it, as it is so completely what I have long been in search of.'[15] And as the generous (or eager) man he was, Gainsborough offered to give

Dodsley a landscape drawing if he could get some more of the paper for him: 'upon my honour I would give a Guinea a Quire for a Dozen quire of it'.

A rough count brings up about 50 landscape paintings and 325 portraits painted by Gainsborough in Bath between the end of 1758 and autumn 1774. Allowing perhaps a year of low production during his illness, this suggests Gainsborough might complete 24 or 25 portraits of all sizes annually. This is a serious workload, and although there will have been seasonal pressure points it is not a crazy one, nor unmanageable. When pressure on him built up, Gainsborough tended to put his smaller portraits on one side – note the interminable pausing of the portraits of Fanny Unwin and Mrs Saumarez – and spend more time on full-lengths. These naturally brought in more money and bolstered his reputation. It generally followed that the commissioners of the larger portraits were much grander than those who ordered the smaller ones, so they themselves needed greater personal attention and esteem from the artist to be satisfied. Thus the world wags. But also, there is a suspicion that he enjoyed painting larger portraits. The expansion of scale allowed him to become more gestural, more painterly in his approach to the canvas, to allow him full rein to use his long brushes, and to enjoy the physicality of painting and the process of lighting and relighting in daylight and candlelight the surface of the canvas and the face of the sitter as he progressed with a 'performance'.

This relatively modest number of portraits per year left room for his landscape-painting endeavours, and suggests that if he felt pressured it was not necessarily on account of a busy coming and going of clients, but because he pressured himself by adding a goodly number of landscape inventions into his daily mix. It may have been in Bath that Gainsborough began his practice of constructing his landscapes as tabletop models using broccoli, moss and stones. William Henry Pyne, years later to write *Wine and Walnuts* as 'Ephraim Hardcastle', was thirteen or fourteen years old when he first met Gainsborough and watched him at work on his models. This will have been in London in the 1780s, as Pyne was too young to have known Gainsborough in Bath, and was probably Pyne's first encounter with the artist, an association

that would lead to his making a career out of extemporising on Gainsborough's character.

> I have more than once sat by him of an evening, and seen him make models, or rather thoughts, for landscape scenery, on a little old-fashioned folding oak table which stood under his kitchen dresser, such as one seen . . . by the fireplace of a little clean country alehouse . . . this table, held sacred for the purpose, he would order to be brought to his parlour, & thereon compose his designs. He would place cork or coal for his foregrounds & make middle grounds of sand and clay, bushes of mosses & lichens, & set up distant woods of broccoli. [16]

At the very least, this shows how easy with company Gainsborough was when he worked on his landscape inventions. The actor James Quin also remembered Gainsborough's joy and painterly energy: 'Sometimes, Tom Gainsborough, the same picture, from your rigmarole style, appears to my optics the veriest daub – and then, the devil's in you – I think you a Van Dyck.'[17] Quin tempered this with a suggestion of potential mood swings: 'If a portrait happened to be on the easel . . . he was in the humour of a congenial growl at the dispensation of all sub-lunary things. If, on the contrary, he was engaged in a landscape composition, then he was all gaiety – his imagination in the skies.'

Nonetheless, pressures there were from clients, and there is a touch of embarrassment or guilt in his letters to Richard Stevens MP, already a small-portrait patron, about delays to the delivery of his portrait of Stevens' sister, Mrs Awse. He had let things slip in 1767, and his letter to Stevens is encrusted with irrelevant metaphor, which itself speaks volumes. He might have been more careful; as a Member of Parliament, Stevens did not lack influence. 'I was tempted to exceed the bounds of good manners in keeping Mrs Awse so long as my situation now requires all the sail I can croud: the truth is Sir, I suffered some hardships in the first part of my Voyage and fancying now that I see Land makes me forget myself. I will send it immediately.'[18]

He then witters on about the frame, and its possible inadequacies, and, not letting the subject drop, writes again about the problem the framemaker had, and the high cost of the frame, and

how he hardly makes anything on portraits (not true), and could Stevens please pay for the packing case because his wife insists he charges. There is fluster here, with too much information being blurted out about what are in the end two Gainsborough portraits which are by no means his best. Gainsborough's embarrassed request to Richard Stevens about the packing case reflects also on the financial dynamics within the Gainsborough family in Bath: 'PS Packing Case cost me 7 shillings which my Wife desires me always to remember and I often forget Voluntarily because I am afraid to mention it.'[19] Margaret, living on the premises, could see what went on.

Given the lack of documentation, few portraits can be securely dated, but those that can, by letter, exhibition or invoice, may be seen as fixed points around which others can be gathered for comparison. As a painting producer, Gainsborough will have depended on an ecology of other trades to supply him with services: the colour-maker, canvas merchant, the framer, the transporter to carry his paintings to their purchasers. Among the framers in Bath and Bristol were James Paty of Broadmead, Bristol, and Thomas King and John Deare of Bath. Payments to them from Gainsborough or his clients come here and there, recorded in surviving invoices and other documentation.[20]

A trusted and efficient transporter was essential for the carriage of pictures from the painting room to the patron. Walter Wiltshire, a member of a successful local family of serial entrepreneurs, was one such, with additional interests in his 'Wiltshire's Assembly Rooms' in Bath, in the New Assembly Rooms on whose committee he sat, in the General Hospital, in the City Council of which he was a member, and in the local transport industry.[21] Wiltshire was everywhere. 'Wiltshire's Flying Wagon', which serviced Bristol, Bath and London, and points between, took advantage of the turnpike system, in whose development and extension in the region he was himself – of course – involved. The wagons covered the distance between Bath and London in two days and two nights: hardly 'flying', but not bad for a horse and cart.

When Gainsborough gets into his stride in Bath, in the early years of the 1760s, he appears, in his portraits of women, to paint

the same dress, or very close variations on it, again and again. Fashion moved slowly in the eighteenth century. Though changes in clothing style are marked across the years of Gainsborough's working life – such as the alterations he made to *The Byam Family* – the fact that clothes were all hand cut and stitched by milliners, dressmakers, and at home, makes it structurally impossible to measure the eighteenth-century rag trade against understandings of the global trade that we have become accustomed to in the late twentieth and twenty-first centuries. While smart clothes were handed down the social scale, so that early eighteenth-century aristocratic dresses might be worn in the mid and late century by housekeepers, actresses, courtesans and prostitutes, they will already by then have been well used at the higher end. It is un-likely that a woman attending a series of socially important balls in Bath would expect to have a new dress every time, just as a couple arriving at series of exhibition openings in Bath, London or New York today would not expect to come in a brand-new car for each new show. We see in Gainsborough's Bath portraits some remarkable similarities in the dresses: Mary Howe's magnificent pink dress, with its four tiers of lace flourishes at its sleeves, is echoed by the pink dress worn by Mary Carr in the three-quarter-length of 1763 to 1765,[22] the same years in which Gainsborough painted Mary Howe. A close variation of the dress had also ap-peared being worn by Mrs Dehaney, in the triple portrait with her husband, Philip, and their daughter, Mary.[23] The dress is again echoed, now in blue silk, as worn by Harriet, Lady Tracy, in the portrait of *c.*1763–5.[24] The multi-tiered lace at the sleeves of the Howe, Carr and Dehaney dresses are further echoed on the sleeves of the white silk dress of Mrs Henry Portman (1764–5),[25] while the serpentine ruched trim around Mrs Portman's gown is present again on Mrs Dehaney. And more: we can see the trim around the hem of Mrs Dehaney repeated in two tiers around the hem of Mrs Portman. So it goes on.

Since 1762, Mary Gibbon's millinery business, across the hall from her brother's showroom, was a source of an array of rich stuff, splendid hats, laces, ribbons and buttons. If Gainsborough's sitters desired to be painted in dresses that displayed the most conspicuous consumption, it was an added benefit that they need

not own the garment themselves, but could rent it or just allow
their heads and features to be transposed upon it. This therefore
raises the question: whose dresses were they? There are signifi-
cant payments in Gainsborough's accounts at Hoare's bank
to Mary Gibbon, though it is not shown what these payments
are for.[26] It is likely that he kept at least a dozen dresses in his
studio cupboard. Interestingly, while he corresponded with her
frequently, there appear to be no more payments made to Mary
Gibbon after Gainsborough left Bath for London in November
1774, when he had no more need to use her services as a milliner,
if he ever did.

Gainsborough's showroom and, for those who could get into it,
his painting room, was a destination in Bath. This became the
more so as the years advanced, particularly when in 1767, after
nearly ten years in the city, he and his family moved from Abbey
Street and Lansdown Road to 17 King's Circus. In the King's
Circus – it is now just known as The Circus – he was away from
the immediate racket of crowds and the bells, nearer to the smoke
of Bath, but, despite intermittent noise from the Assembly Rooms,
in a far classier part of town even than the house on Lansdown
Road. He had some seriously well-connected neighbours: the Duke
of Bedford, Sir Lawrence Dundas Bt, the Earl of Caernarvon,
Sir George Trevelyan, the Earl of Chatham and former Prime
Minister, William Pitt the Elder. He kept the lease on Lansdown
Road, placing advertisements for tenants in the *Bath Journal*, and
also retained his Abbey Street rooms and sublet them, making
about £300 a year in rent.[27] He did not own 17 King's Circus, but
rented it from the leaseholder Hugh Penny, just as Mary Gibbon
rented and sublet the next-door-but-one house from another
leaseholder.

Like all the houses in The Circus, number 17 is articulated
by applied paired columns in the classical orders of architecture,
on four storeys and a basement, with a parapet topped by acorn-
shaped urns. Inside, the two ground-floor parlours, with ceilings
of about fifteen feet high, originally ran front to back to the right
of the front door. One at least of these, with its shallow arch of
decorated plaster, will have been a showroom for his paintings.

Up a wide staircase, Gainsborough's painting room, also with a ceiling about fifteen feet high, was to the left, looking north over the garden, with what was another showroom to the front of the house, looking out over The Circus.[28] Going by the evidence of the stone around the painting-room window, Gainsborough arranged for his window to be much larger than was usual, to admit maximum light. This was becoming standard practice for him – the window in Abbey Street had been similarly enlarged – and those who worked with John Wood must have been expecting it.

From his painting room, Gainsborough could peep through the keyhole and look across the landing to the showroom. He could watch the visitors and see what they made of his pictures. As he said to one sitter, the fashionable preacher Rev. Dr William Dodd of Bath, 'I peep and listen through the keyhole . . . on purpose to see how you touch them out of the pulpit as well as in it. Lord! Says one, what a lively eye that gentleman has!'[29]

In 2017 The Circus has mature trees on a grassed central circle, but in the 1760s it was the slightly domed site of a reservoir, covered by a cobbled surface that filled the entire space. At number 17 Gainsborough could paint his largest canvases with relative ease, and have them lowered down between the sets of stairs for removal. He was now fully and properly set here as an artist of credit and renown. At the bottom of the garden – then probably a place of sheddings and domestic animals – was Gainsborough's mews, a building that survives intact, running across the back of number 17 and its neighbour towards Bennett Street. This generous-sized stone building, which had a door and at least two windows looking back towards the house, is a unique and miraculous survival after what was in 2017 exactly 250 years. It even retains the adjacent one-up one-down hovel, still with its original stone flags and fireplace, for the groom or stable boy. This long barn would have been home for Gainsborough's horses and carriage, and useful also for additional storage.[30] While the house has had cosmetic alterations to convert it to twentieth-century multiple occupancy, what seems to be the only surviving original front-door lamp in The Circus is in place and in working order above Gainsborough's own front door.

There were many visitors to Gainsborough's showroom, among

them, in 1770, Dorothy Richardson: 'We call'd at Mr Gainsbor-
oughs the Painters, to see his Pictures.' Two were finished and
ready to go: the Duke of Northumberland in full fig, with hat and
chain, sword and train, and Sir Robert Fletcher 'in regimentals
with his hat on, three-quarters etc'.[31] Six were still in progress,
and from Dorothy Richardson's very clear account we can observe
the rate of throughput in Gainsborough's painting room by now:

> the following had only the faces compleated, the Drapery being
> unfinish'd – Mrs Hudson of Bessingby with her hair dress'd in
> a High Tapee [i.e. toupée] & leaning on her arm full length.
> Lady Sussex & her little Daughter, full length; the former is
> sitting in white, with her Hair Powdered, & a Cap with Blue
> Ribbon; the Child stands by her in a White Frock lin'd with
> Blue, & a Blue Sash, her Cap dress'd in a very pretty whimsical
> Taste, with a great deal of Blue Ribbon – Mr Harley three quar-
> ters – A Boy & Girl at full length – An Oxonian in his Gown,
> leaning upon his Arm – & Lord Radnor three quarters.[32]

The completed faces and unfinished drapery remind us at the
very least that this was a two- or three-stage process, in which
only the earlier stages required the subject's presence. Dorothy
Richardson also noticed Gainsborough's copy of Van Dyck's *Pem-
broke Family*, some of his landscapes, and maybe a small Dutch
landscape, and Gainsborough's Rubens study of two old men. She
finishes by pointing out that 'Gainsborough paints only in Oil,
& excels most in Landscape; his Portraits are painted in a harsh
manner, but said to be strong likeness's, his landscapes are very
fine.'

But Dorothy Richardson then went down the hill to call on
William Hoare in Edgar Buildings. This is what she saw there:
'In the first room are his four children, 1st Miss Hoare leaning
upon Drawing books' – this may be the Miss Hoare who so en-
thralled William Whitehead. Then, '2nd a little Boy with a Top in
his hand – 3d a Girl Reading & 4th a Child holding a Portcrayon
& a paper with ABC & some rough lines upon it, to show it learnt
its letter & to draw at the same time'.

Hoare knew how to project his business, by hanging charm-
ing pastel portraits of his own children around his showroom.

Then there were some copies of old masters, 'a Madonna in Scarlet Drapery . . . a Venus looking up. The Choice of Hercules . . . & great many other Fancy Pieces all exceedingly fine.' Hoare knew his market and how to attract it. He offered a different kind of service to Gainsborough and his 'harsh' portrait style. Of Hoare she wrote 'I believe he is the best Crayon Painter in the Kingdom . . . if [his pictures] do not reach perfection, I am sure are very near it.'

Dorothy Richardson noticed Hoare's portrait of his children. We do not know if she had also seen in The Circus Gainsborough's full-length double portrait of his daughters, though that canvas may already have gone to its first owner, Richard Brinsley Sheridan.[33] This was the last time Gainsborough would paint Molly and Peggy together: dressed in flowing silks or satins, with their hair pulled back and piled up, he gives them the status of a pair of princesses, or of the daughters of the grandees from whom he made his living. This is a coming-out portrait tinged with sadness. Though on the threshold of adulthood, neither young woman seems particularly thrilled to be alive. They cling together for mutual protection, with the family dog, Tristram – named after Lawrence Sterne's *Tristram Shandy*, a book that, uniquely, Gainsborough might have read – looking in some concern, or desire, like them, for attention. Molly, the elder sister, is generally thought to be the one on the right, but even that is unclear. Gainsborough has caught here some sense of impending family tragedy, and allows no indication of a happiness that any father might at least pretend towards his daughters. While Gainsborough prepares to take the road back to London, his daughters, like orphans in the storm, appear to be unable to make the first step on their path to independent life.

26. At Wilton

Gainsborough generally disliked going 'to Lord's houses', or so he claimed.[1] Nevertheless, he made exceptions, some of which were to his distinct advantage in broadening his experience of art. In July 1764 he spent a week at Wilton, near Salisbury, the palatial home of the earls of Pembroke. This had been altered, improved and made yet more splendid by the genius of the elderly Inigo Jones and the fortune of the 4th Earl just over one hundred years earlier. By the 1760s Wilton was peppered with classical sculpture, hung with fine portraits, and alive with English wealth and history. The then Lord Pembroke, Henry Herbert, 10th Earl, was an energetic, ambitious, courageous but unpredictable man, later described by his son as 'perhaps . . . the most unaccountable of all human beings'.[2] He was married to Elizabeth Spencer, the daughter of the Duke of Marlborough, but had eloped with Kitty Hunter, an MP's daughter, and had a son by her. To the child he gave the inventive names Retnuh Reebkomp (an anagram of Hunter and Pembroke), and went back to his wife. By comparison, Gainsborough was sense and sobriety itself.

Pembroke was 'horse mad', by his own admission, and a brave soldier. He was by now Colonel-in-Chief of the 1st Royal Dragoon Guards, having fought in Germany in the Seven Years War. Following his passion, he built a formal riding school at Wilton, a high square space, a cube room for equestrian display to echo Wilton's cube rooms for human display. There he trained horses and riders for *haute école* in the continental manner, and for war. Strict rules of deportment, presentation and movement were practised there, all evidenced by the series of gouache studies of equitation by Baron d'Eisenberg at Wilton, and paintings by David Morier. Pembroke was the author of the influential *A Method of Breaking Horses, and Teaching Soldiers to Ride* (1761) in which the care and concern for the well-being of the horse was paramount. The care for the rider was not forgotten: "Tis necessary that the greatest

attention, and the same gentleness, that is used in teaching the
horses, be observed likewise in teaching the men, especially at
the beginning.'³ Wilton's riding school, comparable to those at
Bolsover Castle and Welbeck Abbey, was no ordinary stable, and
it was there, among his wonderful horses, that Gainsborough was
bid.

His purposes were evidently mixed. At Wilton Gainsbor-
ough could see and experience a great house, he could observe
the grandee inhabitants and their staff, he could watch, ride and
enjoy the Earl's horses, and he could study Pembroke's collection
of classical sculpture brought to England from Italy by the Earl
of Arundel in the early seventeenth century. Most important of
all he could look closely at portraits of the Pembroke family by
Anthony Van Dyck, commissioned by the 4th Earl, and of Charles
I and Queen Henrietta Maria and their children. But more: the
Earl also had portraits by Clouet, Holbein, Lely, Hals, Rubens
and Rembrandt, and an imposing set of views of Wilton and its
grounds by Richard Wilson. With its art and horses, Wilton had
almost everything Gainsborough might desire. This encounter
would refresh Gainsborough's mild professional interest in sculp-
ture, but much more transformative, it would lead to a group of
serious and substantial paintings with which he would set his seal
on his position as the supreme English portrait painter practising
outside London; a king in exile.

Peter Muilman had long preceded Gainsborough to Wilton.
He and Richard Chiswell had been there on the tour they made
together in 1735:

> Three miles from Salisbury is Wilton Lord Pembroke's seat
> remarkable for the greatest collection of antique Statues in
> England, and indeed almost the only one . . . There are many
> Rooms set all round with these Statues, one particularly
> wherein are the Caesars is very curious.
>
> There is a Noble Room where there are several Family pieces
> done by Van Dyck: and there is a celebrated picture of his, it is
> a group of painting representing this lord's great grand father,
> grand father, and his three Uncles; a daughter in law; and his
> son in law Lord Carnarvon & his lady finely done.⁴

Muilman and Chiswell had been tourists: they had also looked around Blenheim and Badminton on the way. Gainsborough, however, was at Wilton to work, as he tells Unwin, and simply to enjoy being there. He was there 'about a Week, partly for my Amusement, and partly to make a Drawing from a fine Horse of Ld. Pembroke's, on which I am going to set General Honywood, as large as life'.[5]

The sitter would be General Philip Honywood, of Marks Hall, Essex, a soldier, later an MP, who came from an illustrious equestrian military family which included his uncle General Sir Philip Honywood, Governor of Portsmouth, and Pembroke's predecessor as Colonel-in-Chief of the regiment. The thread that ran between the younger Honywood and Pembroke was their distinguished soldiering careers, the honour of their regiment, and the horses and equitation that were their mutual passion. They knew each other well. Honywood knew Gainsborough also: he and the painter had arrived in Bath across the same weeks in autumn 1758, and both will have been early apprised of each other's presence, Gainsborough because he was on the make, and Honywood because Gainsborough put himself about. The final tie that bound these three men together – aristocrat, soldier, artist – was their mutual passion for horses, and Gainsborough's practised skill as a horseman. What would come out of Gainsborough's week at Wilton drawing horses, and taking in all he could of the house, its collections and its grounds, was the largest canvas he had painted to date, almost ten feet square, of General Philip Honywood.[6] When Gainsborough told Unwin that Honywood would be 'large as life', he meant it: the general was six feet three inches tall – and on that canvas, were he to get off the horse, he would be.

The immediate source for the portrait of this fine soldier is unmistakably Van Dyck's equestrian portrait of Charles I, which itself traces back to Titian and antiquity.[7] In evoking this source so blatantly, however, and at a scale traditionally reserved for monarchs, Gainsborough is aiding and abetting his patron in saying to the ruling classes 'but look at me', and allowing a fairly ordinary army general to display himself in a self-serving portrait at a scale that was practically a social affront. Gainsborough makes an

equally clear nod towards the portrait of Philip Honywood's uncle General Sir Philip, who Bartholomew Dandridge had painted in high baroque style, and at the equestrian portraits of Pembroke and his soldiers at Wilton by Morier.[8] The scale of the Honywood canvas, larger yet than *The Byam Family*, indicates Gainsborough's clear ambition to handle grandeur as well as intimacy, as much as it indicates Honywood's own desire for grandeur.

Nevertheless, he is still being bugged by his memories of Great Baddow, the Essex village that had so detained him in his youth. Whatever it was that happened there had the power to affect him fifteen or more years later. Real life always obtruded. In the same letter in which he tells Unwin he has just got home from Wilton, he writes:

> With regard to your Baddow Friends, when you hear them touch my Character, you may assure yourself that they attempt a thing as ridiculous to the full, as if I undertook to draw their Pictures without ever having seen them, for they know nothing of me. That you know the worst of me, I am not sorry for, because I know you have good sense, & Good nature to place things in their proper light; that they have either of those blessings, who held me up to be viewed by you & Mrs Unwin (who, for aught they knew might have been strangers to me) is not quite so clear. However, My Wife's Compliments attend Mrs Itch in here.

In the margin beside his expression 'Mrs Itch in here', clearly a joke at Mrs Itchener's expense, Gainsborough has drawn a short vertical ink line, swollen at the upper end, and surrounded by a cloud of small pen marks. It is impossible to interpret, in its context, this piece of signage as other than representing a vulva cleft surrounded by pubic hair. It ranks in laddishness with the penis drawn fifteen years earlier on Mrs Andrews' skirt. It may be that Mrs Itchener had not been such a friend to Gainsborough after all, but perhaps, had she been Margaret's guardian all those years ago, she had become a source of malicious gossip which induced a fit of pique in Gainsborough's volatile temperament, momentarily masking the profound effect that Wilton and its opportunities had had on him.

Marginalia in letter from Thomas Gainsborough to James Unwin,
10 July 1764.

The collection of Van Dyck portraits then (as now) at Wilton, and
portraits by such other great seventeenth-century masters, pro-
vided Gainsborough with an unrivalled source of inspiration. Van
Dyck's portraits of Charles I, Queen Henrietta Maria, the royal
children and the enormous – seventeen by eleven feet – group
portrait of the 4th Earl of Pembroke and his family dominated
the Double Cube Room. Here was the *ancien regime* restored to
its former social position in the decades following the Restoration
of the monarchy. In one of the grandest rooms in England, one
to rival any in Europe even including Versailles and Venice, the
British ruling classes were back as they had been, painted by the
Veronese or Tiepolo *de leurs jours*. Restored not only were their
persons, costume and attitude, but also their status as a reminder
and reassurance for their successors.

Thomas Gainsborough, a slight, fragile figure who only
nine months earlier had been declared dead, stood alone in the
panelled and gilded splendour of the Double Cube Room whose
ornate painted ceiling rose thirty feet above his head. The vision
of inheritance that Van Dyck created for the Pembrokes was now
announcing itself to Gainsborough and indicating a way to the
future that would celebrate, honour and display the iconography
and fashion of the *status quo ante*. Perhaps in the same sheaf of
drawing paper on which he made the lost drawings of Pembroke's
horses, he now made studies of Pembroke's forebears. Prob-
ably quite soon after returning home, Gainsborough painted a

four-foot-wide version of Van Dyck's *Pembroke Family* both from his studies and from memory. 'Painted from memory, after having seen the original at Wilton' was the official Gainsborough family line on the study's genesis, as published in the catalogue of the sale of the contents of the artist's studio after his death.[9] However, so close is it and Gainsborough's other oil studies to their complex original that memory must have been additionally prompted by their being painted there and then in Wilton's Double Cube Room.

27. The continual hurry of one fool upon the back of another:

Howe, Dartmouth, Ligonier and a charming old Duchess

Gainsborough came home from Wilton, his world turned round by those few days with Van Dyck, Rembrandt, Rubens and Hals. They silently showed him the benchmark against which he could measure his attainment as a portrait painter. While they provided his living, Gainsborough might have reasonably felt that Bath was full of horrible people, scrambling over each other to have a good time. Christopher Anstey expressed it as only he knew:

> Or to Painter's we repair,
> Meet Sir Peregrine Hatchet there,
> Pleas'd the artist's skill to trace
> In his dear Miss Gorgon's face:
> Happy pair! who fix'd as fate
> For the sweet connubial state,
> Smile in canvas *tête à tête.*[1]

He had his share of the Sir Peregrine Hatchets and the Miss Gorgons. He also had the vain and hungry George Lucy who complained when he had to sit for two hours straight. 'I was with Mr Gainsborough on Monday last from two of the Clock till four, by which I lost my dinner.'[2] The Hatchets and Gorgons could come as they pleased, so long as they paid his fee; but then Mary Howe walked through his door (Pl. 40). This was Lady Howe, the elegant and self-possessed wife of the sailor Richard, 4th Viscount Howe, an aristocrat by inheritance, but by profession a celebrated naval captain. He had been on Admiral Vernon's staff, and had spent a good few years in command of ships shooting up the Spanish in the West Indies, the French in the Channel, and opening what would become a great naval career as his life developed. But now, while appointed to the Admiralty and Treasurer

to the Navy, as well as carrying out the none-too-onerous task of serving as MP for Dartmouth, he was in dock in Bath suffering from gout. His wife, however, more engaged by shopping than shipping, had time on her hands.[3]

Mary Howe clearly electrified Gainsborough, and whatever the intentions may have been at the outset, within the year Gainsborough was engaged on a pair of full-length portraits, one of Richard Howe, the other of his wife. Richard Howe leans elegantly against a rock, as any Grand Tourist might against a broken pillar in the Roman campagna (Pl. 39): Gainsborough had depicted many men that way. Howe is dressed in full fig, his legs are crossed at the ankles, and he is indeed a fine fellow in his white silk waistcoat and blue undress naval commodore's uniform with its gold trim. His buttons shine in the light, but he, strangely enough, does not, and he fails to engage the viewer with his eyes. He is distinctly unengaging, even grumpy. His gout must have given him great pain, and is it this pain that Gainsborough reflects, or the pain of marital discomfort? This is a considered portrait, painted with reflection and rumination over time, and we can perhaps expect Gainsborough to transmit what Howe showed him. He may here be remembering Thomas Page's injunction of 1720: to choose 'a fit Posture agreeing with his nature'.[4] Mary, on the other hand, grabs the attention of all who look at her, no doubt as she first attracted Richard Howe himself when they met.

Mary Howe had no aristocratic background; she had been Miss Mary Hartopp from Devon, her father, Chiverton Hartopp, was a wealthy landowner in Nottinghamshire and Leicestershire who became Governor of Plymouth. She and Richard married in Devon in March 1758, and, following the death in action of his elder brother, Richard Howe became the Viscount, and, that same October, he and his new wife came to Bath as Lord and Lady Howe.[5] It may have been on that visit that Gainsborough, newly resident in Bath himself, came to paint Howe's head-and-shoulders portrait.[6] Six years later this golden couple returned to Bath with their young daughter, Sophia. When they walked into the painting room it was naturally Mary, rather than her husband, who caught the artist's eye.

Gainsborough made no attempt to rhyme or coordinate these

portraits, as his husband-and-wife portraits generally are. They both tend from left to right, rather than assent to be in each other's company by looking in each other's direction. Richard looks somewhat wistfully, even crossly, over towards Mary, not quite able to make contact with her, not quite able to make her out. They are in different landscapes, different worlds: there is what seems to be an estuary behind Richard, beckoning him to sea again, while Mary is in a dusky wooded deer park, with a hint of mountains, and a weedy damaged tree. The portraits hung together until at least the end of the century in the Howe's house in Grafton Street, Mayfair, but they are separated now. Mary, sold in 1888 to Agnew's, is now in the Iveagh Bequest, and is one of the glories of Kenwood House. Briefly they were shown together at Kenwood in 1988, but there, even there, they seemed estranged.

Mary's sumptuous pink silk dress, partially eclipsed by a fine embroidered silk gauze pinafore, and offset by the black slash of her velvet bracelet, catches the dying light and fills the painting with colour. It is a wonderfully rich and zesty piece of painting of enlivening stuffs that may have come from Mary Gibbon's millinery shop downstairs. The breath of Van Dyck flows over and around the portrait, and indeed the pose is derived from the figure of Lady Mary Villiers in the foreground of *The Pembroke Family*. Mary Howe's seductive gaze immediately offsets the movement in Gainsborough's free brushstrokes. Her skin is pale, her smile subtle and meaningful, her step direct towards the viewer and away from Richard. The sharp line of her straw Leghorn hat somehow denies the murky weather that Gainsborough has set up for her, and supplies a cutting edge that emphasises the languor of her eyes. This is Gainsborough at his best, showing what he could do for a client at a loose end in Bath. Mary Howe is voluptuous like Ann Ford, but unlike Ford she retains her decorum.

Two graphite-and-chalk drawings by Gainsborough have survived of a woman in a Leghorn hat, and wearing a rich silk dress.[7] These may be studies of a model such as Molly or Peggy posing for the composition, rather than Mary Howe herself. A third related drawing is of a plainly younger woman in a long working dress and apron, which must be one of Gainsborough's daughters;[8] indeed all three may be a Gainsborough daughter. Regardless of

who posed here, the drawings do as a group indicate clearly that when he was of the mind to do so, Gainsborough would make particular effort to evolve a composition, rather than repeat a stock pose as he does with Richard Howe's portrait.

Gainsborough had to get his portraits set up, underway, completed and dispatched across a restricted length of time, while always, as far as he was able, remaining polite and courtier-like towards his clients. When the elderly Mary, Duchess of Montagu, came to the King's Circus painting room in 1768 she brought her black servant Ignatius Sancho with her. Across two, perhaps three, sittings, Gainsborough painted an elegant, humane portrait of a grand woman, gradually ageing, and approaching with dignity the end of her life. By whatever prompting, and through whatever protocol, Gainsborough also painted a striking and affecting portrait of Sancho in a single session that is recorded by an inscription on the reverse of the canvas as having taken one hour and forty minutes.[9]

Ignatius Sancho was no ordinary servant, black or white. Having been born in the late 1720s on a slave ship en route to the Spanish colony of New Granada, now the nations on the northeast quarter of South America, he became an orphan, and was taken to England by his owner and given to a family of three maiden sisters in Greenwich.[10] He must have been short and plump, because the sisters called him Sancho, after Don Quixote's servant Sancho Panza. He soon found service with the Montagus, nearby at Blackheath, and rose to be the 2nd Duke's butler. When the Duke and then the Duchess died he was left a generous lump sum and an annuity. That might have been that: he squandered the money on wine, women and gambling, and then attempted to become an actor, playing Othello in a disastrous production in 1760, which appears to have failed on account of what was thought in Sancho to have been a speech impediment.[11] With his last penny spent, he was taken on again by the 1st Duke of Montagu of the new creation, and saved from destitution.

The man Gainsborough painted was thus much more than a ducal valet, but one who had been through precarious times, saved from slavery, death, destitution and ignominy, and who had a story to tell. Did Gainsborough winkle his story out of him

there and then, for tell his story he would, in a unique series of letters published in 1782 in an edition enhanced by Francesco Bartolozzi's stipple engraving of Gainsborough's portrait. So whether Gainsborough knew of Sancho's talents and experiences when he painted him in 1768, he would certainly have known of them fourteen years later. Ignatius Sancho will not have been the only servant accompanying a grandee to Gainsborough's painting room; nor was he likely to have been the only black servant to do so. Nevertheless, Sancho was the only accompanying member of a domestic staff that Gainsborough seems to have paid serious attention to, sufficient to draw a portrait from him, at least until he came to paint Samuel Whitbread's brewing staff in the 1780s. This can only be on account of Sancho's history, connections and personality. In the gap between his employments with the Montagus, Sancho had become friends with David Garrick, Felice de Giardini and the Rev. William Dodd. He was an active abolitionist, and corresponded on the subject with Lawrence Sterne. Sancho, like Gainsborough, was part of the flow of thespians, artists and literati in London and Bath, and thus it is likely that he and Gainsborough were already acquainted, by reputation if not in person, before he walked through the door carrying the Duchess of Montagu's mantua. Sancho's portrait, therefore, might be classed as the portrait of a friend and fellow artist, rather than a portrait of a client sitter's servant.

The following year the Earl and Countess of Dartmouth called. These were sitters from hell, nice at first, no doubt, but very difficult later. They came to Gainsborough with Dartmouth's step-brother Lord North in tow, and sat for their portraits in April and May 1769. There was some initial studio chit-chat, in which North took part, about people wanting to be painted in fancy dress, and how ridiculous that was. What the Dartmouths (and North, then Chancellor of the Exchequer, but within nine months Prime Minister) may not fully have realised was what most people knew: that if you commissioned William Hoare, you got a Hoare, Joshua Reynolds a Reynolds, and Thomas Gainsborough a Gainsborough. The mistake the Dartmouths seem to have made was that while they were indeed commissioning Gainsborough, what they actually wanted was a Reynolds. So began, two years later,

a correspondence across ten days in April 1771, long after the portraits had been done, delivered and paid for, that drew three extremely polite and explanatory letters from Gainsborough to Lord Dartmouth. Dartmouth's letters are lost – thrown away in a general clear-out of Gainsborough's studio probably; but Gainsborough's responses to Dartmouth do survive. What they make clear is not only his noble patience and reserve when dealing with people, but, by the way, they also give a vivid and unique insight into his approach and (were he a physician) his bedside manner.

Gainsborough first knew that trouble was brewing when he heard that Lord Dartmouth wanted to return the portrait of his wife for alterations. The portrait of the 2nd Earl himself is not mentioned, nor returned, so we can safely assume that that half-length was just fine: 'I shall be extremely willing to make any alterations your Lordship shall require, when Her Ladyship comes to Bath for that purpose, as I cannot (without taking away the likeness) touch it unless from the Life.'[12]

Gainsborough goes on to explain, with all due deference, that if it was really necessary he would paint another of Lady Dartmouth for the same fee, but 'next to being able to paint a tolerable Picture, is having judgement enough to see what is the matter with a bad one'. The painting-room banter with the Dartmouths and North had stuck in Gainsborough's mind: he recalled 'a few impertinent remarks of mine upon the ridiculous use of fancied Dresses in Portraits . . . Lord North made us laugh in describing a Family Piece His Lordship had seen somewhere'. Gainsborough always recommended that his sitters wear their own, contemporary, dress, and evidently the Dartmouths had insisted on fancy or vaguely classical dress for the portrait of Lady D., just as Reynolds might present her, and Gainsborough had been persuaded to do so against his better judgement: 'I will venture to say that had I painted Lady Dartmouth's Picture, dressed as Her Ladyship goes, no fault (more than my Painting in general) would have been found with it.' In other words, 'it looks awful; I told you so'. He must have regretted the conversation in the painting room, and giving way: 'Nothing is so common with me as to give up my own sight in my Painting room rather than hazard giving offence to my best Customers.'

That is the burden of this as any portrait painter: where does he draw the line between the sitter's demands and his own advertised manner of painting, the reason he was approached in the first place? In Gainsborough's view, fancy dress takes away likeness, 'the principal beauty & intention of a Portrait'.[13] 'You see, my Lord, I can speak plainly when there is no danger of having my bones broke, and if your Lordship encourages my giving still a free Opinion upon the matter [I will write again and do so].'

And so he did, five days later. He will start again from scratch, he tells Dartmouth, but listen here: first of all he will have a go at the original, to try to convince the Dartmouths that his way is best, and 'try an Experiment upon that Picture to prove the amazing Effect of dress . . . and dress it (contrary to Lady Dartmouth's taste) in the modern Way'. He will risk Lady D.'s fury, but before he starts he needs to know if she powders her face or not.

Dartmouth must now have pressed Gainsborough for a full setting out of his views. So he gives it to him straight: 'Here it is then. Nothing can be more absurd than the foolish custom of painters dressing people like scaramouches, and expecting the likeness to appear.'

Portraits are not actors moving on stage, he reminds Dartmouth, but 'a face, confined to one View, and not a muscle to move to say here I am . . . [Like a tune] confused by a false Bass that if it is ever so plain simple and full of meaning it shall become a jumble of nonsense, and just so shall a handsome Face be overset by a fictitious bundle of trumpery of the foolish Painter's own inventing.'[14]

That was a clear and unequivocal setting down of his beliefs as a portrait painter, and it is revealing that he uses music as an analogy: 'Forgive me my Lord I'm but a Wild Goose at best,' he added. One or other or both parties, Gainsborough or Dartmouth, was unhappy with the amended portrait, so Gainsborough began afresh as promised a smaller, more intimate, but also more contemporary and satisfactory, portrait of Frances, Countess of Dartmouth.[15]

The Howes came to Gainsborough probably because Richard had commissioned Gainsborough once before. Mary liked the

result, and now there Gainsborough was, living and working in Bath. The Dartmouths came because Gainsborough was the resident Bath artist they thought they preferred. Another more recent customer approached Gainsborough in Bath because they had done business before: this was George Pitt, a career diplomat, MP for Dorset, and ambassador to Turin and subsequently Madrid. Gainsborough had painted a full-length portrait of him, exhibited at the RA in 1769, and now Pitt wanted more. Pitt was a particularly unpleasant character: the *Royal Register* described him as 'well-bred, accomplished, and debauched. He ill-treated his wife, the most charming in the world, who loved him till he deserved to be hated.'[16] This 'brutal half mad husband', as Walpole described him,[17] was not perhaps the most effective of British ambassadors: 'George Pitt is coming home from Turin,' a contemporary wrote, 'they say mad.'[18] His ambition for a peerage was obsessive: to Lord North, now Prime Minister, he wrote: 'your Lordship cannot be surprised that I should now use my utmost endeavour to obtain for my family, what they have so clear right to expect, and which ... I am so perfectly authorised to continue to solicit by every means in my power.'[19]

It may (or may not) be significant that Pitt only seems to have commissioned from Gainsborough a grand portrait of himself, dressed as the Colonel of the Dorset Militia, and not a portrait of his abused wife, Penelope. He was, however, keen to engage Gainsborough again the following year to paint his eldest daughter, also Penelope, and her husband. Penelope had been married since 1766 to the dashing and gallant army officer Edward Ligonier who, in April 1770, had succeeded to his uncle's title, becoming the 2nd Viscount Ligonier. The pair of portraits was intended to celebrate this ascendency that brought some pride to the Pitts, which was at last affirmed when in 1776 Pitt became 1st Baron Rivers.

Writing to James Unwin, who by now had moved to the grand house he had inherited in Staffordshire, Gainsborough described George Pitt as his 'staunch friend'. Pitt had invited Gainsborough to his country house, Stratfield Saye in Hampshire, a fine pile which in 1817 the government was to consider grand enough to buy as a gift for the Duke of Wellington. Gainsborough, however, expected 'only to spend two or three days ... by way of taking

leave of him ... before [his] going to Spain', but found himself
'prisoner' there for a month.[20] How Gainsborough could have
believed this manipulative man to have been his 'staunch friend'
is unclear, but manipulation manifests itself in many guises. On
arrival at Stratfield Saye Gainsborough found two whole-length
canvases waiting for him, and the young Viscount and Viscount-
ess Ligonier themselves there 'in readiness to take me prisoner
for a month's work'. No escape: Gainsborough had to settle down
to paint this couple before they would let him go (Pls 48 and 49).

And what an odd pair of families the Pitts and Ligoniers were
turning out to be. The Ligoniers, married now for nearly five
years, were as ill-assorted as George and Penelope Pitt. Ligon-
ier's first loves were the army and his horse; his wife's were
allegedly her husband's groom and the Italian poet Vittorio,
Count Alfieri. Gainsborough gives us a fine couple staring hard
towards each other, but avoiding the other's gaze, as if they were
poised for litigation. Ligonier vs. Ligonier. Their jaws are hard,
their poses, set in opposition to each other, are uncompromising:
they present each other with a crooked elbow and an arrogant
and aggressive stance of the hip. Fine Renaissance contrapposto
this may be, but it is the contrapposto of a couple at war. Could
they read that when they received the paintings? Who knows.
Gainsborough must have experienced stand-offs at home with
his wife; here he articulates the silent passion and mutual fury
of a Ligonier stand-off. This was an indulgence to Pitt, to whom
elevation to the peerage was a life goal, and for whom a portrait
of his ennobled son-in-law and daughter may have been a tactical
move. Edward and the younger Penelope certainly did not want
to be there; Gainsborough did not want to be there. Rarely have a
pair of portraits been painted under such strained circumstances;
rarely have a pair of portraits been painted in captivity; rarely
(before Goya) has controlled mutual loathing between a married
couple been so well expressed in a portrait.

It may be superfluous to discuss Penelope's fine flowing gown,
her head offset against the striking red of a curtain, and the soft
pale flesh of her breast. Nor should we perhaps linger on Edward,
evidently a handsome brute, whose horse is the most humane and
empathetic participant in the entire affair. When the portraits

were shown at the Academy in 1771 one critic was clearly unset-
tled: 'it is to be feared that such people as affect to be witty, will
say the horse is as good a man as his master'.[21] Life for the Ligon-
iers came very soon to a head. Penelope's infatuation with Alfieri
escalated until their 'mutual imprudence attracted the attention
of her husband',[22] and Edward challenged the lover to a duel with
short-swords in Hyde Park. This was on 1 May 1771; they were
fighting each other when only half a mile away their portraits
were on public show. Ligonier, the tried-and-tested soldier, rap-
idly gained the upper hand, wounded the incompetent Alfieri, and
called the duel off. Nobody died that day, but the marriage was
over. Alfieri prepared to flee with Penelope to France, but called
it off when he found she had been sleeping with her husband's
groom. No wonder the horse looks as if he knows it all; he did.
For our purposes, that was that. The affair was the talk of London
for months, and made even more sensational by the rapid publica-
tion of a novelette, *The Generous Husband; or, The History of Lord
Lelius and the Fair Emilia* (1771). As Gainsborough expressed it to
Unwin from Stratfield Saye, where he felt 'toss'd about like a ship
in a storm', the circumstances of the Ligonier commission had
burst his fuse and sent him wild with frustration:

> ... the curs'd Face Business. If you'll believe me, my Dear
> Friend, there is not a man in the World who have less time to
> call his own ... but the nature of face painting is such, that if
> I was not <u>already crack'd</u>, the continual hurry of one fool upon
> the back of another, just when the magot bites, could be enough
> to drive me Crazy.[23]

George Pitt's younger brother, General Sir William Augustus
Pitt, had married Richard Howe's sister; the Montagus were con-
nected to the Dartmouths through marriage. Thus the English
upper classes circulated and intermarried; thus Gainsborough
hitched on to their coat-tails and earned a fine living while gen-
erally giving excellent service. Nevertheless the vagaries of the
members of his client base in Bath caused him much pain as he
handed the money they paid him over to his wife. None, however,
was quite so ruthless and demanding as George Pitt, none other
imprisoned him quite like that on the pretext of friendship. But

even so, Gainsborough continued to call Pitt his friend: writing to Constantine Phipps two years later he recalled a long night they had just spent together – talking? drinking? looking at drawings?: 'By G— You are the only Great Man, except George Pitt, that I care a farthing for, or would wear out a pair of Shoes in seeking after . . . I intend you shall have a Couple of Drawings . . . as soon as I can please myself half so well as I did in keeping you up with little Sensible George 'til four o'Clock.'[24] Gainsborough's love of company was insatiable.

28. Friendship:

'Swear now never to impart my secret to anyone living'

------◆------

Gainsborough's friendship with David Garrick was fully formed in their Bath years. Garrick was a regular habitué of the place: he performed in his own plays at Orchard Street almost every year from 1750 to 1770,[1] and slipped into the Bath spirit. Garrick referred to Bath as 'this land of Circe': 'I do this, & do that, & do Nothing, & I go here and go there & go nowhere – such is ye life of Bath & such the Effects of this place upon me – I forget my Cares, & my large Family in London, & Every thing.'[2]

He and Gainsborough had Hatton Garden in common, where Garrick had performed in 1740, and Ipswich, where the actor was first announced on the bill, as 'Mr Lydall', in 1741. They both knew the entrepreneurial Joshua Kirby, who sold engravings of Garrick's portrait in Ipswich. Both had the Duke of Bedford as a patron, and they had William Hogarth and Francis Hayman in common as well. Garrick the terrifyingly talented young actor was part of the Covent Garden and St Martin's Lane crowd that had also swept up the young Gainsborough, so if Garrick did not immediately know Gainsborough, who was ten years younger, Gainsborough certainly knew of Garrick the bright star. As Gainsborough reminisced to the actor some twenty years later: 'I wished many years for the happiness of Mr Garrick's acquaintance and pray dear Sir let me now enjoy it quietly.'[3]

By the time they were together in Bath they were firm friends, becoming so because each recognised the madness of the other. This continued in London, where they had fun together at the Adelphi, at the Bull and Bush, and at James Christie's sales in Pall Mall, where together they barracked the audience, making asides and generally amusing everybody. Gainsborough was challenged by Garrick, a difficult, slippery subject, as perhaps he was as a man. Everybody took him on – Batoni, Dance, Hayman, Hogarth, Kauffman, Reynolds, Zoffany – but they were painting

a different man every time. The thrust of Adrienne Corri's book *The Search for Gainsborough*, published in 1984, is Corri's determined attempt to establish Gainsborough as the artist of an early Garrick portrait. In the mid 1760s Gainsborough set out to paint a full-length of the actor with a bust of Shakespeare, but although this was exhibited at the Society of Artists in 1766, it was to Gainsborough's mind a failure, and he worked on Shakespeare again, as a commission from Stratford Town Council, to honour both Garrick and Shakespeare in the Bard's bicentenary year, 1768. Apologising unnecessarily for what he called 'that shabby performance' of the first Shakespeare portrait for which he felt he had been overpaid, Gainsborough this time showed Shakespeare torn between Comedy and Tragedy. This too he thought was a disaster, and he angrily put it aside and threatened to cut it up. It survived, however, and a few years later Gainsborough painted it out, and covered it with a portrait of the musician Johann Christian Fischer, a man who would come to give him far greater grief.[4]

Gainsborough had difficulty with Shakespeare's features – 'damn the original picture of him . . . for I think a Stupider Face I never beheld'.[5] With Garrick's he had trouble also (Pl. 44), for he found he could not pin down an expression. Garrick was one of the few living people whose features confounded Gainsborough, perhaps because Garrick had the actor's essential ability to take on another persona and subordinate their own This was at first disconcerting, but then Gainsborough took it as a challenge to try again: at one point he felt that all he was getting was a portrait that 'does not as much resemble Mr Garrick's Brother as Himself'.[6] When at last he found some kind of likeness, what he caught was the inquisitive, questioning Garrick, a Garrick leaning forward to address you and you only, for Gainsborough's Garrick engages magnetically as he holds his book half closed and grasps your attention. That is how Garrick worked on stage, and this is how he performed for Gainsborough, but even he has failed to get beyond the face. It certainly did not help that Garrick kept trying different expressions when Gainsborough was painting him. He was playing games: he would raise his eyebrows and then drop them

when he was sketching in the eyebrows, and thought he had
hit upon the precise situation, and looked a second time at his
model, he found the eyebrows lifted up to the middle of his fore-
head, and when he a third time looked, they were dropped like
a curtain close over the eye . . . It was as impossible to catch his
likeness as it was to catch the form of a puffing cloud.[7]

'Rot them for a couple of rogues,' Gainsborough wrote to Thick-
nesse about Garrick and their actor friend Samuel Foote. 'They
have everybody's face but their own.'[8] But of course, that was their
job.

This creative block gave Gainsborough pause, and he expressed
it in the one other way in which he had clarity, in a letter. A new
actor turned up in Bath in October 1772, John Henderson, taking
Garrick's glory, and stealing his thunder as Hamlet. Gainsbor-
ough saw Henderson, billed as 'Mr Courtenay', in performance,
and reported back to Garrick:

An amazing copy of you has appear'd on our stage . . . for my
own part, I think he must be your Bastard. He is absolutely a
Garrick through a Glass not quite drawn to its focus, a little
mist hangs about his outlines, and a little fuzziness in the tone
of his voice, otherwise the very ape of all your tricks, and by
G— exceedingly sensible, humble & diffident . . . a knack for
slipping down boild Tripe . . . come out brilliant enough to split
ones ears.[9]

Those words, with their similes and colour, their fluidity and
shifts in meaning, and their touch of the surreal, are practically
the opening strokes of a Gainsborough portrait:

O that I could but touch his features, clean his Person, & sharpen
him out into a real Garrick. Face, Person & Voice, have fallen
to the share of no <u>one</u> Genius but yourself my Friend. Many
as great a Genius has been hang'd, but only yourself bless'd
with every requisite to the last minute touch,[10] so as to show
us <u>Perfection</u>. I'm sure it must please you to see the same thing
short of you, whenever you choose to turn your head back, as
the Jockeys do when they are near the Post.

Gainsborough it seems felt he could only get a side swipe at Garrick, catching him as if reflected in another's face or actions, or in his own peripheral vision. He verges on the obsessed when grappling with Garrick's image, and when writing to Henderson finds himself drawn back to Garrick as a moth to a flame. Bit by bit we do get a portrait out of Gainsborough, but it is progressed by other means: 'Stick to Garrick as close as you can for your life', he advised Henderson: 'you should follow his heels like his shadow in sunshine.'

> Garrick is the greatest creature living in every respect, he is worth studying in every action. Every view and every idea of him is worthy of being stored up for imitation, and I have ever found him a generous and sincere friend.[11]

Gainsborough goes round and round Garrick trying somehow to grasp him, but no good, he too is left with thin air:

> Look upon him, Henderson, with your imitative eyes, for when he drops you'll have nothing but poor old nature's book to look in. You'll be left to grope it out alone, scratching your pate in the dark, or by a farthing candle.

He found other actors tricky subjects to pull off: Samuel Foote bothered him, and Gainsborough came up with a dull portrait as a result, but nonetheless gives him a splendid waistcoat.[12] His *James Quin* (1763), however, reflects the rapport they found together, as Quin seems to pause in conversation, indicating the book he is holding, as the bust of Shakespeare hovers delicately in the background.[13] After Quin's death in 1766, Garrick wrote these lines which were inscribed on Quin's memorial in Bath Abbey:

> That tongue which set the table on a roar
> And charmed the public ear, is heard no more.
> Clos'd are those eyes, the harbingers of wit
> Which spake before the tongue what SHAKESPEARE
> writ.

Gainsborough too was a performer, and would agree with the Academy's assertion that works were 'performances' requiring

particular lighting, placement, a sensitive hang to make them tell. This is only what Garrick also required on stage. Like Garrick, Gainsborough expected a sensitive *mise en scène* to make his performances tell: '[I] beg of Mrs Garrick to hang it in the best light she can find out':[14] 'If you let your Portrait hang up so high, only to consult your Room . . . it never can look without a hardness of Countenance and the Painting flat: it was calculated for breast high & will never have this effect or likeness otherwise.'[15] In demanding breast height for this particular portrait Gainsborough is expecting the viewer too to play his part in the ensemble, to be held by Garrick's eyes. The portrait's owner had a duty to enable this.

For all Garrick's mesmerising abilities on stage and their admiration of each other off it, he and Gainsborough did have a fundamental difference of opinion over the strength and stridency of theatrical colour and sound. This came to a head in 1771 when Philippe Jacques de Loutherbourg, a Franco-German painter and stage designer, came to London. He fell into stage work with Garrick who rapidly discovered his inventive and innovative talent, one able to introduce mechanical jiggery-pokery and dramatic effects into the theatre. But tiring of financial crises and the conflicting demands of actors, de Loutherbourg went on to develop a landscape-painting career. Gainsborough and he found useful ways to collaborate, and certainly Gainsborough was aware of de Loutherbourg's stage work for Garrick from the beginning. It may have been de Loutherbourg's idea to increase the temperature of the colours used on the Drury Lane stage, and Garrick took to it immediately. Gainsborough, however, was disconcerted, and told Garrick so plainly: 'When the streets are paved with Brilliants, and the Skies made of Rainbows I suppose you'll be contented, and satisfied with Red blue & yellow.'[16]

Colour to Gainsborough was power, and it had to be handled with care. With characteristic verbal illumination Gainsborough condemned the overheating that de Loutherbourg was promoting on stage: 'It appears to me that Fashion, let it consist of false or true taste, will have its run, like a run away Horse; for when Eyes & Ears are thoroughly debauch'd by Glare & noise, the returning to modest truth will seem very gloomy for a time.' Gainsborough

went on to remind Garrick about their own joint experiments of a mildly theatrical kind, painting on glass, and how much more effective that was: 'I know you are cursedly puzzled how to make this retreat without putting out your lights, and losing the advantage of all our new discoveries of transparent Painting &c &c. How to satisfy your tawdry friends, whilst you steal back into the mild Evening gleam and quiet middle term.'

Then he suggested some solutions: 'Now I'll tell you my sprightly Genius how this is to be done. Maintain all your Light, but spare the poor abused Colors, til the Eye rests & recovers. Keep up your Music by Supplying the place of <u>Noise</u>, by more Sound, more Harmony & more Tune; and split that curs'd Fife & Drum.' Gainsborough is issuing a warning, and arguing for a return of calm and reflection to all art: 'Whatever so great a Genius as Mr Garrick may say or do to support our false Taste, He must feel the truth of what I am now saying, that neither our Plays, painting, or Music are any longer real Works of Invention but the abuse of Nature's <u>lights</u>, and what has already been invented in former Times.'

Gainsborough sent his portraits of Garrick to the Academy in 1770, de Loutherbourg in 1778, and Henderson in 1780. De Loutherbourg's is an affectionate and affecting portrait, one supreme creative artist with a paradoxical mix of conservatism and radicalism finding a cool, enquiring light of reason to illuminate his friend (Pl. 47).[17] It is a rapid, brushy work, head and shoulders, de Loutherbourg gazing up and out of the canvas, lost in a new idea. He rests his forearms on a couple of books lying on his table, his right hand stuffed into his waistcoat, a pose that was fashionable and probably characteristic. As in so many of Gainsborough's portraits of his friends, the key to this one is the eyes – grey irises, a careful curved delineation of the eyelid, a flick of reflected light, and, in the corner of the left eye, a touch of terracotta underpainting allowed to show through to give it weight. All this in little more than a square inch of canvas. The colours are muted and calm. While Garrick was following de Loutherbourg's ideas of bright colours on stage, here, with brown jacket and subtle touch of golden waistcoat, Gainsborough is demonstrating his own view, as expressed in that letter to Garrick. Gainsborough's portrait of

de Loutherbourg is an object lesson in how to handle colour, both for Garrick and for the sitter himself.

As an aspiring but frustrated musician, Gainsborough knew musicians and enjoyed their company in Bath and London, just as he had in Ipswich, though now there was perhaps less binge-drinking involved. Entering Gainsborough's life in Bath was a supportive and understanding new friend, of the calibre and empathy of James Unwin, but lacking Unwin's powers of reflection and sagacity. This was the musician William Jackson, organist of Exeter Cathedral, a composer of popular songs and instrumental pieces, and a frustrated painter to just the same degree as Gainsborough was a frustrated musician. They had a good, strong friendship that embraced and perhaps mirrored their several artistic weaknesses. However, Jackson was a better painter than Gainsborough was a musician.[18]

They probably met in the early 1760s, and what survives of Gainsborough's letters to Jackson begin in August 1767, though these may not have been the first between them.[19] Three times Gainsborough wrote to Jackson in August and September that year, a full-on conversation by correspondence about the merits of lacing landscape paintings with touches of history. Jackson suggested that such paintings should have historical narrative as a subsidiary theme, and must have urged Gainsborough to paint a subject such as the Flight into Egypt. Evidently, Jackson thought he knew what was good for Gainsborough: but Gainsborough disagreed. 'Do you consider', the painter replied briskly, 'what a deal of work history Pictures require to what dirty little subjects of Coal horses & Jack asses and such figures as I fill up with?'

> But to be serious (as I know you love to be) do you really think that a regular Composition in the Landskip way should ever be filled with History, or any figures but such as fill a place . . . or to create a little business for the Eye to be drawn from the Trees in order to return to them with more glee?[20]

Time is of the essence for Gainsborough. History painting simply takes too long, far longer than it would take him to paint some

quaint figures on their horses and donkeys in a fluffy landscape setting with no real narrative to speak of. He does not have the time, he has a portrait business to run; and anyway he prefers his landscapes peopled with locals, not with gods and Greeks. He wants to make that quite clear.

Gainsborough and Jackson knew each other well, and picked up each other's beat. 'But to be serious (as I know you love to be)' has a touch of irony; they might not have been serious very often in each other's company. They have been talking about painting, and it will transpire later in the correspondence that despite Jackson's reasonable, but in the other's view not realistic, ambition to be a painter, Gainsborough did try to give him some postal tuition. Jackson's reply came quickly. 'To show you that I can be as quick as yourself', Gainsborough shoots back, ''tho: I shall never be half a quarter too clever, I am answering your letter the very moment I receive it.'²¹ Gainsborough is concerned about his characteristic flippancy, which he frames in a wreath of smiles:

> 'Tho I'm a rogue in talking about Painting & love to seem to take things wrong I can be both serious & honest upon any subjects thoroughly pleasing to me . . . let me then throw aside that damn'd <u>grinning trick</u> of mine for a moment & be serious & stupid as a Horse.

He gets to the point. He is concerned for his friend: Jackson is not fulfilling his talent as a musician. Instead, Gainsborough says, you are

> daily throwing your Gift away upon <u>Gentlemen</u> & only study- ing how you shall become the <u>Gentleman</u> too – now damn Gentlemen, there is not such a set of Enemies to a real Artist in the World as they are, if not kept at a proper distance.

Gainsborough recognises that his own weakness is that he fails to focus firmly on anything. But he does know one big thing, and he puts it clearly to Jackson:

> many a <u>real Genius</u> is lost in the fictitious Character of the Gentleman . . . [Gentlemen] make no part of the Artist. Depend upon it Jackson you have more sense in your little finger than

I have in my whole Body & Head: I am the most inconsistent, changeable being, so full of fitts & starts, that if you mind what I say, it will be shutting your Eyes to some purpose.[22]

This is an extremely important and revealing letter, reflecting Gainsborough's profound awareness of what he perceives to be his own faults, and his clear-eyed analysis of his friend: 'Exeter is no place for a Jackson, than Sudbury in Suffolk is for a G[ainsborough].' They are both men for the metropolis: stop looking at other performers, Gainsborough tells Jackson, and consider your own rich talents:

'Tis mighty pretty to be sure to stand and admire another man hop upon one Leg, and forget the use of <u>two damnd long ones</u> ... Why Man you have as good a Stock of haberdashery about you as any of them all, if you had but the same hungry Eyes to look about you. Well after all Bath is a lively Place – not but London is above all. You underthimble me [word torn] hope no offence. I look upon this Letter as one of my most regular performances so don't let's have any of your Airs – I could say a deal more but what can a Man say pent up in a corner thus; if you was a Lady I would say what I have often said up in a corner by way of making the most of the last Inch. Yours up to the hilt. TG

They were good, lifelong friends, despite the underthimbling, whatever that was. There was a moment of concern for Jackson's health when he was living in Bath: shall he send for Dr Moysey, Gainsborough asks anxiously.[23] Another time Gainsborough hoped that Jackson might call on his way home from London to Exeter. Jackson had been to the exhibition of the Society of Artists in May 1768, and he told Gainsborough what he thought of his paintings on show there. His opinions are lost, but the artist responded: 'I will suppose all you say about my Exhibition Pictures to be true because I have not time[24] to dispute it with you ... I can always make up one Bed for a Friend without any trouble and nobody has a better claim to that Title or a better title to that Claim than yourself.'

Gainsborough tried to get Jackson the post of Receiver of Land

Tax for Devon, a post that gave status without being particularly onerous, and wrote to the Duke of Bedford to recommend 'this most worthy honest man'.[25] 'I have outdone myself in a letter to the Duke of Bedford ... I can draw a <u>Character</u> better than I thought for ... If my single plumper will do anything you'll soon hear.'[26]

Jackson did not get the job.

In drawing character in words, Gainsborough was as incisive as he might have hoped he could always be on canvas. On his way home from Exeter he was somehow waylaid by Lord Shelburne, who insisted he break his journey at Bowood, near Chippenham, 'and I don't repent going there (tho' I generally do to all Lord's Houses).'[27] This may have happened after Gainsborough had moved to London in 1774: he is unlikely to have broken a journey from Exeter to Bath at Bowood. There he met John Dunning, the barrister and MP for Calne, and later Lord Ashburton. There is no painted portrait of Dunning by Gainsborough – the peer was painted by Reynolds in the 1780s – but this intense portrait in words touches an aspect of Gainsborough that only very occasionally flashes out in his painting – the thoughts he processes while expressing the topography of a head:

> There is something exclusive of the Clear and deep understanding of that Gentleman most exceedingly pleasing to me. He seems the only man who talks as Giardini plays, if you know what I mean. He puts no more motion than what goes to the real performance, which constitutes that ease & gentility peculiar to damn'd clever Fellows, each in their way. I observe his Forehead jets[28] out, and mine runs back a good deal more than common, which accounts for some difference betwixt our <u>Parts</u> ... but he has an uncommon share of Brains ... He is an amazingly <u>compact</u> Man in every respect; and as we get a sight of every thing by comparison only, think of the difference betwixt Mr Dunning almost motionless, with a Mind brandishing, like Lightning, from corner to corner of the Earth, whilst a Long cross made fellow only flings his arms about like threshing-flails without half an Idea of what he would be at.

Then Gainsborough slips into metaphor: 'And beside that neatness in outward appearance, his Store-Room seems cleared of all French Ornaments and gingerbread Work, every thing is simplicity and Elegance & in its proper place; no disorder or confusion in the furniture as if he was going to remove.'

Jackson also knew Dunning, and the difference in what each found in this great and passionate lawyer is startling. Gainsborough discovered 'deep understanding' and a 'mind brandishing like lightning'. Jackson however noticed only that Dunning was 'perfectly insensible to the fine arts, and ignorant of every science except what related to his profession.' Here we have a fundamental divergence of view that puts perspective into the Gainsborough–Jackson friendship. Jackson has had a mixed press: Charles Burney, who had a musical spat with him soon after Gainsborough's death, described Jackson as being 'strongly alloyed by a mixture of selfishness, arrogance, and an insatiable rage for superiority'.[29] Samuel Taylor Coleridge described him to fellow poet Robert Southey as 'out of all doubt a bad man'.[30] But to Gainsborough he was 'a most worthy honest Man . . . extremely clever and good'.[31] Certainly Jackson was talented as a musician – 'one of the greatest Genius's [sic] for Musical Compositions England ever produced' in Gainsborough's overinflated view[32] – and by his own admission he was opinionated: 'Like Mr Shandy, I not only write my *Life*, but *Opinions*.'[33] Jackson seems to have been a man who crossed people, spoke his mind; a creative artist of some confusion, dissatisfied with the level of recognition he received. So indeed was Gainsborough. They were two of a kind, and found each other's friendship in a world that did not fully accept 'opinion' from an artist or a musician, what we might now call 'attitude', particularly when expressed to a 'gentleman' or a grandee. Painters and musicians, to the late eighteenth-century patron's mind, were there to amuse, entertain, provide and serve, so when Gainsborough told the Earl of Hardwicke that he had better go and buy an old master rather than 'encouraging a man out of his way', and when he spoke his mind to Lord Dartmouth, he is displaying the kind of attitude that risked dividing him from his source of income, but would bring him and Jackson together.

Jackson and Gainsborough corresponded freely about both

music and painting, and, probably around 1765, Jackson gave his friend postal tuition on musical theory, 'the nature of Modulation and the introduction of flats & sharpes'.[34] Gainsborough promised to play for Jackson when they next met: 'you shall hear me play extempore'. They bantered about a young woman student of Jackson whom they both knew, who Gainsborough was unsuccessfully trying to seduce. However, he found himself 'flung', that is, told to get lost: 'I dined with Mr Duntze in expectation (and indeed full assurance) of hearing our scholar Miss Floud play a little, but was for the second time <u>flung</u>; she had best take care [crossed out] beware of the third time, lest I <u>fling</u> Her, and if I do I'll have a Kiss before She is up again.'[35]

This is the vexed context of the famous passage in which Gainsborough goes on to confide to Jackson about his life: 'I'm sick of Portraits and wish very much to take my Viol da Gam and walk off to some sweet Village where I can paint Landskips and enjoy the fag End of Life in quietness & ease.'

Usually these lines are quoted without what immediately precedes and follows, masking the evidence that they were written in a moment of frustration and anger. As a result, removed from their context, they have become overinterpreted and cannot be relied upon as a true expression of Gainsborough's longing. His huge landscape oeuvre plainly shows that he already took advantage of every opportunity to paint landscapes, play his instruments, walk off to a village, enjoy quietness and ease, and so on. But now the floodgates have opened, and Gainsborough, having tried to keep off the subject by talking about music and the young woman he was fantasising about, poured his heart out to Jackson. His daughters were giving him grief; they could be grumpy, wilful and rude:

But these fine Ladies & their D—mnd [crossed out] Tea drinkings, Dancings, <u>Husband huntings</u> &c &c will fob me out of the last ten years, & I fear miss getting Husbands too. But we can say nothing to these things you know Jackson, we must Jogg on and be content with the jingling of the Bells, only d—mn it I hate a dust, the kicking up a dust; and being confined in <u>Harn[ess]</u> to follow the track, whilst others ride in the Waggon,

under cover, stretching their Legs in the straw at Ease, and gazing at Green Trees & Blue Skies without half my <u>Taste</u>. That's d—mn'd hard.

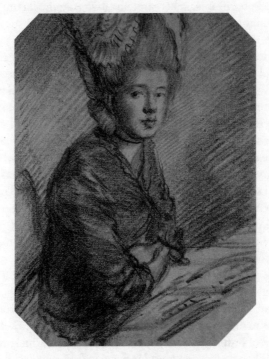

*Study of a Young Woman Seated
(Possibly One of the Artist's Daughters)*, ?1770s.

Gainsborough just hated a domestic scene. Life in Lansdown Road and The Circus must have been tricky for him, with a domineering wife, and two difficult teenage daughters, and a business to run, and clients to manage, and all the pressures of the art world of Bath and London, and then a pretty young student cuts up. Oh it was all too much, so he kept his head down, kept painting, and had some man-talk when he could with his friend. But then he perked up, and counted his blessings. He closed this letter to Jackson with a brief census of the delights that his friend would

naturally appreciate: 'My Comfort is, I have 5 Viol's da Gamba, 3 Jayes and two Barak Normans.'[36] Perhaps he ran his fingers over the instruments when he wrote this, certainly his eyes.[37] Today, a star of the art world might tell a close friend, 'My comfort is, I have 5 Lamborghinis, 3 Ferraris and two Aston Martins.' Their value as status symbols is broadly similar.

Where Jackson listened to Gainsborough's problems and gave him advice on music and musicianship, Gainsborough returned the compliment by mentoring his friend as a painter. Jackson was good with the pencil, but would become an accomplished amateur merely, not a professional artist, in exactly the same way as Gainsborough was no professional musician, fantasise as he might. Ever generous and helpful to his friend, Gainsborough broke a rule of a lifetime and told Jackson one of his greatest professional secrets: how he made the varnished drawings that had become his special trademark. 'Dear Jackson of Exeter', he wrote, recalling the rising artist 'Wright of Derby', exhibiting now in London: 'There is not a Man living that you can mention (besides your self and one more, living)[38] that shall ever know my secret of making those studies you mention.'[39]

He then gives a close and detailed account of how he made his varnished drawings. This *was* a secret, perhaps Gainsborough's closest and most valuable secret. The trick, Gainsborough revealed, is to draw on spongy purple blotting paper stuck down on to a sheet of ordinary white paper, to create a firm, thick, textured surface. Then make a rectangular wooden frame and stretch some sheets of tough paper across it, cutting out a hole to take the prepared drawing paper, half an inch smaller all round. This mount had to be thick and strong, because it would become the temporary stretcher for the drawing. Make your drawing in Indian ink and white chalk – NB: Bristol chalk is harder and better than London chalk, he found – and then dip it in skimmed milk. Make whatever changes you need and dip it in the milk again and let it dry. Add greens, browns, yellows and blues as you wish. Then with hot glue brushed on, stick the drawing into the thick paper mount 'so that when it dries, it may be like a drum.' Then float the whole contraption in gum arabic solution, take it out after a while, and when dry varnish it on both sides with three coats of 'Spirit

Varnish such as I sent you'. When all is dry and finished, and tight as a drum, cut the drawing out with a penknife, and there it is! 'Let any body produce the like if they can . . . Swear now never to impart my secret to any one living.'

The technique here assures that the drawing, and its temporary mount and stretching frame, are all under equal tension so will not tear apart until the process is complete. That is how Gainsborough, with his nimble, practised fingers, made his crisp and atmospheric, even moody, landscape drawings. The process gave them an aura of age and gravitas which was totally artificial and, with skill, repeatable. Anybody could do it with sensible application, and that is why Gainsborough wanted his secret kept. He knew it would be safe with Jackson. Gainsborough gave away many of the drawings he made by this method, having stamped them with his name in bookbinders' tools and given them an attractive decorated edge of tooled gold tape.[40] However, he never divulged how he had made them, only in writing to Jackson, a clear indication of his friendship and kindness. The stiffening recipe – skimmed milk, gum arabic and so on – suggests that a source for it may be found in Sudbury, in the stiffening of lace for shrouds, or, as a milliner's dressmaking trick, from his sister.

A patron who had become a friend, Constantine Phipps, later 2nd Baron Mulgrave, was another beneficiary of Gainsborough's instruction. The key point, he told Phipps, was to keep the wrist free and easy when drawing, but to be sure to distinguish between the different drawing techniques, as 'there must be truth of hand, as well as freedom of hand in Drawing'. Gainsborough set Phipps an exercise in drawing foliage to relax his hand and wrist: 'all I meant by scribbling of Boughs was to set your hand agoing'.[41] Once you can do that you can draw what is before you. Gainsborough recommended 'a little Plaister-Head upon a wire, like a Traitor upon Temple Bar, and draw away in your Closet, all round, in every View. When you can sketch the Outward form . . . then you may begin to express a little light & shade . . . but very faintly, and not before you can sketch freely.'

He proposed to send Phipps some plaster heads to draw by the next carriage from Bath, and offered to 'correct & examine or rather examine & correct' Phipps' drawings if he would post them

to him. 'Is this not a bright thought, to teach you to draw by Letter?'[42] The key thing was that the wrist must be relaxed. Six weeks later, Gainsborough, having been briefly in London, regretted not seeing Phipps and taking the opportunity 'just to shake you by the hand – who knows but a hearty Shake from me might have . . . shaken a freedom of hand into your Drawing for ever.'[43] Freedom of hand and wrist was something that Gainsborough had practised for years; he was doing so in the early drawings in the album at Windsor.

29. A little flirtation with the fiddle

The developing eighteenth-century road transport system transformed British life. For the purposes of this story, it made it so much easier and quicker for musicians, actors and artists to travel round the country. Thus, a musician could perform in London one day, and be in Bath to play a day or two later; an actor could enthral an audience in Bath, then do it again in Tunbridge Wells. It meant Gainsborough could get to Wilton with relative ease, to London regularly, and more or less wherever he needed to go. However, travelling as much as he did, Gainsborough ran the kind of risks on the road that everybody then faced. A pair of highwaymen attacked the carriage taking him and his musician friends Carl Friedrich Abel and Johann Christian Bach to London one fine moonlit night in June 1775. According to a court report they were 'about a half a mile or a mile beyond Hammersmith', so that would be somewhere near Gunnersbury. Gainsborough, 'in corporal fear and danger of his life', had his shagreen-covered pocket watch stolen, along with two guineas.[1] Bach, who had been snoozing, woke up suddenly when the highwayman gave him a poke, and surrendered his watch and money. This was one moment in a rapid and terrifying skirmish on the Great West Road, on 'as light a night as ever I saw', according to the evidence of John Edridge of Davies Street, Mayfair, another victim on that busy night for highwaymen. They put pistols to their victims' breasts, and ordered them to look down so they might not recognise the attackers. But in the moonlight Edridge saw one of the highwaymen clearly, and this led to conviction. It was all over very quickly, but the one victim who was perhaps the most observant in human physiognomy, Thomas Gainsborough, appears to have given no evidence against the attackers, for reasons we do not know – though quite possibly he did and it was not recorded by the clerk. Although we might hope to suggest that Gainsborough's humanity prevented his being complicit in a

conviction of two desperate men, this would not be the case. He had the year before expressed satisfaction at the hanging of two men who had stolen plate and jewellery from another friend of his, so he was no different to most of his contemporaries in his attitude to the death penalty.[2] Both Gunnersbury highwaymen were sentenced to hang.

We do not know where Gainsborough, Abel and Bach had been travelling from, but by June 1775 Gainsborough was living in London, so they could have been at Kew, where Sarah Kirby, now living as a widow, was weeks from death.[3] While they may have been returning from a musical performance at Windsor, it is equally possible that Gainsborough and his friends had been with Sarah in her final days. This journey with Abel and Bach was one of the many excusions Gainsborough took with his musician friends. While he exhibited some self-control in the painterly side of his life to keep his clients coming and wanting more, in his musical life it was rather the other way round. His friends, it seems, wanted less. Writing of their long friendship some years after Gainsborough's death, William Jackson tried his best to be impartial and 'speak of him as he really was'.[4] Jackson had come to know Gainsborough well, though perhaps not better than anybody else, as he claimed. However, he got to the heart of the matter when he pointed out that, while Gainsborough's profession was painting, and music his amusement, that sometimes appeared reversed: 'when music seemed to be his employment, and painting his diversion'.

Gainsborough's obsession with music infuriated his musician friends, many of whom found it very hard to tell him the truth. Jackson and Gainsborough both heard Felice Giardini give a violin concert in Bath, and, according to Jackson, Gainsborough was so bowled over by the performance that he wanted to buy Giardini's violin. It seems he succeeded. Jackson suggested that Gainsborough believed that the musical talent resided in the instrument, not the player: but he surely cannot really have thought that. Next he heard Abel play the viol da gamba, similar in appearance to the cello, and this made him discard Giardini's violin and buy Abel's viol. There is something akin to Mr Toad in *The Wind in the Willows* in Jackson's account, and Jackson may be

polishing the story up. 'Abel's Viol da Gamba was purchased, and nothing heard but melodious thirds and fifths from Morning to Night! Many an Adagio and many a Minuet was begun, but none completed – this was wonderful as it was Abel's <u>own</u> Instrument, and therefore <u>ought</u> to have produced Abel's <u>own</u> Music!'

Then he heard Johann Christian Fischer play the hautboy, an early form of the oboe, and, yes, he wanted that now: this was getting silly. However, he retained Abel's instrument, while going after the hautboy, which Fischer very sensibly refused to give up, and so Gainsborough acquired another. Of course, he could not play that properly: 'I never heard him make the least attempt on it – probably his ear was too delicate to bear the disagreeable sounds which necessarily attend the first beginnings on a wind instrument.'

Giardini, Abel and Fischer were supreme musicians of their day, as was to a lesser extent William Jackson. Gainsborough's behaviour astounded them all, and if Jackson's is an honest account it does seem to be an absurd way to go on. But there was more: Gainsborough next fell in love with the harp.

> He had heard a harper at Bath – the Performer was soon left harpless – and now Fischer, Abel and Giardini were all forgot – there was nothing like Chords and Arpeggios! He really stuck to the harp long enough to play several airs with variations.

Then Abel reappeared and

> brought him back to the viol da gamba. He now saw the imperfection of sudden sounds that instantly die away . . . the viol da gamba is the only Instrument, and Abel is the Prince of Musicians!

For a few years Gainsborough had 'a little flirtation with the fiddle', according to Jackson, until he heard the cellist Richard Crosdill play: 'but, by some irregularity of conduct which I cannot account for, he neither took up, nor bought, the violincello.' Jackson suggested that he might then have turned his attention to the [double] bass. How far can we trust Jackson's account, because it does get worse; there is a suspicion that Jackson is not recalling Gainsborough fondly: perhaps they had a falling-out. This is

the man who Gainsborough loved for his 'honesty, & undesigning plainness & openness of soul',[5] and to whom Gainsborough divulged his greatest professional secret. In the light of that it appears churlish and unkind of Jackson to gossip about Gainsborough's musical fantasies and dreams. Perhaps Jackson was simply unkind and ultimately disloyal. In any event, Jackson continued with this carry-on, and described Gainsborough having seen a theorbo – a kind of lute – in a painting by Van Dyck and thought this must be a fine instrument. He discovered that the composer Rudolf Straub had one, and he was in Bath. Gainsborough found out where he lived. 'Straub, I am come to buy your lute,' he announced on arrival. According to Jackson, this is how the incident developed:

'To buy my lute!'

'Yes, come, name your price, and here is your money.'

'I cannot sell my lute!'

'No, not for a guinea or two, but by God you must sell it.'

'My lute is worth much money! It is worth ten guineas.'

'That it is, see, here is the money.'

'Well, if I must – but you will not take it away yourself?'

'Yes, yes – good bye, Straub.' He goes down stairs, but then comes back.

'Straub, I have done but half my errand. What is your lute worth if I have not your book?'

'What book, Mr Gainsborough?'

'Why, the Book of Airs you have composed for the Lute.'

'Ah, by God, I can never part with my book!'

'Pooh! You can make another at any time. This is the book I mean.' He puts it in his pocket.

'Ah, by God, I cannot . . . '

'Come, come, here's another ten guineas for your book – so, once more, good day.' He goes downstairs, but comes back again.

'Damn it, Straub, what use is your book to me if I don't understand it? And your lute you may take again if you won't teach me to play on it. Come home with me and give me my first lesson.'

'I will come tomorrow.'

'You must come now.'

'I must dress myself.'

'For what? You are the best figure I have seen today.'

'I must shave.'

'I honour your Beard.'

'I must put on my wig.'

'Damn your wig! Your cap and beard become you! Do you think if Van Dyck was to paint you he'd let you be shaved?'[6]

Jackson completes this bullying account with the observation: 'In this manner he frittered away his musical Talents; and tho possessed of ear, taste and genius, he never had application enough to learn his notes. He scorned to take the first step, the second was of course out of his reach and the summit became unobtainable.'

Thus a bleak assessment of Thomas Gainsborough the musician which should be noted, if not unquestioningly accepted, as an honest record of the exchange. However flawed may be Jackson's recollection, second-hand, of an encounter which took place (if it ever did) more than ten years earlier, it does draw out some of Gainsborough's known characteristics – volatility, obsession, extravagance, single-mindedness, and a demanding nature that seems only to have wilted in front of his wife.

Jackson published his account of this bizarre incident some ten years after Gainsborough's death. There are other accounts of the painter behaving badly with musicians and their instruments, beginning with the earliest, written by Philip Thicknesse and published in 1788, in the months after Gainsborough's death. Jackson will surely have known this; none seems to have appeared during the artist's lifetime. According to Thicknesse, the pair fell out both over a portrait and a musical instrument. The account is muddled, and there is no corroboration, but it reads as if Gainsborough sent Thicknesse a study of a portrait of Ann Ford, rolled up with a landscape painting of the same size, with the friendly note: 'Lest Mrs Thicknesse's picture should have been damaged in the carriage to town, this landscape is put as a case to protect it, and I now return you my thanks for having procured me the favour of her sitting for it, it has done me service, and I know it will give you pleasure.'[7]

If this is true, there was once another portrait of Ann Ford, now lost, painted after she married Thicknesse in 1762. Gainsborough

almost certainly kept the large portrait of Ann Ford on display in his showroom at least until he quit Bath in 1774, when he left it behind.[8] Whatever the detail in this narrative, there is an indication of the cause of a major falling-out between the two men over the ownership of Ann Thicknesse's viol da gamba. In short: Gainsborough fell in love with the instrument and wanted to have it, offering one hundred guineas. Given Gainsborough's behaviour, according to Jackson, that sounds in character. This was the year before Gainsborough left Bath for London, so 1773. After supper with the Thicknesses, Ann asked Gainsborough to play her instrument. It was 'after supper', Thicknesse stresses, 'for till poor Gainsborough had got a little borrowed courage (such was his natural modesty) . . . he could neither play *nor Sing*! He then played, and charmingly too, one of his dear friend *Abel's* lessons, and Mrs T told him he deserved the instrument for his reward, and desired his acceptance of it.'

However, she added, in your own time, when you can fit it into your busy painting schedule, please 'give me my husband's picture to hang by the side of my own'.

So Gainsborough accepted the challenge to paint Philip Thicknesse's portrait, to the same scale as his second portrait of Ann Ford, to hang side by side. They would have made a unique and wonderful pairing, on a par with, and perhaps as eccentric and telling as his companion portraits of the Ligoniers and the Howes. 'And do not send the instrument till I have finished the picture,' Gainsborough added.

> The viol da gamba however was sent the next morning, and the same day he stretched a canvas, called upon me to attend, and he soon finished the head, rubbed in the dead colouring, of the full length, painted my Newfoundland dog at my feet; and then it was put by, and no more said of it, or done to it.

When Ann Thicknesse called on Gainsborough some time later she saw the completed, or near-completed, portrait of Johann Christian Fischer (Pl. 43), the one painted on top of Garrick as Shakespeare, 'in scarlet and gold, like a Colonel of the foot guards, and mine standing in its *tatter a ragg* condition by the side of it!' What Ann Thicknesse saw was the informal, rough

underpainting, with some idea of her husband's head and the dog brushed in. This is, as we have seen, how Gainsborough always progressed his portraits. However, he was not getting on with it – this is also totally in character – and he was extremely busy. As there was no real pressure of payment on the Thicknesse portrait, Gainsborough must have allowed other commissions to jump the queue.

> Mrs T knew this was a picture *not to be paid for*, and that it [Fischer] was begun and compleated *after mine*. She would have rejoiced to have seen an hundred pictures finished before mine, that were to be paid for, but she instantly burst into tears, retired, and wrote Mr Gainsborough a note, desiring him to put my picture up in his garret, and not let it stand to be a foil to Mr Fischer's; he did so and instantly sent home the viol da gamba!

Thicknesse claims that he noticed 'concern and shame' on Gainsborough's face at the long-running saga of the unfinished portrait, which he had since given to the Thicknesses. The story ends by the Thicknesses sending the portrait back to Gainsborough:

> every time I went into the room where that scare-crow hung, it gave me so painful a sensation, that I protest it often turned me sick … I desired Mrs T would return the picture to Mr G, and that as she had set her heart upon having my full length portrait, would rather give Mr Pine[9] his fifty guineas for painting it, than be so daily reminded and sickened at the sight of such a glaring mark of disregard … This she consented to do, provided I would permit her to send it with a card, expressing her sentiments at the same time, to which … I too hastily consented. In that card she bid him take his brush, and first rub out the countenance of the truest and warmest friend he ever had, and so done, then blot him forever from his memory.

That was that; blotted forever from memory. That, according to Thicknesse, is why there is no full-length portrait of Philip Thicknesse by Gainsborough. In sum, it is a fuss about nothing except clashing emotional temperaments, and very clear evidence

of Thicknesse's self-regard and his and his wife's inability to comprehend the processes and pressures at work when Gainsborough took on a new portrait subject.

Once again, the gremlin in the middle of this argument was a musical instrument, the price to be paid was the loss of what might have been an exciting portrait, and the motive force was Gainsborough's irrational belief that he was an interesting and accomplished musician: 'Upon the receipt of that note, [Gainsborough] went directly to London, took a house in Pall-Mall at three hundred pounds a year rent, returned to Bath to pack up his goods and pictures, and sent me a note upon a slip of paper wherein he said "God bless you and yours, I am going to London in three days."'[10]

Such major changes in life rarely happen so quickly. Pressure on Gainsborough to move to London was increasing, notwithstanding the fracas with Thicknesse. He had already given notice on Abbey Street, and with his volatile temperament and unpredictability so much gossip had been built up about his rudeness to fellow artists and patrons that he had no option but to leave Bath. Thicknesse tells this story:

> a certain rich citizen was sitting to him with his five guinea new powdered bob wig on, the *chap* looked so *rum*, and sat so very *pretty*, that poor G found it impossible not to burst out in a fit of laughter, and while he was wishing for some occasion to plead his excuse, the Alderman desired him not to overlook the dimple in his chin; no power of face could stand that; Gainsborough burst forth in laughter, threw his pencil upon the ground, and said 'D—m the dimple in your chin, I can neither paint that nor your chin neither.'[11]

This sort of behaviour prompted gossip, and got Gainsborough down. A letter of 1776 says it clearly: Gainsborough 'was uncommonly rude & uncivil to artists in general, & even haughty to his employers, which with his proud prices caus'd him to settle in London'.[12] He was not the universally sweet man of later repute.

V

London again

30. A source of much inquietude

Gainsborough's decision to quit his Abbey Street house after fourteen years of occupation had long been made, and he gave notice in June 1773.[1] Mary Gibbon took over the rental of 17 King's Circus, and added it to her portfolio of properties.[2] In her mid fifties now, and a busy Bath landlady, Mary may also have felt it was time to give up her millinery shop. The Gainsborough daughters, Molly and Peggy, unmarried women in their early and mid twenties, would still have been living at home. Professional life in Bath had settled into routine for Gainsborough. A man who over the years would speak of 'my dam'd business' and 'curs'd face business' and 'damn gentlemen' and 'confounded ugly creatures' cannot be exactly stable and content with his run-of-the-mill daily business activity, like a dentist bored with teeth, or a chicken farmer sick of the sight of chickens. So when Gainsborough writes from Bath to Cipriani in February 1774 that 'I have done nothing but fiddle since I came from London', he was talking about his inability to settle to anything serious, quite as much as his time-wasting musical instruments.[3]

He was longing to get away, and it may be that a row with the Thicknesses, however induced, provided the trigger. Impetuous and impulsive, or as generous as ever, he left dozens of paintings and drawings behind in Bath: the publisher and engraver John Britton counted over fifty in 1801, presumably still on the walls of 17 King's Circus.[4] Galling as it may have been for him to find himself in a house bearing the name of that disgraced, venal and useless physician of Bath, he found suitable accommodation at Schomberg House, Pall Mall. The house, named after a different Schomberg, was extremely well sited, in the heart of royal London, practically next door to St James's Palace and Spencer House, near the fashionable London of Grosvenorshire, and having arty London with Christie's, the Royal Academy and the Society of Artists close by. He was famous from his years in

Bath, wealthy beyond the dreams of a thirteen-year-old son of a shroud-maker from Sudbury, and certain now of the potency that his genius would show in the metropolis.

Thomas Gainsborough took an early initiative and did what he was accustomed to do when moving into a new place: alter his property to make it work for him. When building began we do not know, but it cannot have been long after his arrival. He extended the western end of Schomberg House into the area between it and The Mall and St James's Park at the rear.[5] The new single-storey extension that Gainsborough added, linked to the main house by a passage, gave him additional display space and a new painting room, making an arrangement comparable to that he had enjoyed in Bath. There must also have been a set of high doors in the extension to take frames in and out. The ceiling was, as at 17 King's Circus, at least fifteen feet high because it was here that Gainsborough painted his largest canvases, *The Baillie Family* (1783–4) at eight feet square,[6] a twelve-foot-high portrait of *Banastre Tarleton* (1782), and his portrait of *Sir Francis Sykes* (1787) with galloping horses, a groom and a dog, ten feet high by twelve feet long. These latter two monsters are destroyed, but a copy of part of the Sykes portrait is in Wallingford Town Hall. A further alteration that Gainsborough seems to have initiated was fitting a new staircase behind the entrance hall to link the west and central portions of this much-altered building.

Gainsborough's portion of the property, then numbered 87 Pall Mall, now the right-hand portion of number 80, was, like the Abbey Street house, not quite as grand as it looked. It was a fine address, and had a fine façade, but Gainsborough's portion was narrow, running deep into the plot, and was effectively only two rooms and a closet on each of four floors. It must have been very dark, though that would not necessarily have created a difficulty for a painter prone to paint by candlelight. The largest room was barely eighteen by ten feet, far too small for Gainsborough's accustomed scale, and the ceiling height cannot have been more than ten or eleven feet. However, the view from the back rooms on the first and second floors was spectacular, a wide panorama across The Mall and St James's Park, with the towers of Westminster Abbey

beyond and the Surrey hills in the distance. A rear extension was essential to make this property work, and dust and debris over a protracted period was the price to be paid.[7] According to Pierre-Jean Grosley, the perceptive Frenchman, Pall Mall was where 'all the noblemen live'. It was perfect for Gainsborough:

> [A] fine street ... is already paved in part with [freestone]; and they have also begun to new pave the Strand. The two first of these streets were dry in May, all the rest of the town being still covered with heaps of dirt ... Pall-mall and the other remarkable streets at the court end of town, and which all the noblemen live in, have no court-yards or great gates; their entrances are but small, not above four feet in breadth; adorned with only two pillars of the Doric order, over which stands a heavy pediment, as much out of place as the pillars themselves.[8]

Another echo of Gainsborough's arrangements in Bath was that the eastern section of Schomberg House was occupied by the shop and warehouse of a milliner, mercer, furrier and lace merchant. So, once again, he had a source of fine stuff on his doorstep. In between, however, in the central portion of the house, the portrait painter, amateur architect and fashionable fop John Astley lived and worked. Gainsborough may have chosen Astley as his architect, because, across the previous five years, Astley had himself transformed Schomberg House from a single rambling building into three separate properties united behind one façade.[9] The central section he had 'most whimsically fitted up'[10] for his own requirements, and had advertised his trade with a relief of a reclining female figure holding a palette, brushes and maulstick over the central porch. This is still in place. Astley had married money – as indeed had Gainsborough; something else they had in common – but was more driven to creating a fashionable stir through his own person rather than through architecture and portrait painting. He had known Reynolds as a student with Thomas Hudson, and was later together with Reynolds in Italy, but Astley had subsequently gathered an unhelpful professional reputation that made him no real threat as a portrait painter to Gainsborough. While they shared a womanising tendency, Astley lacked a Margaret

Gainsborough to control him: he became known as 'Beau Astley', and was later described as 'a gasconading spendthrift and a beau of the flashiest order'.[11] He is remembered in Anthony Pasquin's observation:

> As ostentatious as the peacock and as amorous as the Persian Sophi . . . he had a harem and a bath at the top of his house, replete with every enticement and blandishment to awaken desire; and thus lived, jocund and thoughtless, until his nerves were unstrung by age; when his spirits decayed with his animal powers, and he sighed and drooped into eternity![12]

Pasquin also observed that Astley would 'use his naked sword as a moll-stick'. Schomberg House was therefore an enticing place for Gainsborough to live and work: fine fabric for display and sale at one end, high living and eccentric comings and goings in the middle, with a place for parade and display in The Mall to the rear. Years later Gainsborough was reported as describing Schomberg House as 'the occasional museum of living and defunct curiosities, animate and inanimate, subjects for the pencil and the pen, and the rendezvous of wights of science, virtuosi, antiquaries, painters, poets'.[13]

With the happy proximity of the court of St James's practically next door, and the Queen's House (the former name of Buckingham Palace) nearby, the future prospect of a whole new level of clientele was opening up for him. We might also detect that coming to London, and moving to Schomberg House, was part of a strategy for Gainsborough. His snub two years earlier by the Academy when they refused to hang his portrait of Lady Waldegrave rankled fiercely. Gainsborough, with his threatened 'implacable resentment',[14] had landed at the very heart of royal London, with a determination to make his presence felt. They would certainly be hearing from him now.

The London that Gainsborough returned to was quite as filthy as it was when he left it in 1748. 'In the most beautiful part of the Strand and near St Clement's church', Grosley reported,

> I have, during my whole stay in London, seen the middle of the street constantly foul with a dirty puddle to the height of three

or four inches; a puddle where splashings cover those who walk on foot, fill coaches when their windows happen not to be up, and bedawb all the lower parts of such houses as are exposed to it.[15]

In the winter, it was worse, on account of the smoke:

[from] the sea coals made use of in kitchens, apartments, and even the halls of grand houses; and by coals burnt in glass-houses, in houses where earthen-ware is manufactured, in blacksmiths and gunsmiths shops, in dyers yards, &c.[16]

Nevertheless, there was much about London that was new: a reinvigorated Northumberland House, Somerset House under reconstruction, and a Montagu House that was now open to the public and redefined as the British Museum. New squares and estates were in progress, with 'projectors', what we now call property developers, eager and anxious over their investment of bricks and mortar. We learn from Thicknesse that Gainsborough did not at first get on as well as he had hoped. Business was apparently slow. Exceeding even his own levels of patronising candour, Thicknesse recalled his alarm that 'left with all his merit and genius, [Gainsborough] might be in London a long time' before he got the kind of work he needed, 'for of all the men I knew, he possessed least of that worldly knowledge, to enable him to make his own way into the notice of the Great World'.[17]

This hardly rings true. Gainsborough was, by the end of 1774, a painter whose work was eagerly awaited at the London exhibitions, lauded in the press, well paid and overcommitted in that Grosvenorshire outpost of Bath, and well known in London society for the splendour and vivacity of his portraits. He ran his own coach and horses, employed his nephew Gainsborough Dupont as his painting assistant, and had a household with a coachman, footman and other servants.[18] Hanging in London drawing-rooms, now, were his Duke and Duchess of Bedford in Bedford House, his David Garrick in the Adelphi, his Richard and Mary Howe in Grafton Street, and many others. Around the country perhaps three hundred sitters who had paid him best money in Bath could

gaze at their images and recall the novelty of the process: George
Pitt and the Ligoniers in Stratfield Saye, the Byams at Apps
Court, and the Spencers and William Poyntz at Althorp. Gains-
borough had already put himself about very well indeed, and did
not need Thicknesse's concern. However, he was reported to have
asked General James Johnston to sit for him in London 'in order
to bring himself into vogue,' and this might betray some concern
for his immediate future.[19]

It was not the 'Great World' (Thicknesse sets this in capital
letters, as if it mattered) that was the problem, but the Art World,
particularly those legions of portrait painters now assembling
themselves in London in societies and academies from whom
Gainsborough, by placing himself in the far west, had kept aloof.
His was not a social problem, but a problem of massively increased
competition. Having been a very big fish in a small pond, with only
William Hoare to be really concerned about, Gainsborough was
now one of a dozen or more top-quality portrait painters in town,
with their address books, London contacts, roots and reputations.
Sir Joshua Reynolds stood at the pinnacle here like the Lord of
All; George Romney, with his loathing of Reynolds, would soon
return from Italy and continue to paint his limpid series of exotic
portraits; Francis Hayman and Johan Zoffany were at work, as
were many, many others, including odd new people popping up
and disappearing again, like Jean-Etienne Liotard.[20] Only Joseph
Wright of Derby had absented himself from the London scene,
which he nevertheless disdained, by taking himself off . . . to Bath.
Good luck to *him*.

Moreover, London was not like Bath with its rapid turnover
of men and women with money on their backs, vanity to express
and time intransigent to kill, but a huge, throbbing city complete
unto itself, full of rumour, clique and counter-clique, moneymen,
aristocracy and royalty. Even the latter grouping was a minefield,
as Gainsborough found when he had tried to exhibit his portrait
of the King's brother's mistress, Lady Waldegrave. In Bath the
clients circled to find the painters; in London, quite the other way,
the painters had to circle to find their clients, paying attention
to local social patterns. One of Gainsborough's supporters was
the Rev. Sir Henry Bate Dudley, nominally a parson, but a rare

attender at his parishes in Essex and Hendon.[21] Bate Dudley was a controversial, controlling and charismatic figure who dominated his newspaper's columns, and who remained famous for an incident in Vauxhall Gardens in 1773 when he beat a man's face to 'a perfect jelly' for paying too close attention to his fiancée's sister.[22] Fearless in the boxing ring, this pugilistic parson was fearless also in print, and took up Gainsborough as a cause. He noted Gainsborough's hesitant start in the *Morning Post*, which he owned, and then, after 1780, in the *Morning Herald*, which he set up after quarrelling with the *Morning Post*. Bate Dudley later remarked that Gainsborough's first few weeks in London were spent 'not very profitably'.[23] This may however mean that he slipped into his old ways of misguidedly using London as a city of frolic and fun with his many musician friends, rather than sensibly networking with fellow artists and their clients. On the other hand, settling into Schomberg House brought problems of its own. Certainly, for the first few weeks in London, Margaret was not there to keep an eye on him, and that initial sense of freedom may have been intoxicating.

The picture that emerges of Gainsborough's return to London is one of an artist who wished both to be in the swim and aloof at the same time. His attitude to the Royal Academy was off-hand. He was made a member of its Council in 1774, but never attended meetings, took no active part in its management, and was even refusing to show there. The absence of his image in Zoffany's group portrait of the Academicians suggests exasperation on the part of the organisation as much as his own half-hearted interest. One does wonder therefore why he should be so surprised when hanging committees treated him with less respect than he thought he deserved. He had already upset the Academy once by withdrawing his work from exhibitions after the *Lady Waldegrave* debacle, and now he was a totally ineffective Council member. The Academy was becoming jumpy about complaints it had received from artists about the hanging of its exhibitions. Gainsborough's case is the only well-documented dissatisfaction, but there would have been many others expressed through gossip and muttering that did not get recorded.[24] It will have been these, collectively, that prompted the Council to propose guidelines for artists at a

meeting that Gainsborough himself should have attended, but
seems not to have done so. The debate was aimed, among others,
at him:

> the hanging of pictures &c ... has been a source of much in-
> quietude ... dissatisfied people will always take this occasion
> of calling [Academy Officers'] Judgement or their Integrity
> into question ... [I]f in future times the successors of the
> present Gentlemen who so worthily fill those Offices, should
> from interested or other views have any improper partialities
> for, or prejudices against any particular Academician, & should
> they confederate for such dishonest purpose, by passing the
> present Motion into Law, such confederacy would be rendered
> ineffectual; And the Exhibition will remain as it ought, a field
> of generous contention, established upon equitable principles,
> & where Envy, Pique or any other unjust, base motive (that
> might hereafter arise amongst us, & that have always arisen
> amongst Men where their Passions & Interests are concerned)
> will have no opportunity of exerting themselves with any
> success.[25]

These new hanging guidelines were passed, albeit narrowly, by
four votes to three.

'Defamation is sufficiently copious', wrote Samuel Johnson,
musing in *The Idler* about portrait painting.[26] Gainsborough was
used to defamation, particularly from the hostile wing of the
London press which had upset him dreadfully, and from the Royal
Academy bureaucratically.[27] He had also had it from Thomas
Underwood spitefully, from Philip Thicknesse creepily, and from
Lord Dartmouth insidiously. Gainsborough knew what his task
was, precisely: he was a professional celebrant of the person.
He earned his living by creating the possibilities of generating
pleasure in others: 'Whoever is delighted with his own picture
must derive his pleasure from the pleasure of another', Johnson
continued. Gainsborough's art was designed for the purpose
of 'diffusing friendship, in reviving tenderness, in quickening
the affections of the absent, and continuing the presence of the
dead'.

London circles might seethe with malice, might bubble with

rivalry, might boil with envy. Beyond all that, as a returner, Thomas Gainsborough designed to come back at the top, to pick up where he left off in 1748 as a 'justly esteemed eminent master', and, in Pall Mall, to create a quarter of his own.

31. Humphrey, Scheming Jack and Mary Gibbon

After sixteen or seventeen years in Bath, Gainsborough's stock had changed with regard to his Sudbury family. He was now a famous artist, successful, worldly, slightly unhinged, but still of concern to them, and still recognisably the lovably weird and generous younger brother that had grown up beside them. He was closest perhaps to his sister Mary Gibbon, not least because they were hand-in-glove in their businesses in Bath. She was also, like Thomas, a busy rentier, investing in property and making money as a landlady. Mary was by now a trifle deaf, for she seems to have worn an ear-trumpet, if her brother's reference to her 'head-piece' catching a quiet conversation is any guide.[1] Like Thomas, Mary was a natty dresser, famous in Bath as an elderly, overdressed clothes-horse, and, having everything she needed in her millinery shop, prone to running terrible risks with clothes and make-up. 'Whether deck'd in lace or ribbons', she must have looked quite a sight with all that and her ear-trumpet too.[2]

'Scheming Jack' was most probably still working on his plans and promises in Sudbury, 'where he always resided', according to Thicknesse.[3] Jack and his wife had many daughters – Thicknesse counted seven when he visited them in the 1760s – all 'clean, but clothed in the most humble manner . . . endowed with good sense, but their countenances, even the children, were overcast with distress'.[4] Jack's wife told Thicknesse that Thomas would often send them five guineas, 'but the instant my husband gets it, he lays it out in brass work to discover the longitude'. When Thicknesse called on the family, Jack gave him some self-justifying farradiddle about the advice he had given to the horologist John Harrison, the longitude man. Poor 'Scheming Jack' was a fantasist and a failure, nevertheless he shared the gene of practical ingenuity and manual skill that his brothers Humphrey and Thomas so eloquently exploited, but which had somehow passed their father by. There were however two creations of his that would charm anybody who

saw them in Sudbury – a model of St Gregory's Church with bells that chimed every hour, and the royal arms that he painted on the Moot Hall on Market Hill. Thomas apparently said, unkindly, that this was the only thing his brother ever finished.[5]

Humphrey Gainsborough, by the mid 1770s well settled in Henley, was not quite so well known in the London world of science and invention as his brother was as a painter, but he was in his own way just as distinguished. During the previous decade he had won awards from the Society of Arts for a model tide mill, a drill plough, and a weighing machine for wagons and their contents,[6] and by contributing to the improvement of agricultural equipment he was helping to make it possible for many farmers, including some of his brother's early Suffolk sitters, to improve their farming yields. The late eighteenth century vies with the early twenty-first as a period fully aware of the urgent need for technological change to balance human demands on the natural environment. Humphrey Gainsborough, one of his period's pioneers, understood this. He designed locks on the Thames around Henley, and worked with the owners of Harpsden Court, Fawley Court and Park Place nearby to improve their estates and houses: he built a bridge at Park Place for Henry Seymour Conway and improved the dangerous gradient of the road down White Hill along Seymour Conway's boundary. This was big engineering. Humphrey's inventions became increasingly ambitious as his life went on. In addition he designed a fire-proof safe, improved the operation of domestic security locks, and devised a means to keep fish fresh in transport. Perhaps the most elaborate and controversial of his inventions was his prototype steam engine. The scale of Humphrey's endeavours demonstrates how wide his creativity flowed. Like the Rev. Gilbert White of Selborne, this country divine was as concerned with the improvement and understanding of the natural world as he was with the improvement and understanding of souls. To build a steam engine he would have needed a technical and organisational supply line that demanded a network of support, which his wealthy friends at Harpsden, Fawley and Park Place generously gave.

In a ruminative letter to his sister back in Bath, Gainsborough indicates that by Christmas 1775, over a year after the family had

moved to London, business was on the move. 'What will become of me time must show', he writes, but 'I can only say that my present situation with regard to encouragement is all that heart can wish.'[7] If he had ever suffered anxieties about making it at the highest level in London, it cannot have lasted long. Within a year he was heavily employed on portraits including those of the Duke of Gloucester, the judge and pioneer of legal training Sir William Blackstone and his wife, the engineer John Wilkinson, Mary Graham, and, for the Society of Arts, a dead man, their first president, the late Lord Folkestone.[8] Four of these were full-lengths. However, he is still not wholly sanguine. He was a naturally reflective, ruminative man:

> But as all worldly success is precarious I don't build happiness, or the expectation of it, upon present appearances. I have built upon sandy foundations all my life long. All I know is that I live at a full thousand pounds a year expense, and will work hard and do my best to go through withal; and if that will not do let those take their lot of blame and sufferings that fall short of their duty, both towards me and themselves.

He goes on to Mary with frankness and self-knowledge:

> Had I been blessed with your penetration and blind eye towards fool's pleasures, I had steered my course better. But we are born with different Passions and gifts, and I have only to hope that the Great Giver of All will make better allowance for us than we can make for one another.

With this letter Gainsborough may have been musing on his own mortality and on the death, in June 1774, of his good friend, staunch support, and fellow incomer from Suffolk, Joshua Kirby. Art politics had pulverised Kirby when he tried unsuccessfully to hold the Society of Artists together in the face of an emergent Royal Academy, and those pressures weakened this good and proud man's resolve and physical stamina. Since that rejection Kirby had come increasingly close to the court of George III at the King's country retreat at Kew, and it was at St Anne's Church in Kew that he was buried. Kirby knew the value of friendship, and knew the concern Gainsborough felt for him. This was reflected in Gainsborough's

41. *Isabella, Viscountess Molyneux*, 1769. With shimmering satin and reverberating glance Gainsborough demonstrated his greatness through this portrait at the first exhibition of the Royal Academy.

42. *Dr Ralph Schomberg*, c.1770. Elegant, neat, courteous and enquiring: this seems to represent the ideal physician. Schomberg may have been good at his job, but he was avaricious and possibly venal, and left Bath in disgrace.

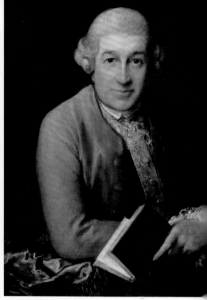

43. *Johann Christian Fischer*, 1774. Elegance, inspiration and charm: but this accomplished musician broke Peggy's heart, and then married and soon abandoned Molly, damaging Gainsborough's trust in him for ever.

44. *David Garrick*, 1770. A true friend to Gainsborough, as innovative and energetic as an actor-dramatist as Gainsborough was as a painter. But Gainsborough found him practically impossible to capture, despite trying at least three times.

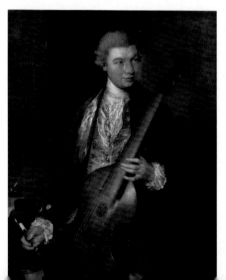

45. *Carl Friedrich Abel, c.*1765. A consummate musician, and another true friend. Gainsborough painted his last self-portrait (see front cover) for 'this man I loved'.

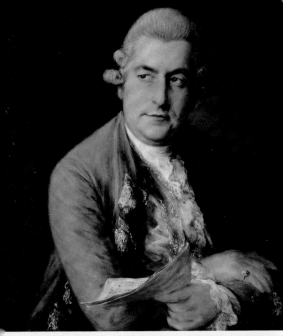

46. *Johann Christian Bach*, 1776. Gainsborough was at his happiest when in the company of musicians, and he responded to their friendship through his elegant and insightful portraits.

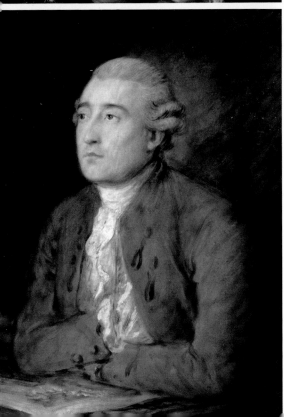

47. *Philippe Jacques de Loutherbourg*, 1778. This serious-minded painter and stage-designer is presented in muted tones, in contrast to his delight in strident colour and sound effects in the theatre.

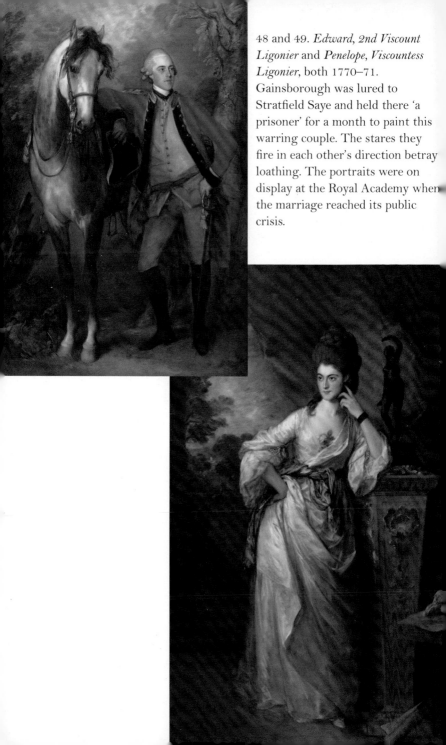

48 and 49. *Edward, 2nd Viscount Ligonier* and *Penelope, Viscountess Ligonier*, both 1770–71. Gainsborough was lured to Stratfield Saye and held there 'a prisoner' for a month to paint this warring couple. The stares they fire in each other's direction betray loathing. The portraits were on display at the Royal Academy when the marriage reached its public crisis.

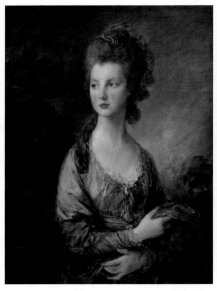

50 and 51. *The Hon. Mrs Thomas Graham*, both *c.*1775–7. Painted in close sequence, one for domestic display, the full-length for exhibition at the Royal Academy. Mary was eighteen when she first sat for Gainsborough, and perhaps already suffering from the consumption that killed her in 1792.

52. *Mr and Mrs William Hallett, 'The Morning Walk'*, 1785. A masterpiece of hope and harmony, effectively a church-door wedding picture in which the couple embark on married life.

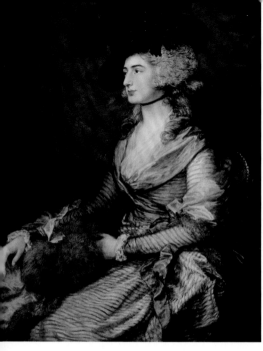

53. *Mrs Siddons*, c.1785. Gainsborough shows the great dramatic actress in her own character, preparing not to step out onto the stage, but waiting to go to lunch. The rich rewards of a grand career are plainly evident.

54 and 55. *King George III*, 1780–81, and *Queen Charlotte*, 1781. Though not the official court painter, Gainsborough was the King and Queen's favourite portrait artist. Charming, modest and able, he became their friend, repaying trust with dignified portrayals that reveal the human side of royalty.

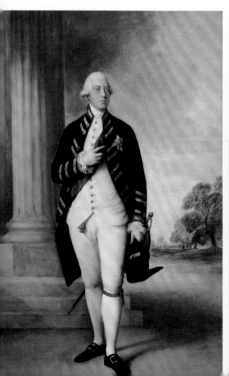

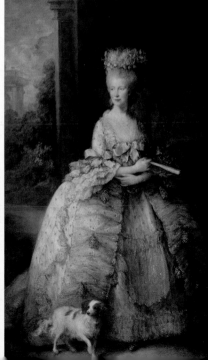

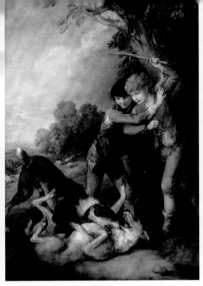

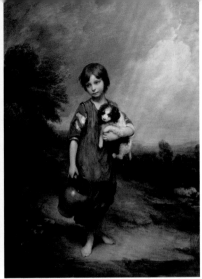

56. *Two Shepherd Boys with Dogs Fighting*, 1783. An uncharacteristically violent subject that may contain allusions to circulation battles within the press, or to Gainsborough's own perceived maltreatment by the Royal Academy.

57. *Girl with a Pitcher*, 1785. A figure of simple country innocence, where the young girl hugs her puppy but ignores the sheep trotting away behind her.

58. *Mountain Valley with Figures and Distant Village*, 1773–7. A late landscape in which mountain wildness ominously embraces a shepherd and his vulnerable family. This is the kind of composition that Gainsborough developed from table-top models of broccoli, moss and stones; invention not experience.

59. *The Mall*, 1783–4. A breezy scene of trees and people, with their coquettish exchanges of glances, made after Gainsborough returned from Antwerp. It was painted at the suggestion of the King, but never acquired by him.

60. *Diana and Actaeon*, *c.*1784–5. An uncharacteristic mythological subject born of many studies and trials. While based loosely on Titian, it might also be read as a version of *The Mall* unclothed.

particular generosity to Kirby, the gift, over the years, of very many drawings and some early paintings.[9] All of these, as the great world of art history slowly turns, were by rare coincidence and luck an early source of inspiration and affirmation to a very young aspiring artist who visited Joshua Kirby's daughter, Sarah Trimmer, in Brentford. This was J. M. W. Turner; we shall come to him by and by.

During the autumn and winter the Gainsboroughs had a diffi-cult time, cramped as they must have been in the confined spaces of Schomberg House, with the building work going on around them, and dragging on for months. Before the extension was built, there were two daughters, footmen, a maid or two, David the groom, and probably young Dupont also to accommodate in that cramped house with its all-important room set aside for work. They all caught a 'sort of cold attended by a bad cough' that was going about London. Margaret seems to have had it worst: 'My wife has been but very indifferent with the disorder . . . it has gone through our family, servants and all; but, thank God, we are upon the mending hand: we don't hear of many people dying of it, though 'tis universal'.

Thomas's brother Humphrey came to see them. He was in a bad way too. His wife had just died, but he 'was as well as could be expected, considering his affliction for the loss of his poor wife. We did all we could to comfort him, and wish him every possible happiness, as he is a good creature'.[10]

These remarks are from letters to Mary Gibbon, living still in Bath. Brothers and sisters that they were – Thomas, Mary and Humphrey, and Sarah Dupont too, who was in touch from Sud-bury through her son Gainsborough – they were very affectionate towards each other and pulled together with advice, support and understanding. Where Thomas and Margaret had a tough, frac-tious marriage, with their daughters difficult to handle, sibling affection was as strong and as loving as could be. In later life Gainsborough's sisters looked after him as they had when he was a little boy. His late portrait of Humphrey, surely painted during this visit, shows a sensitive and thoughtful grey-haired man, soft, liquid eyes looking upwards, serious, profound (Pl. 31).[11] This is quickly painted, thinly brushed, the weave of the canvas showing

through at the nose and cheek, and reflects the artist's true affection for his gentle subject. 'We return our best thanks for the excellent present of fish', Gainsborough told Mary.

> [This] turned out as good as ever was eaten, and came very timely for brother Humphry [*sic*] to take part with us. He went home to Henley today, having been with us ten days, which was as long as he could well be absent from his business of collecting the tolls upon the river.[12]

He goes on to tell his sister:

> I am glad to hear business in the lodging-house way goes on so well. I know you would willingly keep the cart upon the wheels, till you go to heaven, though you deserve to ride there in something better. I told Humphry you were a rank Methodist, who says you had better be a Presbyterian, but I say Church of England. It does not signify what, if you are but free from hypocrisy, and don't set your heart upon worldly honors and wealth.[13]

Religion was important to them as a family, but, coming from a mixed-religion background, it did not seem to be much of a problem for any of them. They could banter about these mild differences freely and with good humour. Directly after Christmas, Gainsborough wrote again to Mary: this is the letter quoted above in which he writes of his 'sandy foundations'. While he is direct and realistic about his professional success and the money he is making, he reflects frankly on the shadows in his life: 'I could now enter into particulars as my heart finds itself affected, but what would it all signify? If I tell you my wife is weak but good, and never much formed to humour my Happiness, what can you do to alter her?'[14]

Well, nothing; that is his problem. From a perspective of two hundred and fifty years we might suggest Thomas and Margaret should perhaps talk more to each other; he could buy her flowers occasionally, rather than complain to his sister about her; but *plus ça change*. The current problem is the girls, both still living at home, and their love life. Whatever it is that is holding them back might include misplaced parental pressures and control: 'If

I complain that Peggy is a sensible good Girl, but Insolent and proud in her behaviour to me at times, can you make your arm long enough to box her ears for me whilst you live at Bath?'

Then there is this, in which Gainsborough suggests that one of his close and trusted friends has been deceiving him: 'And (what has hurt me most of late) were I to unfold a secret and tell you that I have detected a sly trick in Molly by a sight I got of one of her letters.' This was a letter to Johann Christian Fischer, Gainsborough's musician friend, who in true Gainsborough fashion the family had taken in as a lodger.[15] He had been playing the daughters, not his oboe, carrying on with them in a way that was bound to cause unhappiness and division between them and within the family. Gainsborough thought Fischer had his eye on Peggy, but then he found a letter to him from Molly. 'What could all your cleverness do for me there?' he asks his sister, envious of her ear-trumpet, useful for picking up stray conversation:

And yet I wish for your Head-piece to catch a little more of the secret, for I don't choose to be flung under the pretence of Friendship. I have never suffered that worthy Gentleman ever to be in their Company since I came to London; and behold while I had my eye upon Peggy, the other Slyboots, I suppose, has all along been the Object. Oh d—n him, he must take care how he trips me off the foot of all happiness.

He adds a postscript: 'She [i.e. Molly] does not suspect I saw the letter.'

Domestic troubles came in their battalions for Gainsborough in these early years in London. Mary Gibbon was a rock for him: she at least was happy and fulfilled back in Bath, and it might be that there were times when Gainsborough wished he had never moved away. On the one hand he was doing well at work: 'My present Situation is that of being as much encouraged as the World can bestow, with every success in my business.'[16] On the other, however,

Counteracted with disobedience, Pride and insolence, and eternal Obraidings & reflections – I was induced to try how far Jealousy might be cured by giving into [my wife's] Hands every

Farthing of the Money as I earn'd it, but very soon found th[at] (as a punishment for so unmanly a condescention) instead of convincing, it was a further incouragement to Govern me, and invert the order of Nature in making the Head the foot and the foot the Head.

He saw very quickly that that was not a sensible way of going about things, but presumably there was little he could do about it now. So he continued by straightening his shoulders and thinking positive:

I have taken the Staff into my own hands again, and purpose (God willing) to try my own Virtue and strength to walk straight and do the best for my Children. Let them follow the Vanity of the Age, or weakness of their Leader as they will – I am at an Age now to see right from wrong; and have a pretty good knowledge of Mankind.

These are platitudes, but he is trying to cheer himself up, despite 'my own Health which has been but indifferent of late'.

To cap it all, before two months were up, their brother Humphrey was dead, collapsing on the tow-path at Henley while collecting tolls. Thomas was his executor, and in addition to his daily workload and domestic stresses he had to mastermind the collection of Humphrey's valuable prototype steam engine. This was still in Henley, and had to be safeguarded on account of the technical innovations it carried: it was, as Humphrey had told Matthew Boulton, 'a totally different invention from that of Mr Watt',[17] and as such was of particular interest to Boulton, Watt, and the other anxious innovators in the febrile atmosphere of the world of steam. In the 1770s this ran abreast of the febrile atmosphere of the world of art. In due course Humphrey's engine came to London and was deposited at the bottom of Thomas's garden in Pall Mall, an ungainly, complex, evocative iron lump. As it slowly rotted away, Gainsborough painted, for Humphrey's friend Thomas Hall of Harpsden Court, a third portrait of Humphrey. This must have been posthumous, a version of the portrait study. While it is more complete as a painting, it lacks the study's resonance.[18] Nevertheless, it was a fine memorial to a fine man,

painted by a loving brother and paid for by a firm and grateful friend.

For years Gainsborough must have looked at the rotting engine and wondered what to do. He was offered £1,000 for it, but prevaricated. John Wilkinson, one of Gainsborough's early London sitters, told his fellow engineer Matthew Boulton, 'He is at a loss to act being no judge – whether to sell it for that sum or take out a patent.'[19] This must have been studio-talk, a confidence passed between sitter and artist, and not really something that Gainsborough might have expected to be passed on – though the worldly-wise artist might just have been seeking advice.

As if this was not enough family stuff to be going on with, 'Scheming Jack' turned up at Schomberg House in September 1783, looking a bit of a wreck: 'villainously old he is indeed grown', Gainsborough told their sister Sarah.[20] Jack did not have two pennies to rub together, and with his family to support here was history threatening to repeat itself. This was their father John Gainsborough's financial chaos all over again, so of course the family rallied round. Thomas told Sarah that he had promised Jack a half-crown per week, on top of both the two shillings that Mary Gibbon was giving him weekly, and an allowance from another Gainsborough cousin. Such silent generosity saved Jack and his family from penury, though it was a close shave. To keep him sensible, Gainsborough asked Sarah to show Jack the correspondence, and make the situation clear to him, in order to 'give you a better power to manage him, if troublesome to you'.

32. The Hon. Mrs Graham, and other good women

It was in this ruminative, transitory state that Gainsborough painted Mary Graham. She was barely eighteen when she came to see him, delicate, nervous, and presumably accompanied by her new husband. He was Thomas Graham, son of a Perthshire land-owner whose fortune had sent him on the Grand Tour and then to Christ Church, Oxford. Graham inherited his father's Balgowan estates, and set himself to follow the new agriculture, reforming animal husbandry and improving crop yields at Balgowan, much as Gainsborough's earlier clients had done in Suffolk. Graham was a modern man, one with strong civic interests and a sense of community, who stood in the Whig interest as parliamentary can-didate for Perthshire in a 1772 by-election. So in marrying Mary Cathcart – as a daughter of Lord Cathcart she became the Hon. Mrs Graham in her own right – he was uniting land with title. As a couple, as Scots, they were the new rising breed of post-Act of Union Britons, living in Perthshire, London and in Brooksby, Leicestershire, and in the 1770s on the continent.

Gainsborough painted Mary Graham at least twice, though he may not initially have expected to do so. With the liquid paint that so emotionally captured the light in Humphrey's face, Gains-borough made a three-quarter-length portrait of Mary wearing a low-cut, lightly flowing silk dress trimmed with what might be gold ribbon (Pl. 50).[1] She carries a shawl lit by more golden lustre, and a single pearl drop hangs at her breast. Her hair is piled high, interlaced with more pearls, and hangs down in a long loose plait at her right shoulder. She is the picture of charm and simple elegance, painted thinly, with the canvas weave visible at her neck and cheek. Her eyes are liquid like Humphrey's, the iris blue, the orbit watery, and the life in her eyes sparkles with white highlight glanced on in a moment. This was 'the bird of the eye' caught in full flight.[2] Thomas Graham was in love with her, but

so perhaps was Thomas Gainsborough across the few hours he will have spent with this portrait. The rapid, free brushwork on Mary's dress suggests the use of his extra-long brushes, while the blush on her cheek, her lips, a nail, and the warm pink gland in the corner of her eye suggests close and attentive looking on Gainsborough's part. This was the one perk of his practice, the obligation to gaze deep and close at his subject's face, under candlelight, without the slightest hint of impropriety.

For this painting Mary Graham came in her own clothes; he painted her at speed, and with inspiration, for her husband. In the full-length portrait he painted her slowly for his own purposes, though there is no question that Thomas Graham will have paid for the result. Here we may detect Gainsborough's techniques of persuasion at work. Surely one portrait – and a beautiful, rare, touching work it is – might have been enough for the pragmatic Thomas Graham; but no, for reasons which may not have been entirely the patron's choice, there are two, possibly three. Gainsborough had a reputation to maintain and to rebuild, a requirement for shock and awe to be felt among his peers, within the art world of London, and by royalty, to whom his ambition directly led.

Gainsborough dressed Mary Graham up, powdered and pomaded her, gave her an elaborate Rubensian silk hat lined with pearls and topped off by ostrich feathers, made a collar for her out of spun sugar, and gave her a white silk bodice dripping with pearls and revealing a ruched and ruffled crimson underskirt (Pl. 51). The collar, a palisade of spears to protect the lady's virtue, is the apotheosis of the formal ruff seen in northern European and English seventeenth-century portraits. Mary Graham rests beside a plinth and column, echoing its form in her wide dress and slender upper body, while the final gleam of evening sunlight rhymes in its amorphous shapes with the curl and quiver of her plume. Thus he created an overblown Van Dyckian beauty, fine material for an anachronistic portrait of the mistress of a seventeenth-century monarch.[3]

Grand and time-honoured though the full-length portrait of Mary Graham is, it has none of the intimacy of the three-quarter length, nor its deliquescent sparkle. The gentle passions that inspire the smaller portrait are quite absent in the full-length: there

Gainsborough gives us an innocent country girl rebranded as royalty: Jane Grey, Diana Spencer, Kate Middleton. There is distinct Gainsborough mischief here: before he came to London his demure portrait of Lady Waldegrave, a real-life royal mistress, was banned; here, now, was an unworldly Scottish woman dressed like an overcooked Queen of Sheba, outshining all of them. *The Hon. Mrs Graham*, Washington version, was begun at its small scale, perhaps when builders were at work on Gainsborough's extension, and his working space compromised. The full-length Edinburgh version, at eight feet high, must have been among the first portraits he was able to complete in his new painting room, with its higher ceiling, for exhibition at the Royal Academy when he returned in 1777 for the first time since the Waldegrave-portrait debacle.

Mary soon fell ill, her incipient consumption already evident perhaps in the blanching of her face in the portraits. The Grahams went to Portugal and Spain for the climate, then, after returning to Scotland, Mary was no better, so they travelled to the Mediterranean. There, in June 1792, off the coast at Hyères in the Côte d'Azure, Mary died. There were no children. Thomas brought her body back to Scotland, but on the way through post-revolutionary France, her coffin was abused, broken into by officials looking for contraband, infuriating Thomas and turning him implacably against the French. He had nothing more to lose. From there on he dedicated himself to politics and soldiering, becoming an MP for Perthshire, and also rising dramatically through the army command and campaigns to become one of Wellington's generals on the Iberian Peninsula, and a scourge of Napoleon's armies. In 1814, as General Graham, he was created Baron Lynedoch of Balgowan. Of the portraits, the smaller one he kept, bequeathing it to his cousin, the 2nd Baron Lynedoch. The full-length, however, he could not bear to see again, so packed it away and left it in London. It was eventually bequeathed to the National Gallery of Scotland where it remains, on condition that it never leaves Scotland.

The 1777 Royal Academy exhibition was Gainsborough's bold, orchestrated comeback. *The Hon. Mrs Graham*, exhibited as 'Portrait of a Lady: whole length', took her first step into public attention, and eventual world fame. She was, however,

soon identified in the *Morning Post* as 'Mrs Graham, sister of the Duchess of Atholl'.[4] Also by Gainsborough at that exhibition were six other works, including his portrait of *Carl Friedrich Abel* (Pl. 45),[5] the pair of full-length portraits of the Duke and Duchess of Cumberland, and the seminal landscape masterpiece *The Watering Place*.[6] This Horace Walpole described as 'in the style of Rubens, & by far the finest landscape ever painted in England, & equal to the Great Masters'.[7]

Mary Graham, however, was not the only woman to wear that astounding dress. The Hon. Frances Duncombe, who Gainsborough had already painted in a head-and-shoulders portrait in Bath in 1773, came to Schomberg House perhaps across the same months that Mary Graham fell under the artist's attention. In the Frances Duncombe full-length the dress she wears is a blue bodice and overskirt with a white silk underskirt, but apart from the difference in colour and minor variations it is patently the same as the dress that Mary Graham is wearing – dramatically upraised collar, strings of pearls and all.[8]

Frances Duncombe's portrait, possibly commissioned by the Earl of Radnor, was not exhibited at the Academy, so apart from Frances Duncombe, if she went to the Royal Academy exhibition, nobody would ever know that two women were wearing the same dress. The clear conclusion here is, of course, that neither woman wore the dress, but that it was part of the set of props that Gainsborough had in his painting room, or was supplied by the milliner conveniently trading at the other end of Schomberg House. The portrait-painting process, in the industrial production line that Gainsborough and Dupont were developing in London as they had in Bath, the subject's head, expression, glance and mood were painted from life, while the dress and accessories could be added when the sitter was a hundred miles away. Thus we might conclude that the women presented by Gainsborough in this grand way were equally projections of fashion, status and likeness, with insight into personality or character being an extra that might or might not emerge.

Across the months of preparation for the 1777 exhibition Gainsborough was divided in his focus between music, painting, and helping William Jackson become a better artist. He had also

been trying to pin Johann Christian Bach down about some musical activity the trio were planning together: 'I have been 4 times after Bach, and have never laid Eyes on him . . . surely I shall catch [him] soon to get an Answer to your Letter.' He was trying also to get a parcel of drawings and brushes to Jackson, with some notes about music, but despite packing them up and addressing the parcel, it had not got on to the Exeter coach

> by the neglect of two blockheads. One my Nephew, who is too proud to carry a bundle <u>under his Arm</u> . . . And my d—mnd cowardly footman who forsooth is afraid to peep into the street for fear of being press'd for Sea service, the only service God almighty made him for . . . damn me if I don't carry them myself to the Inn tomorrow.[9]

With Mary Graham's portrait to complete, and the Duke and Duchess of Cumberland, and *The Watering Place* all needing his attention, time and application, his activity was frenetic. Frustration at delays, and the unwillingness of servants and so on to do as they were told induced tetchy behaviour: Gainsborough's anger could flash like lightning. He adds to Jackson that with the parcel of drawings he has enclosed 'a letter of Nonsense' about musical notation 'which you may read or wipe your Arse with as you hap to be in humour when you see the Drawings'.[10]

Gainsborough was now consolidating his hold on portrait painting in London. There are more than seventy portraits recorded as being painted in his early years at Schomberg House, from 1774 until 1777, and about the same number from 1778 until 1780. He and Dupont would also provide copies of portraits as required. As a team, they were hard-working, in demand, and Gainsborough was trying as best he could to keep a balance in his life, but probably sensed he was in danger of being overwhelmed. It was Bath all over again. He showed two landscape paintings and eleven portraits at the 1778 Academy exhibition, four of them full-lengths. There the notorious Grace Dalrymple Elliott and Clara Heywood faced off the Earl and Countess of Chesterfield, and the auctioneer James Christie looked across towards Philippe Jacques de Loutherbourg.[11]

Grace Elliott, a long, lanky, vivacious good-time girl, known as

'Dally the Tall', will have felt at home in Schomberg House when she came to be painted. She certainly knew high-class bagnios and bawdy houses such as the one Gainsborough's neighbour John Astley ran.[12] The courts and the newspapers had been full of Dally and her marriage in 1771 to a society physician, and her affairs with a libertine Irish peer and a libidinous English earl. Her later conquests took in the French aristocracy, an adventure that led to her imprisonment during the Revolution, and a narrow escape from the guillotine. Gainsborough painted her before she got mixed up in France, and presented her as a grand lady in a rich gold dress, her hair piled up and up, greyed and ribboned, and topped with an ostrich feather. This hairdo occupies about twice the acreage of canvas as her face. But Gainsborough has caught a sadness about her that was probably as real as her life had become artificial. One journal suggested that from the evidence of Grace Elliott and Clara Heywood, Gainsborough was 'a favourite among the demireps'.[13] Other 'demireps' that he painted – the word was unkindly defined by Henry Fielding as 'a woman ... whom everybody knows to be what no body calls her'[14] – include Nancy Parsons, later the Viscountess Maynard, and the unfortunate but highly talented actress and poet Mary 'Perdita' Robinson. He was able to transmute these interesting and lively women into the goddesses that they perhaps craved to be, and to a status that some may briefly have achieved. Reynolds also painted courtesans and actresses, some of whom, such as Mary Robinson and Sarah Siddons, also sat to Gainsborough. It was characteristic of Gainsborough to approach each with decorum and sympathy, seeing beyond their crazy piled-up hair and fashion-madness. He tended to show them keeping their chins up. Looking at these women, translating them into paint with his ineffable concern and insight, he is identifying with them wholly. He saw through the façade that Oliver Goldsmith rabidly observed:

[English women have] red cheeks, big eyes, and [their] teeth of a most odious whiteness are not only seen here, but wished for ... There appears a sickly delicacy in the faces of their finest women. This may have introduced the use of paint, and paint

produces wrinkles, so that a fine Lady should look like an hag at twenty-three. But as in some measure they never appear young, so it may be equally asserted, that they actually think themselves never old; a gentle Miss shall prepare for new conquests at sixty, shall hobble a rigadoon when she can scarce walk without a crutch, shall affect the girl, play her fan and her eyes, and talk of sentiments, bleeding hearts, and expiring for love, when actually dying with age.[15]

When he put his brushes aside for the day, Gainsborough will have walked along his new corridor, past a group of his landscape paintings and perhaps a portrait or two, gone through the back door of the original part of Schomberg House, and entered the parlour he shared with the three good-looking, good women in his life, Margaret, Molly and Peggy. They, too, were his subjects from time to time, and it may be that while painting them he could relax. Were she not his wife, Margaret might have aspired to be painted by Gainsborough as a paying client. 'I have some right to this', Margaret said to her niece Sophia, indicating a fine dress she was wearing, 'for you know, my love, I am a prince's daughter.'[16] A prince's daughter would also expect to have her portrait painted as a matter of course.

Across the years of their marriage, Gainsborough painted his wife at least four times, probably more. In each known depiction she is shown to be well and even expensively dressed, as befits 'a prince's daughter'. About ten years separates each surviving portrait: as a young mother leaning affectionately towards her husband and their first child in the late 1740s (Pl. 23);[17] then as a mother in her thirties, presented c.1758/9 as a court beauty in a dreamy pose, as if by Sir Peter Lely (Pl. 28). Painted just before the family left Ipswich for Bath, Margaret is here shown wearing a low-slung dress, her hand to her ample bosom, and gazing lovingly out at her husband.[18] This is as it should have been in their marriage, and no doubt often was. Gainsborough gives his wife a look of contentment, status and in her full silk-bedecked and ribboned figure the evident prosperity that he as a successful portrait painter was bringing her.

Margaret glances sideways at her husband in that work, while

in the portrait of the late 1770s, when the family was well settled
in London, Margaret looks out directly in what is perhaps one of
the most loving portraits in all art of an artist's wife after perhaps
twenty-five years of marriage (Pl. 29).[19] Despite Gainsborough's
strictures about Margaret – he claimed she was 'never much
formed to humour my Happiness'[20] – and her strong, controlling
personality, it is patently clear that in painting a portrait such as
this he is in love with her. She fingers her fine lace shawl, her ex-
pression is quizzical but full of understanding, her touch – for this
is a portrait about touch, of fingers, of lips, of eyes – gentle and
caressing. Though by Gainsborough, this is not (almost) an Eng-
lish portrait, but one of French or even Scandinavian sensibilities.

The final surviving portrait of Margaret is a little one, six
inches high, painted on card perhaps in the 1780s when Margaret
was in her fifties (Pl. 30).[21] This is a busy, determined woman who
takes no nonsense. Her bonnet is firmly tied under her chin, pro-
tecting a fine head of hair, her eyes twitch watchfully, her mouth
is firm. She knows her husband well.

33. Margaret, Molly, Peggy, and an unfeeling churl

Sir Benjamin Truman, bluff, hearty brewer and founder of a dynasty, posed for Gainsborough for a full-length portrait in September 1777. His granddaughter, Frances Read, later Mrs William Villebois, also came along for the sitting, and by the middle of the month Gainsborough was 'doing the Ladies Face ... [She] came out of Wiltshire on purpose to Sit'.[1] This would become a full-length portrait of much splendour.[2] Margaret, Molly and Peggy went off to Ipswich to stay with the Kilderbees for a fortnight, and that gave Gainsborough some space to himself to get on with his work.

The family had now arrived at a satisfactorily high social status in their extended Pall Mall home, and off the ladies went in Gainsborough's carriage, with David the coachman cracking the whip, and no doubt a ladies' maid on board as well. This was the life! They were the family of a 'capital' artist on a thousand a year, portrait painter to the aristocracy, living in the best street in London. If Molly's shoes got muddy when she stepped into the street she could get a new pair; if a bramble in The Mall tore Peggy's stocking it could be replaced. They did not quite live like royalty, but in Pall Mall they did live near royalty. They had come a long way since childhood in Sudbury and Ipswich. But no sooner had the ladies reached Ipswich this time than they said they wanted to come home, and would he please come and fetch them. In frustration Gainsborough told his sister: 'Either people don't pay them hon[our] enough for Ladies that <u>keep a Coach</u>, or e[lse] Madam is afraid to trust me alone at home in this great Town.'[3]

Domestic life was tough at Schomberg House. Margaret was firm about money and still had tight control over her husband's earnings, despite Gainsborough trying to wrest it back. 'I have this moment 50 Guineas in my pocket that I received for the half

pay from Sir Benj: but you know it would be certain death to make use of a farthing of it for private as I am under everlasting engagements to deliver up to my Wife.'[4] Nevertheless he did manage to keep something back for himself. Margaret did not know what Gainsborough was paid for his landscapes, because he chose not to tell her. 'The Duke of Dorset is [to] buy two Landskips as soon as his [House is] ready, and there I cribb a few guineas in spite of the D—l.'

Henry Angelo, a fashionable teacher of fencing with connections at court, reported that Gainsborough was 'afraid of his wife, and consequently ill at ease at home'.[5] When he added that Gainsborough 'was not entirely comfortable abroad, lest his Xantippe should discover what he expended on his rambles', there is real evidence of tough financial management at Schomberg House. 'Xantippe' is Angelo's description of Margaret Gainsborough, likening her to Socrates' allegedly argumentative and scolding wife. That she might have been, but she did have a lot to put up with. 'It is true,' Angelo adds, in a moment of male bonding, '[Gainsborough] was no economist of his cash; but the parsimony of his lady was beyond the endurance of any man possessing the least spirit of liberality, and Gainsborough was liberal to excess.'

With his sister Mary, Gainsborough was frank, honest and open. She was probably the only woman he could happily unburden himself to. Mary sent provisions to the family – an 'excellent present of fish'; 'cheeses . . . extremely acceptable to all parties.'[6] He explained why he wanted her to keep quiet about the money he was going to earn from the Duke of Dorset, and on the strength of it asked her to lend him £20 to give to a woman he had known in Bath who had been abandoned in London by 'some worthless ungrateful Villain' who had gone abroad, and was in a desperate condition. She had a suppurating sore on her leg 'as wide round as the top of a Tea Cup and down to the bone'. Gainsborough, seeing the woman again, simply could not bear it, asked for the loan, and promised to pay Mary back as soon as he could.[7] Mary, living as a successful rentier in Bath, had ready cash and could well afford it.

Mary's piety impressed and chastened her brother. He was

himself a devout Anglican, generally looking forward to Eternity when it came, and offering prayers for his sister with the hope that 'no <u>doubt</u> of perfect happiness in Eternity [would] ever enter your mind'.[8] But Mary was an even more devout Methodist, as her brother remarked to Rice Charlton: 'I have a d—mned plague with Her when she comes to Town, to find out new Methodist Chapels enough for Her, for she Prays double Sides, and cares not a farthing for what Bishops can say.'[9]

Gainsborough tried hard for his family, 'd—m'd hard', as he might have put it. If he took a tough line with his daughters it was a reflection of his anxiety for them. It was naturally to his sister that he turned when he discovered that the opportunist Fischer was wooing Molly, and breaking Peggy's heart in the process. This had been going on for five years, and burying himself too deeply in his work, Gainsborough had not really taken enough notice: 'I had not the least suspicion of the attachment being so long and deeply settled', he told Mary. Molly and Fischer were married in February 1780: 'it was too late for me to alter anything, without being the total cause of unhappiness on both sides, my consent . . . I needs must give, whether such a match was agreeable or not.'[10]

Fischer, a genius on the oboe and startlingly handsome, was a man whose musical talents had effortlessly lifted him, like Carl Friedrich Abel, into the group of musicians who played for Queen Charlotte. Like Abel, he came from Dresden, where he had been one of the cohort of musicians connected to the ducal and princely German courts. He was also a favourite of that other émigré from Germany, Queen Charlotte herself, who laughed at his jokes, and loved the King to repeat to her and their daughters the latest witticism from that wisecracker, the 'eccentric, inscrutable humorist'.[11] Gainsborough had been completely hoodwinked by the affair, but even at this late stage refused to doubt Fischer's 'honesty or goodness of heart, as I never heard anyone speak anything amiss of him; and as to his oddities and temper, she must learn to like as she likes his person, for nothing can be altered now'.

He may have been recalling his feelings of five years earlier: 'Oh, d—n him, he must take care how he trips me off the foot

of all happiness,' he had written. Now he had Molly gone and Peggy in tears, 'but I endeavour to comfort her, in hope that she will have more pride and goodness than to do anything without first asking my advice and approbation'.[12] Gainsborough clearly decided to make the best of it, and accept Fischer into the family unconditionally. Soon after the marriage he dusted down the seven-foot-high portrait of his then friend, now his son-in-law, which he had painted in Bath, long before he had any inkling that Fischer and Molly would become an item, let alone marry.

He exhibited the portrait (Pl. 43) at the 1780 Academy, a wry public statement of his acceptance of his daughter's marriage. Gainsborough shows his son-in-law standing at his harpsichord, with his oboe and violin nearby, and piles of music books. The harpsichord, so its inscription announces, was made in London by J. J. Merlin, a good friend both of the painter and the musician. Fischer is at work with a quill pen on a composition, and gazes upwards in inspiration. He was certainly a composer, and wrote some cheerful music, but in England he was known principally as a performer. It seems therefore curious that Gainsborough should portray him apparently in the throes of composition, until we remember that this canvas originally held the failed figure of Shakespeare, posing between Comedy and Tragedy, as an X-ray reveals.[13] So, beginning again from scratch, Gainsborough painted over Shakespeare with the figure of his disreputable son-in-law.

This is a remarkable portrait, far larger perhaps than Gainsborough might have expected to paint Fischer, who was not paying for it, and would not in any case have had the money to do so. It was a piece of opportunism on both artists' part: for Gainsborough it was a means of using up a decent canvas and obliterating a failure; for Fischer it was a way of getting a career-enhancing portrayal from a good friend whom he would in due course deceive. Fischer had his reward, while Gainsborough pulled off a masterpiece. In the Fischer portrait Gainsborough has given a total conception of what it was that spurred him into action: music, musical instruments, elegance of person, inspiration, creativity and friendship. Fischer's perfectly modulated coat and trousers are enveloped in a kind of ectoplasm, a faint white shimmer that skitters all over the figure, creating lively highlights and entertaining the eye.

The hanging of Gainsborough's exhibits in 1780, and his re-
sponse to their placement, would become a bugbear between him
and the Academy, and, in time, the cause of their final separa-
tion. In the *Morning Post*, Henry Bate Dudley put his finger on
the issue; while eulogising Gainsborough's 'superior excellence
in either style [portrait or landscape]', he deeply regretted that
'his beautiful landscapes could not have been placed in such
light and at such distance for which they were so evidently
painted'.[14] Picture hanging, like orchestral conducting, had not
yet progressed into the art it has become, but Gainsborough
painted pictures that required particular treatment of height
and light. Bate Dudley spotted and expressed this need, while
the Academy's Hanging Committee were, intentionally or not,
blind to it.

This was a moment of respite for Gainsborough. The flood
waters soon broke upon his family, as within eight months the
Fischers' marriage collapsed amid deceit and discord. Johann
clearly did not have enough money to keep his wife. 'Fischer has
deceived me in his circumstances and his Wife has been playing
the Devil to raise money,' Gainsborough wrote to his sister.[15]
Molly, who reportedly 'thought herself a queen',[16] and imagined
that the Prince of Wales was in love with her, had put an order
for sixty yards of white satin at one shop, and for lengths of
sarsenet, a fine dress-making silk lining, at another. This was
very expensive material, the best quality, the stuff her father
painted. Molly asked their old silversmith friend George Coyte
to take the lengths from her and sell them all for a profit. Coyte
was by now in his late sixties, probably not used to this kind of
sharp business practice, and it is quite clear that the suppliers of
the fabric had not been paid and had no knowledge of the scam.
Coyte will have known Molly from childhood, and was probably
charmed into helping her out without really knowing the whole
story.

Gainsborough was furious and hurt; Margaret referred to
Fischer as 'a German brute'.[17] 'I have stopt the Whole Scheme',
Gainsborough told Mary, 'but want sadly to know if these terrible
undertakings are by his consent.' He asked his sister to talk to
Fischer, to find out what if anything he knew about it; and remind

him that the couple could be transported to the West Indies or America for this. Molly's comment to her father, 'that she would go to the Gallows to serve this man', suggests that Fischer, nearly twenty years older than his wife, had an unhealthy controlling influence on her.

Discord with this beguiling musician, 'an unfeeling churl as a husband',[18] generated gossip among the royal concert parties of London and Windsor. What interested the gossips, then as now, was other people's marriages. After nearly forty years together, Thomas and Margaret Gainsborough, however, must themselves have found some areas of harmony: Thomas's many loving remarks about Margaret, and his tender portraits of her, are testament to that. But Fischer, with a staggering lack of tact, would tease his father-in-law for putting up with Margaret's domination. He described his mother-in-law as 'receiver-general, paymaster-general, and auditor of her own accounts'.[19] We might see her, by this description, standing in the doorway, apron round her waist, arms akimbo, rolling pin in one hand, and the other held out palm upwards: but that would be to turn her into a twentieth-century comic figure. Hattie Jacques springs to mind. So when Queen Charlotte put this question to her favourite jokester: 'Mr Gainsborough is a very liberal [i.e. generous] man, is he not, Mr Fischer?' and Fischer replied 'yes, and please your majesty,' she quite reasonably added: 'Which is not *entirely* agreeable to his lady?' Fischer put the situation in a nutshell, as he saw it: 'Not at all so – not at all, may it please you, Madam. My mother-in-law is twin sister of the Old Lady of Threadneedle Street. She shall not be content, not if my father-in-law pour into her lap the amount of the whole national debt!'

The Queen only smiled.

When Gainsborough made his powerful return to the public arena of the Royal Academy exhibition the press lauded him with encomia. His 'particular merit as a portrait painter' was noted by the *Morning Chronicle*, which added that Gainsborough 'in some instances . . . treads so close upon the heels of that Chief of the Science, that it is not always evident Sir Joshua has superiority'.[20] The *Public Advertiser*, carrier of the artist's blast in 1772, challenged

'the Connoisseurs' to determine the branch of art, landscape or portrait, in which Gainsborough most excelled – 'if they can.'[21] Sir Joshua Reynolds now faced the most potent challenge to his reputation and position that he had ever known.

34. 'Hey, Gainsborough, hey!'

He paints the royal family

———

Glittering in the sun, and swaying with the weight it carried, a carriage flashing brass and shiny leather clattered down Piccadilly and on past Hyde Park Corner. The coachman gave a coin to a tollman, the horses pulled ahead, and the noise from the wheels changed from its screech on stone flags to a soft susurration of pebbles on the road below. This was Thomas Gainsborough travelling to Windsor with two good friends in July 1782. They were on their way to see the man whom Gainsborough called 'England's Morning Star', King George III, and his gentle, attentive and empathetic Queen Charlotte.[1] For all three men the royal couple was a source of income, occupation and status.

Facing the direction of travel were Gainsborough himself and Henry Angelo, whose father, Domenico, had preceded Henry as teacher of swordsmanship to the King and princes. Opposite, his back to the driver, was the composer Carl Friedrich Abel, virtuoso player of stringed instruments, and a favourite of Queen Charlotte. Abel was a large and heavy man: best to give him a seat to himself. Along they trotted, the morning sun throwing their shadows before them. Gainsborough, 'as usual in tip-top spirits', kept them cheerful 'with an anecdote, a pithy remark, or some humorous observation'.[2] They had all offered to contribute to the cost of the trip, but Gainsborough would have none of it – this was his treat, it was his own coach and horses, and he would do as he pleased.

Arrived at Windsor Castle, Gainsborough was overwhelmed by the view over the Great Park: 'Look, Abel, my old shepherd. The cattle grazing down there ... gems on a cushion of green velvet ... dame nature's perfection!' He turned to the King's pictures. Portraits by Van Dyck were the first to meet his eye: there was Queen Henrietta Maria in white satin. 'That woman had taste,' he

remarked, adding: 'Why don't French women dress like that now? Ye gods, how they have degenerated!'[3]

When Gainsborough was commanded in 1780 to paint King George III and Queen Charlotte he had already painted the King's brothers, the dukes of Gloucester and Cumberland. 'The Duke and Duchess of Gloucester', the *Morning Chronicle* reported coyly (but inaccurately) in 1775, 'are often going to a famous painter's in Pall Mall.'[4] What might normally be called 'commissions' were, with the royal family, commands. No record of how such commands were transmitted to Gainsborough or received seem to have survived, but when the impossibly young Thomas Lawrence received his call from Queen Charlotte in 1789, a year after Gainsborough's death, it was couched thus: 'I am commanded by Her Majesty to desire you will come down to Windsor and bring your painting apparatus with you.'[5] Commands to Gainsborough would have followed the same pattern.

Dukes and duchesses, royal or otherwise, came to him in Pall Mall; but to paint the monarch and his queen Gainsborough had to do the travelling, whether the few yards from Schomberg House to St James's Palace, to the Queen's House nearby, or to Windsor Castle. St James's Palace was George III's principal residence, as before him it had been the residence of his grandfather George II and of his great-grandfather George I. Further back it had been the London home of Tudor and Stuart monarchs. Centuries as the focus of heavy-going ceremonial, diplomatic and political use had by the mid eighteenth century left St James's dilapidated and shabby, peeling, crumbling, draughty and disliked.

St James's was where the monarch held his court, where ambassadors were received, and petitions accepted. While it remained the centre of state ceremony, the King bought Buckingham House in 1763 as a more domestic but still appropriately grand place for him and his family to live. 'One hardly wonders St James was quitted', the diarist Caroline Lybbe-Powys reported in 1767. At the Queen's House, as the new residence was called, 'Majesty may reside in <u>comfort</u> as well as State, at St James tis impossible as it now is.'[6] Lybbe-Powys showed her delight when she described the Queen's House as 'altogether more worth notice than any in

Town, from ye variety of curiosities it contains, indeed in itself tis
an excellent one.'

> The Hall and Staircase are particularly pleasing. The whole of
> the Ground floor is for the King whose apartments there are
> fitted up rather neatly elegant than profusely ornamental. The
> Library consists of three rooms, two oblong and an octagon.
> The books are said to be the best collection anywhere to be
> met with, and one is more apt to believe so, as their outsides
> are not so gilded and lettered as one generally sees in rooms of
> this kind.[7]

The Keeper of the Queen's Robes, better known to us as the
diarist and novelist Fanny Burney, reported concisely on court
procedure. In London the royal family lived at the Queen's House,
but alternated between Kew and Windsor Castle in the summer.
Their principal house at Kew, the White House, was adjacent to
what is today known as Kew Palace, or 'the Dutch House', which
they increasingly used in the 1780s as their family grew. The
White House, demolished in 1802, was a relic of the King's father,
Frederick, who had died in 1751 when Prince of Wales. This was
a weird place, 'a large house of plain exterior', altered into a Pal-
ladian style by William Kent in the 1730s, with a hugger-mugger
complex of domestic buildings around it.[8] Frederick had been a
wild and inconstant son to his father, George II, from whom he
became estranged, and a trial and a worry. He left behind him
at Kew, for his son to inherit, a tapestry-hung ground-floor par-
lour with japanned furniture, a first-floor state drawing-room
hung with green silk, a ceiling decorated by grotesqueries, a
gallery glittering in blue and gold, and an upper floor stuffed
with astronomical instruments. This was the 'Kew Palace' that
Gainsborough would have known when he visited Joshua Kirby, a
cold, draughty, dilapidated place where, after court formalities in
London, the King and Queen and their growing family could nev-
ertheless unwind. By the late 1770s there was an ever-increasing
supply of princes and princesses, starting with Prince George,
aged twenty-one, already a difficult young man, until, in 1783, the
youngest, Princess Amelia, was born. The younger children were
farmed out by night from house to substantial house across Kew

Green, while the older princesses, Charlotte, Augusta and Elizabeth, had rooms of their own in the Dutch House attic. Fanny Burney noted that life at Kew was

> very different to Windsor, having no early prayers, the Queen rises later, & as there is no form or ceremony here of any sort, her Dress is plain, & the Hour for the second Toilette extremely uncertain. The Royal family are here always in so very retired a way that they live as the simplest Country Gentlefolks. The King has not even an Equerry with him, nor the Queen any lady to attend her when she goes her airings.[9]

The King's good sense, economy and learning were always evident. The Queen's apartments in the Queen's House, 'ornamented as one expects a queen's should be', were rich with the scent of flowers: 'though but in March every room was full of roses, carnations, hyacinths, etc disposed in the prettiest manner imaginable in jars and different flower pots on stands'. Ornaments, pictures, cabinets of 'the finest Dresden and other china, [and] cabinets of more minute varieties' furnished her rooms. 'The famed [Raphael] cartoons from Hampton Court' hung there, 'and numbers of small paintings more beautiful than any I ever saw. One room is panelled with the finest Japan; the floors are all inlaid in a most expensive manner'. The Queen's House was warm in even the coldest weather, for

> fires it seems are kept the whole day even in the closets, and to prevent any accidents to furniture so costly, from the neglect of the attendance, there is in every chimney a lacquered wire fireboard, the cleverest contrivance that can be imagined, as even the smallest spark cannot fly through them, while you have the heat, and they are really ornamental.[10]

These were the domestic and decorative delights that Gainsborough will have noticed around him at the Queen's House, where, along with those at Windsor, his engagements with the royal family took place. His full-length portrait of George III shows the King in the pose of an officer on parade, feet close together, wide-hipped, broad torso, small head, set against a bland landscape of columns and a glimpse into Windsor Great Park (Pl. 54). The

overall conception that Gainsborough created is one of duty and a lack of ostentation, in uniform that all would recognise: the King indicates his star of the Order of the Garter, looks into the far distance, and, while royally dressed, he has minimal frogging on the plain navy-blue-and-white 'Windsor uniform', that he himself designed. Gainsborough portrayed the King as a man who would lead, inspire and command respect, presenting quite a different set of values to his fellow monarch across the Channel, Louis XVI of France, who, within the decade, would lose his head as the price of revolution. When Gainsborough remarked on the degeneracy of French aristocratic women's dress he was more prescient than he knew. While standing in Gainsborough's portrait, like a skittle, a precarious, vulnerable, finely balanced pose, George III is a king who neither courts nor dreads political disaster.

By comparison, Gainsborough' charming and romantic portrait of Queen Charlotte in her wide gleaming silk gown, touched here and there with golden thread and dangles, is the image of quiet and unassuming regality (Pl. 55). Light touching the Queen's dress coming in from the left is expressed by fine and deliberate parallel white lines, gently laid on. This directly contradicts the anecdote, with its implication of slapdashery, that Gainsborough and Dupont stayed up all night to finish the painting. Perhaps they did, but there is no fatigue evident in the completed work. The Queen does not look at the artist, nor therefore at the viewer, so the queenliness of this thoughtful and empathetic woman has no trace of grandeur, and appears detached from the entire process of monarchy. Gainsborough dances with a rich visual heritage here: while he shows Charlotte carrying her role as Queen of England so modestly, he nevertheless touches gently on the form and composition, and to some extent content, of portraits of Queen Elizabeth I. Neither of Gainsborough's portraits are official state works – such official portraits, to be sent around the country, were the job of Sir Joshua Reynolds and Alan Ramsay – instead these are portraits of the King and Queen for the King and Queen. Hanging side by side at Windsor as intended, the King on the left (looking to the right) expresses formal duty, while the Queen on the right (looking left) demonstrates concern and empathy. Her dog adds a suggestion of uncertainty

as to what might happen next, unpredictable, like her nation.

There are mixed reports of where the royal portraits were painted. On 14 September 1782, the *Morning Herald* indicated sessions at Windsor, but Henry Angelo records a conversation between Gainsborough and Dominic Angelo at the Queen's House in 1782 when Gainsborough was taking sittings one by one from the princes and princesses. This was for the 'family set' of fifteen royal portraits, to be hung as a group. There they were ranged around on easels, each a fine picture of health, wealth and happiness, ready to be hung close together, reflecting their closeness as a family, or like a set of kit-cat portraits for a club. But what a club this was, the grandest and most exclusive of clubs, impenetrable by outsiders. Gainsborough told Angelo how beautiful he found the royal children to be: he was overwhelmed by them, and was touched particularly by the death in August 1782, before the age of two, of the youngest in the group, Prince Alfred. He painted the little boy from memory, and left him broadly and sketchily expressed. Princess Amelia was yet to be born. Gainsborough was 'all but raving mad with ecstasy in beholding such a constellation of youthful beauty', Angelo wrote. 'He used to rattle away in so hyperbolical a strain upon the subject of his art, that any indifferent observer would have concluded the painter was beside his wits.'

'Talk of the Greeks,' Gainsborough exclaimed to Angelo, 'the pale-faced, long-nosed, unmeaning visage ghosts! Look at the living, delectable carnations of royal progeny. Talk of Dame Cornelia, mother of the Gracchi!' Here Gainsborough evokes the quintessential virtuous Roman wife. Then, indicating his series of portraits of these fresh-faced, auburn-haired sons and daughters of England's Morning Star: 'Sir, here you behold half a score of youthful divinities – look on, ye gods!' Gainsborough would not keep his voice down: 'Hist!' said Angelo. 'Mr Gainsborough! You will be overheard! We'll both be sent to St Luke's!' Gainsborough did not care. He laughed: 'St Luke's? Ha, I'm a painter – so a son of St Luke!'[11] St Luke's was a London hospital for the insane, and Luke is the patron saint of painters.

Gainsborough was soon well established as a favourite of the royal family. Commissions for a portrait of the Prince of Wales

with his horse, and a head-and-shoulders of his younger brother Prince William, then a sixteen- or seventeen-year-old off to sea with the navy, also came his way: 'Gainsborough's fame is now quite established at Buckingham House. His success with the royal portraits . . . is even outdone by the happy manner in which he has hit off the portrait of the Prince. So that he is now, vice Zoffany, and other predecessors, the Apollo of the Palace.'[12]

This Apollo of the Palace, this son of St Luke, was one of the many artists who were employed to teach the royal family drawing and painting. Gainsborough gave lessons to the Queen, and to Princess Charlotte, the Princess Royal, in his pet technique, his 'moppings', where much ink was shed, wash floated and fingers dabbled to make imaginary landscapes emerge magically from the paper. Princess Charlotte showed herself to be a highly spirited artist, and not just in pen and ink: her etchings after Benjamin West are accomplished and knowing.[13]

Gainsborough's open, friendly charm allowed him to talk with ease as much to cottagers as to kings, 'bawdy to the King and morality to the Prince of Wales'.[14] With George III he adopted an admirable mix of deference and authority: he discussed modern fashion, and suggested that the King's painters should be employed to design the costumes worn at court. The King agreed entirely, and immediately challenged him to go ahead: 'Why don't you and Sir Joshua set about it? . . . But they are bewitching enough as it is – hey, Gainsborough! Hey!' Quick as a flash, Gainsborough nearly spoiled it all by giving a retort that he might have regretted. He told Angelo: 'Why, like a saucy dog as I am – what our gracious King listened to – and only answered with a smile. I said (faith I am ashamed to repeat it), "Yes, and please your Majesty – it were as well to leave the dowdy angels alone."'[15]

There is more of this good-hearted banter recorded between the King and Gainsborough. The King evidently warmed to Gainsborough's easy manner, and for his part Gainsborough found the King to be what he was, a good and experienced connoisseur, sensible, shrewd and receptive, who knew about the paintings he owned and the artists who painted them. He clearly enjoyed discussing painting with a man who had spent his life doing it; unlike Reynolds, Gainsborough had charm, and it paid off. Gainsborough

observed that the King's conversation was sprightly, decorated and amusing, and that he 'uttered more original *petits jeux-de-mots* . . . in a playful style, purely his own, than any person of rank whom he had ever known'. However, Gainsborough found that the King tended to repeat his *bon mots* again and again, and they became less funny and interesting by repetition. The courtiers, on the other hand, he found to be haughty and ignorant, 'lordlings, who, for all their prate about contour, carnations, and gusto, prefer a racer to a Raffael, and a stud to the studio of Michael Angelo himself'.[16]

The King kept Gainsborough on his toes, kept him thinking, and left him mildly uncertain as to where a conversation might be leading. One ambiguous exchange was reported by Angelo: looking at a portrait that Gainsborough had just finished, the King turned suddenly and observed that he hoped Gainsborough had not entirely given up painting landscapes. Whatever did he mean? Gainsborough assured him that he had a satisfactory number of landscape commissions in train: 'what I prefer is landscape painting', he responded, but he also took advance payment for portraits, and those had to be finished. Yes, payment in advance, very good idea, remarked the King. Reynolds had started that technique, the King asserted, but other painters aren't quite so conscientious about it. Then the King mused about human vanity:

'Doubtless portraiture is a tantalizing art – no pleasing your sitters, hey! All wanting to be Venuses and Adonises, hey! Well, Mr Gainsborough, since you have taken to portraiture, I suppose everyone wants your landscapes, hey! Is it not so?'

'Entirely so, your Majesty.'

' Aye, aye! That is the way of the world, I knew it would be so.'[17]

More was said on the economics of art between king and subject, as, perhaps twenty years later, the painter James Ward was able to report. A conversation between George III and Ward went something like this:

THE KING: 'Gainsborough once told me that when he painted landscapes he was starving, but when he painted portraits people bought his landscapes. Is that the case with you?'

WARD: 'I engrave to live, and paint from my love of the art.'

THE KING: 'Oh just so, just so.'[18]

The King was as aware as he could be in his position of the trials of the artist. Practice of the arts was greatly and positively encouraged in the royal palaces. Not only in painting, where the King and Queen were themselves closely involved in the development of the royal portrait collection, and in their drawing lessons from the finest talent available, including Alexander Cozens, William Chambers, Joshua Kirby and Gainsborough, but Gainsborough himself was given every opportunity to study the royal collection of old masters. According to Angelo – another conversation that is recorded second-hand, so perhaps to be read with caution – Gainsborough was not particularly impressed by the collection, except by the Van Dycks, which 'riveted his attention'. When he remarked, on seeing the portrait of Queen Henrietta Maria, 'Why do not the French women dress with that elegant simplicity now?' he was regretting the ostentatious dress of the French court, soon to be no more. Abel, who was with them, retorted in a roundabout continental way, heavily reinterpreted by Angelo: 'Yes, but whosoever that may be, what a strange degeneracy of your countrywomen to imitate all the trumpery fashions from France!'[19] In other words, 'Englishwomen are just as ostentatious'.

Of the vast array of old masters available to Gainsborough's eye and mind in the royal collection, it may have been the informal that attracted him most. It is impossible to accept Angelo's assertion that Gainsborough lacked enthusiasm for what he saw at Windsor and the Queen's House, from Breughel to Rembrandt to Canaletto. One example among many: the King owned a substantial group of remarkably fluid drawings by the seventeenth-century Italian artist Giovanni Benedetto Castiglione bound into a set of four albums. These are predominantly religious subjects from the Old and the New Testament, and while the subjects have little in common with Gainsborough, in their balanced use of bistre, pen and ink and lightly washed blue they echo the freedom in Gainsborough's own later drawing manner. His accomplished drawing *Peasants going to market*, dated on no real evidence to 1770–74,[20]

has sources in Rembrandt and Salvator Rosa, but it is also thoroughly in tune with Castiglione. Later Gainsborough drawings, broadly drawn, well worked, dappled, richly felt, demonstrate a kinship with Castiglione across the centuries.[21]

Musical performance was a regular and greatly anticipated court diversion. Fischer, Abel, Johann Christian Bach and the thoroughly English oboist John Parke were among the members of the Queen's band. Gainsborough, if ever he attended, would have been in familiar company. Fischer was a regular soloist, and Fanny Burney one of the many who heard him play: 'Imagine what a charm to my ears ensued on the opening of the evening concert, when the sweet-flowing, melting, celestial notes of Fischer's hautboy reached them! It made the evening pass so soothingly I could listen to nothing else.'[22]

Fischer had been appointed to the Queen's band of chamber musicians around 1781. According to Fanny's father, Charles Burney, he was 'the most pleasing and perfect performer on the hautbois, and the most ingenious composer for that instrument that has ever delighted our country during full sixty years.'[23] This may reflect a general opinion of his musicianship, though no less a talent that Mozart dismissed Fischer when he heard him play in Holland: 'he certainly doesn't deserve the reputation that he has . . . he plays like a wretched pupil . . . his tone is entirely nasal.'[24] As Gainsborough himself well knew, Fischer's private life was even less to be commended: Charles Burney added that Fischer 'had not a single grain of sense but that he breathed through his reed'.[25]

It was perhaps two years since he had seduced Gainsborough's gentle, deluded daughter Molly into their brief and troubled marriage. If he had been party to his wife's idiotic criminality, he must have been aware that he risked being charged as an accessory, his career and reputation facing ruin, and no more hob-nobbing at Windsor or the Queen's House for him. Word had got round by now, as Angelo remarked, that Fischer was 'anything rather than an uxorious spouse',[26] and it is very likely that Gainsborough did not want to encounter Fischer with the royals.

Gainsborough had to settle for being the palace's Apollo, for it was Joshua Reynolds who in 1769 got the knighthood, and who

was appointed King's Painter in Ordinary on the death of Alan Ramsay in 1784. The King's choice no doubt rankled for a while with Gainsborough; but how could it be other? There was Sir Joshua, top dog, painting like the genius-courtier-politico he was; he had his reward. Gainsborough, however, had the royal family's friendship and trust, access to all their palaces, and he could talk to them without flummery. He may even have taken Molly and Peggy with him along Pall Mall to Carlton House, and have the Prince of Wales say something sweet to Molly; how else might she have got the idea that the prince was in love with her? What better occasion for Gainsborough to 'talk morality' to the prince? Gainsborough had danced lightly into royal confidence through sheer personality, trustworthiness and charm, and had won their esteem. If there was no knighthood in the offing in the 1780s, it would likely have come to him in due course had he not so unexpectedly died. Reynolds' knighthood was awarded as much for his organising genius and grand vision as the founder of the Royal Academy, as it was for his revolutionary art.

Reynolds bought Gainsborough's *Girl with Pigs* from the 1782 Academy exhibition: its painter was indeed flattered. 'I may truly say that I have brought my Piggs to a fine market,' he told Sir Joshua in one of their very rare moments of contact.[27] The purchase of Gainsborough's *Pigs* by this great panjandrum became part of the chatter. Dr Johnson said grandly that 'such instances of homage to contemporary talent – these men being considered by the world as rivals – may be received as a testimony of the improved moral advantages of the high civilization to which our age has attained'.[28] That's something of a high-minded response to a painting that was the product of a girl modelling for him sitting on a step, and a couple of piglets squealing round his new painting room. But Queen Charlotte put it differently, with wisdom, sense and affection: 'I almost envy him [Sir Joshua] the possession; but the circumstances will do greater honour to its author than had it been placed in any royal gallery in Europe.'[29]

In early autumn 1783, Gainsborough painted *The Mall*, a touching, late effusion of slow-moving figures and quick-shifting glances in an enclosed, stagey landscape (Pl. 59). In conversation

with his friend William Pearce, the Chief Clerk to the Admiralty, Gainsborough told how the painting came about:

> King George III . . . expressed a wish to have a picture representing that part of St James's Park which is overlooked by the Gardens of the Palace – the assemblage being there, for five or six seasons, as high and fashionable as Ranelagh, employed [Gainsborough] to paint it. 'His Majesty', said Gainsborough, 'very sensibly remarked that he did not desire the high finish of Watteau, but a sketchy picture' and such was the picture produced.[30]

Apart from those conversations recorded by Henry Angelo, and this one by William Pearce, those between Gainsborough and the King and Queen are lost. However, what these fragments suggest is that Gainsborough was able to lead King George and Queen Charlotte towards an understanding of painting that their Painter in Ordinary would never have been able to convey. The King wanted a 'sketchy picture' of The Mall and its parade, and got it. Translated into portraiture, this 'sketchy' manner brought vivacity and feeling, qualities that Gainsborough aimed to evoke at all times. The royal family continued in their affection for Gainsborough and enjoyed his company; indeed Gainsborough's obituary in the *Morning Post* revealed the measure of the King's attachment to Gainsborough by reporting that he went so far as to visit Gainsborough at the cottage he rented on Richmond Hill.[31] Perhaps because he was not their official painter they pushed him to further achievement in ways which reflected their fondness for him. His work for King George III and Queen Charlotte had become pleasure not duty.

35. Whilst he breathes

Since 1777, when Gainsborough returned to exhibiting with the Royal Academy, the Academy's Council had begun to relax as a law-making authority. No longer were they so stiff with demands about strict send-in dates to the annual so-called 'Royal Exhibition'. They knew themselves all to be pressured as artists in their common 'field of generous contention', and needed to give themselves some slack. So now in the Council minutes 'indulgences' creep in. The 1779 minutes record 'indulgences' to sixteen artists, send-in delays granted because the paint is still wet, the frame not yet made and so on. These would never have been allowed in the earliest years. Gainsborough is permitted to send his pictures 'next Monday', and he is given extra time to finish in 1781 and 1783.[1] But in 1777, he returned with a vengeance to exhibit his lustrous paintings of *The Hon. Mary Graham*, *Carl Friedrich Abel* (Pl. 45) and *The Watering Place*. This, however, was also the year in which one of his sitters perished violently. The Rev. Dr William Dodd, priest of Bath and London, admired and loved by his many congregations, sailed too close to the wind and was hanged for forgery at Tyburn, where his lively eye flashed for the last time.

Gainsborough hit his stride in his portrait of his more fortunate friend Philippe Jacques de Loutherbourg, shown in the 1778 Royal Academy exhibition (Pl. 47). Moving on from Garrick, to whom he brought glare, colour, noise and brilliance of light, de Loutherbourg devised an alternative theatrical experience which drew large crowds attracted as much by its curious title as to its visual offerings. His Eidophusikon [*eido* = 'form' or 'shape'; *phus* = 'physical'; *ikon* = 'picture'] was the production that de Loutherbourg set up in 1781, and which required no actors, no theatre, and could be managed by the artist and an attentive team of friends. Beyond its eight-by-six-foot proscenium at his home in Lisle Street, for two seasons de Loutherbourg brought wrapt audiences

scenes of storm and shipwreck both from nature and from Milton and Shakespeare. During one performance a real storm broke during a scene of a tempest off Naples, and Gainsborough and some others went up on to the roof of the theatre to watch. From there they could look down on the staged storm from above, and were greatly impressed by the artifice below: 'Bravo! Our thunder is *decidedly* the best!'[3] Gainsborough would see the Eidophusikon again and again, and 'never went away without receiving instruction as well as amusement'.[4] Subsequently the entire production transferred under new management to a room in Exeter 'Change.[2]

De Loutherbourg's curiosity and inventiveness touched Gainsborough's own, and when he returned to London it led him to continue digging deep into long-neglected wells of creativity. He had already experimented in painting on glass, and printed the wet ink from the glass on to a sheet of paper, giving a rough, fragmented surface to the beginnings of an image. This could then be worked on and embellished. He continued these experiments in the figure of a Comic Muse, painted on glass, which he installed in 1775 in the room in Hanover Square that Bach and Abel had decked out for their concerts. At night the figure was lit from behind by candles, enhancing the room with a mysterious allure. Carrying this idea further, and with inspiration from de Loutherbourg and the glass-painter Thomas Jervais, Gainsborough devised in the early 1780s his own modest home theatre, a hefty table-size lightbox, about three feet high, through which, with a lens on a slider, the viewer could see a set of illuminated landscapes and seascapes painted in thin oil on sheets of glass. This is now in the Victoria and Albert Museum, encased in perspex.[5] The box and its paraphernalia of candleholders, diffusing screen, lens and slide-change pulley-system, all out of sight within the box, appears to have been manufactured by a professional joiner to Gainsborough's specifications for his own study purposes, so he could consider his various compositions under close dramatic lighting. While he certainly showed it off to visitors, who we can imagine gasped at its ingenuity, this was not primarily for drawing-room entertainment. The subjects he painted for the box are echoed across his later landscape work – mountain

scenes, estuaries, moonlit glades – each one refined and amended with the help of this mechanical and optical research tool. Here was Gainsborough the inventor, following family example from childhood, and emulating Scheming Jack's creative thought and Humphrey's technical brilliance. This same impulse led him to take up printmaking once more, and explore techniques of aquatint, a relatively new process that required equipment such as a dust-proof box, bellows, an acid bath, and some care and patience in handling things.

The practice of painting was joined in Schomberg House by a more coherent system of printmaking. While Gainsborough experimented with aquatint and soft-ground etching, his nephew Dupont became in his own right a remarkably accomplished engraver of Gainsborough's portraits. By the late 1770s a little industry had formed around the portraits, many being engraved for wider circulation through the initiative of the owner, usually the sitter. Gainsborough himself did not engrave them, but in a whole new network of workshops in London the engraving profession continued in much the same way, though with technical innovations, as it had in Gainsborough's youth: Francesco Bartolozzi, Joseph Collyer, Valentine Green, James Heath, George Keating and John Raphael Smith were among the talented engravers of Gainsborough's portraits. A dozen or more made money out of engraving after Gainsborough, so there were any number of workshops where Dupont could learn the trade, with encouragement to learn and the money to pay for it certainly coming from his uncle.[6] Dupont's value to his uncle rose also as he became efficient as a copyist, able to turn out versions of Gainsborough's portraits when and where multiple oil-on-canvas copies were required.

In 1780 the Royal Academy moved to its new home in Somerset House, and that year's exhibition was greeted with crowds and general delight. For Gainsborough this was a grand and important presentation: new subjects, new galleries, and a new, enlarged audience. He showed his portraits of *Johann Fischer* (Pl. 43), 'so like, but so <u>handsome</u>', swooned Fanny Burney's sister, Susan;[7] his actor friend *John Henderson*; his old friend *George Coyte*, lately compromised by Molly Fischer's behaviour; and as many as thirteen other portraits and landscapes. In the *Morning Post* Bate

Dudley, whose portrait by Gainsborough was also in the show, wrote that the carriages of 'the concourse of people who attended the opening of the exhibition yesterday ... filled the whole wide space from the New Church to Exeter Change. It is computed that the doorkeepers did not take less than £500 yesterday for the admission of the numerous visitants of all ranks.'[8] This was public adulation of the highest degree: painting in the late eighteenth century was the old rock'n'roll.

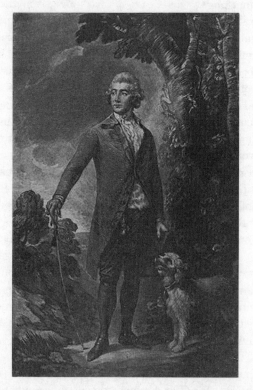

Gainsborough Dupont, after Thomas Gainsborough, *Rev. Sir Henry Bate Dudley*, late 1780s or 1790s.

But it was Joshua Reynolds' royal portraits that caught the eye, prompting a partisan response from Bate Dudley in the *Morning Post*: 'At the end of one of the [noble suite of rooms] are portraits

of their Majesties by Sir Joshua Reynolds, which, if it were not likely to be deemed high treason against the Prince of Painters, we should be apt to criticise pretty freely.[9]

Gainsborough's contribution, however, was a series of sixteen heavy drumbeats that made his presence and importance perfectly clear. Among the landscapes was *The Cottage Door* and another with a shepherd and his flock described as 'most enchanting ... touched with infinite spirit and grace'.[10]

Before the year was up Bate Dudley had moved from the *Morning Post* and founded the *Morning Herald*, of which he became proprietor and in sole control. When the following year Gainsborough returned to the Academy with three portraits and four landscape and subject pictures, Bate Dudley and the *Morning Herald* were at his side against the intermittent hostility of journals such as the *London Courant*. Gainsborough was now banging his drum for public notice and esteem, with his establishment status assured by his portraits of the King and Queen displayed for the first time in public. Gainsborough's unfamiliar seascape subjects, which Horace Walpole described as being 'so free and natural that one steps back for fear of being splashed', gave him another direction for his public to contemplate.[11] In the *Morning Herald* Bate Dudley wrote:

> Mr Gainsborough is confessedly the principal support of the present exhibition. The critic eye alternately wanders from his portraits to his landscapes and becomes too enraptured with either to decide which are the most entitled to pre-eminence. The King's [portrait] is by far the most striking ... The Queen's is the only happy likeness we ever saw portrayed of her Majesty ... the *Shepherd Boy* in a tempestuous scene is evidently the *chef d'oeuvre* of this great artist ... two sea-views show the universality of his genius ... the landscape of cattle passing over a bridge is equally fine, but the effect of it, like that of his other productions, is shamefully destroyed by the picture being hung almost close to the ground. Strange that the fame of an artist who is honoured with the most flattering marks of his Sovereign's favour should be sacrificed on the pitiful shrine of ignorance or jealousy.[12]

The difficulty of arranging so large an exhibition in new galleries, which were not yet fully familiar even to those in charge of the hang, was already beginning to stoke discord. Whether the artists liked it or not, the Hanging Committee had no choice but to give some paintings inadequate placement. Where the largest paintings were generally in the middle of the walls, smaller works became pushed out, either too high, too low, or just overwhelmed by the pressure. The result was a visual cacophony. Controversy and disagreement was rife, with the hanging committee always in the firing line. Battle lines between Reynolds and Gainsborough in particular were clear in some sections of the press. The *London Courant* had it:

> A morning paper that struggles to erect itself into the *Herald* of renown and infamy, has sounded the first blast with the name of Gainsborough; a name ... not honourable enough to head a class or to be often repeated by posterity ... Such is [the critic's] impertinent and ignorant rapture in a place that exhibits sixteen pieces by Reynolds, the least of which exceeds the power of Gainsborough as far as Johnson's that of Bate.[13]

Gainsborough and the Royal Academy were, if not on a collision course, at least set up for a stand-off. This was not of Gainsborough's doing, nor perhaps of Sir Joshua's, but rather the inevitable result of a baiting atmosphere generated by parts of the press, and journals fighting each other for circulation. Having been wooed back into the Academy's arms after five years in the cold, Gainsborough now showed annually with spirit, commitment and integrity. He was part of an ecology, part of a bunch of respected artists whose idiosyncrasies and attitudes coloured national artistic life, and whose differences, clashes, common ground and temperaments were blown out of all proportion in the press.

In 1782 Gainsborough's submission included one landscape and one subject picture, *Girl with Pigs*, and nine portraits including *The Prince of Wales*, *Giovanna Bacelli*, and the twelve-foot-high *Sir Banastre Tarleton*, 'very large', Walpole observed, but now destroyed. Gainsborough had intended also to show his *Mary 'Perdita' Robinson*, commissioned by the Prince of Wales, her lover, but withdrew it following criticism in the *Public Advertiser* that it was

a poor likeness. These were four controversial figures, all of whom balanced on the knife-edges of applause and opprobrium: a dancer and ducal mistress; a cavalry hero just back from the American wars; a glamorous actress famed for her Perdita in *A Winter's Tale*; and Perdita's lover the Prince of Wales. While Bacelli's lover, the Duke of Dorset, had also been painted by Gainsborough and was intended for the 1782 exhibition, Dorset withdrew himself to still gossip.[14] But there were already plenty of titbits on or near the 1782 Academy walls, a *ménage à trois*, fruit for a juicy sitcom, being acted out for the gallery visitor: the Prince loved Mrs Robinson; Mrs Robinson, however, was being badly treated by the Prince, and she threatened to publish his letters to her. She in turn was in love with Colonel Tarleton and they reportedly timed their sittings with Reynolds and Gainsborough so that their paths would cross at the studio door. Beyond the Academy walls, in the lives of these people so innocently depicted, were high-beating hearts.[15]

The choices of subject to show at the Academy were calculated and planned well ahead, but the final choice was volatile and dependent on the whims of the sitter, the artist, space available, and press and public reaction. Everybody had something to say about the Prince, Mrs Robinson, Tarleton and Bacelli. They were already much painted and their images were performances to be judged, like an opera production or a hundred-metre sprint. While Gainsborough's star was rapidly rising, Reynolds was still the boss, and always able to pull off yet another subtle and characterful portrait to delight. In full knowledge of each other's intentions, and the sitter no doubt also complicit, both Gainsborough and Reynolds exhibited portraits of Tarleton in 1782, and in the sudden absence of Gainsborough's rendition of Mrs Robinson, Reynolds showed a sly, even petulant, half-length portrait of her. It was not a dancer, an actress, a soldier or a prince who stole the show, however, but a *Girl with Pigs*, which Reynolds bought for 100 guineas, forty guineas more than the asking price.[16] Past tantrums were put aside, and the President, now the proud owner of Gainsborough's pigs, had with ineffable diplomacy smoothed what ruffled feathers he imagined Gainsborough might have had. But Reynolds' diplomacy was transparent, possibly unkind, and

only skin-deep. Writing to his client the Earl of Upper Ossory four years later he spoiled it all by offering to exchange Gainsborough's pigs, which he described cuttingly as 'by far the best picture [Gainsborough] ever painted or perhaps ever will',[17] for a dubious knocked-about Titian copy in which, as Reynolds admitted, 'the Venus is not handsome and the Adonis is wretchedly disproportioned.'

Gainsborough's imagined triumph in selling his *Girl with Pigs* to Reynolds may have encouraged in him a sense of false security, a misunderstanding of where he stood with the Royal Academy. This may further have led him the following year into being perhaps rather too specific to the Hanging Committee with a request which could be read as instruction. Hanging committees do not like to be told what to do. He had sent twelve works, including his fifteen royal portraits, the family set, which counted as one work in the cataloguing of the show:

> I wd beg to have them hung with the Frames touching each other, in this order [a clear sketch set out Gainsborough's desires], the Names are written beneath each Picture.
>
> God bless you. Hang my Dogs & my Landskips in the great Room. The sea Piece you may fill the small Room with.[18]

Before he could expect a response, he wrote cheerfully to Sir William Chambers, the senior Academician architect who had designed Somerset House, to ask if Chambers could help an out-of-work joiner, a relation of his wife's in Scotland, who needed employment. 'It has occurred to my good woman that as you must necessarily have a great number of hands at your <u>feet</u> that you might be so good as to think of him when convenient.' He goes on to say nice words about William Newton, the secretary of the Hanging Committee, who had been unwell, and added that he has sent his *Two Shepherd Boys with Dogs Fighting* (Pl. 56) to the Academy, and next year might swap things round and paint the boys fighting and the dogs looking on. 'You know my cunning way of avoiding great subjects in painting & of concealing my ignorance by a flash in the pan', he continued: well, he plans to carry on painting portraits for three more years or so, and then

give it up: 'sneak into a cot[tage] & turn a serious fellow; but for the present I must affect a certain madness. I know you think me right as a whole, & can look down upon Cock Sparrows as a great man ought to do with compassion.'[19]

What, indeed, was *Two Shepherd Boys with Dogs Fighting* all about? So violent a subject had not before come from Gainsborough's brush, and we may be looking at metaphor here, Gainsborough's rendition of newspapers fighting each other to the death while the poor artists look on impotently. In his letter to Chambers there is no hint of concern about the gallery hang, and Gainsborough is relaxed enough to reveal to Chambers his dream for the future.

He must have written to Chambers about these future hopes before getting wind of the idea that his set of royal family portraits were to be hung high, 'above the line' – that is, above the level of the top of the doors – too high for them to be properly appreciated. That prompted this stinging rebuke, and an unfortunate ultimatum:

> Mr Gainsborough presents his Compliments to The Gentlemen appointed to hang the Pictures at the Royal Academy; and begs leave to <u>hint</u> to Them, that if The Royal Family, which he has sent for this Exhibition, (being smaller than three quarters) are hung above the line along with full lengths, he never more, whilst he breaths, will ever [crossed out] send another Picture to the Exhibition.
>
> This he swears by God.[20]

The committee's immediate reaction is not recorded in any words, but whether with conviction or in dismay it silently did what Gainsborough asked of it: these were after all royal portraits for the 'Royal Exhibition'.

Gainsborough now made plans to go on one of his infrequent journeys away from southern England. With Sam Kilderbee he planned to travel to the Lake District, staying on the way with James Unwin in the grand baronial house he had inherited at Wootton, Staffordshire. He wanted to take a new direction in his landscape painting, and make some mountain and lake subjects

for next year's exhibition. So certainly, despite the recent con-
tretemps, he had every intention of showing again at Somerset
House, and indeed to surprise them all again. He wrote to William
Pearce, a man whose portrait he had recently painted: 'I'm going
along with a Suffolk Friend to visit the Lakes in Cumberland &
Westmorland; and purpose when I come back to show you that
your Grays and Dr Browne's were tawdry fan-Painters. I purpose
to mount all the Lakes at the Exhibition, in the great Stile.'[21]

What he means here is that he will produce a series of lake and
mountain landscapes echoing the fashionable manner of Claude,
Salvator Rosa and Gaspard Poussin, and show that the writers
on the Picturesque, Thomas Gray and John Brown, were a minor
pair of talentless amateurs. The fact that neither Gray nor Brown
claimed to be artists does not seem to have occurred to him.

However, it is not entirely clear that Gainsborough actually
made the journey. While he exhibited mountainous scenes in the
1783 exhibition, these were painted before his putative journey,
and thus generated from his landscape models, imagination, and
memories of Bath, its 'rocks of the finest forms for a painter'.[22]
There is no record that his 1784 exhibition submission contained
the promised mountain subjects. However, while he listed the
eight portraits he would send, the fact that there is no record of
any landscapes does not mean that none was submitted. The pu-
tative 1783 journey may be thrown into some doubt because he
is also known to have travelled to Antwerp in 1783, and such an
extended journey would have been a heavy programme for him
to set himself in his mid fifties. But it could be done: travel to
Antwerp, across the North Sea from London or Harwich was a
regular trading route. Had he been in the Lake District he need
not have returned to London, but could have caught a packet from
Hull.

While the Lake District journey may be shrouded in mystery,
Gainsborough's visit to Antwerp is not: William Jackson touched
on it in a letter in October 1783: 'Soon after my Arrival here I
visited Gainsborough – he is just returned from Antwerp – to say
only that he entertained me by a Relation of his Travels would
be saying nothing – if I could have writ as fast as he spoke, I
could then present you with a second Sentimental Journey not a

bit inferior to the first.'[23] Jackson's reference to Sterne's novel *A Sentimental Journey* suggests nothing more than that Gainsborough's telling of his traveller's tale to his friend must have been full of incident, richly fulfilling, and breathlessly told down to the last detail.

One might reasonably ask why Gainsborough chose this time to go to Antwerp. At fifty-six he must have felt that it was now or never. He was a courageous and experienced traveller, certainly around the south of England, but age and gathering mortality might have made him think twice – or listen to advice from his family – and change his mind about going to the Lake District as well: not only are there no surviving drawings clearly of Lake District subjects from 1783, but also there is little evidence of mountainous landscape paintings having been refreshed by visiting the places themselves. He was also not very well: he had begun at around this time to develop a tumour on his neck, later described as 'cancerous' in the understanding of late eighteenth-century medicine. 'When He occasionally mentioned it, he was led by others to believe it only a swelled kernel.'[24] For this reason he came to refer to it, with dark humour, as his 'Lieutenant Colonel'.[25] It is perhaps likely that he intended to go to the Lakes, but he changed his plans, or had them changed for him, and went to Antwerp instead. One clue of the Antwerp trip remains. The writer William Seward recorded this observation:

> This ingenious artist ... used to say, comically enough, of florid Gothic architecture, that it was like a cake *all plumbs*. The enthusiasm that he felt in the churches (when he went to Flanders) he compared nearly to insanity – 'the union', added he, 'of fine painting, fine music, and the awful and imposing solemnities of religion'.[26]

Gainsborough's painting post-Antwerp contains clear suggestions that his visit had borne fruit. He returned to his 1767 *Harvest Wagon* subject, with its Rubensian echoes, and painted another *Harvest Wagon*.[27] Here the debt to Rubens is even greater: not only is there the reprise on the theme of Rubens' *Descent from the Cross*, but the theme of the country cart with figures and horses in a bosky landscape is one which Rubens had made his own, and

which was very much in evidence in Antwerp. If he were making conscious plans to set a new course for his life, extract himself from portrait painting and devote himself to landscape subjects, Antwerp was, for Gainsborough, the place to go and to have Sir Peter Paul Rubens whisper in his ear. It was at this time that Gainsborough painted *The Mall* for the King. When Jackson made his call on his friend he had just finished its multitude of figures in the bosky setting of St James's Park. One can certainly see a Rubensian or Rembrandtian source for this mellifluous painting of women out walking in their finery and eyeing each other significantly.

He had a stack of work waiting for him on his return from Antwerp. The 1784 Academy exhibition was only seven months away, and he may already have had his submission of portraits in mind: three royal princesses, two Tomkinsons and their dog, two Buckinghamshires, six Baillies, a Rodney, a Rawdon and a Hood. When he assembled them for the exhibition, Gainsborough carefully and properly listed them, as he had before, with thumbnail sketches.[28] These were eight large paintings, in big frames: six were full-length portraits, one of the two brothers Edward and William Tomkinson with their dog, one each of the Earl and Countess of Buckinghamshire, and another, a half-length, of Samuel, Viscount Hood. The largest, *The Baillie Family*,[29] parents and four children, was nine by eight feet in its frame. Then there was the triple portrait of the three older princesses, commissioned for Carlton House by the Prince of Wales. He told the Hanging Committee that the princesses would come later because the King and Queen wanted to see their friend's new painting privately at the Queen's House. He was unable to send the empty frame to mark its place, as was sometimes done with delayed paintings, because the frame was with the picture. This request was granted: he was given leave with ten other artists to send in later.[30]

What happened next was a final showdown, which Gainsborough provoked, but could never win. Once again he must have heard that the hanging of the paintings already delivered was not going his way, and so he tried his old tactic:

Mr Gainsborough's Compliments to the Gentlemen of the

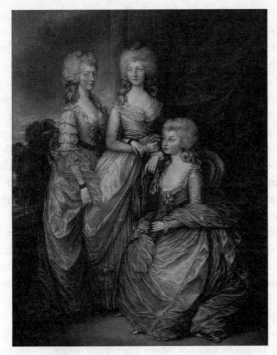

Gainsborough Dupont, after Thomas Gainsborough, *The Three Princesses: Charlotte, Augusta and Elizabeth*, 1793.

Committee, and begs pardon for giving Them so much trouble; but he has painted this Picture of the Princesses in so tender a light, that notwithstanding he approves very much of the established Line for strong Effects, he cannot possibly consent to have it placed higher than five feet and a half, because of the likenesses & work of the picture will not be seen any higher; therefore, at a word, he will not trouble the Gentlemen against their inclination, but will beg the rest of his pictures back again.[31]

How long the Academy committee considered this we do not know, but its response was to call Gainsborough's bluff. As the minute in the Royal Academy Council records, 'the Council have ordered Your Pictures to be taken down'.[32] This will have caused chaos in the hanging process, and fury to the committee, as these large

pictures were clearly already on the walls, and a space reserved for the princesses, so the whole exhibition would have to be re-organised. There is no doubt that Gainsborough realised that this would be messy, infuriating, time-wasting and highly disruptive to his friends and colleagues, but what did he care? He was off. He would now display his pictures on his own, in his own showroom, in his own house, and stuff the lot of them. Schomberg House would be his gallery. The art that he pretended to be longing to give up was causing him more pain than it was worth. Being so good at it did not mean that he had to keep on doing it. He could not sacrifice the income it brought him, but could return some grief to those whom he perceived were complicit in expecting him to carry on as a portrait painter.

But keep on painting portraits he did. The 1780s is the decade of Gainsborough's most dramatic and insightful portraits, as well as of his final profound landscape statements, and his so-called 'fancy pictures'. Despite gathering illness and much physical pain he was able to pull together a body of work that caused him even-tually to remark that he was 'quitting the world when he was beginning to feel his strength in art'.[33] Still to come were his por-traits of William and Elizabeth Hallett (known as *The Morning Walk*, 1785; Pl. 52), and *Mrs Siddons* (1783–5; Pl. 53).[34] Less glam-orous, but no less insightful, is his set of portraits commissioned by Samuel Whitbread the Elder of his son, Samuel, and members of his brewing staff.

Away from the pressures of home and studio life in Pall Mall, Gainsborough found in 1785 a small cottage on Richmond Hill, a hundred yards down from Sir Joshua Reynolds' grand house at the edge of Richmond Park, The Wick.[35] This was the place he had long promised himself he would 'sneak into . . . and turn a serious fellow'. It was a mature, realistic and purposeful decision. The cottage was not a place for portrait painting, but it was the perfect place to follow his dreams of playing his viol da gamba in the country, and draw and compose landscapes. He took some of his Dutch pictures there, and while he may not have had many patrons call, the King was a visitor, according to the *Morning Post*, calling not only to see his sick friend, but also to admire Gainsborough's Ruidsael.[36] It may have been at the Richmond

cottage that Gainsborough made studies of country people for his 'cottage door' paintings, watched dogs chase foxes, woodmen collect faggots, and a cart bump off to market. However, it may also be the case that, being so close to Sir Joshua and sharing his magnificent view across the Thames towards Twickenham, moving to Richmond was part of a strategy. Gainsborough had been trying to make overtures to Reynolds, but, as Farington expressed it: 'thought himself slighted by [Reynolds] in some occasional advances which he made towards him. Gainsborough proposed two or three years before his death that they should paint each other's pictures. Sir Joshua sat once to Gainsborough, but did not seem ready to make a second appointment.'[37]

James Prior puts it slightly differently: that it was Reynolds who took the initiative to meet Gainsborough soon after he came to London, so perhaps late 1774 or 1775; and that Gainsborough ignored him 'for several years, but at length called and solicited him to sit for his picture'. After one sitting to Gainsborough, Reynolds reportedly had a minor stroke and, according to Prior, went to Bath for a cure. While Reynolds suggested they try again, Gainsborough ignored him, and that was that.[38] There is no trace of whatever preliminary study Gainsborough might have made of the President of the Royal Academy.

The fact that neither of them could effectively get their acts together is to be regretted: it would have been a fascinating encounter, but was an idea doomed to failure. Perhaps each feared that too much intimacy, or truth, might emerge from the brushes of the other; but, what is more likely, perhaps each feared that the other's would be the better portrait.

36. Repaired with gold and silver

In late April or early May 1784 Gainsborough was faced with the prospect of suddenly having to take back eight very large framed paintings that had been summarily ejected from the Royal Academy. Like it or not, he had been flung. There may have been a handy warehouse where such unwieldy objects could be stored temporarily for transfer, but in any event this unilateral decision demanded a serious practical response. Before the wagon carrying the rejected paintings trundled away from Somerset House, Gainsborough had to decide what to do next. This was valuable, delicate property; the paintings no longer belonged to him, commissioned, as they had all been, by others.

The simplest solution would be for them all to return to Schomberg House where they could be immediately displayed, to show anybody who might be interested what a vivid set of portraits the Academy had rejected. There was, therefore, much coming and going at Schomberg House in mid April 1784. In his letter to the Hanging Committee, Gainsborough described his portrait of the brothers Edward and William Tomkinson as 'Two Boys with a Dog Master Tomkinson'. There is no sign of a dog in the painting now, but as the thumbnail distinctly shows a dog in the right-hand corner, the creature was evidently painted out with foliage, suggesting that the portrait came back to Schomberg House for this amendment.[1]

Gainsborough's new painting room and showroom extension gave him the quiet he needed to get on, and seclusion both for himself and for his distinguished clients. Nevertheless, whether he liked it or not, he came to have noisy neighbours. Four years after John Astley moved out, the central section of Schomberg House had, from 1781, an occupant who attracted crowds and turned heads. If people had become curious about Gainsborough's passing trade this was as nothing to the trade his new neighbour practised. Dr James Graham was the well-travelled and experienced

sex therapist, fresh, as Gainsborough was, from Bath.[2] For some years Graham had practised in the Adelphi and it is likely that for a time he occupied both premises. After Astley, with his 'harem and a bath at the top of his house', Schomberg House was becoming used to this sort of thing. Graham attracted trails of clients enticed by his twelve-by-nine-foot 'celestial bed' – larger even that Gainsborough's largest painting – with its mirrors, glass pillars, drapery, and massive magnets and electrical machines designed to create showers of sparks and encourage sexual response. He gave and arranged lectures and musical erotic performances, advertising his Schomberg House as 'The Temple of Hymen', and offered publications such as 'Private Medical Advice to Married Ladies and Gentlemen – to those especially who are not blessed with Children'.[3]

This was something of an unexpected glut of one of Gainsborough's lifelong sources of pleasure, wrapped up, commodified, and delivered next door; much too close to home and family. It was basically an upmarket brothel, legitimised by quack medicine. Graham's presence cannot really have aided Gainsborough's portrait-painting practice: crowds came to Pall Mall, as they had to the Adelphi, to the extent that Graham claimed that he had to issue tickets to manage 'the multitudes of people, of every rank and station . . . the number of whom . . . often exceeds Two Hundred daily'.[4] To all appearances it was becoming like Abbey St, King's Circus and the New Assembly Rooms in Bath rolled into one; but Graham may be making too vivid a claim to drum up business, as he was already on the verge of bankruptcy. Gainsborough's clients would have to fight their way through this lot. Emma Lyon, later to become Sir William Hamilton's wife, Nelson's mistress, and a component part of Britain's history, was among Graham's assistants in the Adelphi. She may also have performed in Schomberg House as 'VESTINA! The rosy GODDESS OF HEALTH! . . . assisting in the display of the celestial meteors'.[5] Emma's talents as a model and a dancer were breathtaking, popular and well documented, particularly by George Romney, but by the early 1780s she had moved on.[6] Thus it is unlikely that she became known to Gainsborough professionally, having turned her attention north to Cavendish Square where she posed regularly for Romney, and

had her engraved image posted for sale in every printshop. Thus the rumour that the painting known as the nymph *Musidora*, Gainsborough's only surviving nude, was modelled by Emma is likely to be just that, rumour.[7]

When James Graham departed, near-bankrupt, carrying his celestial bed, magnets, batteries and all away with him, he was succeeded as Gainsborough's neighbour by the controversial, highly successful but disagreeable miniature painter Richard Cosway and the painter Maria Cosway, his wife. With the Cosways' presence in the building Schomberg House continued as the mecca for the arty, the literati and the glitterati of the day. Pausing in front of the building, a coming patron might understandably be bemused: to the left were Mr Lavie and Mr King the mercers, where the finest silks and the best ostrich feathers could be had.[8] Directly ahead were the Cosways, where perfection in a miniature painting might be procured. To the right, for those wanting to commission a larger portrait, Mr Gainsborough awaited. Caleb Whitefoord, a friend of many artists, remarked 'had I been a portrait painter, I should have tried my luck at Schomberg House'.[9]

Cosway carried on the tradition of the central section of Schomberg House as a centre of portraiture and libertarian living with some aplomb. In his 1772 Academicians' group portrait Zoffany had devised a striking visual double entendre in his depiction of the diminutive painter, showing him with his walking cane placed squarely on the pudenda of a plaster cast of a female classical nude statue. Gainsborough and the Cosways did have some social contact, though this is very thinly documented. They shared an enjoyment of soirées and musical evenings, and it is inconceivable that the Gainsboroughs would stand aloof from the fun and laughter coming from next door. A curious undated letter from Gainsborough to the Cosways suggests that he would call on his neighbours on Monday evening, 'on condition [crossed out] if they do not expect any other company'.[10] He seems to want to have a quiet word with them. A second, even odder and also undated letter has Gainsborough presenting his compliments, having found 'there has been a loss of <u>Iron</u> betwixt us, he begs in case it must be repaired with <u>Gold or Silver</u>, that he may be permitted to share the expense with Mr Cosway'.[11] It has been

prosaically suggested that this may refer to the collapse of some jointly owned ironwork on the building.[12] Maybe; but if so, why not just repair it with iron? Given Gainsborough's facility with words, the verbal fluxions he performs in his letters, his rich use of metaphor, and the ultra-sophistication of both parties, there must be more to it than that. Rather than the need for a blacksmith to call at Schomberg House, this may refer to a falling-out between the two artists, a loss of respect, a regrettable infringement of personal or professional boundaries, and indeed a misunderstanding of Gainsborough's characteristic irony, which must be repaired with a precious rapprochement that both parties should observe. The underlinings suggest code. Both of these letters are lost: the first has not been seen since 1916, the second since 1945, so we are flying in the dark here. However, they are surely related: the quiet word being required as a result of the 'loss of <u>Iron</u>'.

Having forfeited his right to exhibit at Somerset House, Schomberg House now became Gainsborough's showroom, a kind of 'Fort Gainsborough' where his clients came, his painting supplies were delivered, his family lived, his paintings were made, shown, and removed on purchase. While the attention he generated may not have been comparable to Graham's, nevertheless clients and visitors beat a path to his door: royalty, the grand, the wealthy. His self-ejection from the Academy does not appear to have led to a diminution of his output; there are nearly one hundred portraits datable to the four years left to him before he died, and in the years he painted perhaps thirty landscapes. He continued to make models, listening to advice as he did so: modelling a dog's head under Nollekens' eye, he was advised: 'you should model it more with your thumbs; thumb it about'.[13]

Ejection from the Academy might have been a kind of release for Gainsborough as no longer need he feel any sense of responsibility over its well-being, if he ever did. His work was selling well, so he had no concerns there. As paintings, notably *The Market Cart*, left his walls one by one, Bate Dudley in the *Morning Herald* put it like this: 'When the room is thus stripped of its best ornaments little else will remain to gratify the visiting eye; and when the loss will be supplied who can determine? No respite, it seems, can be allowed the artist from portrait painting; and because he

has lately advanced his terms he is more sought after than ever.'[14]

So, indeed, was Reynolds. The early 1780s were for him years of triumph as a painter as they were for him as an organiser, innovator, encourager, political operator, teacher and Great Man. Bate Dudley reminded his readers that while Gainsborough's prices were now 'forty guineas for a three-quarters, eighty guineas for a half-length, and a hundred and sixty for a full-length. Sir Joshua's charges are, however, still higher'.

The two artists were, jointly, image-creators to the pinnacle of society. They had sitters in common, including Sarah Siddons, Mary Robinson, the Duchess of Devonshire, Colonel Banastre Tarleton, as well as the King and Queen. Reynolds, a giant in the Renaissance mould, was an artist of unsurpassed visual invention in his or any time. His *Mrs Robinson* (1782), a woman bandied about in a love triangle between the Prince of Wales and Colonel Tarleton, suppresses contempt and fury.[15] His *Colonel Tarleton* (1782), calmly fixing a buckle in the heat of battle, is the image of elegant cool, as horses begin to panic and enemy fire comes nearer.[16] Gainsborough's agenda is quite different to Reynolds', now as ever. A free spirit, taking no responsibility save the maintenance of his household and the fulfilling of his contracts, he discovers the silent pulse within his sitters, and resists forever turning a pose into a composition. So, Mary Robinson: she threw off the turmoils of her love affairs and became a novelist and poet of some distinction. Gainsborough gives us not the embittered and smouldering woman that Reynolds presented, but a tough, confident individual with a future.[17] She holds a miniature portrait of a past lover – the Prince of Wales – in her hands, but turns away. Sarah Siddons also: Reynolds presents her as the Tragic Muse, enthroned, distracted, one arm active, the other passive, an Olympian form beset by termagants.[18] To Gainsborough, however, she is waiting for lunch; a very special lunch, certainly, she is dressed up, off out, and ready for a good time which does not include entertaining a paying audience. She might be awaiting a guest, one in particular, an earlier sitter to Gainsborough, the Earl of Hardwicke: 'Mrs Siddons hopes Ld H will take his coffee with her in Leicester Fields as he proposes. She is truly sensible of the honour.'[19]

Beside a wooded grove a young couple walk: they are William and Elizabeth Hallett, recently married, he the grandson and heir of the earlier William Hallett who had bought the ruins of Cannons, and had made the frame for Gainsborough's *Charterhouse* all those years ago, she formerly Elizabeth Stapleton, the daughter of a surgeon, and a woman of great fortune.[20] The painting, known to us as *The Morning Walk* (Pl. 52), was likely paid for by Mrs Hallett. Begun, according to William Hallett, before they were married in July 1785, it was completed and delivered the following year.[21] So when they first came to Schomberg House their faces, painted there and then, reflected their confidence. Largely in their absence, as he painted their costume and setting, Gainsborough proclaimed this hope with his brushes as the couple and their lively dog step out together. A fine balance of light and shade, stasis and movement in a narrow colour range, articulate *The Morning Walk*, the couple radiating happiness, the dog, as so eloquently also in Gainsborough's portrait of Queen Charlotte, prefiguring the unexpected. Gainsborough, here, has given us a wedding picture, as if at a church gate, a couple taking their first step together into the future. He had his own experience of what marriage to fortune could bring.

Philip Thicknesse is the source of the disagreeable gossip about Thomas and Margaret Gainsborough's marriage, and should be taken, as ever, with caution. Despite their quarrel in Bath, Thicknesse would turn up at Schomberg House from time to time, and he clearly got on Margaret's nerves. He detested her, and made that very clear in his rambling, spiteful and self-serving *Memoirs and Anecdotes*. It is likely she saw right through him.

The wife of the first artist in this Kingdom, nay of any Kingdom, and who frequently earns fifty guineas before he sits down to dinner, carries beggarly disposition to such a pitch scarce to be conceived. Her husband . . . stands upon his feet during five or six hours every day, and then before dinner walks into the park for a little fresh air, or into the city upon business, by which time, he becomes so *foot sore*, that he takes a hackney coach to return home, but he durst as soon eat his own *palette* as be set down within sight of his own door, for fear of *another set down*,

from a little bit of *red flesh* which grows in this Scotch woman's mouth!![22]

Thicknesse goes on to describe Margaret as 'beggarly', and as a 'mean-spirited jealous-pated wife' who drove her husband's friends away. This is tough and unjust. His friends would call as they always did.

Making the fine and adequate income that he was, Gainsborough continued to paint portraits of his friends – some for nothing – as well as taking in paying customers off the street. He painted his friend from Corsham, Paul Methuen, in 1784, and was paid by this wealthy man for it; and he painted Richard Brinsley Sheridan's son, the actor Tom Sheridan, and probably was not. A man close to his heart, and a man of talents comparable both to their mutual friend de Loutherbourg and Gainsborough's own brothers Humphrey and 'Scheming Jack', was the inventor John Joseph Merlin. He was a universal man, one who reportedly never passed an idle day in his life, the inventor and perfector of pianos, roller skates, a Dutch oven with a rotating spit, a wheelchair, and a rotating table so a hostess could pour a dozen cups of tea without leaving her seat.[23] He showed these things off in his Mechanical Museum in Hanover Square; and Gainsborough himself showed off Merlin's piano in his portrait of Fischer. Gainsborough's *John Joseph Merlin* (1782) is a cheerful, light and affectionate portrait, akin to his *De Loutherbourg*, but with more colour, laced with gold and silver.[24] With Merlin, Gainsborough does not need to make a point about bright colour, he does not have to wag a finger, he is just happy to amuse and delight his good and inventive friend.

In May and June 1784 Gainsborough had an unexpected opportunity to take serious stock of his future: it must then have occurred to him that one at least of the eight large portraits flung out of the Royal Academy *did* in fact belong to him because it was not yet paid for: *The Three Princesses*, commissioned by the Prince of Wales for Carlton House. This might also have reminded him that the same client had thirteen other paintings of his on credit, so he might after all be able to salvage something from the inconvenience of the wagon-load of portraits coming back so precipitately from Somerset House. Since 1781 the Prince of Wales had racked

up a considerable debt with Gainsborough and Dupont, portrait painters to the gentry, aristocracy and crown. An invoice survives in the Royal Archives which lists fourteen works – four head-and-shoulders portraits of the Prince, three full-lengths of Colonel St Leger with his horse, heads of Lord Cornwallis, Mrs Elliott and Mrs Fitzherbert, a full-length of Mrs Robinson, two 'large Landskips' and *The Three Princesses*. The total sum owing by June 1784 was £1228.10s, a colossal sum: multiply by fifty or eighty for a present-day equivalent.[25] The invoice alone throws light on the activity in the new painting extension at Schomberg House: multiple versions of the portraits of the Prince and of St Leger demonstrates the work building up on the two painters as they fulfil their orders, the delivery of canvas and paint, the making up of stretchers, the busy traffic back and forth to framers and so on; work coming in, work going out. This high-pressure business concern, which must have employed others in menial studio tasks, required the prompt settlement of its accounts in order to prosper.

37. 'No apology can be made for this deficiency':
Gainsborough and Reynolds

The deep rift between Gainsborough and Reynolds was the product of Gainsborough's dissenting attitude and Reynolds' demand for cohesion. Here were two adult alpha males who never experienced conciliation services. Reynolds behaved like the autocrat he was, the all-powerful organiser and strategist who knew how to bring the self-esteem and insecurities of artists together and turn them into a political and cultural force. His ambition was to orchestrate the profession of art to the extent that it could take its place beside, and impress, other institutions in London: the monarchy, parliament, the Church of England, the law, the army and the navy. The Royal Academy required a sense of stability and responsibility if it was ever going to teach the coming generations of artists to influence the Establishment and national life. Gainsborough, on the other hand, behaved towards it like a spoilt child. Across his life there is no real evidence of interest in belonging, unless it was to the drinking club with tunes attached that was the Ipswich Music Club, or to music in Bath where every indication is that he wanted to be the soloist among musicians who would prefer him not even to be in their band. That they seemed to tolerate his presence as a musician reflects more on their kindness and humanity than on Gainsborough's tact and his awareness of the needs of others. Gainsborough was to music as Winston Churchill was to art.

Gainsborough's engagement with the Society of Artists in the 1760s had been limited to his appearance with them as an exhibitor at Spring Gardens. He might have attended the Society's meetings, but if he did it was largely an excuse to get away from Bath, and into London for a week of freedom. While he signed up as a founding member of the Royal Academy he did so because he knew it would bring him greater exposure, not because he had any interest in the political power that might accrue were he to

take a role in running it. When he was invited to sit on its Council he failed to turn up for meetings. It was, however, obligatory for Academicians to take their turn on the Academy Council, and in 1775, six years after the foundation, the final three reluctant Academicians, Thomas Gainsborough, James Barry and Richard Cosway, could no longer avoid their responsibilities. He, and they, were forced to contribute. The minutes of the General Assembly of Academicians, the main governing body of the RA which directed traffic democratically, put it pithily: 'Not having served . . . they being the last on the List. Resolved that they are Members of Council of Course.'[1]

Gainsborough was a useless Council member. It looks as if he never turned up, but curiously it was at the first meeting after his mandatory 'election', and in his apparent absence, that Gainsborough Dupont was admitted as a student at the Academy Schools.[2] This looks, quite literally, like nepotism. Gainsborough's lack of application to his task as a Member of the Royal Academy Council led to what must have been some kind of joke. A colleague unknown put Gainsborough's name forward to stand as President in the December 1774 election, in opposition to Sir Joshua Reynolds. He was currently sulking and refusing to exhibit with the Academy, so this nomination was truly subversive; maybe he nominated himself. He got one vote against twelve for Reynolds.[3] Four years later somebody did it again: this time he got one vote to Reynolds' nineteen.[4] Gainsborough would have made a lousy President of the Royal Academy anyway. Nor was he much good in the General Assembly of the Academicians: he seems to have been to only two meetings, but at each he made a decisive contribution: one to vote at the election of Associates when Gainsborough's friend Edmund Garvey was elected ARA in competition with Joseph Wright of Derby; and the second time when Agostino Carlini was elected Keeper of the RA.[5]

No wonder Reynolds thought him half-hearted as a colleague, and no wonder too that his presence, though planned and prepared by Zoffany, was omitted from Zoffany's Academy group portrait, perhaps under presidential pressure. Gainsborough was not a team-player. Reynolds' problem, however, was that Gainsborough was a consummate artist, and not one who could ever

be dismissed. He had also been around as long as Reynolds him-self, almost to the day, and knew London and London's ways as well as did Reynolds. Gainsborough's London was not, however, principally the intellectual or court London that Reynolds knew – soirées with Sir Joseph Banks, conversazioni at Dr Johnson's house, audiences at St James's – but jaunty musical London with Abel, Bach, Fischer and Giardini, and the underworld of the capi-tal where his red-headed Venus roamed.

Reynolds could not, did not try to, emulate Gainsborough's free and fluid brushwork in his formal exhibition portraits. He was a deliberate and crafty chess-player to Gainsborough's flashy matador. Where Gainsborough's handiwork with the brush could take the viewer's breath away, it was in portrait composition that Reynolds excelled, inventive and nimble and various as a dancer. Gainsborough's portrait compositions hardly varied from their well-worn winding track. Reynolds did not venture into landscape subjects for exhibition; certainly landscape played no measurable part in his portfolio as an artist. On the other hand, Gainsborough saw, and demonstrated, landscape to be an equal, occasionally dominant, partner in his production, and as such might be con-fusing to other artists bent on developing their public profiles. Gainsborough did not aspire to teach the young, though he taught Dupont as much as he could, and he did at least try to teach his daughters and some of his friends to draw by correspondence course. It may have been Gainsborough's tendency to loose living that induced the following in Reynolds' first discourse to Royal Academy students in January 1769. What was a current concern was more easily expressed within the cloak of history: 'When we read the lives of the most eminent painters, every page informs us that no part of their time was spent in dissipation.'[6]

So, keep pure and sober, lads, the President advises the young, and do not, he adds, be distracted by 'dazzling excellences'. What were certainly 'dazzling excellences' had already been seen in the portraits Gainsborough had exhibited at the Society of Artists, and perhaps this was a warning to students about what might come from this artist to whom dissipation seemed to be second nature. Reynolds had anxieties of his own, a serious and real concern that the Academy should succeed. He closed his First Discourse with

these words: 'Permit me to ... express my hope, that this insti-
tution may answer the expectation of its Royal Founder; that the
present age may vie in Arts with that of Leo the Tenth; and *that
the dignity of the dying Art* (to make use of an expression of Pliny)
may be revived under the reign of George the Third.'[7]

This smacks of coat-trailing, and of establishing a non-existent
difficulty with a misleading implication to create a platform for
debate. Only four months after Reynolds' address to his students,
the Royal Academy's first exhibition took place. There Gains-
borough showed his portrait of *Isabella, Viscountess Molyneux*,[8]
a 'dazzling' portrait in silver and black, with 'excellences' that
embrace shimmering satin, fractured lace, and reflective eyes
that look away, or they would pierce the heart (Pl. 41). To find a
comparable artist for this outstanding work one must look to the
future, to Goya or Manet at either end of the nineteenth century.
The bravura in this portrait demonstrates dramatically that the
art was not dying. Reynolds knew that perfectly well, but it served
his case to suggest that it might. With Gainsborough about, the
unruly guest at the party, the loose cannon at the Academy, paint-
ing never would die.

'We must trace the art back to its fountain-head', Reynolds
averred in the Sixth Discourse (December 1774), 'to that source
from whence they drew their principle excellences, the monuments
of pure antiquity.' This would not have impressed Gainsborough,
who referred to Greek sculpture as 'pale-faced, long-nosed, un-
meaning visage ghosts'.[9] Reynolds was particularly partial to
'excellence'; he invokes it time and again. He says how much he
admires the seventeenth-century Dutchman Jan Steen, 'one of
the most diligent and accurate of observers', but wishes Steen
'had had the good fortune' to have been born in Italy rather than
Holland, to have lived in Rome rather than Leyden, and had had
Michelangelo and Raphael as his masters instead of Brouwer and
Van Goyen. If that had been the case, Reynolds sincerely believed,
'he would have ranged with the great pillars and supporters of
our art'.[10] But then he would not have been Steen.

This may throw light on the problem Reynolds had with Gains-
borough: that Gainsborough had the background he had, and the
mentors that he chose or happened upon, rather than those that

Reynolds might prefer for him. Gainsborough was country, local, trade, restless, irresponsible, married, and a natural talent that knew not Italy. Reynolds, on the other hand, had taken the ortho- dox route to greatness in painting – apprenticeship to Thomas Hudson, the formal and pedantic image-maker to the aristocracy; the experience of Italy; innate business skills and social and po- litical nous; no encumbrance of family taking him away from the centre of action; high ambition that matched his talent. Gains- borough, 'the most inconstant, changeable being, so full of fits and starts',[11] was not the stuff of Reynolds' rigorous Academy, and never could be. Nevertheless, Reynolds' own country origins, despite the trouble he took to acquire his town bronze, was evi- dent to some. The diarist Cornelia Knight, companion to Princess Charlotte, spotted this:

> [Reynolds'] pronunciation was tinctured with the Devonshire
> accent, his features were coarse, and his outward appearance
> slovenly ... Sir Joshua loved high company, and wished his
> house to be considered as a Lyceum. In this he had Rubens and
> Vandyck in view. He was, indeed, surrounded by the wits and
> men of learning, and their society was harmonised by the good-
> ness of his disposition, and the purity of his sister's character
> and manners.[12]

So, the handsome, elegant, neat, unpredictable artist from Suffolk, with his company of raucous musicians and actors, his angry and controlling wife and difficult daughters, met the coarse-featured, slovenly artist from Devon, his sophisticated and well-connected friends, and his good and attentive sister. No wonder they did not get on.

They did, however, have a subtle appreciation of each other. William Hoare sent Gainsborough a copy of Reynolds' Fifth Discourse in the months after it was delivered in December 1772. 'Amazingly clever', Gainsborough responded. It 'cannot be too much admired (together with its Ingenious author) by every candid lover of the Art'. But Gainsborough qualified his view: it is too much directed towards history painting 'which he must know there is no call for in this country'. Gainsborough remarks that Reynolds spoke about the 'ornamental style', which in Reynolds'

words was useful 'in softening the harshness and mitigating the rigour of the great style, than if it attempt to stand forward with any pretensions of its own'.[13] This 'ornamental style', Gainsborough asserted, 'seems form'd for Portraits . . . in Portrait Painting there must be a Lustre and finishing to bring it up to individual Life'. Let's talk about this 'some evening over a glass', Gainsborough adds.

The world of art in London had, already, seeds of division within it. By comparison to its political division twenty years later, however, this was as nothing. Battle lines were drawn in the press, in an early instance of the national papers taking serious interest in matters of painterly style at a time when war with France and revolution in America must have been more pressing. In his review of the 1777 Academy exhibition Bate Dudley gave, unusually, the column a headline in capital letters: THOMAS GAINSBOROUGH R.A. 'As the pencil of this gentleman has evidently entitled him to this distinction we have impartially placed him at the head of the artists we are about to review.'[14] This is a real welcome to the great portrait painter returning to the Royal Academy's fold after a five-year absence, and a clear indication to Reynolds and others that they had a true master in their midst, but that there might be trouble brewing.

In his Seventh Discourse, on taste, beauty and immutable truth, given in December 1776, five months before the 1777 exhibition, the President said

> It has been the fate of arts to be enveloped in mysterious and incomprehensible language . . . If, in order to be intelligible, I appear to degrade art by bringing her down from her visionary situation in the clouds, it is only to give her a more solid mansion upon the earth.

And a bit further on in this long Discourse:

> Every man is not obliged to investigate the causes of his approbation or dislike.

Here Reynolds is accepting the inevitability of alternative points of view. Shortly after Gainsborough's death, in a long-delayed encomium, he warned his students to beware what he referred

to as Gainsborough's 'want of precision and finishing': what he meant was beware of Gainsborough's brave, flamboyant exuberance, and wherever that might lead. At last, in public, he praises Gainsborough, warmly, generously and sincerely, something he could easily have done when the man was still alive. Nevertheless he leaves the students with a warning:

> no apology can be made for this [i.e. Gainsborough's] deficiency, in that style which this Academy teaches, and which ought to be the object of your pursuit . . . I wish you to profit, by the peculiar experience and personal talents of artists living and dead . . . but the moment you turn them into models, you fall infinitely below them . . . you may be corrupted by excellences . . . and become bad copies of good painters, instead of excellent imitators of the great universal truth of things.[15]

To put this in twenty-first-century terms, what we seem to be witnessing here is a University Vice-Chancellor trying very hard to maintain orthodox standards and keep the students and Senate onside, while a popular professor bangs on in the media about freedom of expression, and is effectively out of institutional control.

Samuel Johnson had a great fondness for Reynolds. They travelled together, looked at pictures together, and enjoyed each other's conversation. Johnson was also touched and amused by Gainsborough's painterly expression, and the plangency of his art. 'Your sprightly friend' and 'the ingenious Mr Gainsborough' are affectionate epithets.[16] Reynolds' purchase of Gainsborough's *Girl with Pigs* gained Johnson's magniloquent approval. Though rivals in painting, and rivals also in the choice and conception of some of their subjects, Reynolds and Gainsborough were each other's secret admirer. If anybody warmed the bond between them, and kept them alive to one another, it was that great man who served them equally as Professor of Ancient Literature at the Royal Academy, Dr Samuel Johnson.

38. A sense of closure:

Gainsborough's landscapes

In the catalogue of the studio sale held in Schomberg House seven months after Gainsborough's death, 41 oil paintings were listed with the title 'A Landscape', or 'A Landscape with Figures'. There are in addition 45 or more works by other artists, including Poussin, Rubens, Van Dyck, Velázquez and many seventeenth-century Dutch masters. Some attributions might be optimistic or plain wrong, but Gainsborough probably understood them to be genuine. Further down the catalogue are 148 landscape drawings by Gainsborough, some listed as watercolour, others as pen and ink, while the majority were most probably in black and white chalk.

We can draw a number of conclusions here: first it demonstrates Gainsborough's productivity, the drive he found within himself to create paintings which he must have known would never sell, and the energy with which he threw himself into drawing. This was 'art for art's sake' *avant la lettre*, a creative passion comparable to Turner's in quantity even though it can never match the depth of Turner's intellectual engagement. Inevitably, the drawings are repetitive, suggesting that the act of drawing was as important for Gainsborough as its outcome.

Secondly, living as he was with one of the grandest views in England beyond his breakfast room, it is notable that he made nothing of it in his drawing: it was left to Richard Cosway to reveal the extent of what could be seen from Schomberg House. Nor does he appear to have drawn the view of London from Hampstead or of the River Thames from Richmond Hill, a subject that entranced Turner throughout his life. Instead Gainsborough preferred to shut himself away with coal, broccoli and candle to construct his dreams of a glimmering world. This touches on landscape senility. Thirdly, the sale catalogue demonstrates Gainsborough's passion for collecting, that he took a committed

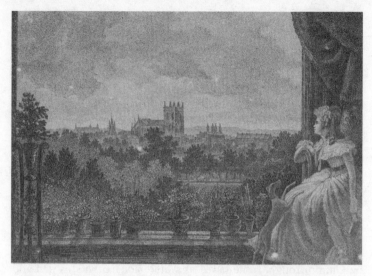

William Russell Birch, after Richard Cosway, *A View from Mr Cosway's Breakfast-Room, Pall Mall*, 1789.

interest in the art trade and attended auctions himself or engaged others to bid for him. In June 1787 he was called as a witness at a trial to determine the authenticity of a Poussin belonging to the dealer Noel Desenfans. Claiming modestly that he was 'no judge of the hands of the masters', he nevertheless added that he would not have given five shillings for this one. It was reported at the trial that Gainsborough's 'repartee possessed that peculiarity of genius and fancy for which his conversation is so remarkable'.[1] The auctioneer James Christie had his own experience of this, and remembered that Gainsborough could sometimes be an amusing presence at his sales, entertaining buyers with banter, and generally having such a welcome effect on the mood in the room that he might add fifteen percent to Christie's commission.[2] So here is an artist active in all areas of the art business, from devising and supplying to buying and selling. Fourthly, it reveals that Gainsborough must surely have found whatever it was he was searching for all his life: some kind of creative balance between the demands of portrait painting and the rewards of landscape. As Allan Cunningham so elegantly put it, 'portrait painting, like

the poet with the two mistresses, had his visits, but landscape and music had his heart'.[3]

Gainsborough found wealth and fame through his portraits, and esteem and honour from his landscape paintings. He continued to find the energy and time he needed for landscape, but with all those unsold paintings and drawings hanging around the house, and the memory of the fifty-odd he left behind in Bath, Margaret might have long realised that there was no point demanding money from the proceeds of her husband's landscape painting. While he treasured his early landscapes – he once bought back *Cornard Wood* from the art trade, then sold it again – it is unlikely that many of the landscapes in the 1789 sale were early works. Most probably, having left so many behind in Bath, they were paintings he had made at Schomberg House. So, overwhelmingly, what went under the hammer will have been late works – cottages, glowing sunsets, cows, pigs, children and what-not. These were the 'glimmering landscapes' of Gray's *Elegy*, in which the poetic word became paint.

The late landscapes are wide-angle, fuller versions of the kind of backgrounds we see in some of the full-length portraits, such as *Mary 'Perdita' Robinson* and *The Morning Walk* (Pl. 52). It is also clear that he is overcoming the aversion to straight-line architecture that had driven him away from anything to do with Canaletto, and to paint so many leafy landscapes and portraits in the 1760s and 1770s. Architecture within these 1780s landscapes, such as *Charity Relieving Distress* (1784) has a softness that does not overwhelm, and exhibits none of the grandeur that he might have wanted to project in the architecture that he and his family occupied in Bath.[4] Around it, however, hovers a flavour of the shallow wings of Schomberg House, though lacking its heightened colour and the toothiness of its stone quoins.

While he had some premonition that his days were numbered, Gainsborough lacked none of his physical powers in his last few years. Indeed he was fired with sustained bursts of energy over the final four years of his life, manifesting itself in canvases of great size, such as *The Morning Walk* (1785), *Girl with a Pitcher* (1785), *The Market Cart* (1786), *The Woodman* (1787) and the unique and curious *Diana and Actaeon* (c.1785).[5] If he knew he was coming

to a close, this was his answer. Everything that Gainsborough had loved, learned and assimilated across his career is distilled into these final years. Companionship, union and hope for the future in *The Morning Walk*; sympathy and solidarity with tough rural life in *The Market Cart*, where the old horse, shorn of his harness, takes his load gently to market, knowing every step of the way; simple innocence in the *Girl with a Pitcher*, who hugs her puppy and ignores the sheep trotting away behind her (Pl. 57). These are themes which we can trace back to Gainsborough's twenties, and beyond that to Dutch and Flemish seventeenth-century painting, where the roots of his 'fancy pictures' can be found.

For a man professedly unintellectual, Gainsborough practises a rural classicism that depends wholly on the old master tradition. His disarming claim at the 'Poussin trial' that he was no judge of old masters was a ruse. He looked close and hard at old masters, as many sources testify. His copy of Rembrandt's *Man in a Cap* is a case in point. He will have seen the original at Argyll House when it was owned by the Duke of Argyll; his copy has sensitivity, eloquence and a light touch, such that William Hazlitt, who saw Gainsborough's copy at Windsor, described it as 'a fine, *sombre*, mellow head'.[6] Gainsborough's 'cottage door' subjects have their roots in Nativities and the *Rest on the Flight to Egypt*; his *Girl with a Pitcher* evolved out of the Carracci and Murillo; his *Woodman* is otherwise a baroque saint in ecstasy; the faggot collector in *The Market Cart* might be a supplicant angel from an altarpiece. He might never have expressed it in so many words, but these artists are the giants upon whose shoulders Gainsborough stands. The accents of his French, Italian and German musician friends therefore manifested themselves also in the continental sources of his inspiration.

Gainsborough was continually alive to the art market, and while on the one hand he painted landscapes that he could not or would not sell, on the other he combined landscapes and figure groups within the popular genre of 'fancy pictures'.[7] These span a wide emotional range, from the sweetness of his *Good Shepherd*, after Murillo (*c*.1778–80) and *Girl with a Pitcher*, to the sudden violence of *Two Shepherd Boys with Dogs Fighting* (1783; Pl. 56).[8] Some critics preferred this seam in Gainsborough's work, the

Public Advertiser suggesting that they were subjects that 'the Friend of Gainsborough and the Art' would wish to see him 'always occupied – in which he works evidently and successfully *con amore*'.[9] This is a curious statement, given the rarity of violence in Gainsborough's work, though the picture might be read as a painterly uprising of that same volatility that could overtake Gainsborough's own behaviour from time to time.

Unique in his oeuvre though it certainly is, *Diana and Actaeon* also has its roots in Gainsborough's past (Pl. 60).[10] Diana and her companions romp in the woods, and, before they were so rudely interrupted by Actaeon, they were having as good a time there as Peter Muilman and his pals were with their flute beside the trees, or John Chafy with his cello. While mythological subjects such as Diana and Actaeon had never been typical for Gainsborough, the idea of people having fun in the country had long engaged his art. It is a small step from another of Gainsborough's large late canvases, *Haymaker and Sleeping Girl* (*c*.1785),[11] where the couple might equally be Mars and the sleeping Venus, to removing all clothes and depicting a crowd of figures as Diana and Actaeon. Here it is merely the nakedness that makes *Diana and Actaeon* a classical subject rather than a bit of evening crowd enjoyment as in *The Mall* (Pl. 59). It may be that such a step was prompted in Gainsborough after a visit to Knole in Kent where the Duke of Dorset had inherited impressive contemporary copies of Titian's *Diana and Actaeon* and *Diana and Calisto*. There is so little documentary record of Gainsborough's travels around country houses that it is impossible to prove that he went to Knole. But to have done so would have been in character, and consistent with the course of the commissions he received, in this case, for a portrait of the 4th Duke of Dorset and the vivacious dancing figure of Giovanna Bacelli.[12]

There is a strong sense of closure in Gainsborough's late landscape paintings. This may be easy to spot with hindsight, but as Gainsborough himself saw the end coming so perhaps can his audience. When we see the little family at the cottage door as the sun goes down we are sharing an intimate moment when work has ended for the day and all, for the moment, is quiet. Farewell.

39. From a sincere heart

By the middle of 1787 Gainsborough seems to have been developing serious concerns about his family, his legacy and his health. The easy-going, light-hearted, irresponsible Gainsborough of earlier years was becoming submerged beneath a tide of anxieties that were gathering like furies. His dear friend Abel (Pl. 45) died in June, 'the man I loved from the moment I heard him touch the string ... My heart is too full to say more.'[1] By now his daughters were in their mid thirties, getting on for their forties, Molly separated from Fischer, Peggy unmarried. To have one daughter at home on the way to becoming an old maid would be concern enough for a well-to-do late eighteenth-century family; to have another who was apart from her husband and widely thought to be mad was certainly a misfortune.[2] But the Gainsboroughs of Pall Mall were no ordinary well-to-do family.

Gainsborough's concern for his legacy as an artist came to a focus in September 1787 when Edmund Garvey brought news to the Academy Council that his friend wanted to paint a picture for them, presumably a landscape, to hang over the fireplace in the Council Room at Somerset House. This was a rum offer from an Academician who never turned up at meetings: forever after, the Council and Officers of the Royal Academy would look up from their notes and see their least useful member's work looking back at them. They made no apparent response to this offer: perhaps it took them aback, and made them wonder if it would ever be delivered. But it does show that Gainsborough had the Royal Academy close to his heart as he felt death's touch.[3]

Further concern for his legacy erupted with characteristic volatility when Gainsborough saw what Bartolozzi had done in engraving his recent portrait of William Petty, 1st Marquess of Lansdowne. Gainsborough greatly admired Bartolozzi's work, but this time he had been let down; in his opinion the engraver had removed all the sparkle from his rendering of Lansdowne's

'chearful Countenance'. 'I beg pardon my Lord', he wrote to Lansdowne, 'but I'm in a damn'd passion about it, because I have ever been partial to Bartolozzi's work.' Bartolozzi had altered the sitter's height, sloped his shoulders, and lengthened his naturally round head. Gainsborough vented his fury on what he knew of Bartolozzi's private life:

> Why will Bartolozzi, my Lord, spend his last precious moments in f—g [*sic*] a young Woman, instead of out doing all the World with a Graver; when perhaps all the World can out do Him at the former Work?
>
> Pray My Lord apply these private hints as from your own Eyes, lest I should have my throat cut for my honesty.[4]

He was nevertheless in cheerful correspondence with Henry Bate Dudley, to whom he had sent a gift of drawings. John Boydell had bid at a lively auction, and secured *Cornard Wood* when the hammer fell at seventy-five guineas. Reflecting on this important early work, Gainsborough felt it had 'very little idea of composition', and that it was immature – not 'one of my riper performances'. But he remained very proud of it: since he had first sold *Cornard Wood* 'it has been in the hands of twenty picture dealers, and I once bought it myself during that interval for <u>Nineteen Guineas</u>. Is that not curious?'[5] He felt rightly proud that this seminal early work was still doing so well in the market, and although he deemed it 'in some respects a little in the <u>schoolboy</u> stile', he did not think about the painting 'without some secret gratification'.

For some time Gainsborough had felt that his days were numbered, and told Sheridan so. 'Now don't laugh, but listen,' he said. 'I shall die soon – I know it – I feel it – I have less time to live than my looks infer – but for this I care not. What oppresses me is this – I have many acquaintances and few friends; and as I wish to have one worthy man to accompany me to the grave, I am desirous of bespeaking you – will you come – aye or no?' Sheridan agreed to do so, 'and the looks of Gainsborough cleared up like the sunshine of one of his own landscapes'.[6]

Thomas Gainsborough was one small figure in the huge crowds that came together at Westminster Hall for the trial of Warren Hastings, facing impeachment for corruption as Governor-General

of Bengal. After lengthy, detailed and highly publicised discussion in parliament, the trial, in front of members of the Houses of Lords and Commons and the general public, opened in February 1788. It was to be a long, long trial; the verdict came seven years later. On the seventh day in Westminster Hall, Charles James Fox spoke for the prosecution, when 'near 300 members of the House of Commons' were present. There was

> eagerness to hear Mr Fox ... [the public] nearly filled the galleries and the seats for Peers tickets at so early an hour as nine o'clock; and at ten not a seat was to be procured within the hearing of the Speaker ... Mr Fox broke out in a flow of language the most energetic and impressive ... Mr Hastings broke through every law of honour and good faith ... he appropriated large sums of money to his own use.[7]

Gainsborough was already unwell. He may not have been able to hear much above the susurration of the crowds and the loftiness of the hall. Even the *Times* correspondent had difficulty: 'we could hear but very indistinctly'. He might have gone to the trial with Molly or Peggy, as one of them years later told Cunningham that he sat with his back to an open window, and became chilled.[8] According to the *Morning Herald*, Gainsborough was suffering greatly from his neck as early as May, so the Warren Hastings trial had to go on without him in the crowd: '[Gainsborough's] indisposition proceeds from a violent cold caught in Westminster Hall; the glands of his neck have been in consequence so much inflamed as to require the aid of Mr John Hunter and Dr Heberden.'[9]

He told a perfect stranger, who might have written to him as a result of the press attention, and set out his symptoms detail by detail:

> What this painful swelling my Neck will turn out, I am at a loss at present to guess, Mr John Hunter found nothing in it but a swell'd Gland, and has been most comfortable in persuading me that it will disperse by the continued application of a seawater poultice. My neighbour Dr Heberden has no other notion of it. It has been 3 years coming on gradually, and having no pain 'til lately, I paid very little regard to it; now it is painful

enough indeed, as I can find no position upon my pillow to admit of getting rest in Bed. I would fain see what turn it will take before I alarm myself too much.[10]

To Mary Gibbon, according to Thicknesse, Gainsborough confided: 'if this be a cancer I am a dead man'.[11] Good friends and business acquaintances wrote to him in concern: the miniature painter and print dealer Robert Bowyer, and William Pearce. Somebody, almost certainly his sister Mary, sent the family some cheeses; more than they could eat, so he sent two on to the Pearces.[12] He was selling paintings from his showroom, one, a landscape with cows, being bought by Thomas Harvey, a collector and amateur painter from Norwich, for £73. From his bed, restless and unable to get comfortable, Gainsborough mused to Harvey about his condition: 'My Swelled Neck is got very painful indeed, but I hope is the near coming to a Cure.'[13] He longed to be up again, and better, and travelling to Yarmouth '[to] enjoy the coasting along til I reach'd Norwich and give you a call. God only knows what is for me, but hope is the Pallat of Colors we all paint with in sickness.'

He did not try to get to Yarmouth; he was even unable to spend much time in his Richmond cottage, as despite the warm summer weather his health deteriorated and he came home to Pall Mall.[14] Then he revealed he was still working a little, and made this most touching statement, one that characterises his life: 'Tis odd how all the Childish passions hang about one in sickness. I feel such a fondness for my first imatations [sic] of little Dutch Landskips that I can't keep from working an hour or two of a Day, though with a great mixture of bodily Pain. I am so childish that I could make a Kite, catch Gold Finches, or build little Ships.'[15]

Life went on of course. Caroline Lybbe-Powys saw Sarah Siddons perform at Drury Lane in Bertie Greatheed's tragedy, *The Regent*. She visited Merlin's exhibition and saw his 'mechanical Easy Chairs for the gouty or infirm'.[16] In the meantime Gainsborough dreamt of kites, goldfinches, little ships and sailing around the coast of East Anglia. He drew up his will and signed it on 5 May, the day that the *Morning Herald* published details of his illness. The will must have been some time in the writing, so

despite occasional flurries of hope Gainsborough knew this was the end. Musing about how he might be remembered after his death, and looking perhaps in a mirror to see how the tumour was getting along, he made a firm decision. He looked again at the small self-portrait he had painted as a gift for Abel, a token of love that he was now unable to share (see cover image). He looked quizzically at the face staring quizzically back at him, noted the neatness of his hair lately trimmed and tidied by a barber nearby. 'It is my strict charge', he wrote, 'that after my decease no plaster cast, model, or likeness whatever be permitted to be taken. But that if Mr Sharp, who engraved Mr Hunter's print, should choose to make a print from the three-quarter sketch which I intended for Mr Abel, painted by myself, I give free consent.'[17] The artist who was the supreme agent of control of so many peoples' images over the previous forty years wished to ensure that his own image was as well controlled.

Then there was one final piece of unfinished business. He had heard that Sir Joshua Reynolds had expressed an 'extreme affection' for Gainsborough, an admission from Reynolds that would seem unthinkable, though he had expressed admiration in 1782 by buying *Girl with Pigs*. Gainsborough wanted to see Reynolds for the last time, and in a wobbly, infirm and uncertain hand wrote to tell him so:

> I am Just to write what I fear you will not [be able to?] read, after lying in a dying state for 6 month. The extreme affection which I am informed of by a Friend which Sir Joshua has ex-presd induces me to beg a last favour, which is to come once under my Roof and look at my things, my Woodman you never saw, if what I ask more is not disagreeable to your feeling that I may have the honor to speak to you. I can from a sincere Heart say that I always admired and sincerely loved Sir Joshua Reynolds.[18]

Reynolds, according to Joseph Farington, came to Gainsborough's bedside, and sat with him. Gainsborough told his great contemporary that he 'regretted leaving the world at a time when he thought he had discovered something new in the Art'. Farington went on to record what everybody knew, that 'a little jealousy of

each other seemed to exist in the minds of Sir Joshua & Gainsborough. The latter thought himself slighted by the former in some occasional advances which he made towards him.'[19]

But it was not just the older generation of great men that came to see him: he was visited also by the great men of the future, one in particular, the nineteen-year-old Thomas Lawrence, as precocious a portrait painter in 1788 as Gainsborough had been in the 1740s. History was beginning to repeat itself; the baton passing between generations. Lawrence came to Schomberg House to look at Gainsborough's drawings, paying particular attention to the figure studies that the older man had made for *The Mall*.[20]

There was a sad succession of other callers. We can be sure that Margaret and their daughters hovered constantly, trying to make him comfortable, calming him. Samuel Kilderbee, by now a very important man in Ipswich, a former Town Clerk, was one caller. Gainsborough expressed regret for his irresponsible behaviour in the past, but added, 'they must take me altogether. Liberal, thoughtless and dissipated'. He told William Jackson that he was leaving life just as he was beginning to achieve something, a modest reflection, but one that shows that even at this final stage he knew he was getting better and better as an artist: 'We are all going to heaven', he told Jackson, 'and Van Dyck is of the company'.[21]

Gathered around his bed were Margaret, Molly and Peggy, their cousin Gainsborough, and others who came and went politely. A letter written by the author Barbara Hofland probably in the early 1840s contains an intimacy that she might have picked up years later from Molly or Peggy:

[Gainsborough's] charity was indiscriminate, and his extravagance wild, which he bitterly lamented when on his death bed thinking that when his wife died, his daughters would be in positive distress save for what his pictures might fetch. On this point Mrs G soothed him by saying 'as he always threw his money about, leaving it at the mercy of every one, she had taken in the course of 20 or 30 years as much as had enabled her to secure £10,000 in the funds and with that and the sale of the woodman and other pictures doubtless their children could

subsist in comfort.' He thanked her and blessed her warmly
saying 'she had done perfectly right but it was true he had some-
times thought he had more bills [i.e. banknotes] than he found,
and been puzzled about it, but he never suspected anybody nor
thought much about it.'[22]

So that's where the money went. Thomas Gainsborough died on
Saturday 2 August 1788 at two o'clock in the morning. Margaret
smoothed his brow, closed his eyes, and snipped a neat lock from
his hair. This she slipped into an envelope inscribed: 'The Hair of
Thos Gainsborough RA cut by his Wife Aug 2nd 1788 (the day
of his death[)].'

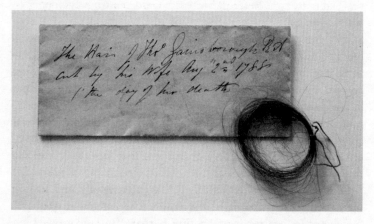

Inscribed envelope containing a lock of Thomas Gainsborough's hair.

In the Gainsborough's House archive I turned the envelope over
in my hands, the final physical relic of a grand, immortal artist
contained within. Any nearby barber, such as William Turner
of Maiden Lane, will have got his boy to sweep such trimmings
away with busy aplomb, but this lock Margaret kept to treasure.
The curl of hair, tied with cotton, is brown, maybe with a reddish
cast. Gainsborough kept his youthful hair colour, as he kept his
youthful outlook, to the day he died.

40. Epilogue

Gainsborough's grave on the south side of the narrow church-yard of St Anne's, Kew Green, was restored and enclosed in 1865. Whatever grave slab had been laid down by Gainsborough's executors was removed and replaced at that time. The words on the new stone, which must surely follow the text of the original, is set out in hard, formal capital letters, plain, as Gainsborough himself had requested. Beside Thomas lie Gainsborough Dupont, who died in January 1797 aged forty-two, and Margaret, who followed nearly two years later in December 1798. She was seventy-one. He was buried quietly there, next to Joshua and Sarah Kirby, with Zoffany nearby, so there is quite a collection of old pals. It was a sad little procession that summer day: Sir Joshua was at the graveside, Sir William Chambers, Benjamin West, Academy grandees all of them, and Sheridan, Linley, Bartolozzi and Sandby. The family was represented by Gainsborough Dupont, and if Margaret, Molly or Peggy were present, there is no record of it. Sooner or later the papers that Gainsborough must have left behind at Pall Mall were destroyed, perhaps during preparations for the posthumous sales. Speculation as to who may have done this points at Gainsborough's own home team, Margaret, their daughters, and Gainsborough Dupont, who carried the portrait-painting practice on until his own death. They had all had a lot to put up with; on the other hand, they did very well out of the product of Thomas's energy and genius.

Looking across the arc of Gainsborough's life we see an artist who is purely eighteenth century, without any taint of the nineteenth. He is the last lyric painter of his generation, saving all that he could from the ruins of eighteenth-century innocence and sensibility. While Turner was a pioneer whose achievement remains within his century but which relentlessly affects our own time, Gainsborough is the songbird who could, however, have operated in the twentieth century exactly as he did in the eighteenth.

Looking for a place for him in the first two or three decades of the twentieth century we could see him as a rival of John Singer Sargent. Financiers, socialites, aristocrats, actors and artists of the 1910s and 1920s would be his bread and butter as they were Sargent's. He would travel to Europe and the United States to work in differently charged artistic and economic areas. His mix of portraits, music and landscape would echo through his work into the twentieth century as it had in the eighteenth. Placing Gainsborough in between the wars we might find him giving William Orpen and James Gunn a run for their money, and challenging Stanley Spencer to think about this rival in his market. Further on into the 1960s we can see Thomas Gainsborough, David Hockney, Allen Jones and Peter Blake drinking coffee together and going their separate ways after studying at the Royal College of Art. They would keep a close eye on each other as they gathered their dealers, exhibitions, patrons and friends among the art collectors of Swinging London and the new post-industrial money emerging in the United States. In the 1970s and 1980s he is with Francis Bacon and Lucien Freud, drinking in the Colony Room.

Gainsborough is a twentieth-century man in exactly the same way that Turner is not. Turner, the barber's son from Maiden Lane, sits nowhere but the nineteenth century, and the twentieth would not have been the same without his commanding, columnar presence. Gainsborough, however, the chameleon of art, could migrate with ease from one era to another, making ugly people beautiful with his flowing paint and loose, flexible wrist. This was entirely the product of his professional strategy: he rarely went out of his way to find people, they came to him, one by one, into his painting room and sat before him to be Gainsboroughed. The landscape background to his career was the relief to Gainsborough's mind and brush as the village of Cookham was to Spencer's. Both erred and strayed within their familiar places; both embraced and articulated them; both used them as vehicles for their own private fantasies.

The studio sale that Gainsborough Dupont organised at Schomberg House in March 1789 revealed the private Gainsborough, the man who held Van Dyck as his mentor and guide,

and who built his early foundation on the landscape painters of seventeenth-century Holland.[1] Scattered among the 109 lots of paintings, the majority his own landscapes, and nearly 150 drawings, the names of Ruisdael, Wynantz, Pynacker, Snyders and others emerge. Then we notice 'after Rembrandt', 'after Velasquez', 'after Titian' and 'after Murillo' among the lots: here, despite all, was an enquiring mind, pitting his own art against those of his esteemed predecessors. And now we see among these entries, doubled and redoubled, the words 'after Van Dyck' – the Pembroke family, the Duke of Richmond and Lennox, a portrait of Inigo Jones. Plainly, Gainsborough's week at Wilton resonated with him for the rest of his life.

With no added embroidery, James Ward sets it out most clearly. Ward had called on Peggy, by now living in Acton. In his Journal of 1819 he set down what Peggy must have told him: 'his last word was Vandyke'.[2]

Cast of characters

* The subject of a portrait by Gainsborough

Carl Friedrich Abel*	Musician	1723–1787
Joseph Addison	Writer	1672–1719
Frances Andrews*	Wife of Robert Andrews	1732–1780
Robert Andrews*	Suffolk landowner	1725–1806
Henry Angelo	Fencing master and memoirist	1756–1835
Christopher Anstey	Poet	1724–1805
Anthony Ashley-Cooper, 3rd Earl of Shaftesbury	Writer and philanthropist	1671–1713
John Astley	Architect and painter	1724–1787
James Barry	Artist	1741–1806
Lambe Barry*	Suffolk landowner	1704–1768
Francesco Bartolozzi	Engraver	1725–1815
Rev. Cutts Barton	Churchman	1706–1780
Rev. Sir Henry Bate Dudley*	Editor, critic and churchman	1745–1824
Henry Somerset, 3rd Duke of Beaufort	Margaret Gainsborough's father	1707–1745
Panton Betew	Art dealer, publisher	1722–1799
John Boydell	Art dealer, publisher	1720–1804
Fanny Burney	Diarist and correspondent	1752–1840
Margaret Burr	See: Margaret Gainsborough	
George Byam*	Plantation owner	1734–1779
Giovanni Antonio Canal, 'Canaletto'	Artist	1697–1768
Robert Cardinall	Artist	*fl.*1715–1730
William Carter*	Landowner and businessman	d.1748
Rev. John Chafy*	Churchman	1719–1782
Mason Chamberlin RA	Artist	1727–1787
Dr Rice Charleton*	Physician	1710–1789
John-Baptiste Claude Chatelain	Engraver	1710–1758
James Christie*	Auctioneer	1730–1803
Giovanni Battista Cipriani	Artist	1727–1785
Rev. John Clubbe*	Churchman	1702–1773
Thomas Coram	Seaman, philanthropist	1668–1751
Maria Cosway	Artist	1760–1838
Richard Cosway	Artist	1742–1821
Charles Crokatt*	Merchant	1730–1769

Richard Dalton	Librarian to George III	c.1715–1791
Samuel Derrick	'King of Bath'	1724–1769
Noel Desenfans	Art dealer	1745–1807
Arthur Devis	Artist	1712–1787
Philip Ditcher*	Physician	d.1781
Rev. Dr William Dodd*	Churchman	1729–1777
John Dunning, Lord Ashburton*	Lawyer	1731–1783
Gainsborough Dupont*	Artist, Gainsborough's nephew	1754–1797
Philip Dupont*	Carpenter, Gainsborough's uncle	c.1722–1788
Grace Dalrymple Elliott*	Courtesan and adventuress	1754–1823
Joseph Farington RA	Artist, diarist	1747–1821
Johann Christian Fischer*	Musician, Gainsborough's son-in-law	c.1733–1800
Claude Fonnereau	Landowner	1677–1740
Thomas Fonnereau	Landowner, politician	1699–1779
Ann Ford*	Musician	1737–1824
George Williams Fulcher	Printer, Gainsborough's biographer	1795–1855
Humphrey Gainsborough*	Churchman, inventor, Gainsborough's brother	1718–1786
John Gainsborough	Gainsborough's father	c.1683–1748
John 'Scheming Jack' Gainsborough*	Gainsborough's brother	1711–1789
Margaret Gainsborough, née Burr*	Gainsborough's wife	1728–1798
Margaret 'Peggy' Gainsborough*	Gainsborough's daughter	1751–1820
Mary Gainsborough, née Burrough	Gainsborough's mother	1690–1755
Mary 'Molly' Gainsborough*	Gainsborough's daughter	1750–1826
Robert Gainsborough	Gainsborough's uncle	1673–1754
Thomas Gainsborough	Gainsborough's uncle and benefactor	1678–1739
David Garrick*	Actor	1717–1779
Edmund Garvey	Artist	fl.1767–1813
Felice de Giardini	Musician	1716–1796
Mary Gibbon	Gainsborough's sister	1713–c.1790
Joseph Gibbs*	Musician	1699–1788
The Hon. Mrs Mary Graham*	Wife of Thomas Graham	1757–1792
James Graham	Quack doctor	1745–1794
Thomas Graham	Landowner, politician, army officer	1748–1843
'Gravelot' [Hubert-François Bourguignon]	Engraver	1699–1773
Elizabeth Hallett*	Wife of William Hallett, Jnr	1764–1833

William Hallett, Jnr*	Landowner	1764–1842
William Hallett, Snr	Furniture-maker	c.1707–1781
Francis Hayman	Artist	1708–1776
John Theodore Heins	Artist	1697–1756
Caroline Herschel	Astronomer	1750–1848
William Herschel	Musician and astronomer	1738–1822
Rev. Henry Hill*	Churchman and agriculturalist	1715–1775
Rev. Robert Hingeston*	Churchman and teacher	1699–1766
William Hoare	Artist	1707/8–1792
Barbara Hofland	Writer	1770–1844
William Hogarth	Artist	1697–1764
Wenceslas Hollar	Engraver	1607–1677
General Philip Honywood*	Soldier	c.1710–1785
Jacob Houblon	Banker	1710–1770
Jacobus Houbraken	Engraver	1698–1780
Mary, Lady Howe*	Wife of Viscount Howe	1732–1800
Richard, Viscount Howe*	Naval officer	1726–1799
Thomas Hudson	Artist	1701–1779
Ozias Humphry	Artist	1742–1810
Elizabeth Itchener	Vicar's wife	1702–1775
William Jackson*	Musician	1730–1803
James Johnston*	Army officer	c.1721–1797
William Keable*	Musician	1714–1774
Rev. Alexander Keith	Churchman	d.1758
Samuel Kilderbee*	Lawyer	1725–1813
John Kirby*	Topographer	c.1690–1753
John Kirby, Jnr	Lawyer	1715–1750
Joshua Kirby*	Artist, publisher, teacher	1716–1774
George Lambert	Artist	1700–1765
Thomas Lawrence	Artist	1769–1830
Edward, Viscount Ligonier*	Army officer	1740–1782
Penelope, Viscountess Ligonier*	Estranged wife of Edward Ligonier	1749–1827
Elizabeth Linley*	Singer	1754–1792
Mary Linley*	Singer	1763–1784
Thomas Linley*	Musician	1733–1795
Sir Richard Lloyd*	Lawyer	1696–1761
Richard Savage Lloyd*	Lawyer	1710–1810
Philippe Jacques de Loutherbourg*	Artist, theatre designer	1740–1812
Caroline Lybbe-Powys	Diarist	1738–1817
Thomas Major	Engraver	1720–1790
William Mayhew*	Lawyer	1706–1764
John Joseph Merlin*	Inventor	1735–1803
Abel Moysey*	Physician	1715–1780
Henry Muilman	Merchant and landowner	1700–1772

Peter Muilman	Merchant and landowner	1706–1790
Peter Darnell Muilman*	Merchant	1730–1766
Richard 'Beau' Nash	'King of Bath'	1674–1761
George Harcourt, Viscount Nuneham	Landowner	1736–1809
John Palmer	Entrepreneur	c.1720–1788
John Parke	Musician	1745–1829
Nancy Parsons*	Courtesan and political mistress	c.1735–1814/15
William Pearce*	Chief Clerk of the Admiralty	c.1751–1842
Lord Pembroke, Henry Herbert, the 10th Earl	Landowner, aristocrat	1734–1794
Constantine Phipps, 2nd Baron Mulgrave*	Landowner	1744–1792
Robert Edge Pine	Artist	1730–1788
George Pitt*	Politician and diplomat	1721–1803
John Plampin*	Agriculturalist	1727–1805
Arthur Pond	Artist and dealer	1701–1758
Robert Price*	Landowner	1717–1761
Uvedale Price	Landowner and writer	1747–1829
Uvedale Tomkyns Price*	Landowner and writer	1685–1764
Sir William Pulteney, Bt*	Landowner and entrepreneur	1729–1805
William Henry Pyne	Artist and critic	1769–1843
Alan Ramsay	Artist	1713–1784
Sir Joshua Reynolds	Artist	1723–1792
Jonathan Richardson	Artist	1667–1745
Mary 'Perdita' Robinson*	Actress and writer	1757–1800
George Romney	Artist	1734–1802
Sir William St Quintin*	Landowner and patron	1699–1770
Ignatius Sancho*	Writer and actor	1729–1780
Ralph Schomberg*	Physician	1714–1792
Rudolf Straub	Musician	1717–1783
Luke Sullivan	Engraver	c.1725–1771
Brook Taylor	Mathematician	1685–1731
Philip Thicknesse*	Soldier, adventurer, writer	1719–1792
Benjamin Truman*	Brewer	d.1780
Ebenezer Tull	Artist, teacher	1732–1762
Thomas Underwood	Poet	b.1739/40
Frances Unwin*	Wife of James Unwin	d.1813/14
James Unwin*	Lawyer, banker	1717–1776
Admiral Edward Vernon*	Naval officer, politician	1684–1757
George Vertue	Engraver, diarist	1684–1756
William Villiers, 3rd Earl of Jersey	Aristocrat	d.1769
Francis Vivares	Engraver	1709–1780
Captain William Wade*	'King of Bath'	1734–1809

Samuel Wale	Artist	1721–1786
James Ward	Artist	1769–1859
William Whitehead	Poet, playwright	1715–1785
Richard Wilson	Artist	1713/14–1782
Walter Wiltshire	Transport entrepreneur	1718–1799
William Wollaston*	Politician	1731–1797
John Wood the Elder	Property developer	1704–1754
John Wood the Younger	Property developer	1728–1782
Joseph Wright of Derby	Artist	1734–1797
Arthur Young	Agriculturalist, traveller, writer	1741–1820
Johan Zoffany	Artist	1733–1810

Abbreviations to Notes

Angelo, 1823 Henry Angelo, *The Reminiscences of Henry Angelo*, vol. 1, 1823.

Angelo, 1830 Henry Angelo, *The Reminiscences of Henry Angelo*, vol. 2, 1830.

Anstey Christopher Anstey, *The New Bath Guide; or, Memoirs of the B[lu]n[de] r[hea]d Family: in a series of Poetical Epistles*, 1766. Reprinted from *c.*1820 edition, Kingsmead Press, 1978. The book went to forty editions across the author's lifetime.

BAJ *British Art Journal*.

Bath and Bristol Guide *The Bath and Bristol Guide: Or, Trademen's and Traveller's Pocket-companion*. Published by Thomas Boddley, 1753.

BBJ *Boddley's Bath Journal*.

Belsey, *Gainsborough's Family* Hugh Belsey, *Gainsborough's Family*, Gainsborough's House, 1988.

Belsey, *Love's Prospect* Hugh Belsey, with Paul Danks, *Love's Prospect: Gainsborough's Byam Family and the Eighteenth-Century Marriage portrait*, Holbourne Museum of Art, 2001.

Belsey, *Cottage Doors* Hugh Belsey, *Gainsborough's Cottage Doors: An Insight into the Artist's Last Decade*, Paul Holberton, 2013.

BM British Museum.

BRO Bath Record Office.

BStERO Bury St Edmunds Record Office.

Burl. Mag. *Burlington Magazine*.

Cunningham Allan Cunningham, *Lives of the most Eminent British Painters, Sculptors and Architects*, vol. 1, 1829.

Edwards, *Anecdotes* Edward Edwards, *Anecdotes of Painters who have been born in England*, 1808.

FD *The Diary of Joseph Farington RA 1793–1821* (ed. Kenneth Garlick, Angus Macintyre & Kathryn Cave), 16 vols, Yale University Press, 1978–84.

Fraser's Mag. 'The Greater and Lesser Stars of Old Pall Mall', *Fraser's Magazine*, Nov. 1840, pp. 550–59.

Fulcher George Williams Fulcher (edited by his son), *Life of Thomas Gainsborough RA*, 1856.

Garrick, *Letters* David M. Little and George M. Kahrl (eds), *The Letters of David Garrick*, 3 vols, 1963.

Gents Mag. *The Gentleman's Magazine*.

GHA Gainsborough's House Archive.

GHR *Gainsborough's House Review*.

GHR, **'Jackson'** Amal Asfour and Paul Williamson (eds), 'William Jackson of Exeter, New Documents', *GHR*, 1996/7.

GHS Gainsborough's House, Sudbury.

Gosse Philip Gosse, *Dr Viper: The Querulous Life of Philip Thicknesse*, Cassell, 1952.

Harcourt Harcourt Papers, Bodleian Library, University of Oxford.

Hardwicke Hardwicke Papers, British Library.

Hayes, *Landscape Paintings* John Hayes, *The Landscape Paintings of Thomas Gainsborough: A Critical Text and Catalogue Raisonné*, London, 2 vols, Sotheby Publications, 1982.

Hayes John Hayes (ed.), *The Letters of Thomas Gainsborough*, Yale University Press, 2001.

Hodson C. F. D. Sperling (ed.), *A Short History of the Borough of Sudbury in the County of Suffolk, compiled from material collected by W. W. Hodson*, 1896.

Kirby, *Perspective* Joshua Kirby, Painter, *Dr Brook Taylor's Method of Perspective Made Easy, Both in Theory and Practice . . .*, 1754.

New Bath Guide Cornelius Pope (ed.), *The New Bath Guide; or, Useful Pocket Companion . . . to which is added The Life, Character &c of the late Richard Nash, Esq. New Edition; corrected and Improved*, 1762.

ODNB *Oxford Dictionary of National Biography*.

PRO Public Record Office.

Prob Probate Registry.

RA Royal Academy, London.

RA Dictionary of Contributors Algernon Graves, *The Royal Academy of Arts, a Complete Dictionary of Contributors and their Work, from 1769 to 1904*, 8 vols, 1905–6.

Sloman, 'Lodging house' Susan Sloman, 'Gainsborough and "the lodging-house way"', *GHR*, 1991/2, pp. 23–44.

Sloman, 'Prince's daughter' Susan Sloman, 'Mrs Margaret Gainsborough, "A Prince's daughter"', *GHR*, 1995/6, pp. 47–58.

Sloman, *Bath* Susan Sloman, *Gainsborough in Bath*, Yale University Press, 2002.

Smith, *Nollekens* J. T. Smith, *Nollekens and His Times*, 2nd ed., 1829.

Stainton & Grosvenor, 'Genius' Lindsay Stainton and Bendor Grosvenor, *'Tom will be a genius': New landscapes by the Young Thomas Gainsborough*, Philip Mould, 2009.

TG Thomas Gainsborough.

Thicknesse Philip Thicknesse, *A Sketch of the Life and Paintings of Thomas Gainsborough*, 1788.

Thicknesse, *Memoirs* Philip Thicknesse, *Memoirs and Anecdotes of Philip Thicknesse*, 1788.

Thicknesse, *Bath Guide* Philip Thicknesse, *Bath Guide*, 1778.

***Town and Country Mag.*, 1772** *Town and Country Magazine; or, Universal Repository of Knowledge, Instruction, and Entertainment*, Sept 1772, pp. 484–6.

Tyler, 'Daughters' David Tyler, 'Thomas Gainsborough's daughters', *GHR*, 1991/2, pp. 50–66.

Tyler, 'Births, marriages and deaths'. David Tyler, 'The Gainsborough

family: births, marriages, and deaths re-examined', *GHR*, 1992/3, pp. 38–54.

Tyler, 'Hatton Garden' David Tyler, 'Thomas Gainsborough's days in Hatton Garden', *GHR*, 1992/3, pp. 27–32.

Tyler, 'Out from the shadows' David Tyler, 'Out from the shadows: Robert Gainsborough, the artist's eldest brother', *GHR*, 1997/8, pp. 55–69.

Tyler, 'Humphrey Gainsborough' David Tyler, 'Humphrey Gainsborough (1718–1776): Cleric, Engineer and Inventor', *Trans. Newcomen Society*, 76 (2006), pp. 51–86.

Universal Mag. Pictor, 'The Art of Painting, Limning &c.', *Universal Magazine*, Nov 1748, pp. 225–33.

V&A Victoria and Albert Museum, London.

Vertue Notebooks of George Vertue, vols 1–6, *Walpole Society*, vols 18, 20, 22, 24, 26, 29 (index to 1–5) and 30, 1938–52.

Waterhouse Ellis Waterhouse, *Gainsborough*, Spring Books, 1966.

Whitley W. T. Whitley, *Thomas Gainsborough*, Smith, Elder & Co., 1915.

Whitley Papers A large wooden box full of files and papers left by W. T. Whitley to the British Museum. Kept under a table in the Department of Prints and Drawings.

Wine and Walnuts Ephraim Hardcastle [W. H. Pyne], *Wine and Walnuts*, 1824, vols 1–2.

Young Arthur Young (ed.), *Annals of Agriculture*, vols 2–6, 1784–6.

Notes

1. A portrait of Thomas Gainsborough

1 Cunningham, p. 340.
2 Whitley Papers, guard book 1, p. 14.
3 Sir James Prior, *Life of Edmond Malone*, 1860, p. 394.
4 Letter William Jackson to Thomas Jackson, 18 Oct. 1783. 'Twenty Letters', *GHR*, 1996/7, p. 113.
5 *FD*, 6 Jan. 1799, vol. 4, p. 1129.
6 Blushing: Thicknesse, p. 33; Guffawing: Thicknesse, p. 31; 'grinning trick': letter TG to William Jackson, 2 Sept. 1767. Hayes, no. 23.
7 *FD*, 6 Jan. 1799, vol. 4, p. 1129. The emphasis is Farington's.
8 Cunningham, p. 343.
9 Walter Thornbury, *The Life of J. M. W. Turner RA*, 1897 edn, pp. 247–8.
10 Letter Barbara Hofland to . . . Hall [or Hale?], nd [after 1839 and before 1844], GHA, 2003.001.
11 Thicknesse, p. 18.
12 *Town and Country Mag.*, 1772.
13 *Wine and Walnuts*, vol. 2, p. 215.
14 Letter TG to David Garrick, 27 July 1768. Hayes, no. 34.
15 *FD*, 29 Oct. 1794, vol. 4, pp. 255–6. Sir James Prior, *op. cit.*, p. 393.
16 A recollection of Gainsborough's later years, from Thicknesse, *Memoirs*, pp. 173–4.
17 Angelo, 1823, p. 218.
18 *FD*, 6 Jan. 1799, vol. 4, p. 1129. Letter TG to William Jackson, 2 Sept., early 1770s. Hayes, no. 39.
19 Thomas Gray, *Elegy Written in a Country Churchyard*, 1751.
20 Letter TG to William Jackson, 2 Sept. [?mid 1770s]. Hayes, no. 39.
21 *Fraser's Mag.*
22 Barbara Hofland letter, *cit.*
23 *Town and Country Mag.*, 1772.

2. Obliged to pink

1 Tyler, 'Out from the shadows'.
2 'Scheming' here I think means having big plans, schemes, with no pejoratives like 'plotting' being attached to his nickname, though as things turned out this might have become applicable: *Norwich Gazette* and *Ipswich Journal*, both 10 Dec. 1743.
3 Fulcher, p. 14.
4 *Ibid.*, p. 6.

[5] *Ibid.*, p. 21.

[6] http://dissacad.english.qmul.ac.uk/sample1.php?detail=achist&histid=29&acadid=107.

[7] Tyler, 'Humphrey Gainsborough'.

[8] 1723. Sudbury Orders and Decrees 1717–33 allowed John Gainsborough a maximum of forty-four feet for his wall. BStERO, EE501/2/9. I am grateful to Louisa Brouwer for measuring the façade of Gainsborough's House for me: 42 feet 9 inches. See also Barry Wall, *Sudbury: History and Guide*, Tempus Publishing 2016, p. 85.

[9] http://www.historyofparliamentonline.org/volume/1690-1715/constituencies/sudbury.

[10] http://www.historyofparliamentonline.org/volume/1715-1754/constituencies/sudbury.

[11] Susan Mitchell Sommers, *Parliamentary Politics of a County and Its Town: General Elections in Suffolk and Ipswich in the Eighteenth Century*, Praeger 2002, p. xix.

[12] *London Gazette*, 16–20 Oct. 1733.

[13] Sommers, *op. cit.*, p. 6. See also A. G. E. Jones, 'Suffolk bankruptcies in the eighteenth century', *Suffolk Review*, 2.1 (March 1959), pp. 4–10; Frank Grace, 'Food riots in Suffolk in the Eighteenth Century', *Suffolk Review*, 1 (1980), pp. 32–46; Paul Muskett, *Riotous Assemblies: Popular Disturbances in East Anglia 1740–1822*, Ely, 1984

[14] Dr Johnson's *Dictionary* defines the word as coming from the French for silk, *soie*, but adds (1785 edn) that this meaning was already obsolete.

[15] Fulcher, p. 5.

[16] Cornelia Knight, *Autobiography*, 1861, vol. 1, p. 16. Joseph Gilbert (ed.), *Autobiography and Other Memorials of Mrs Gilbert (formerly Ann Taylor)*, 3rd edn, 1878, p. 102.

[17] Lessees of chapel pews are listed in parish records: 'South side pew no 52 lett to Tho. Gainsborough . . . south side 46 John Gainsborow 6 seats gallery £3.0.0.' BStERO, FK3 501/1/5.

[18] Tyler, 'Out from the shadows', note 66.

3. Sepulchre Street

[1] Daniel Defoe, *A Tour through the Whole Island of Great Britain*, 1724–26. Everyman edn, 1962, vol. 1, p. 48.

[2] http://www.historyofparliamentonline.org/volume/1715-1754/constituencies/sudbury.

[3] Extracts from William Dowsing's Journal, BStERO, FL540/13/5/1. http://www.williamdowsing.org/journalnoindex.htm.

[4] Installed 1913.

[5] The traditional distribution is still made each year at St Gregory's on St Thomas's Day. Barry Wall, *Sudbury: History and Guide*, Tempus Publishing, 2016, p. 49.

[6] Belsey, *Gainsborough's Family*. This contains full information on the family, illustrated with portraits and with family trees.

[7] Prob 11/695/272ff. Tenter yards and fields were areas where new cloth was stretched out to fix a rectangular shape.

[8] *London Gazette*, no. 7240, 16–20 Oct. 1733. John Gainsborough in the office of postmaster: *Ipswich Journal*, 24 Dec. 1748.

[9] Fulcher, p. 4.

[10] Further evidence of the elder Thomas Gainsborough's involvement in local property deals can be found in BStERO, FK3 501/3/5 and 3/6. See also Allan W. Berry, 'The Gainsboroughs and the Freedom of Sudbury', *GHR*, 1993/94, pp. 43–5.

[11] Prob 11/695/272ff.

4. The very bird of the eye

[1] *Morning Chronicle*, 8 Aug. 1788; letter TG to Thomas Harvey, 22 May 1788. Hayes, no. 108.

[2] Whitley, p. 5. Stephen Conrad, 'Thomas Gainsborough's first self-portrait', *BAJ*, vol. XII, no. 1 (Summer 2011), pp. 52–9.

[3] *Gainsborough*, exhn. cat., Tate Britain, cat.1. Private collection.

[4] *Morning Post*, 5 Aug. 1788.

[5] Anecdote of John Jackson RA, published in Smith, *Nollekens*, vol. 2, pp. 146–52. The 1828 edition has a variant on the story, pp. 149–50.

[6] Fulcher, p. 25.

[7] The drawings are published by Hugh Belsey, 'A Second Supplement to John Hayes's *The Drawings of Thomas Gainsborough*', *Master Drawings*, vol. 46, no. 4, 2008, nos. 1004–11. The drawings at Windsor are held in an album erroneously tooled in the nineteenth-century 'Sketches of Sir E. Landseer'. This caused them to be overlooked. Delia Millar, *Victorian Watercolours and Drawings in the Collection of Her Majesty the Queen*, Philip Wilson Publishers 1995, vol. 1, p. 530.

[8] *Fraser's Mag*.

[9] Thicknesse, p.6.

[10] Thomas Page, Jnr, *The Art of Painting in Its Rudiment, Progress, and Perfection: Delivered exactly as It is put in Practice, so that the Ingenious may easily understand its Nature, to perform it . . .* Norwich, printed by W. Chase, in the Cockey-Lane for the Author, 1720. Preface, np.

[11] *Ibid.*, ch. 2, pp. 10–11.

[12] *Ibid.*, ch. 11, pp. 75ff.

[13] *Ibid.*, ch. 12, p. 91.

5. Joshua Kirby

[1] *ODNB*, John Kirby.

[2] Felicity Owen, 'Joshua Kirby (1716–74): a biographical sketch', *GHR*, 1995/6, pp. 61–75.

[3] John Kirby, *The Suffolk Traveller*, 1735; 2nd edn, 1764, p. 267.

[4] Nathaniel Bacon, *Landscape*. Ashmolean Museum, Oxford, F635. The painting, on copper, was collected by the Tradescants as a curiosity.

[5] Vertue, vol. 6, p. 203.

[6] Owen, *op. cit.*

[7] *Ipswich Journal*, 31 March 1751; Owen, *op. cit.*

[8] Full title: Joshua Kirby, Painter, *Dr Brook Taylor's Method of Perspective Made Easy, Both in Theory and Practice. In Two Books. Being an Attempt to make the Art of Perspective easy and familiar; to Adapt it intirely to the Arts of Design; and to make it an entertaining Study to any Gentleman who shall chuse so polite an Amusement.* Illustrated with Fifty Copper Plates; most of which are engraved by the Author. Ipswich, 1754. Printed by W. Craighton, for the Author; and sold by him in Ipswich.

[9] Brook Taylor, *op. cit.*, Preface.

[10] https://en.wikipedia.org/wiki/Taylor_(crater).

6. Some light handy craft trade

[1] Whitley, p. 5. This copy of Cunningham is allegedly in the National Art Library, V&A, but a search by me and library staff failed to locate it. Tyler, 'Births, marriages and deaths', note 11.

[2] Exhn. cat. *Conversation Pieces*, 1983, no. 2. Leger Gallery, London.

[3] *Morning Post*, 5 Aug. 1788. TG's obituary in *Gents Mag.*, vol. 58, Aug. 1788, pp. 753–6 has the footnote 'In the neighbourhood of his father's was a very respectable clergyman of the name of Coyte. With the sons of this gentleman young Gainsborough and his brothers passed much of their time.' Elaine Barr, 'Gainsborough and the Silversmith', *Burl. Mag.*, Feb. 1977, p. 133.

[4] John Gay, *Trivia; or, the Art of Walking the Streets of London*, Penguin edn, 2016, pp. 14–15.

[5] Edward Ward, *The London Spy, Compleat, in Eighteen Parts*, The Casanova Society, 1924. First published 1698, then 1703, collected version, 1717–24, part 2, p. 35.

[6] *Ibid.*, part 2, p. 30.

[7] *Ibid.*, part 8, p. 178.

[8] 'Narration of Some of the Occurrences in the life of Edmund Howard', 1785, Chelsea Reference Library, SP 210 (B), quoted in Peter Thorold, *The London Rich*, 1999, p. 96.

[9] P. J. Grosley, *A Tour to London [in 1765]*, 1772, vol. 1, p. 31.

[10] Gillian Wagner, *Thomas Coram, Gent.*, Boydell Press, 2004, p. 138.

[11] Alexander Pope, 'The Uses of Riches', *Epistle 4*, ll. 99–100.

[12] My paces.

[13] Quoted *History of the County of Middlesex*, vol. 13, City of Westminster, part 1, 2009, p. 111.

[14] Obituary, *Gents Mag.*, vol. 52, 1782, pp. 45–6.

7. Key to every man's breast

[1] Joseph Addison, 'Reflections in Westminster Abbey', *Spectator*, no. 26, 30 March 1711; Susan Owens, *Jonathan Richardson By Himself*, Courtauld Institute of Art, 2015.

[2] William Hogarth, *The Analysis of Beauty. Written with a view of fixing the fluctuating Ideas of Taste*, 1753, p. 6.

[3] *Ibid.*, p. 16.

[4] *Ibid.*, pp. 56–7.

[5] *ODNB*, John Clubbe.

[6] John Clubbe, *Miscellaneous tracts of the Rev. John Clubbe, Rector of Whatfield and Vicar of Debenham, Suffolk*, vol. 1, *Physiognomy; being a Sketch only of a larger Work upon the same Plan: wherein the different Tempers, Passions and Manners of Men will be particularly considered*. Nd [?1750s].

[7] For a start, see Jenny Uglow, *Hogarth: A Life and a World*, Faber & Faber, 1998.

[8] Cunningham reports that Hogarth was 'rather below the middle size'; Cunningham, p. 172.

[9] Quoted Mark Hallett, *Reynolds: Portraiture in Action*, Yale University Press, 2014, p. 25.

[10] *Ibid.* A transcription of Samuel Reynolds' letter is in the RA Archive, REY/3/951.

[11] Kirby, *Perspective*, 2nd edn, 1754.

[12] Edward Dayes, *Works*, 1805, p. 329. In his *Memoirs of the Royal Academicians*, published in 1796, the journalist John Williams [pseud. Anthony Pasquin] also reported that Gainsborough studied with Grignion: p. 102, note.

[13] *FD*, 1 July 1806, vol. 8, p. 2800.

[14] *ODNB*, Gravelot.

[15] Vertue, vol. 3, p. 105.

[16] Gainsborough's collection of European prints was sold at Christie's, 11 May 1799. See also Antony Griffiths, *The Print Before Photography*, British Museum, 2016.

[17] 'Biographical anecdotes of celebrated characters', *Edinburgh Magazine*, 1792, c.1, vol. 16, p. 323.

[18] *Ibid.*, p. 322; J. Strutt, *A biographical dictionary of all the engravers . . .* , 1785–6, p. 194, quoted *ODNB*, Hollar.

[19] *Edinburgh Magazine, loc. cit.*

[20] J. Ireland, *Hogarth Illustrated*, 2nd edn, vol. 3, 1804, pp. 343–4.

[21] J. Strutt, *op. cit.*, p. 347.

[22] *ODNB*, Luke Sullivan.

[23] Vol. 1 with 81 portraits, published 1743; vol. 2, with 38 plates published in 1751. The volumes were, *inter alia*, advertised for sale in the *Ipswich Journal*, 26 Sept. 1747. See also John Hayes, 'The ornamental surrounds for Houbraken's "Illustrious Heads"' (Notes on British Art), *Apollo*, vol. 79, no. 83, Jan. 1969, pp. 1–3.

[24] *Morning Herald*, 4 Aug. 1788.

[25] Christie's, 11 May 1799, lot 102.

[26] Louise Lippincott, 'Arthur Pond's journal of receipts and expenses, 1734–1750', *Walpole Society*, vol. 54, 1988, pp. 220–333.

8. The makings of a rake

1 Brian Allen, *Francis Hayman*, Yale University Press 1987, p. 1.

2 Fulcher, p. 29.

3 *FD*, 6 Jan. 1808, vol. 9, p. 3192.

4 Pierre-Jean Grosley, *A Tour to London; or, New Observations on England and Its Inhabitants* [trans. Thomas Nugent], 2 vols, London, 1772, vol. 1, p. 103.

5 Oliver Goldsmith, *The Citizen of the World; or, Letters from a Chinese Philosopher residing in London to His friends in the East*, 1762, Folio Society edn, 1969, letter LXXI, p. 218.

6 Thicknesse, p, 6. Cunningham, p. 342. National Gallery, London.

7 Letter TG to John Henderson, 27 June 1773. Hayes, no. 68.

8 *The Musical Entertainer*, engraved by George Bickham, Jnr. This is undated, but one of the engravings is dated 1735. GHA, 1995.019. 'The Apology' is on p. 52.

9 Song 'Rural Beauty, or Vaux-hal Garden', words by Mr Lockman, set by Mr Boyce, *ibid.*, p. 21.

10 Pierre-Jean Grosley, *op. cit.*, vol. 1, p. 153.

11 Vertue, vol. 3, p. 76.

12 William Hogarth, *Apology for Painters*, c.1760.

13 Charles Watkins and Ben Cowell (eds), 'Mr Price the Picturesque', introduction to 'Letters of Uvedale Price', *Walpole Society*, vol. 68, 2006.

9. Hatton Garden

1 Tyler, 'Hatton Garden'. Little Kirby Street was later renamed St Cross Street. See also Rachel Lichtenstein, *Diamond Street: The Hidden World of Hatton Garden*, Hamish Hamilton, 2012.

2 Robert Dodsley, *London and Its Environs Described*, 1761, vol. 3, p. 176.

3 John Strype, *Survey of the Cities of London and Westminster*, 1720, book 3, ch. 12, p. 255.

4 Laetitia M. Hawkins, *Memoirs, Anecdotes, Facts and Opinions*, 1824, vol. 1, p. 315.

5 Gillian Wagner, *Thomas Coram, Gent.*, Boydell Press, 2004, pp. 126ff.

6 *Ibid.*, p. 142.

10. Go over the face very curiously

1 *Norwich Gazette* and *Ipswich Journal*, both 10 Dec. 1743. http://www.foxearth.org.uk/BecclesAreaNewspapers/Norwich%20Gazette1709-1720.html.

2 Private collection. It is likely that only the face in this portrait is by Gainsborough.

3 Fulcher, p. 206. When Fulcher was writing Gainsborough's biography the portrait was owned by the family's Dupont relations. It is now in the Corcoran Gallery, Washington, DC. Bequest of Edward C. and Mary Walker, 1937.18.

4 Diane Perkins, *Gainsborough's Dogs*, Gainsborough's House, 2006.

[5] Arthur Young, *General View of the Agriculture of the County of Suffolk*, 1813, p. 362.

[6] Hayes, *Landscape Paintings*.

[7] At a London sale in 1762, the collection of a Mr Oldfield, lot 17 was: 'A Dutch landscape repaired by Mr Gainsborough'; lot 56: 'Wynantz, a landscape, figures by Mr Gainsborough'. Waterhouse, p. 13. See also Susan Foister, 'Young Gainsborough and the English taste for Dutch Landscape', *Apollo*, vol. 146, no. 426, Aug. 1997, pp. 3–11. Foister points out that at his death Gainsborough owned three Ruisdaels, a Wynantz, a Pijnacker and other Dutch paintings.

[8] Paintings from Gainsborough's early years are discussed in Stainton Grosvenor, 'Genius'.

[9] Vertue, vol. 22, p. 149.

[10] *Universal Mag.*

[11] *Ibid.*

11. A marvellous time to be in London

[1] Louise Lippincott, 'Arthur Pond's journal of receipts and expenses, 1734–1750', *Walpole Society*, vol. 54, 1988, pp. 220–333.

[2] Letter Allan Ramsay to Alexander Cunningham, 10 April 1740. National Records of Scotland, GD 331/24/20, quoted Ellis Waterhouse, *Painting in Britain*, 2nd edn, 1962, p. 141.

[3] He had been baptised Pantin Buteux.

[4] Smith, *Nollekens* vol. 1, pp. 174ff.

[5] Henry Fielding, *The History of Tom Jones, a Foundling*, 1749, book 8, ch. 10.

[6] Smith, *loc. cit.*

[7] *Town and Country Mag.*, 1772.

[8] Letter James Ward to J. G. Pratt, 8 March [*c*.1805]. Fitzwilliam Museum, Cambridge. Gift of C. Fairfax Murray, 1917.

[9] Ilaria Bignamini, 'George Vertue, Art Historian, and Art Institutions in London 1689–1768', *Walpole Society*, vol. 54, pp. 1ff.

[10] Rica Jones, 'Gainsborough's materials and methods – A "remarkable ability to make paint sparkle".' *Apollo*, vol. 146, no. 426, Aug. 1997, pp. 19–26; also Rica Jones, 'Technical and contextual study of young Thomas Gainsborough', paper given at *The Painting Room: The Artist's Studio in Eighteenth-Century Britain*, conference at the Paul Mellon Centre and Gainsborough's House, Oct. 2015. There Jones suggested that the Griffiers might have been the source of Gainsborough's knowledge of the use of ground glass.

[11] British Framemakers, 1600–1950. http://www.npg.org.uk/research/conservation/directory-of-british-framemakers/h.php.

[12] Vertue, vol. 3, p. 157. There is a suggestion in the text that Vertue thought that Gainsborough, like the other artists, had contributed more than one roundel.

[13] Fulcher, p. 31.

[14] Brian Allen, *Francis Hayman*, Yale University Press 1987, p. 92.

[15] *Daily Telegraph*, 27 Dec. 2016. I am grateful to Hugh Belsey for drawing this portrait to my attention.

[16] British Art Center, Yale.

[17] Private collection. Hugh Belsey suggests that this portrait may equally be by Mason Chamberlin.

[18] Thicknesse, p. 11.

[19] Headline to article, *Morning Chronicle*, 8 Aug. 1788.

[20] Tate Britain, London.

[21] Eg. the pencil drawing *Wooded landscape with a river, cattle and figures, after Jacob van Ruisdael*, Whitworth Art Gallery, Manchester.

12. Thomas and Margaret get married

[1] Letter TG to G. B. Cipriani, 14 Feb. 1774. Hayes, no. 72.

[2] Portrait now untraced. Cunningham, p. 323; Fulcher, pp. 32–3.

[3] Barry Wall, *Sudbury: History and Guide*, Tempus Publishing, 2016, p. 88, quoting the late Miss Holden of Sudbury, a direct descendant of Robert Andrews.

[4] Lindsay Stainton, Susan Sloman and David Tyler have all thrown rich new light on Margaret's origins. Stainton & Grosvenor, 'Genius', pp. 26–8; Sloman, 'Prince's daughter'; Tyler, 'Daughters' and 'Births, marriages and deaths'.

[5] Anon. [A Gentleman, probably Henry Bate Dudley], *A New and Complete History of Essex . . .* , 6 vols, 1770, vol. 1, p. 144.

[6] Letter TG to James Unwin, 1 March 1764. Hayes, no. 13.

[7] Letter TG to James Unwin, 10 July [1764]. Hayes, no. 14. The particular usage 'Mrs Itch in here' will be discussed in a later chapter.

[8] Letter TG to James Unwin, 21 Jan. 1765. Hayes, no. 18.

[9] Elizabeth Marvell, christened St James, Westminster, 8 March 1702.

[10] Letter TG to James Unwin, 1 March 1764. Hayes, no. 13. Elizabeth Murvell/Marvell married George Itchener at Ingatestone, Essex, on 16 March 1748.

[11] Letter TG to James Unwin, 10 July 1764. Hayes, no. 14.

[12] Stainton & Grosvenor, 'Genius', p. 27.

[13] Susan Sloman quotes research, as at 2002, by David Tyler into Margaret Burr's family background: Sloman, *Bath*, p. 222, n. 19. See also James Holloway, *William Aikman 1682–1731*, Scottish Masters Series, no. 9, National Galleries of Scotland, 1988, pp. 12ff.

[14] Sloman, 'Prince's daughter', Appendices I, II and III transcribe relevant documents in the Family Papers of Henry, 3rd Duke of Beaufort.

[15] Letter 3rd Duke of Beaufort to his brother Lord Charles Noel Somerset, 30 Jan. 1744 [old style]. Badminton Muniments, Fm J 2/34/17.

[16] Sloman, *Bath*, Appendix II.

[17] *General Advertiser*, 20 July 1744, and elsewhere. See G. J. Armytage, *The registers of baptisms and marriages at St George's chapel, May Fair*, Harleian Society, 1889, pp. viiiff. and 66. The entry reads: 'Mr Thomas Gainsborough

of St Andrew's Holborn & Mrs [abbrev. for 'Mistress'] Margaret Burr of St
George's Hanr Square. [Marriage number] 3250.'

[18] *ODNB*, Alexander Keith.

[19] Tyler, 'Hatton Garden'.

[20] Stainton & Grosvenor, 'Genius', p. 27.

[21] Fulcher, p. 35. It is not clear who 'Madam Kedlington' was, but handsome
she must have been. There is a portrait painter, Elizabeth Keddington,
recorded in Suffolk in the eighteenth century, and Keddington is a Suffolk
village. Keddington is among the names of subscribers to John Kirby's
Suffolk Traveller.

[22] Tyler, 'Hatton Garden'. Guildhall Library, Burial Register for St Andrew's
Church, Holborn, 1735–55 (MS 6673/10). Date of burial: 1 March 1748
[new style calendar]. No age is given; there can be no certainty that this
is their child, but given the coincidence of name and place it is more than
likely. There is no apparent birth record for Mary Gainsborough within the
expected date range.

13. Retreat to Sudbury

[1] David Tyler, 'Out from the shadows'.

[2] For useful early information about Gainsborough, see John Bensusan-
Butt, *Thomas Gainsborough in his Twenties*, 1989. Barry Wall has suggested
that Thomas and Mary Gainsborough moved to Red House in Bullock's
Lane, just behind Friars Street. Barry Wall, *Sudbury: History and Guide*,
Tempus Publishing, 2016, p. 87; *East Anglian Daily Times*, 26 Nov. 2016. The
thoroughfare is variously described as 'Lane' and 'Street'. It was systematised
as 'Friars Street' in the late nineteenth century.

[3] Letter TG to the Hon. Constantine Phipps, 13 Feb. 1772. Hayes, no. 56.

[4] *Ipswich Journal*, 2 April 1748.

[5] Ibid., 16 April and 7 May 1748. 'Blowing' in eighteenth-century parlance
means 'blooming'. See Dr Johnson's *Dictionary*.

[6] But see ch. 11, note 17.

[7] National Gallery, London.

[8] Letter TG to Rev. Henry Bate Dudley, published after TG's death in
Morning Herald, 23 April 1789. Hayes, no. 104.

[9] No. 31555.

[10] I am grateful to Lindsay Stainton for sharing her thoughts about the album
with me.

[11] No. 31554 v.

[12] Gainsborough's House, Sudbury.

[13] Minneapolis Institute of Arts.

[14] Philadelphia Museum of Art.

[15] Longleat House, Wiltshire.

[16] National Gallery of Scotland, Edinburgh.

[17] GHA, 2001.021. Gainsborough gives his address on the receipt, dated 9 May
1759, as 17 Hatton Garden. This is curious in itself, but indicates that he kept
a base in Hatton Garden.

18 Tate Britain, London.

19 *ODNB*, Richard Lloyd.

20 *Burke's Peerage*, 100th edn, 1953. Family: Winchilsea and Nottingham, p. 2254.

21 *ODNB*, Richard Lloyd; http://www.historyofparliamentonline.org/ volume/1715-1754/member/lloyd-richard-1696-1761#footnote2_kose6y6. His will, proved 28 Sept. 1761, Prob 11/868/480.

22 British Art Center, Yale.

23 Fitzwilliam Museum, Cambridge. Two of Gainsborough's lay figures were sold at Christie's, 11 May 1799, lots 91 and 92.

24 National Museum of Wales, Cardiff.

25 See Jane Munro, *Silent Partners: Artist and Mannequin from Function to Fetish*, Yale University Press 2014, pp. 20–21.

26 Joshua and Sarah: National Portrait Gallery, London; John and Alice: both canvases Fitzwilliam Museum, Cambridge.

27 *ODNB*, John Kirby; https://kirbyandhisworld.wordpress.com/2012/12/01/ sir-richard-lloyd.

28 Will of John Kirby, proved 26 July 1750, Prob 11/781/229.

29 National Gallery, London.

30 Tate Britain, London.

31 Private collection, on loan to Gainsborough's House, Sudbury.

32 Memorial Art Gallery of the University of Rochester, NY.

33 University of California at Los Angeles. Hayes, *Landscape Paintings*, vol. 2, pp. 361–3.

34 Dulwich Picture Gallery, London.

35 Tate Britain, London.

36 Will of Rev. John Chafy, PRO 11/1089/385.

37 'Gainsborough's materials.' Paper given by Spike Bucklow, Hamilton Kerr Institute, at the *Artists' Studios* conference at Gainsborough's House in October 2015.

38 Letter TG to James Unwin, 25 May 1768. Hayes, no. 31.

39 Online article Huw T. David, 'Patronage: Mercantile Sitters', Painting in Focus; *Tate Research Publications*. http://www.tate.org.uk/research/ publications/in-focus/muilman-crokatt-keable-thomas-gainsborough/the-painting/patronage.

40 After her husband's death Anna married the insurance broker J. J. Angerstein. Arthur F. Day, *John C. F. S. Day: His Forbears and Himself*, 1916, pp. 39 and 182. Angerstein's collection would come to form the nucleus of the National Gallery in 1824.

41 Thicknesse, p. 8.

14. Mr and Mrs Andrews of Bulmer

1 Sudbury Orders and Decrees, 1717–33, BStERO, EE501/2/9.

2 Sentence [judicial decision] on Robert Andrews' will, 21 Jan. 1737; PRO 11/684/1. Andrews family tree in John Bensusan-Butt, 'The Carters and the Andrews', *GHR*, 1992/3, pp. 33–7.

3 From Mary Magrath, née Daniells, of Bury St Edmunds, the Catholic family who owned it after the Dissolution. Bensusan-Butt, *op. cit.* Letter John Bensusan-Butt to Judy Egerton, 17 June 1991, National Gallery Archive.

4 Will of Robert Andrews, proved 9 Feb. 1737, PRO 11/687/298. This superseded an earlier will of 1734.

5 Tyler, 'Out from the shadows'.

6 Will of William Carter, proved 3 Sept. 1750, PRO 11/784/160.

7 Will of Martha Andrews, proved 6 March 1750, PRO 11/777/284.

8 I am most grateful to Nigel Burke for allowing me to roam about the Auberies landscape. Twenty yards to the right of 'Gainsborough's oak' is another mature oak which Mr Burke tells me is a relatively quick-growing Turkey oak, 150 years old at the most, and so it would not have been there in the 1740s. The woods to the north and east were planted in the 1960s by Nigel Burke's father.

9 Young, vol. 6, 1786, p. 222.

10 Young, vol. 2, 1784, pp. 32–3.

11 Footnote to Robert Andrews, 'On the advantages of mixing lime with dung', Young, vol. 4 (1785), p. 48.

12 British Art Center, Yale.

13 Robert Andrews, 'On the profit of farming', Young, vol. 4, 1785, pp. 252–8.

14 I am grateful to Tom Birch Reynardson for his thoughts on the season, and the gun and its accoutrements in the painting.

15 The outline of the pheasant is perfectly clear in the painting in the National Gallery: http://www.nationalgallery.org.uk/cid-classification/classification/picture/thomas-gainsborough,-mr-and-mrs-andrews/281826/*/moduleId/ZoomTool/x/-370/y/-230/z/3.

16 After the 1927 exhibition in Ipswich, *Mr and Mrs Andrews* was shown in an exhibition of eighteenth- and nineteenth-century British painting in Brussels in 1929, then intermittently in London (Tate Gallery, 1953), Rotterdam, Paris, Fort Worth and Sudbury. Its formal and rather stiff title was the description it was given when it was acquired by the National Gallery. When it was shown at the RA (1934), Rotterdam (1955) and Sudbury (1958) it was listed as 'Robert Andrews and his Wife'.

17 He married Mary Smith of Sudbury, *London Gazette*, 4 June 1781.

18 *Bury and Norwich Post*, 28 May 1806.

19 Sale notice *Morning Chronicle*, 28 Aug. 1806; result of sale, 27 Sept. 1806.

20 The new Auberies was engraved in *Rackham's Country & Town Ladies Memorandum Book*, 1810. GHA, 2000.101.

21 Now Weavers Lane.

22 Conversation exchange drawn from *Town and Country Mag.*, 1772.

15. They did not know his value till they lost him

1 Sloman, 'Prince's daughter', note 41.

2 Barbara Hofland letter, *cit.*

3 Caroline Lybbe-Powys Diaries, vol. 10. Second Norfolk Tour, 1781. BL Add MS 42169, f. 6.

[4] T. K. Cromwell, *Excursions in the County of Suffolk*, 1818, p. 141.

[5] *Ipswich Journal*: Microcosm, 6 Jan. and 3 Feb. 1753; Female Sampson, 27 Jan. 1753; Dancing bears, 5 May 1753.

[6] *Ipswich Journal*, 10 Feb. 1753.

[7] Kirby, *Perspective*, book 2, p. 58.

[8] Thicknesse, p. 8.

[9] Fulcher, pp. 37–8.

[10] Whitley, p. 22.

[11] Sale notice, *Ipswich Journal*, 20 Oct. 1759.

[12] Letter TG to William Mayhew, 13 March 1758. Hayes, no. 5.

[13] Fulcher, p. 57.

[14] Cunningham, p. 328.

[15] Letter TG to David Garrick, 27 July 1768. Hayes, no. 34.

[16] *Ipswich Journal*, 30 Dec. 1752.

[17] Letter TG to David Garrick, *cit*. The reference to 'Mr Giardini of Ipswich' may be an ironic comparison between a local violinist and Felice de Giardini, one of the most accomplished musicians of the day. I am grateful to Lindsay Stainton for this suggestion.

[18] Fulcher, pp. 53–5.

[19] Letter John Constable to J. T. Smith, 7 May 1797, published Fulcher, pp. 53–4.

[20] Identified in *East Anglian Daily Times*, 5 March 1917.

[21] The identities of the figures were uncovered by Fulcher, pp. 56–7.

[22] There was allegedly a third general scene of drunken riot painted by Gainsborough, of the Ipswich Punch Bowl Club, on a longcase clock. According to the then curator, Frank Woolnough, the clock was presented to Christ Church Museum, Ipswich, by M. St G. Cobbold. *East Anglian Daily Times*, 6 March 1917. Press cutting in Whitley Papers, British Museum. Whitley has pencilled the word 'ABSURD' on the cutting.

[23] *FD*, Tues. 29 Jan. 1799, vol. 4, p. 1149.

[24] Fulcher, p. 53, quoting 'one of [Gainsborough's] contemporaries'.

16. Gainsborough de Ipswich

[1] Kilderbee's collection was sold at Christie's, 30 May 1829: 'A very choice and fine assemblage of works of that admired landscape painter, Gainsborough, both paintings and drawings . . . for whom a few of these were painted expressly by the artist.'

[2] I saw a photograph of it years ago, but cannot for the life of me remember where.

[3] National Gallery, 5984. Stella Newton advises, in a note in the painting's folder in the National Gallery Archive, that Plampin's 'short waistcoat, narrow sleeves and moderate cuffs' would not have been in general use until after 1755, thus indicating an Ipswich period date to the portrait.

[4] John Plampin, 'Account of a plantation', Young, vol. 4, 1785, pp. 10–12.

[5] Portrait in Christchurch Mansion, Ipswich, acquired 2000. Robert and Katharine Hingeston's epitaphs in St Helen's, Ipswich, are recorded in *Gents Mag.*, Nov. 1817, p. 396.

6 See Pennington's 1778 map of Ipswich. Illustrated Whitley, facing p. 21;
 www.ipswich-lettering.co.uk/map1778.html

7 Fulcher, pp. 48–9.

8 Thicknesse, p. 6; Cunningham, p. 343.

9 Art Gallery of Western Australia, Perth.

10 Letter TG to William Mayhew, 24 Feb. 1758. Hayes, no. 4.

11 Fulcher, p. 40.

12 Letter TG to William Mayhew, 13 March 1758. Hayes, no. 5.

13 The Tankard Inn was just round the corner from Gainsborough's house in
 Foundation Street, and will have been well known to him.

14 John Clubbe, 'A Letter of Free Advice to a Young Clergyman', *Miscellaneous
 tracts of the Rev. John Clubbe, Rector of Whatfield and Vicar of Debenham,
 Suffolk*, 1765, vol. 2, pp. 33–6.

15 National Gallery of Ireland, Dublin.

16 Tyler, 'Humphrey Gainsborough'.

17 National Portrait Gallery, London.

18 Letter TG to Elizabeth Rasse, nd [1753]. Hayes, no. 1; Cunningham, p. 324.

19 Letter TG to 'Mr Harris', 1 May 1756. Hayes, no. 2. 'Harris' has been
 identified as either Josiah Harris the Ipswich cabinet-maker and auctioneer,
 or Charles Harris, churchwarden of St Mary Key, Ipswich.

20 Thomas Green, *Extracts from the Diary of a Lover of Literature*, Ipswich, 1810.
 Later extracts are published in *Gents Mag.*, this one May 1841, p. 471, entry
 dated 22 April 1818.

21 Gainsborough's portrait prices and their sources from October 1758 are
 listed in Sloman, *Bath*, Appendix III, p. 213.

22 Numbers of works derived from Waterhouse.

23 Sloman, 'Prince's daughter', note 41.

24 Thicknesse, p. 28.

25 *Ipswich Journal*, 6 Oct. 1753.

26 Letter from seamstress S. Gubbins, London, to Lady Blois at Cockfield
 Hall in Yoxford, Suffolk, 23 May 1764. Ipswich RO, 50/22/27.4 (24). In the
 Fitzwilliam Museum, Cambridge, S. G. Perceval Bequest, 1922, there is a
 trade leaflet, dated 5 April 1775, for 'Gubbins, Towne and Whitehead, at
 Naked Boy, Henrietta Street, Covent Garden. Linen drapers. Sold linen, satin
 and dimity robes, childrens clothes etc etc.' P.12670-R.

27 *Ibid.*, 23 December 1764. Ipswich RO, 50/22/27.4 (25).

17. They say I'm a quarrelsome fellow

1 http://www.historyofparliamentonline.org/volume/1754–1790/member/
 lloyd-sir-richard-1696-1761.

2 *Ipswich Journal*, 9 March 1754.

3 Susan Mitchell Sommers, *Parliamentary Politics of a County and Its Town:
 General Elections in Suffolk and Ipswich in the Eighteenth Century*, Praeger,
 2002, p. 15.

4 Quoted Gosse, p. 12.

[5] Absent from the historical record.

[6] Fulcher, p. 42.

[7] Gosse, *loc. cit.*

[8] The painting, or a version of it, known as *Tom Peartree*, survives now in Christchurch Mansion (Colchester and Ipswich Museum Service).

[9] Cunningham, p. 324.

[10] Thicknesse, p. 11 (Thicknesse's capitals).

[11] Thicknesse, p. 12.

[12] *ODNB*, Thomas Major.

[13] Thicknesse, p. 14.

[14] Prices as quoted by Tim Clayton, 'Gainsborough and his engravers', *GHR*, 1990/91, pp. 38–48.

[15] Thicknesse, *Memoirs*, pp. 173–4.

[16] Reproduced by Thicknesse in his collection 'The Humours of Landguard Fort'. BL Add MS 24669.

[17] Gosse, p. 121.

[18] Thicknesse, p. 15.

[19] The painting from which this print is derived is at Hayes, *Landscape Paintings*, vol. 2, pp. 367–8.

[20] Edwards, *Anecdotes*, p. 142. A surviving proof is at Gainsborough's House, 1987.22. Others are in the RA, London, and the Glynn Vivian Museum, Swansea. See also Hugh Belsey, 'Two prints by Gainsborough', *GHR*, 1989/90, pp. 40–44.

[21] Story recounted by Henry Trimmer, Joshua Kirby's grandson, in Walter Thornbury, *The Life of J. M. W. Turner RA*, 1897 edn, p. 247.

[22] It is now, repaired, in Tate Britain, London.

[23] Thicknesse, p. 13.

[24] *General Magazine and Impartial Review*, Jan. 1789, p. 25.

[25] Thicknesse, p. 15.

[26] Private collection.

[27] National Portrait Gallery, London.

[28] *Town and Country Mag., 1772.*

18. The painter daughter's, a butterfly, their cat, and a sad little girl

[1] National Gallery, London.

[2] *FD*, Tues. 5 Feb. 1799, vol. 4, p. 1152. Trimmer: Thornbury, 1897 edn, p. 249; Whitley Papers, Gainsborough material 1799–1914, Whitley's note of a meeting with Reginald Lane Poole in Oxford in 1914. Lane Poole, a distinguished curator at the Ashmolean, was Gainsborough's great-great-great nephew.

[3] Letters TG to James Unwin, such as 24 July 1763. Hayes, no. 9.

[4] Tyler, 'Daughters'.

[5] Advertised in the *London Gazette*, 13 Dec. 1715. By the 1750s *The Wharton Sisters* was at Houghton House in Robert Walpole's collection. Katharine Eustace has made this apt suggestion to me.

[6] National Gallery, London.

[7] Franz Xaver Winterhalter, *Queen Victoria*, 1843. Royal Collection.

[8] Ashmolean Museum, Oxford.

[9] W. H. Pyne, *Somerset House Gazette*, 7 Aug. 1824. Quoted Belsey,
 Gainsborough's Family, p. 87.

[10] Their starting date at Blacklands is indicated in TG's letter to James Unwin,
 21 Jan. 1765, Hayes, no. 18.

[11] *FD*, 29 Jan. 1799, vol. 4, p. 1149.

[12] Worcester Art Museum, MA.

[13] Letter TG to James Unwin, 1 March 1764. Hayes, no. 13.

19. Freedom is the only manner

[1] National Galleries of Scotland.

[2] British Art Center, Yale.

[3] BM, P&D, 200.C5. Gainsborough's drawings were bound after their
 accession into the BM with others by John Hoppner and John Jackson. Some
 have subsequently been removed from the volume and mounted.

[4] The drawing at p. 16(a) shows a large house with two towers nearby or
 integral. This may be a place Gainsborough knew.

[5] A 'stump' is a tight roll of paper tapered to a point, used to smudge chalk or
 charcoal to create gradations of tone.

[6] Accession no. Oo,2.4.

[7] No. 31535.

[8] *Cornard Wood* study: No. 31555; possible study of Holywells Park: No. 31544.

[9] Tate Britain, London.

[10] Thicknesse, pp. 44–5.

[11] *View near King's Bromley-on-Trent, Staffordshire.* Richard Dorment, *British
 Painting in the Philadelphia Museum of Art: From the Seventeenth through the
 Nineteenth Century* Pennsylvania Press 1986, pp. 116–18. Gainsborough's trip
 to north Devon is referred to in a letter from Uvedale Price to Sir George
 Beaumont, 17 Sept. 1816. Charles Watkins and Ben Cowell (eds), 'Mr Price
 the Picturesque', introduction to 'Letters of Uvedale Price', *Walpole Society*,
 vol. 68, 2006.

[12] 200.C5, O.o.2-32 to -38.

[13] Letter TG to the Hon. Constantine Phipps, nd [1771 or 1772]. Hayes, no. 55.

[14] Thomas Page, Jnr, *The Art of Painting*, 1720, p. 91. 'Masticot', or massicot, is
 white lead calcined by fire that can either be a white or yellow pigment.

[15] This is probably the painting exhibited at the Society of Artists, 1766, as 'A
 large landscape with figures'. Private collection.

[16] Barber Institute of Fine Arts, University of Birmingham.

[17] Now in the Courtauld Institute.

[18] Rubens' original is in Antwerp Cathedral; Gainsborough's version is in
 GHS.

[19] *GHR*, 'Jackson', p. 64.

[20] Tate Britain, London.

[21] Worcester Art Museum, MA.

[22] Thomas Gray, *Elegy Written in a Country Churchyard*, 1751.

20. I pant for Grosvenorshire

[1] Tyler, 'Births, marriages, and deaths'.

[2] http://digital.library.upenn.edu/women/fiennes/saddle/saddle.html.

[3] *Town and Country Mag.*, 1772.

[4] *Bath and Bristol Guide*, p. 25.

[5] *FD*, 10 Nov. 1807, vol. 8, p. 3138.

[6] *BBJ*, 9 Oct. 1758. Sloman, *Bath*, pp. 36ff.

[7] Whitehead's arrival noted *BBJ*, 20 Nov. 1758. His play *The Roman Father* had been performed in Bath in 1754, and his *School for Lovers* would be performed in 1763. Arnold Hare (ed.), *Theatre Royal Bath: The Orchard Street Calendar, 1750–1805*, Kingsmead Press, 1977. It became the Theatre Royal in 1768.

[8] Letter William Whitehead to Viscount Nuneham, 9 Dec. 1760. Harcourt 3844, f. 65v.

[9] Arrivals reported in the 1758 *BBJ*: 30 Oct.: the Howes; 6 Nov.: Col. Honywood [here spelt 'Honeywood']; 4 Dec.: the Dorsets; 11 Dec.: Sir William St Quintin and Miss St Quintin.

[10] Arrivals reported in the 1758 *BBJ*: 25 Nov.: the Muilmans; 18 Dec.: the Woollastons; 23 Dec.: the Rustats. 'Mr Barry' arrived on 4 Sept., and this may have been Gainsborough's friend Lambe.

[11] *BBJ*, 10 Nov. and 4 Dec. 1758.

[12] Letter William Whitehead to Viscount Nuneham, 16 Nov. 1758. Harcourt 3844, f. 28.

[13] Letter William Whitehead to Viscount Nuneham, 6 Dec. 1758. Harcourt 3844, f. 30r. & v. Hayes, p. 12; Sloman, *Bath*, p. 38.

[14] Sloman, *Bath*, Appendix I.

[15] The practice ceased in 1786. *St James's Chronicle*, 5–7 Dec. 1786.

[16] Thicknesse, pp. 16–17. Lee portraits receipt for 8 guineas dated 19 April 1759, National Gallery Archive.

[17] *Town and Country Mag.*, 1772. See also Michael Rosenthal, 'Testing the Water: Gainsborough in Bath in 1758', *Apollo*, vol. 142, no. 403, Sept. 1995, pp. 49–54.

[18] GHA, 2001.021.

[19] Such as *The Rural Lovers / Les Amans Champêtres*, 1760. Proof in BM, 1872.1.13.852.

[20] *Ipswich Journal*, 20 Oct. 1759. See also Whitley, p. 22.

[21] Thicknesse, p. 15.

[22] There appears to be no note of their arrival in 1759 issues of *BBJ*.

[23] Sloman, *Bath*, p. 49.

[24] *Bath and Bristol Guide*, 3rd edn, [1755], p. 13.

[25] Advertisement announcing Mary Gibbon's move to Bath in *Ipswich Journal*, 6 April 1762. Sloman, 'Lodging house'.

[26] Bath Council Minutes, 28 Dec. 1761. BRO.

[27] Sloman 'Lodging house', p. 23 and note. 8.

[28] 'From the Publick Baths' is inscribed on the 'Elevation and ground plan of Gainsborough's house, Abbey Street', attributed to John Wood the Elder, c.1745, RIBA Library. Sloman, *op. cit.*

[29] Memorandum in Gainsborough's hand on the reverse of the signed lease on the property. I have amended it only with modern spellings and punctuation. BL Egerton Charter 6060. Quoted Sloman, 'Lodging house'. See also Susan Sloman, 'Artists' picture rooms in eighteenth-century Bath', *Bath History*, vol. 6, 1996, pp. 133–54.

[30] Anon. [Philip Thicknesse], *New Prose Bath Guide for 1778*, 1778, p. 49.

[31] Thicknesse, p. 19.

[32] 'and in that state it hangs up in my house at this day', Thicknesse, p. 17.

[33] Letter TG to William Mayhew, 13 March 1758. Hayes, no. 5.

[34] Cunningham, p. 324.

21. That fluctuating city

[1] Anstey, Letter II.

[2] 'A Tour from London with Mr Muilman', 19 April 1735, from 'Notes on journeys made in France and England', Journals of Richard Chiswell the Younger, Bodley, MS Don. D. 194, ff. 9–10.

[3] Letter Lord Royston to Lord Hardwicke, Bath, April 4 1763. Hardwicke 35352, f. 321

[4] George Augustus Walpole, *The New British Traveller*, 1784, p. 365.

[5] John Loadman and Francis James, *The Hancocks of Marlborough: Rubber, Art and the Industrial Revolution*, OUP, 2009, p. 3.

[6] Bath Council Minutes, 24 Jan. 1757. BRO.

[7] Letter Whitehead to Nuneham, 25 Dec. 1759. Harcourt 3844, f. 52.

[8] Letter Whitehead to Nuneham, 13 Dec. 1766. Harcourt 3844, f. 162r.

[9] Letter Whitehead to Nuneham, 21 Dec. 1766. Harcourt 3844, f. 165r.

[10] Letter Whitehead to Nuneham, 27 April 1767. Harcourt 3845, f. 3v.

[11] Letter Whitehead to Nuneham, 7 Feb. 1768. Harcourt 3845, f. 23.

[12] Tobias Smollett, *The Expedition of Humphry Clinker*, 1771, Penguin edition, ed. Shaun Regan, 2008, p. 43. Smollett puts his observations in the words of his character Matthew Bramble.

[13] Letter TG to Richard Stevens, 13 Sept. 1767. Hayes, no. 27. The 'certain Ditch' will be either of the London rivers, Fleet or Thames.

[14] Tobias Smollett, *op. cit.*, pp. 57–8.

[15] The surviving Bath City Council minute books and a typed abstract are in the BRO.

[16] *Bath and Bristol Guide*, p. 20.

[17] *Ibid.*, p. 21.

[18] *Ibid.*, p. 14.

[19] Letter Whitehead to Nuneham, 27 April 1767. Harcourt 3845, f. 3v.

[20] Anstey, Letter V.

21 Letter Whitehead to Nuneham, 13 Dec. 1766. Harcourt 3844, f. 163.

22 *Ibid.*, f. 162v.

23 Letter Whitehead to Nuneham, 28 March 1769. Harcourt 3845, f. 49.

24 *The New Bath Guide.* The copy in GHA, inscribed 'Doro: Richardson 1770'. Dorothy Richardson's notes, from which this is transcribed, are written into a gathering at the end of the volume.

25 Susan Sloman, 'The Holloway Gainsborough: Its subject re-examined', *GHR*, 1997/8, pp. 47–54.

26 Anstey, Letter II.

27 *New Bath Guide.*

28 Bath Council Minutes, 7 April 1760. BRO.

29 James Beresford (ed.), *The Diary of a Country Parson: The Rev'd James Woodforde (1740–1803)*, 1924, vol. 1, p. 104. Quoted Hugh Belsey, *The Moysey Family*, Gainsborough's House, 1984.

30 *ODNB*, Ralph Schomberg.

31 Letter William Jones to Lady Spencer, Bath, 30 Dec. 1777. G. Cannon (ed.), *The Letters of Sir William Jones*, Oxford, 1970, vol. 1, pp. 256–7 . Barbara Brandon Schnorrenberg, 'Medical men of Bath', *Studies in Eighteenth-Century Culture, Proceedings of the American Society for Eighteenth-Century Studies*, vol. XIII, 1984, pp. 189–203.

32 Thicknesse, *Bath Guide*, pp. 28–9.

33 Tobias Smollett, *op. cit.*, p. 42.

34 Sir William Forbes, *An Account on the Life and Writings of James Beattie LL.D*, 1807, vol. 3, p. 114.

35 Letter Lord Royston to the Earl of Hardwicke, 11 April 1763. Hardwicke 35352, f. 327.

36 The one-guinea consultation fee is as reported by the Rev. James Woodforde, in James Beresford (ed.), *op. cit.*

37 Letter Lord Royston to the Earl of Hardwicke, 5 May 1763. Hardwicke 35352, f. 344.

38 Letter TG to Lord Royston, 21 July 1763. Hardwicke 35350, ff. 9–10. Hayes, no. 7.

39 Alexander Stephens, 'Mrs Thicknesse', *Public Characters*, 1806, vol. 8, p. 88. The best-known tune for 'All ye that pass by' is not Ann Ford's but 'Wareham', composed by William Knapp (1698–1768).

40 Letter Whitehead to Nuneham, 16 Nov. 1758. Harcourt 3844, f 28.

41 Letter Whitehead to Nuneham, 6 Dec. 1758. Harcourt 3844, f. 30.

42 Letter Whitehead to Nuneham, 16 Dec. 1758. Harcourt 3844, f. 32v.

43 *Ibid.*

44 Letter Whitehead to Nuneham, 9 Dec. 1760. Harcourt 3844, f. 66.

22. The nature of my damn'd business

1 TG's obituary, *Gents Mag.*, vol. 58, Aug. 1788, p. 755. Busts of Rousseau and Voltaire owned by Gainsborough were sold at Christie's, 11 May 1799, lot 79.

2 André Rouquet, *L'Etat des Arts en Angleterre*, Paris and London, 1755. Quoted

Mark Hallett, *Reynolds: Portraiture in Action*, Yale University Press 2014, p. 30.

3 Evelyn Newby, 'The Hoares of Bath', *Bath History*, vol. 1, 1986, pp. 90–127. See also http://www.paul-mellon-centre.ac.uk/collections/evelyn-newby.

4 Royal United Hospitals, Bath.

5 Vertue, vol. 22, p. 152.

6 *Ibid.*, p. 149.

7 Evelyn Newby, *op. cit.*

8 Now in the V&A, A.3&A-1965.

9 *Sigismunda*: Coll. Tate Britain; *The Lady's Last Stake*: Coll. Albright-Knox Art Gallery, Buffalo, NY.

10 *Ann Ford*: Coll: Cincinnati Art Museum, OH.

11 See Michael Rosenthal, 'Thomas Gainsborough's *Ann Ford*', *Art Bulletin*, Dec. 1998, vol. 80, no. 4, pp. 649–65.

12 Letter Mrs Delany to Mrs Dewes, 23 Oct. 1760. Lady Llanover (ed.) *The Autobiography and Correspondence of Mary Granville, Mrs Delany*, vol. 3, p. 605.

13 Waterhouse, no. 716.

14 Letter TG to James Unwin, 1 March 1764. Hayes no. 13.

15 *Gents Mag.*, vol. 31, Jan. 1761, pp. 33–4, and Feb. 1761, pp. 79–80.

16 Letter William Warburton to Charles Yorke, 18 Oct. 1762. *Letters from the Reverend Dr Warburton . . . to the Hon. Charles Yorke from 1752 to 1770*, Philanthropic Society, 1812. Dyce Collection, 10,408. NAL, V&A.

17 Letter David Garrick to James Quin, 20 June 1763. Garrick, *Letters*, vol. 1, no. 306.

18 Letter TG to Henry Townsend, 22 April 1762. Hayes, no. 6. See also note at p. 14.

19 Letter TG to David Garrick, nd, perhaps late 1760s, early 1770s. Hayes, no. 50.

20 Belsey, *Love's Prospect*, cat. 7.

21 *Ibid.*, p. 20.

22 Letter Margaret Penrose, 18 April 1766. Brigitte Mitchell and Hubert Penrose (eds), *Letters from Bath 1766–1767, by the Rev. John Penrose*, A. Sutton, 1983, pp. 40–41. Quoted Belsey, *Love's Prospect*, pp. 20–21.

23 The frame is labelled 'Rebecca St Quintin', but Rebecca had died unmarried in 1758. In the *BBJ* announcement of the St Quintins arrival on 11 Dec. 1758 the daughter is listed as 'Miss St Quintin', which Mary would have become after her elder sister's death. Before that death, as a younger daughter, she would have been 'Miss Mary St Quintin'. I am grateful to Sir Charles Legard for insight into his family tree.

24 Letter George Lucy to Philippa Hayes, 23 Feb. 1760. Warwickshire PRO L 6/1454. Quoted Susan Sloman, 'Sitting to Gainsborough in Bath in 1760', *Burl. Mag.*, vol. 139, no. 1130, May 1997, pp. 325–8.

25 Letter Hardwicke to Royston, 9 April 1763. Hardwicke 35352, f. 326.

26 Letter Royston to Hardwicke, 8 May 1763 [as a PS]. Hardwicke 35352, f. 347.

[27] Letter TG to Lord Royston, 21 July 1763. Hardwicke 35350, ff. 9–10. Hayes, no. 7.

[28] *ODNB*, Jemima Yorke.

[29] Letter TG to 2nd Earl Hardwicke, date unknown, but after March 1764. Hardwicke 35350, f. 11. Hayes, no. 15.

[30] Letter TG to William Jackson, 2 Sept. 1767. Hayes, no. 23.

23. The foolish act

[1] A short word at the edge of the sheet was crossed out in curly line by TG at time of writing, and further irretrievably obscured later.

[2] Letter TG to James Unwin, 24 July 1763. BL Add MS 48964, ff. 7–8. Hayes, no. 9.

[3] Hayes interprets this as quinine, found in cinchona bark, and magnesium. Note to letter TG to Unwin, 15 Sept. 1763. Hayes no. 10.

[4] Letter TG to James Unwin, 1 March 1764. Hayes no. 13.

[5] Note of Sir William St Quintin's arrival in Bath: *BBJ*, 24 Oct. 1764.

[6] *BBJ*, 24 Oct. 1763.

[7] Letter TG to James Unwin, 25 Oct. 1763. Hayes, no. 11.

[8] Letter TG to James Unwin, 30 Dec. 1763. Hayes, no. 12.

[9] Tobias Smollett, *The Expedition of Humphry Clinker*, 1771, Penguin edn, ed. Shaun Regan, 2008, p. 43.

[10] Anstey, Letter III.

[11] Sloman, *Bath*, p. 53.

[12] My thanks to Carol and Richard Waterfall.

[13] Signed 11 March 1765. RA Archive ref. Hayes, nos 17 and 18.

[14] 'Biographical Sketches of Eminent Contemporary Writers', *The World*, 4 Sept. 1790. I am grateful to Susan Sloman for the identification of its author.

[15] *Fraser's Mag.*

[16] *Ibid.*

[17] James Boswell, *The Life of Samuel Johnson*, Folio Society edn, 1968, vol. 1, p. 100.

[18] *Fraser's Mag.*

[19] *Wine and Walnuts*, vol. 2, p. 235.

[20] Cunningham, p. 340.

[21] *Wine and Walnuts*, vol. 2., pp. 183–4.

[22] *Ibid.*, p. 215.

[23] Letter William Mostyn to 4th Duke of Beaufort, 11 Jan. 1764. Badminton Muniments, Fm L 4/4/4.

[24] Letter TG to William Jackson, 11 May 1768. Hayes, no. 30; letter to Jackson, 9 June 1770. Hayes, no. 45; letter to Lord Dartmouth implying that he might be able to be in London, 13 April 1771. Hayes, no. 53.

[25] Letter TG to the Hon. Constantine Phipps, 28 May 1772. Hayes, no. 61.

[26] Letter TG to Cipriani, 14 Feb. 1774. Hayes, no. 72.

[27] 13 June 1773. Annie Raine Ellis (ed.), *The Early Diary of Frances Burney*, 1889, vol. 1, p. 213.

[28] *ODNB*, Jemima Yorke, née Campbell.

29 Letter TG to James Unwin, 25 May 1768. Hayes, no. 31.

30 Letter TG to James Unwin, 1 March 1764. Hayes, no. 13. The long word crossed out heavily here appears to end in 'ally'. BL Add MS 48964, ff. 11–12. Hayes, no. 13.

24. Zouns, I forgot Mrs Unwin's picture

1 Letter TG to James Unwin, 10 July [1764]. Hayes, no. 14.

2 Letter TG to James Unwin, 30 Dec. 1763. Hayes, no. 12.

3 Letter TG to James Unwin, 1 March 1764. Hayes, no. 13.

4 Prices evolved from Sloman, *Bath*, Appendix III.

5 Letter TG to James Unwin, 21 Jan. 1765. Hayes, no. 18.

6 Letter TG to James Unwin, 10 July 1770. Hayes, no. 46.

7 Letter TG to James Unwin, 7 Nov. 1765. Hayes, no. 20.

8 Thomas Underwood, 'A Poetic Epistle, Address'd to Mr Gainsborough, Painter at Bath, in which the author reminds him of his promise made in April last to present him with a whole length picture'. Published by subscription in Bath in 1768 in *Satyric Poems, Epigrams, Poetic Epistles &c.*

9 Letter TG to David Garrick, nd [?1771]. Hayes, no. 51.

10 A lively account of this turbulent period is Charles Saumarez Smith, *The Company of Artists: The Origins of the Royal Academy of Arts in London*, Modern Art Press, 2012.

11 'Memoirs of Thomas Jones', *Walpole Society*, vol. 32, 1946–8, p. 14.

12 Letter Joshua Kirby to William Kirby, 22 Nov. 1760. John Freeman, *Life of Rev. William Kirby MA of Barham*, 1852, p. 10. The year of the letter is given erroneously as 1768. The Rev. William Kirby of the title was Joshua Kirby's nephew.

13 Letter TG to Joshua Kirby, 5 Dec. 1768. Hayes, no. 37.

14 James Hamilton, *London Lights: The Minds that Moved the City that Shook the World*, John Murray, 2007.

15 Walker Art Gallery, Liverpool, and Cleveland Museum of Art respectively. For the reference to George Pitt's character, see chapter 27.

16 Private collection, on loan to GH.

17 Which one is unknown.

18 Note in RA exhn cat. Algernon Graves, *The Royal Academy of Arts, A Complete Dictionary of Contributors . . . 1769–1904*, 1905, vol. 3, p. 191.

19 14 Oct. 1771. Furnishing at Assembly Rooms. MS 1413, 0028A/5. BRO. Letter TG to William Jackson, 8 July 1779. Hayes, no. 84.

20 19 March 1771. Assembly Rooms: Journal of the Proceedings of the Subscribers 1769 to 1772. MS 1415. BRO.

21 *Subscribers to the New Rooms*, printed list, nd. BRO.

22 16 May to 12 Aug. 1771. Furnishing at Assembly Rooms. MS 1413, 0028A/5. BRO.

23 24 and 31 Oct. 1771. BRO, *loc. cit.*

24 Letter John Palmer to David Garrick, 1771 [late October]. Quoted Whitley, pp. 79–80.

[25] Algernon Graves, *loc. cit.*

[26] The indenture document, dated 14 Jan. 1772, is in GHA.

[27] Letter TG to William Pulteney, nd [prob. early April] 1772. Hayes, no. 58.

[28] Bath Council Minutes, Feb. 1768, Jan. 1769 and Feb. 1774.

[29] *Public Advertiser*, 4 May 1772.

[30] *Middlesex Journal*, 23–6 April, 1772 p. 4.

[31] *Westminster Magazine*, May 1772. Quoted in Whitley, p. 87.

[32] Barber Institute of Fine Arts, University of Birmingham.

[33] Letter TG to Edward Stratford, 1 May 1772. Hayes, no. 59.

[34] *The Portraits of the Academicians of the Royal Academy*, Royal Collection.

[35] Letter TG to the Hon. Constantine Phipps, 13 Feb. 1772. Hayes, no. 56.

[36] For a full analysis of *The Portraits of the Academicians of the Royal Academy*, see Mary Webster, *Johan Zoffany 1733–1810*, Yale University Press, 2011, pp. 252–61.

[37] Two of them are included as portraits framed on the wall behind – Mary Moser and Angelica Kauffman. As women they were not expected to be in the presence of a naked male model.

[38] Legal agreement set out in Sloman, 'Prince's daughter'.

[39] Quoted Whitley, p. 95.

[40] Letter TG to James Unwin, 25 May 1764. Hayes, no. 31.

25. In the painting room

[1] RA Archive, Humphry Papers, HU/1/20–40. Humphry was in Bath *c.*1762–4. Quoted Sloman, *Bath*, pp. 56–7.

[2] Angelo, 1823, p. 218.

[3] Smith, *Nollekens* vol. 2, p. 151. Cunningham, p. 339.

[4] *Mary Carr*: British Art Center, Yale; *Harriet Tracy*: GHS; *Mrs Henry Portman*: Portman Settled Estates.

[5] Cunningham, p. 340.

[6] *Robert Nugent*: Holburne Museum, Bath; *Thomas Haviland*: National Museum, Stockholm.

[7] Neue Pinakothek, Munich.

[8] *ODNB*, Uvedale Price.

[9] Letter Anne Price to her aunt Lady Anne Coventry, 18 June [1714], Somerset Family Papers. Badminton Muniments, Fm T/B 1/2/23. Discovered by Susan Sloman, and first published in Sloman, *Bath*, p.149. See also Charles Watkins and Ben Cowell (eds), 'Mr Price the Picturesque', introduction to 'Letters of Uvedale Price', *Walpole Society*, vol. 68, 2006, Preface, pp. 5–77.

[10] Beryl Hartley, 'Naturalism and Sketching, Robert Price at Foxley and on tour', essay in Stephen Daniels and Charles Watkins (eds), *The Picturesque Landscape: Visions of Georgian Herefordshire*, University of Nottingham, 1994.

[11] A family tree showing the links between the Somersets and the Prices is in Sloman, *Bath*, p. 147.

[12] Lost letters from Gainsborough: see Charles Watkins and Ben Cowell (eds), *op. cit.*, pp. 254 and 257.

[13] Angelo, 1823, pp. 218–19

[14] Letter TG to James Dodsley, 10 Nov. 1767. Hayes, no. 25.

[15] Letter TG to James Dodsley, 26 Nov. 1767. Hayes, no. 26.

[16] 'An Amateur of Painting' [W. H. Pyne], *Somerset House Gazette*, vol. I, 1824, p. 348.

[17] Angelo, 1823, pp. 220–21.

[18] Letter TG to Richard Stevens, 13 Sept. 1767. Hayes, no. 27.

[19] Letter TG to Richard Stevens, 2 Oct. 1767. Hayes, no. 28.

[20] http://www.npg.org.uk/research/programmes/the-art-of-the-picture-frame/artist-gainsborough.php; Sloman *Bath*, Appendix II.

[21] *ODNB*, Walter Wiltshire.

[22] British Art Center, Yale.

[23] Private collection.

[24] GHS.

[25] Coll. Trustees of the Portman Settled Estates.

[26] 21 Aug. 1762: £32; 25 Feb. 1763: £20; 5 Mar. 1763: £10; 2 Dec. 1763: £30; 29 July 1766: £30; 14 May 1768: £20; 30 Sept. 1768: £10; 1 Oct. 1768: £45; 2 Nov. 1768: £25; 10 Feb. 1774: £50; 8 Mar. 1774: £50. See Sloman, *Bath*, Appendix II. Lot 113 in the 11 May 1799 sale of Gainsborough's effects reads: 'Walpole on Painting [vols] 1 and 2 – Dresses 2, and 11 more.'

[27] Lansdown Road let: *Bath Journal*, 16 March and . . . Sept. 1767. See also Sloman 'Lodging house'.

[28] My thanks to Prof. Iann Barron.

[29] Letter TG to Rev. Dr William Dodd, 24 Nov. 1773. Hayes, no. 71.

[30] My thanks to Philip Fletcher.

[31] Formerly Montreal Museum of Fine Arts, stolen 1972. Hugh Belsey, 'A visit to the studios of Gainsborough and Hoare', *Burl. Mag.*, vol. 129, no. 1007, Feb. 1987, pp. 107–109.

[32] Dorothy Richardson's annotated copy of *New Bath Guide*, GHA.

[33] Private collection.

26. At Wilton

[1] Letter TG to William Jackson, 2 Sept. [year unknown]. Hayes, no. 39.

[2] *ODNB*, Henry Herbert, 10th Earl of Pembroke, quoting S. Herbert, ed., *Pembroke Papers, Letters and Diaries of Henry 10th Earl of Pembroke and His Circle*, Jonathan Cape, 1939–50, vol. 2, p. 260.

[3] Henry Herbert, Earl of Pembroke, *A Method of Breaking Horses, and Teaching Soldiers to Ride. Designed for the Use of the Army, and Others*, 1761, p. 6.

[4] Journal of Richard Chiswell the Younger, Bodleian Library, MS Don. D. 194.

[5] Letter TG to Unwin, 10 July [1764]. BL Add MS 48964, ff. 13–14. Hayes, no 14.

[6] John and Mabel Ringling Museum, Sarasota, FL.

[7] National Gallery. During Gainsborough's lifetime this was at Blenheim Palace, owned by the Duke of Marlborough.

[8] Dandridge's equestrian portraits were usually about three feet high, not ten. Examples in the National Portrait Gallery and the National Army Museum. *General Sir Philip Honywood* was published as a mezzotint by James Macardell in 1751.

[9] GHA.

27. The continual hurry of one fool upon the back of another

[1] Anstey, Letter IX.

[2] Letter George Lucy to Philippa Hayes, 12 April 1760. Warwickshire PRO, l/1463. Quoted Susan Sloman, 'Sitting to Gainsborough in Bath in 1760', *Burl. Mag.*, vol. 139, no. 1130, May 1997, pp. 325–8.

[3] *ODNB*, Richard Howe; Anne French (ed.), *The Earl and Countess Howe by Gainsborough: A bicentenary exhibition*, Kenwood House, 1988. For Mary Howe see also Julius Bryant, *Kenwood: Paintings in the Iveagh Bequest*, 2003, English Heritage, pp. 184ff.

[4] Thomas Page, Jnr, *The Art of Painting*, 1720, ch. 11, pp. 75ff.

[5] *BBJ*, 30 Oct. 1758.

[6] Private collection.

[7] BM, P&D, 1855-7-14-70; Ashmolean, WA 1959.9.

[8] BM, P&D, 1960-11-10-1.

[9] *Portrait of Ignatius Sancho*, National Gallery of Canada, Ottawa. Inscription by William Stevenson, gives the date of the sitting as 29 Nov. 1768. Reyahn King, *Ignatius Sancho: An African Man of Letters*, National Portrait Gallery, 1997, p. 17.

[10] Vincent Caretta (ed.), *Letters of the Late Ignatius Sancho, an African*, 1782. Penguin edn, 1998, Introduction.

[11] Sujata Iyengar, 'White Faces, Blackface: The Production of "Race" in *Othello*', essay in Philip C. Kolin (ed.), *Othello: New Critical Essays*, Routledge, 2002, p. 106.

[12] Letter TG to Lord Dartmouth, 8 April 1771. Hayes, no. 52.

[13] PS to letter TG to Lord Dartmouth, 13 April 1771. Hayes no. 53.

[14] Letter TG to Lord Dartmouth 18 April 1771. Hayes, no. 54.

[15] Private collection.

[16] 1781. Quoted http://www.historyofparliamentonline.org/volume/1754-1790/member/pitt-george-1721-1803.

[17] Letter 22 Dec. 1772. *Horace Walpole's Correspondence with Sir Horace Mann*, Yale University Press, 1937–83, vol. 23, p. 451.

[18] George Hobart to Andrew Mitchell, 24 June 1763. BL Add MS 6860, f. 366. http://www.historyofparliamentonline.org/volume/1754-1790/member/pitt-george-1721-1803.

[19] George Pitt to Lord North, 3 Jan. 1773. http://www.historyofparliamentonline.org/volume/1754-1790/member/pitt-george-1721-1803.

[20] Letters TG to William Jackson, 9 June 1770, and to James Unwin, 10 July 1770. Hayes, nos 45 and 46.

[21] Robert Baker, *Observations on the Pictures now in the Exhibition*, 1771.

[22] *Memoirs of the Life and Writings of Victor Alfieri*, 1810, vol. 1, p. 204.

[23] Letter TG to James Unwin, 10 July 1770. Hayes, no. 46.

[24] Letter TG to the Hon. Constantine Phipps, 13 Feb. 1772. Hayes, no. 56.

28. Friendship

[1] Garrick's plays in Bath included *Lethe*, *The Lying Valet* and *Miss in her Teens*. Arnold Hare (ed.), *Theatre Royal, Bath: The Orchard Street Calendar, 1750–1805*, Kingsmead Press, 1977.

[2] David Garrick to Hannah More, 4 May 1775. Garrick, *Letters*, vol. 3, no. 907.

[3] Letter TG to David Garrick, 27 July 1768. Hayes, no. 34

[4] Letters TG to David Garrick, 27 July and 22 Aug. 1768. Hayes, nos. 34 and 36. See also Martin Postle, 'Gainsborough's "lost" picture of Shakespeare', *Apollo*, vol. 134, no. 358, Dec. 1991, pp. 374–9.

[5] Probably the Chandos Portrait, National Portrait Gallery, London.

[6] Letter TG to David Garrick, 22 June 1772. Hayes, no. 62.

[7] *European Magazine*, Aug. 1788, pp. 118–23.

[8] Thicknesse, p. 54.

[9] Letter TG to David Garrick, 1 April [1773]. Hayes, no. 66. The original is lost, and Hayes's transcription is partial.

[10] Here, 'minute' as in 'very small indeed', *my-newt*; not 'minute' as in 'time', *minnit*.

[11] Letter TG to John Henderson, 27 June 1773. Hayes, no. 68.

[12] Private collection.

[13] National Gallery of Ireland, Dublin. NGI 565.

[14] Letter TG to David Garrick, 22 June 1772. Hayes, no. 62.

[15] Letter TG to David Garrick, nd [1772]. Hayes, no. 63.

[16] Letter TG to David Garrick, nd [1772]. Hayes, no. 63.

[17] Dulwich Picture Gallery, London.

[18] *ODNB*, William Jackson. *GHR*, 'Jackson': the entire issue is given over to Jackson material.

[19] Letter TG to William Jackson, 23 Aug. [1767]. Hayes, no. 22.

[20] *Ibid.*

[21] Letter TG to William Jackson, 2 Sept. 1767. Hayes, no. 23.

[22] Letter TG to William Jackson, 14 Sept. [1767]. Hayes, no. 24.

[23] Letter TG to William Jackson, nd. Hayes, no. 38.

[24] Hayes reads this as 'tried'. To my eye, from the original in the RA Archive, it is clearly 'time'. Letter TG to William Jackson, 11 May 1768. Hayes, no. 30.

[25] Letter TG to the 4th Duke of Bedford, 29 May 1768. Hayes, no. 32.

[26] Letter TG to William Jackson, 29 May [1768]. Hayes, no. 33.

[27] Letter TG to William Jackson, 2 Sept., ny [not before 1765. See *ODNB*, Dunning]. Hayes, no. 39.

[28] Hayes reads 'juts' here. It is to my eye clearly 'jets'.

[29] *GHR*, 'Jackson', p. 19.

[30] Coleridge to Southey, 15 Oct. 1799. *Samuel Taylor Coleridge Collected Letters*, 1956, vol. 1, p. 539. Quoted *GHR*, 'Jackson', p. 42.

[31] Letter TG to the 4th Duke of Bedford, 29 May 1768. Hayes, no. 32.

[32] *Ibid.*

[33] *GHR*, 'Jackson', p. 60.

[34] Letter TG to William Jackson, 4 June, ny [?1765]. Hayes, no. 40.

[35] Hayes tentatively identifies 'Miss Floud' as a daughter of Alderman Flood of Exeter, possibly Elizabeth Flood.

[36] Hayes points out that the Jayes had been violin-makers in Southwark since the early seventeenth century, and Barak Norman made stringed instruments from the Restoration, mid to late seventeenth century. Gainsborough's remaining musical instruments were sold at Christie's, 11 May 1799, lots 114–8.

[37] *Fraser's Mag.* suggests he preferred running his hands over his instruments to playing them.

[38] Probably Gainsborough Dupont.

[39] Letter TG to William Jackson, 29 Jan. 1771. Hayes, no. 64.

[40] An example is Ashmolean, WA 1948.108.

[41] Letter TG to the Hon. Constantine Phipps, 1771 or 1772? Hayes, no. 55.

[42] Letter TG to the Hon. Constantine Phipps, 31 March 1772. Hayes, no. 57.

[43] Letter TG to the Hon. Constantine Phipps, 28 May 1772. Hayes, no. 61.

29. A little flirtation with the fiddle

[1] https://www.oldbaileyonline.org/browse.jsp?id=t17750712-25&div=t17750712-25&terms=gainsborough#highlight. Whitley, pp. 117ff.; Bow Street Court reports, London Metropolitan Archives. I am grateful to Julian Hall for insight into this case.

[2] Letter TG to Edward Stratford, 21 March 1771. Hayes, no. 49.

[3] The Kirby gravestone records Sarah's death as August 1775. The space for the day appears uncut, but may read '5'. I am grateful to Michael Snodin for his observation.

[4] Account of TG by William Jackson, 1790s. RA Archive, GAI/14. William Jackson, *The Four Ages*, 1798. Published also in *Universal Magazine*, March 1798, pp. 155–8.

[5] Letter TG to William Jackson, prob. April 1770. Hayes, no. 43.

[6] I have adapted the not-so-funny cod-German accent that Jackson ascribes to Straub.

[7] Thicknesse, pp. 19–20.

[8] I am grateful to Hugh Belsey for this opinion.

[9] Robert Edge Pine. Portrait painter in London until 1784 when he left for Philadelphia.

[10] Thicknesse, p. 31.

[11] Thicknesse, pp. 42–3.

[12] Letter John Warren to Andrew Caldwell, MP, 23 Nov. 1776. Philip McEvansoneya, 'An Irish artist goes to Bath: Letters from John Warren to Andrew Caldwell, 1776–1784', *Irish Architectural and Decorative Studies*, vol. 2, 1999, p. 165. Quoted Belsey, *Cottage Doors*, p. 25.

30. A source of much inquietude

[1] Letter TG to Richard Whatley, Steward to the Duke of Kingston, 22 June 1773. Hayes, no. 67.

[2] Sloman, 'Lodging house'.

[3] Letter TG to G. B. Cipriani, 14 Feb. 1779. Hayes, no. 72. 'Fiddle' in Dr Johnson's *Dictionary* is also defined as 'to trifle; to shift the hands often, and do nothing'.

[4] T. E. Jones (ed.), *The Auto-Biography of John Britton*, 1849, vol. 1, p. 225.

[5] Google Earth reveals a long building behind, aligned towards The Mall, and although this is new, it may nevertheless sit on the footplate of Gainsborough's painting room. http://www.british-history.ac.uk/survey-london/vols29-30/pt1/pp368-377#fnn48.

[6] Tate Britain, London.

[7] An upper floor was added to Gainsborough's extension in the nineteenth century. Schomberg House was gutted in the early twenty-first century, and only the façade remains intact.

[8] Pierre-Jean Grosley, *A Tour to London; or, New Observations on England and Its Inhabitants* [trans. Thomas Nugent], 2 vols, London, 1772, vol.1, pp. 35 and 42.

[9] *ODNB*, John Astley.

[10] Edwards, *Anecdotes*, pp. 124–6.

[11] *A History of the Works of Sir Joshua Reynolds PRA*, 1899, vol. 1, p. 36.

[12] Anthony Pasquin, *Memoirs of the Royal Academicians, and an Authentic History of the Artists of Ireland*, 1796.

[13] *Fraser's Mag.*

[14] *Public Advertiser*, 4 May 1772.

[15] Pierre-Jean Grosley, *op. cit.*, vol. 1, p. 33.

[16] *Ibid.*, p. 43.

[17] Thicknesse, p. 32.

[18] References to these come in letters in Hayes, nos 74, 79 and 80.

[19] *Horace Walpole's Correspondence*, Yale University Press, 1937–83, vol. 9, p. 28, n.19.

[20] Gainsborough appears to have owned a self-portrait by Liotard in black and white chalks. Sold at Christie's, 11 May 1799, lot 39.

[21] On inheriting a fortune from an uncle in 1780, Bate would assume his benefactor's surname, becoming Henry Bate Dudley.

[22] *Morning Chronicle*, 26 July 1773.

[23] *Morning Post*, 5 Aug 1788.

[24] Conversation with Mark Pomeroy has helped me to formulate these ideas.

[25] RA Archive, Council minutes, 30 Dec. 1775, p. 210.

[26] Samuel Johnson, *The Idler*, no. 45, 24 Feb. 1759. *The Works of Samuel Johnson, LL.D*, vol. 7, 1801, pp. 178–82.

[26] *FD*, 3 June 1802, vol. 5, p. 1784.

31. Humphrey, Scheming Jack and Mary Gibbon

[1] Letter TG to Mary Gibbon, 26 Dec. 1775. Hayes, no. 76.

[2] Anstey, Letter III.

[3] Thicknesse, p. 57.

[4] Belsey records three daughters only, and no sons. Belsey, *Gainsborough's Family*, table II.

[5] St Gregory's Church model: *Bury and Norwich Post*, 2 Oct. 1860; royal arms: Hodson, p. 49.

[6] Tyler, 'Humphrey Gainsborough'.

[7] Letter TG to Mary Gibbon, 26 Dec. 1775. Hayes, no. 76.

[8] Letter TG to the Secretary of the Royal Society of Arts, 11 Dec. 1775. Hayes, no. 75.

[9] Among them: *Landscape with Gipsies*, Tate Britain; and *Return from Shooting, after Teniers*, National Gallery of Ireland, Dublin.

[10] Letter TG to Mary Gibbon, 13 Nov. 1775. Hayes, no. 74.

[11] British Art Center, Yale.

[12] Letter TG to Mary Gibbon, 13 Nov. 1775. Hayes, no. 74.

[13] Letter TG to Mary Gibbon, 26 Dec. 1775. Hayes, no. 76.

[14] *Ibid.*

[15] *Fraser's Mag.*

[16] Letter TG to Mary Gibbon, 10 June 1776. Hayes, no. 77.

[17] Letter Humphrey Gainsborough to Matthew Boulton, 1 Aug. 1776. Boulton and Watt MSS, Birmingham Archives, MS 3219/6/113. Quoted *ODNB*, Humphrey Gainsborough.

[18] Private collection. Illustrated *Gainsborough* (exhn. cat.), Tate, 2002, p. 211.

[19] Letter John Wilkinson to Matthew Boulton, 12 Nov. 1776. Boulton & Watt Papers, box 20/2. Quoted Tyler, 'Humphrey Gainsborough'.

[20] Letter TG to Sarah Dupont, 29 Sept. 1783. Hayes, no. 93.

32. The Hon. Mrs Graham, and other good women

[1] National Gallery of Art, Washington, DC. There is conjecture that *The Housemaid* (Tate Britain, London) is an unfinished third portrait of Mary Graham in a 'fancy' manner.

[2] Thomas Page, *The Art of Painting*, 1720, ch. 2, pp. 10–11.

[3] National Galleries of Scotland, Edinburgh.

[4] *Morning Post*, 25 April 1777.

[5] Huntington Library and Art Gallery, San Marino, CA.

[6] National Gallery, London.

[7] Walpole's annotated catalogue of the 1777 RA exhibition. Quoted Hayes, *Landscape Paintings*, p. 467.

[8] Frick Collection, New York.

[9] Letter TG to William Jackson, 25 Jan. 1777. Hayes, no. 79: 'damn me' has been crossed out by another hand. The 'Inn' will be where the coach picked up its passengers and mail.

[10] *Ibid.*: 'wipe your Arse with' has been crossed out by another hand.

[11] *Mrs Elliott*, Metropolitan Museum of Art, New York; *Clara Heywood*, private collection; *Countess of Chesterfield* and *James Christie*, John Paul Getty Museum, Malibu, CA; *Philippe Jacques de Loutherbourg*, Dulwich Picture Gallery, London.

[12] *ODNB*, Grace Elliott

[13] *Morning Chronicle*, 25 May 1778.

[14] *OED*.

[15] Oliver Goldsmith, *The Citizen of the World; or, Letters from a Chinese Philosopher residing in London to His friends in the East*, 1762, Folio Society edn, 1969, letters III, p. 31; and LXXVIII, p. 237.

[16] Cunningham, p. 324; Sloman, 'Prince's daughter'. Margaret's use of the word 'prince' has caused a flutter in Gainsboroughland, with the conjecture that she was an illegitimate daughter of Frederick, Prince of Wales, and that the Duke of Beaufort nobly covered up for him. This is unlikely.

[17] National Gallery, London.

[18] Gemaldegalerie, Berlin.

[19] Courtauld Institute of Art, London.

[20] Letter TG to Mary Gibbon, 26 Dec. 1775. Hayes, no. 76.

[21] GHS.

33. Margaret, Molly, Peggy, and an unfeeling churl

[1] Letters TG to Mary Gibbon, 12 and 22 Sept. 1777. Hayes, nos 80 and 81.

[2] It entered the Cowdray Collection in Sussex in the 1920s. Sold Christie's, July 2011, for £6.5m.

[3] Letter TG to Mary Gibbon, 12 Sept. 1777. Hayes, no. 80.

[4] Letter TG to Mary Gibbon, 22 Sept. 1777. Hayes, no. 81: 'half pay' indicates that Gainsborough expected half of the commission to be paid at the start, and the balance paid on completion.

[5] Angelo, 1823, p. 350.

[6] Letters TG to Mary Gibbon, 13 Nov. 1775 and 12 Sept. 1777. Hayes, nos 74 and 80.

[7] Letter TG to Mary Gibbon, 22 Sept. 1777. Hayes, no. 81.

[8] Letter TG to Mary Gibbon, 12 Sept. 1777. Hayes, no. 80.

[9] Letter TG to Dr Rice Charlton, 24 June 1779. Hayes, no. 83.

[10] Letter TG to Mary Gibbon, 23 Feb. 1780. Hayes, no. 86.

[11] Angelo, 1830, p. 349.

[12] Letters TG to Mary Gibbon, 26 Dec. 1775 and 23 Feb. 1780. Hayes, nos 76 and 86.

[13] Martin Postle, 'Gainsborough's "lost" picture of Shakespeare', *Apollo*, vol. 134, no. 358, Dec. 1991, pp. 374–9.

[14] *Morning Post*, 4 May 1780.

[15] Letter TG to Mary Gibbon, 21 Oct. 1780. Hayes, no. 87.

[16] Conversation with Reginald Lane Poole, Oxford. Whitley Papers, Gainsborough material 1799–1914, p. 19.

[17] *Fraser's Mag.*

[18] *Ibid.*

[19] Angelo, 1823, p. 351.

[20] *Morning Chronicle*, 25 April 1777.

[21] *Public Advertiser*, 26 April 1777.

34. 'Hey, Gainsborough, hey!'

[1] Angelo, 1823, pp. 349 and 352.

[2] Angelo, 1828, p. 352.

[3] Angelo, 1823, p. 353.

[4] *Morning Chronicle*, 24 April 1775. It was in fact the Cumberlands. Belsey, *Cottage Doors*, p. 30.

[5] Letter Henry Crompton, royal page, to Thomas Lawrence, Sept. 1789. Quoted A. Cassandra Albinson, Peter Funnell and Lucy Peltz, *Thomas Lawrence: Regency Power and Brilliance*, exhn cat., National Portrait Gallery, 2010, p. 94.

[6] Caroline Lybbe-Powys Diaries, vol. 1, 25 March 1767. BL Add MS 42160, f. 20.

[7] *Ibid.* The present title of the Queen's House, Buckingham Palace, was not given to it until the 1820s.

[8] http://www.british-history.ac.uk/vch/surrey/vol3/pp482-487#fnn69.

[9] 28 July 1786. *The Court Journals and Letters of Frances Burney* (ed. Peter Sabor), vol. 1, 1786; 2011, p. 52.

[10] Caroline Lybbe-Powys Diaries, *loc. cit.*

[11] Angelo, 1823, p. 192.

[12] Quoted Whitley, p. 177.

[13] Jane Roberts (ed.), *George III and Queen Charlotte*, 2004, Royal Collection, pp. 73ff. Angelo, 1823, p. 194.

[14] *FD*, 6 Jan. 1799, vol. 4, p. 1129.

[15] Angelo, 1823, pp. 353–4.

[16] *Ibid.*

[17] *Ibid.*

[18] Adapted from letter James Ward to J. G. Pratt, nd [*c.*1805], Fitzwilliam Museum, Cambridge. I am grateful to Kate Heard for drawing this letter to my attention.

[19] What Angelo actually reported Abel to say was: 'Yes, but whosoever dat may be, vot a strange degeneracy of your gountryvomans for to imidade all the drumperry fashions from France!' Angelo, 1823, p. 353.

[20] GH, 1993.001.

[21] See Timothy J. Standring and Martin Clayton, *Castiglione, Lost Genius. Masterworks on Paper from the Royal Collection*, Royal Collection Trust, 2015.

[22] 23 July 1786. Fanny Burney, *The Diary and Letters of Madame D'Arblay*, 1842, vol. 1, p. 421.

23 Charles Burney on J. C. Fischer in A. Rees, et al, *The Cyclopaedia, or Universal Dictionary of Arts Science and Literature*, vol. 14, p. 319.

24 Mozart to his father, Vienna, 4 April 1787. Cliff Eisen (ed.), *Wolfgang Amadeus Mozart: A Life in Letters*, Penguin, 2006, pp. 526–7.

25 Charles Burney, *loc. cit.*

26 Angelo, 1828, p. 350.

27 Letter TG to Joshua Reynolds, nd [1782]. Hayes, no. 88.

28 *Fraser's Mag.*

29 *Ibid.*

30 William Pearce, 11 Feb. 1834, recorded by J. W. Croker, 1842, in brown card folder inscr. 'Letters memoranda &c / in reference to / Drawings by T Gainsborough'. Pfungst Papers, GH Archive, 1999.016.

31 *Morning Post*, 4 May 1789.

35. Whilst he breathes

1 RA Archive, Council minutes, 11 April 1779, p. 268; 13 April 1781, p. 303; 11 April 1783, p. 342.

2 *Wine and Walnuts*, p. 297.

3 *Fraser's Mag.*

4 Anthony Pasquin, *Memoirs of the Royal Academicians, and an Authentic History of the Artists of Ireland*, 1796, p. 78. Cornmarket Facsimile, 1970.

5 The Show Box and its glass slides are in the V&A, P.32-44-1955. Jonathan Mayne, *Thomas Gainsborough's Exhibition Box*, V&A Museum Bulletin Reprint, no. 18, 1971.

6 John Hayes, *Gainsborough as Printmaker*, A. Zwemmer, 1971.

7 Philip Olleson (ed.), *The Journals and Letters of Susan Burney: Music and Society in Late-Eighteenth Century England*, Routledge, 2012, p. 162.

8 *Morning Post*, 17 May 1780. The 'New Church' is St Clement Danes. *Johann Fischer*: Royal Collection, London; *John Henderson*: NPG, London; *George Coyte*, J. G. Johnson Collection, Philadelphia.

9 *Ibid.*

10 *London Courant*, 3 May 1780. *The Cottage Door*: Huntington Library and Art Gallery, San Marino, CA. The identity of the landscape is not known.

11 6 May 1781. *Horace Walpole's Correspondence*, Yale University Press, 1937–83, vol. 29, p. 138.

12 *Morning Herald*, 1 May 1781.

13 *London Courant*, 3 May 1781.

14 Elizabeth Einberg, *Gainsborough's Giovanna Bacelli*, Tate Gallery, 1976.

15 Mr Robinson had been in and out of prison, but seems by now to have vanished.

16 *Morning Herald*, 1 May 1782.

17 Letter Joshua Reynolds to the Earl of Upper Ossory, 10 July 1786. John Ingamells and John Edgcumbe (eds), *The Letters of Joshua Reynolds*, Yale University Press, 2000, no. 153.

18 Letter TG to Francis Newton, April 1783. Hayes, no. 89. 'My Dogs' is *Two*

Shepherd Boys with Dogs Fighting, Kenwood House.

[19] Letter TG to William Chambers, 27 April 1783. Hayes, no. 91.

[20] Letter TG to the RA Hanging Committee, April 1783. Hayes, no. 90.

[21] Letter TG to William Pearce, Summer, 1783. Hayes, no. 92.

[22] *FD*, 10 Nov. 1807, vol. 8, p. 3138.

[23] Letter William Jackson to Thomas Jackson, 18 Oct. 1783. *GHR*, Jackson, p. 113.

[24] *FD*, Wed. 29 Oct. 1794, vol. 1, p. 255.

[25] James Ward's Journal, 13 Aug. 1819. Edward Nygren, 'James Ward, RA (1769–1859): Papers and Patrons', *Walpole Society*, vol. 75, 2013, p. 56.

[26] *Whitehall Evening Post*, 21–3 Aug. 1798. Quoted in Amal Asfour and Paul Williamson, *Gainsborough's Vision*, Liverpool University Press, 1999, p. 250.

[27] Art Gallery of Ontario, Toronto. See Paul Spencer-Longhurst and Janet M. Brooke, *Thomas Gainsborough: The Harvest Wagon*, exhn. cat., Birmingham and Toronto, 1995.

[28] Letter TG to the RA Hanging Committee, before 10 April 1784. Hayes, no. 95. *Earl and Countess of Buckinghamshire*, two full-lengths, Blickling Hall; *Lord Rodney*, Dalmeny House, near Edinburgh; *Lord Rawdon*, Sào Paulo, Brazil, Museu de Arte; *Edward and William Tomkinson*: Coll. Taft Museum of Art, Cincinnati.

[29] Tate Britain, London.

[30] RA Archive, Council minutes, 9 April 1784, p. 358.

[31] Letter TG to the RA Hanging Committee, 10 April 1784. Hayes, no. 97. Transcribed from the rediscovered original, RA Archive, RAA/SEC/2/35/2. Belsey has suggested that this was all a ruse, intended to provoke a negative reaction from the Academy, and that some of the portraits may not yet have been painted. Belsey, *Cottage Doors*, pp. 59–63.

[32] RA Archive, Council minutes, 10 April 1784, p. 358.

[33] *FD*, 29 Oct. 1794, vol. 1, pp. 255–6.

[34] Both National Gallery, London.

[35] John Cloake, 'A view of Richmond Hill in the late 1740s', and 'Thomas Gainsborough's House at Richmond', *Richmond History: Journal of the Richmond Local History Society*, vol. 25, 2004, pp. 16–33 and 24–6. The cottage was at or near the site of the present no. 126 Richmond Hill.

[36] *Morning Post*, 4 May 1789.

[37] *FD*, 29 Oct. 1794, vol. 1, pp. 255–6. Planned meetings are listed in Reynolds' sitters' book, Sunday, 3 November and Sunday, 10 November 1782; RA Archive. Belsey, *loc. cit.*, suggests that this was merely a front for airing the two artists' differences.

[38] Sir James Prior, *Life of Edmond Malone*, 1860, p. 393.

36. Repaired with gold and silver

[1] http://www.taftmuseum.org/collections/collection_highlights/18-1931-412_tma.

[2] *ODNB*, James Graham.

[3] *Dr Graham's Private Medical Advice to Married Ladies and Gentlemen*, 1783.

[4] *Ibid.*, pp. 37–8.

[5] *Ibid.*

[6] Kate Williams, *England's Mistress: The Infamous Life of Emma Hamilton*, Hutchinson, 2006, pp. 54–9.

[7] Whitley, p. 109. *Musidora* is in Tate Britain, London.

[8] Across Gainsborough's time at Schomberg House the mercers in the eastern wing of the building were, in succession, Gregg and Lavie (1769–75), Lavie (1776–81) and William King (1785–96). http://www.british-history.ac.uk/survey-london/vols29-30/pt1/pp368-377.

[9] Angelo, 1823, pp. 224–5. For Whitefoord, see James Hamilton, *A Strange Business: Making Art and Money in Nineteenth Century Britain*, 2014, ch. 6.

[10] Letter TG to Richard Cosway, nd. Hayes, no. 99.

[11] Letter TG to Richard Cosway, nd. Hayes, no. 100.

[12] The suggestion of Jacob Simon. Hayes, no. 100, note.

[13] Smith, *Nollekens*, vol. 1, p. 185. Christie's sale of Gainsborough's effects on 11 May 1799 has as lot 119 'a pair of curious groups modelled in clay, with glass cases'.

[14] *Morning Herald*, 7 May 1787.

[15] Waddesdon, The Rothschild Collection (National Trust).

[16] National Gallery, London.

[17] Wallace Collection, London, P42.

[18] Huntington Library and Art Gallery, San Marino, CA.

[19] Sarah Siddons to the Earl of Hardwicke, nd [?1783–4], Letters to Hardwicke from Artists and Writers, BL Add MS 35350, f. 98.

[20] National Gallery, London. WIll of William Hallett III, dated 3 Dec. 1834. Typescript, checked against Prob 11/1998/ff. 315–17, Picture file, National Gallery Archive. *Gents. Mag.*, 30 July 1785, p. 664, names her as Elizabeth Stephen.

[21] Payment of £126 to TG entered in ledgers of William Hallett's account in Drummonds Bank, 4 March 1786. Picture file, National Gallery Archive.

[22] Thicknesse, *Memoirs*, pp. 171–2.

[23] *ODNB*, J. J. Merlin.

[24] Kenwood, English Heritage.

[25] Royal Archives, GEO/MAIN/26791. The head-and-shoulders portraits were 30 guineas (£31.10s) each, the Mrs Robinson full-length and the landscapes were 100 guineas (£105) each, and the St Leger portraits 120 guineas each (£126).

37. No apology can be made for this deficiency

[1] RA Archive, General Assembly minutes, 10 Dec. 1774, p. 93.

[2] RA Archive, Council minutes, 6 March 1775, p. 192.

[3] RA Archive, General Assembly minutes, 10 Dec. 1774, p. 93. Benjamin West and Charles Catton were also nominated for President this year. They received one vote each.

[4] *Op. cit.*, 10 Dec. 1778, p. 129.

[5] RA Archive, General Assembly minutes, 11 Feb. 1783, p. 165; 3 March 1783, p. 167.

[6] Joshua Reynolds, *First Discourse*, Jan. 1769.

[7] 'Hactenus dictum sit de dignitate artis morientis': 'This must for the time being be sufficient about the dignity of this dying art.' Pliny the Elder, *On Painting*. See Jacob Isager, *Pliny on Art and Society*, Routledge, 2010, p. 122.

[8] Walker Art Gallery, Liverpool. Exhibited as 'A portrait of a lady, whole length'.

[9] Angelo, 1823, p. 192.

[10] Joshua Reynolds *Sixth Discourse*, Dec. 1774.

[11] Letter TG to William Jackson, 14 Sept. 1767. Hayes, no. 24.

[12] *Autobiography of Miss Cornelia Knight, Lady Companion to the Princess Charlotte of Wales, with extracts from her journals and anecdote books*, 2 vols., 1861, vol. 1 p. 9.

[13] Joshua Reynolds, *Fifth Discourse*, Dec. 1772. Letter TG to William Hoare, 1773. Hayes, no. 65.

[14] *Morning Post*, 25 April 1777.

[15] Joshua Reynolds, *Fourteenth Discourse*, Dec. 1788.

[16] *Fraser's Mag.*

38. A sense of closure

[1] *Morning Herald*, dated June 1787; Whitley, pp. 279–81.

[2] Whitley, p. 112.

[3] Cunningham, p. 328.

[4] Private collection, on loan to GHS.

[5] *The Morning Walk* and *The Market Cart*, National Gallery; *Girl with a Pitcher*, National Gallery of Ireland, Dublin; *Diana and Actaeon*, Royal Collection. *The Woodman* is destroyed, and now known only through its engraving of 1790.

[6] Rembrandt's original is in the National Gallery, London. Gainsborough's copy may have been acquired by Queen Charlotte after Gainsborough's death. See William Hazlitt, *Criticisms of Art and Sketches of the Picture Galleries of England*, 1843, p. 63.

[7] See Martin Postle, *Angels & Urchins: The Fancy Picture in 18th Century British Art*, exhn cat., Nottingham and Kenwood, 1998.

[8] *Good Shepherd*: private collection; *Two Shepherd Boys with Dogs Fighting*: Kenwood House.

[9] *Public Advertiser*, 2 May 1783. Quoted Postle, *op. cit.*, p. 60.

[10] See also Christopher Lloyd, *Gainsborough's 'Diana and Actaeon' Revealed*, GH, 2011; Michael Rosenthal, *The Art of Thomas Gainsborough*, 1999, ch. 10; Amal Asfour and Paul Williamson, *Gainsborough's Vision*, 1988, ch. 8.

[11] Museum of Fine Arts, Boston, MA.

[12] There is at Knole a drawing by Joseph Nash (1808–78), *Giovanna Baccelli Posing to Gainsborough in the Ballroom at Knole*; pen and pencil on paper, laid

down on canvas, 90 x 115.5. This is an imaginative historicising account of events.

39. From a sincere heart

[1] Letter TG to Henry Bate Dudley, 20 June 1787. Hayes, no. 101.
[2] Tyler, 'Daughters'.
[3] RA Archive, Council minutes, 13 Sept. 1787, p. 45.
[4] Letter TG to Marquess of Lansdowne, 8 Dec. 1787. Hayes, no. 103.
[5] Letter TG to Henry Bate Dudley, 11 March 1788. Hayes, no. 104.
[6] Cunningham, p. 340.
[7] *Times*, 23 Feb. 1788.
[8] Cunningham, p. 341.
[9] *Morning Herald*, 5 May 1788.
[10] Letter TG to an unknown recipient, 'a Gentleman to whom I have not the honor of being the least known'. Nd [perhaps after 5 May 1788]. Hayes, no. 105.
[11] Thicknesse, p. 50.
[12] Letters TG to Robert Bowyer and William Pearce, 1 [and nd] May 1788. Hayes, nos 106 and 107.
[13] Letter TG to Thomas Harvey, 22 May 1788. Hayes, no. 108.
[14] Obituary, *Gents. Mag.*, Aug. 1788, pp. 753ff.
[15] Letter TG to Thomas Harvey, 22 May 1788. Hayes, no. 108.
[16] Caroline Lybbe-Powys Diaries, vol. 1, May 1788, BL Add MS 42160, f. 108.
[17] Letter TG to unknown recipient, 15 June 1788. Hayes, no. 109.
[18] Letter TG to Sir Joshua Reynolds, [nd] July 1788. Hayes, no. 110.
[19] *FD*, Wed 29 Oct. 1794, vol. 1, p. 255.
[20] John Hayes, 'Gainsborough's Richmond water-walk', *Burl. Mag.*, 111, no. 790 (Jan. 1969), pp. 28–31. William Pearce, 11 Feb. 1834, recorded by J. W. Croker, 1842, in brown card folder inscr. 'Letters memoranda &c / in reference to / Drawings by T Gainsborough'. Pfungst Papers, GH Archive, 1999.016.
[21] Cunningham, p. 341.
[22] Letter B[arbara] Hofland (1770–1844) to Mr and Mrs Hall [or Hale], nd, but probably *c*.1840, as the writer describes herself in the letter as 'a fragile old woman'. GH, 2003.001.

40. Epilogue

[1] Sale catalogue in GHA Archive.
[2] James Ward's Journal, 13 Aug. 1819. Edward Nygren, 'James Ward, RA (1769–1859): Papers and Patrons', *Walpole Society*, vol. 75, 2013, p. 56.

Select Bibliography

Most major books on Gainsborough have extensive bibliographies, so I refer the reader to those, and will not repeat them here. However, the following books, published in the twentieth and the twenty-first centuries, are those I have found particularly interesting.

Amal Asfour and Paul Williamson, *Gainsborough's Vision*, Liverpool University Press, 1999.

Hugh Belsey, *Gainsborough's Family*, Gainsborough's House, 1988.

Hugh Belsey, *Thomas Gainsborough: A Country Life*, Prestel, 1988.

Hugh Belsey, with Paul Danks, *Love's Prospect: Gainsborough's* Byam Family *and the Eighteenth-Century Marriage Portrait*, Holburne Museum of Art, 2001.

Hugh Belsey, *Gainsborough at Gainsborough's House*, Paul Holberton, 2002.

Hugh Belsey, *Gainsborough's Cottage Doors: An Insight into the Artist's Last Decade*, Paul Holberton, 2013. This author has written widely on Gainsborough, and has curated many exhibitions of his work. I have drawn with gratitude on his many articles. His catalogue raisonné of Gainsborough's portraits will be published in due course.

Ann Bermingham (ed.), *Sensation and Sensibility: Views of Gainsborough's* Cottage Door, Yale University Press, 2005.

Timothy Clifford, Antony Griffiths and Martin Royalton-Kisch, *Gainsborough and Reynolds in the British Museum* (exhn. cat.), British Museum, 1978.

Malcolm Cormack, *The Paintings of Thomas Gainsborough*, Cambridge University Press, 1991.

Adrienne Corri, *The Search for Gainsborough*, Jonathan Cape, 1984. Adrienne Corri (1930–2016) had a passion for Gainsborough, and undertook a personal quest for truths about him. The steam that drove her also powered her energy and flair as an actor. This refreshing book is as much about the vicissitudes of touring theatre in Britain in the 1970s and 1980s as it is about finding Gainsborough.

John Hayes, *The Drawings of Thomas Gainsborough*, 2 vols, A. Zwemmer, 1970.

John Hayes, *Gainsborough as Printmaker*, A. Zwemmer, 1971.

John Hayes, *Thomas Gainsborough* (exhn. cat.), Tate Gallery, 1980.

John Hayes, *The Landscape Paintings of Thomas Gainsborough: A Critical Text and Catalogue Raisonné*, London, 2 vols, Sotheby Publications, 1982.

John Hayes (ed.), *The Letters of Thomas Gainsborough*, Yale University, 2001.

Nicola Kalinsky, *Gainsborough*, Phaidon, 1995.

Benedict Leca (ed.), *Thomas Gainsborough and the Modern Woman*, D. Giles, 2010.

Jack Lindsay, *Gainsborough, His Life and Art*, Granada, 1981.

Christopher Lloyd, *Gainsborough's* Diana and Actaeon *Revealed*, Gainsborough's House, 2011.

Martin Postle, *Thomas Gainsborough*, Tate Publishing, 2002.

Michael Rosenthal, *The Art of Thomas Gainsborough: 'A little business for the eye'*, Yale University Press, 1999.

Michael Rosenthal and Martin Myrone (eds), *Gainsborough* (exhn. cat.), Tate Publishing, 2002.

Susan Sloman, *Gainsborough in Bath*, Yale University Press, 2002.

Susan Sloman, *Gainsborough's Landscapes: Themes and Variations*, Philip Wilson and the Holburne Museum of Art, 2011.

This author has written widely on Gainsborough, and I have also drawn with gratitude on her many articles. Her *Gainsborough in London* will be published in due course.

Paul Spencer-Longhurst and Janet M. Brooke, *Thomas Gainsborough:* The Harvest Wagon, Birmingham and Toronto, 1995.

Lindsay Stainton and Bendor Grosvenor, *'Tom will be a genius': New landscapes by the Young Thomas Gainsborough*, Philip Mould, 2009.

Hugh Stokes, *Thomas Gainsborough*, Philip Allan, 1925.

David Tyler, many articles, published mainly in *Gainsborough's House Review*.

William Vaughan, *Gainsborough*, Thames and Hudson, 2002.

Ellis Waterhouse, *Gainsborough*, Spring Books, 1966 edn.

This was the first full detailed catalogue of all of Gainsborough's paintings then known. Hugh Belsey is currently preparing a catalogue raisonné of the portraits.

W. T. Whitley, *Thomas Gainsborough*, Smith, Elder & Co., 1915.

Index